HOLOCAUST MEMORY REFRAMED

HOLOCAUST MEMORY REFRAMED

Museums and the Challenges of Representation

JENNIFER HANSEN-GLUCKLICH

RUTGERS UNIVERSITY PRESS
New Brunswick, New Jersey, and London

Library of Congress Cataloging-in-Publication Data
Hansen-Glucklich, Jennifer.
Holocaust memory reframed : museums and the challenges of representation /
Jennifer Hansen-Glucklich.
pages cm
Includes bibliographical references and index.
ISBN 978-0-8135-6324-4 (hardcover : alk. paper) — ISBN 978-0-8135-6323-7
(pbk. : alk. paper) — ISBN 978-0-8135-6525-5 (e-book)
1. Museum architecture. 2. Holocaust, Jewish (1939–1945)—Museums. 3. Holocaust,
Jewish (1939–1945), and architecture. 4. Memorialization. 5. Symbolism in architec-
ture. 6. Holocaust, Jewish (1939–1945)—Study and teaching. 7. Museum techniques.
8. Jüdisches Museum Berlin (1999–) 9. Yad va-shem, rashut ha-zikaron la-Sho'ah
vela-gevurah. Muze'on. 10. United States Holocaust Memorial Museum. I. Title.

NA6690.H36 2014
940.53'18074—dc23 2013021941

A British Cataloging-in-Publication record for this book is available from the British
Library.

Visit our website: http://rutgerspress.rutgers.edu

Manufactured in the United States of America

"Find yourself a teacher and make a friend for life" (*Pirkei Avot* 1:6).

For Renate Voris, my teacher and friend

CONTENTS

ILLUSTRATIONS

- They show persecutors' arch + technology of death,
Jews thru Nazi eyes, victims' perspectives + artifacts
+ images, liberators + Jews thru liberators' eyes.
 - what is missing from the museums?

① the lives of the perpetrators + their images
in an effort to understand that terrible
evil hides in the mundane. effort to
understand that it can happen again
if we fail to recognize it + its causes

② the collaborators + their situations
Knows history to avoid it. How can
it be recognized + avoided. How could
these be included w/o detracting
from the empathy for the real victims?

PREFACE AND ACKNOWLEDGMENTS

Writing, as often lamented by those like myself who struggle with the written word in a perpetual battle for clarity and simplicity, is at times difficult as well as lonely work. As Ernest Hemingway famously quipped, "There is nothing to writing. All you do is sit down at a typewriter and bleed." Bringing this project to a close, I realize how deeply indebted I am to my teachers, colleagues, friends, and family for seeing me through the past few years, both intellectually and personally. Writing a first book in particular has meant, in this author's case, leaning heavily on others who generously shared their time, advice, and ideas.

I would first like to thank Marlie Wasserman, the director at Rutgers University Press, for believing in this project and for her helpful assistance throughout this process, as well as for her kind patience with a first-time author. I am especially grateful, and remain forever in debt, to my professor and adviser Renate Voris at the University of Virginia. I could not have wished for a more inspiring and devoted *Doktormutter*; her insight and her critical—yet always kind—attention to my work, as well as the intellectual and personal support she has given me over the years, made this book possible. Renate is the teacher one hopes for but so rarely finds, and it is to her that I dedicate this book, in boundless gratitude and admiration.

I would also like to thank Benjamin Bennett, Asher Biemann, and Jeff Grossman at the University of Virginia. I owe a special thanks to Asher Biemann for his kind encouragement, his active interest in and support of my work, and his friendship. I am grateful to Jeff Grossman as well for always making time for me and for my work; for helping me in a thousand ways, both during my graduate studies and since; and for sharing with me his insights and thoughts. I am also grateful to Paul Jaskot, K. Hannah Holtschneider, and Vanessa Ochs for their helpful advice and comments on various parts of this book and to Gabriel Finder for starting me on the path of Jewish Studies at the University of Virginia. I am especially grateful to Jonathan Skolnik, who gave me an inestimable gift many years ago at the University of Maryland, College Park, when he introduced me to the essays of Jean Améry. This well-worn volume still accompanies me on my travels.

I am particularly indebted to the anonymous reader for Rutgers University Press, who invested a great deal of time and thought in reading and critiquing my manuscript and in offering many helpful suggestions, which have much improved this work. Finally, I am grateful to Susan Silver for her careful copyediting of the manuscript.

I am grateful for the institutional and financial support I have received during the time I spent researching and writing. This book was made possible (in part) by funds granted to the author through a 2008–2009 Diane and Howard Wohl Fellowship at the Center for Advanced Holocaust Studies, United States Holocaust Memorial Museum. The statements made and views expressed, however, are solely my responsibility. I am also grateful to the center for awarding me with a 2007 Dorot Foundation Summer Graduate Research Assistantship and to the center's Emerging Scholars Program for its support in the publication of this volume. I would like to thank the University of Virginia for a generous research award in 2010 that allowed me to travel to Germany and Israel at the beginning of this project and also the German Academic Exchange Service (DAAD) for a research grant in Berlin. Finally, I would like to thank the University of Mary Washington for a faculty development grant that helped support the publication of this book. In particular, I am grateful to Marcel Rotter, Leonard Koos, and Ana Chichester for their assistance in securing the grant (and to Marcel for his kind encouragement over the past two years as well).

Portions of this book have appeared in previous publications, and I am grateful for the permission granted me to reprint them here. Chapter 1 reproduces in part material published in the article "Evoking the Sacred: Visual Holocaust Narratives in National Museums," *Journal of Modern Jewish Studies* 9, no. 2 (July 2010): 209–232. Chapter 6 contains an argument that appears, in nascent form, in "Disfigured Memory: The Reshaping of Holocaust Symbols in Yad Vashem and the Jewish Museum Berlin," in *Nexus: Essays in German Jewish Studies*, edited by William Donahue and Martha Helfer (Rochester, NY: Camden House, 2011).

I owe a special thanks to the artists who have generously shared photographs of their work for this book: Michael Bielicky, Arnold Dreyblatt, Via Lewandowsky, Michal Rovner, and Uri Tzaig. I would also like to thank Franziska Windisch at the Jewish Museum Berlin for her assistance and, at Yad Vashem, Naama Shilo, Leah Teichthal, and Estee Yaari.

I am particularly grateful to the clay animator, artist, professor, and author Rony Oren, who not only photographed Yad Vashem for this work but also cheerfully traveled to Berlin to take photographs of the Jewish Museum so that this book might benefit from his artistic eye. I thank as well Erle Sørheim, my friend and host in Berlin, and Oliver Volmerich, for his generous hospitality in Dortmund on many occasions.

Though I am grateful to all my friends who have supported me throughout this process, I must especially name my dear friends Selma Erdogdu-Volmerich, Maria Ramos, and Melissa Wiser, as well as Michal Aharony and Kristan Sternberg. Their affection and humor—and their always-ready pep talks—have meant the world to me. Finally, I am grateful to my mother, Linette Dugo; my sister, Erica Mumford; and my maternal grandmother, Norma Haag, for their love and for inspiring me more than they know. I would also like to thank my husband's family in Israel, especially Avner Glucklich and Sarah Itzhaki, for their warm interest in this work and in its author.

My greatest debt is owed to my husband and teacher, Ariel Glucklich, who has helped me through every stage in the life of this project, from its first conception to its final existence as a book. His unwavering devotion and encouragement, and especially his sharp editor's eye, merciless pen, and often-miraculous patience, are to thank for the virtues this book possesses. I am grateful to him, finally, for spending more hours wandering through Holocaust museums than should be expected of any Israeli and, above all, for his kindness and love.

HOLOCAUST MEMORY REFRAMED

INTRODUCTION

In a personal meditation on exile and homesickness titled "How Much Home Does a Person Need?" (1966) the Jewish, Austrian-born Holocaust survivor and essayist Jean Améry writes, "Anyone who is familiar with exile has gained many an insight into life but has discovered that it holds even more questions. Among the answers there is the realization, which at first seems trivial, that there is no return, because the re-entrance into a place is never also a recovery of the lost time."¹ In the original German, these lines reveal more poignantly the resonant echo between the words *Wiedereintritt* (reentrance) and *Wiedergewinn* (recovery), thereby ironically underscoring the abyss between the two concepts.

Améry's deceptively simple realization returned to me suddenly, many years after first reading these lines, as I encountered for the first time Daniel Libeskind's Jewish Museum extension on Berlin's Lindenstraße and observed the shattered Star of David that extends scar-like across its zinc facade. Faced with the task of designing a museum dedicated to German Jewish culture and history in Berlin—the very landscape within which German Jews were stripped of their citizenship and from which they were violently cast out into either exile or death—Libeskind created an extension that illustrates Améry's insight with a poet's economy of phrase. Time here is frozen—the shattered German Jewish relationship and culture lie in pieces, and a coherent narrative that might have connected past and present remains broken. The visitor may enter the museum and may survey the past by reentering, so to speak, the places of history depicted in the exhibits. However, as Améry admonishes us, although one may return to the places of the past, such a reentrance is never a recovery of lost time as well, and the rupture, or caesura, in German Jewish history remains irreparable.

The question [handwritten marginalia]

The leitmotif that runs throughout this book is this chasm between reentrance and recovery; more specifically, the book engages with the question of how three museums that memorialize the Holocaust—Yad Vashem: The Holocaust Martyrs' and Heroes' Remembrance Authority in Jerusalem, the Jewish Museum Berlin, and the United States Holocaust Memorial Museum (hereafter USHMM) in Washington, DC—draw on particular aesthetic techniques of representation to evoke specific forms of Holocaust remembrance. Because this is a book about Holocaust remembrance and about how Holocaust museums and exhibits encourage different kinds of memory, it necessarily is bound to the past. In his now-classic reading of Paul Klee's painting *Angelus Novus*, Walter Benjamin describes how the angel of history stands with staring eyes, open mouth, and spread wings, his face turned toward the past in which he sees a single catastrophe whose consequences continue to pile "wreckage upon wreckage" before him. The angel would like to stay, Benjamin writes, to "awaken the dead and make whole what has been smashed," but the storm called "progress"—the inevitable and unrelenting passage of time—"irresistibly propels him into the future to which his back is turned, while the pile of debris before him grows skyward."[2]

With every passing year the Holocaust recedes further into history and the number of survivors dwindles, but—for many of us—the Holocaust remains the single catastrophe that continues to pile wreckage upon wreckage, growing skyward until it threatens to obscure even the "glimmerings of the dawn" and to darken "twilight stars," to quote Job 3:9. Despite its backward gaze toward that which can never again be made whole, this is still a book about the present—as all books about memorialization inevitably are—and perhaps a bit about the future as well, for the issues at stake concern not only how we encounter the past but how we understand this past in relation to the present and how that understanding shapes the future.

Museums are often conceptualized as containers for memory, and in a certain sense this metaphor rings true; after all, museums with a historical focus are places devoted to constructing a particular view of the past and to putting that chosen past on display, thereby claiming to offer the visitor a window into another time and place for a brief moment. In another sense, and more fundamentally, however, the metaphor falls conspicuously short because it suggests stasis. It fails to acknowledge the transformative effects of a museum—it ignores, in other words, the way that a museum can create, through a particular poetics or language of representation, a narrative powerful enough to

initiate in the visitor a change in consciousness. The impact that an aestheti-cally innovative museum such as the new Yad Vashem in Jerusalem may have on a visitor might be akin to any experience that dramatically alters the way one understands the world and one's place in it. As this book argues, the aes-thetic presentation and use of visual techniques in the museums under dis-cussion have real consequences in terms of how we perceive and remember the Holocaust. The framing of authentic artifacts, the display of photographic images, and the commission of original artworks in Holocaust museums and exhibits do not simply illustrate the story being told; rather, they *are* the story, and they largely determine how we remember the past and, therefore, how we understand the present.

Argument 1

Writing in the first decades of the postwar years, Améry expressed his fear that "natural time" would soon allow the crimes of the Third Reich to be regarded as "purely and simply history, no better and no worse than dramatic historical epochs just happen to be, bloodstained perhaps, but after all a Reich that also had its everyday family life. The picture of great-grandfather in his SS uniform will hang in the parlor, and the children in the schools will learn less about the selection ramps than about an astound-ing triumph over general unemployment."[3] Améry was, thankfully, mis-taken, and the proliferation of Holocaust memorials and museums across the German landscape is only one of the more visible signs that contempo-rary Germany has not allowed such a disgrace to take place. Having com-mitted suicide in 1978, Améry did not live to witness the transformation of Germany—the decades of efforts at atonement and the acts of penance and the processes of *Vergangenheitsbewältigung* and *Aufarbeitung der Vergan-genheit* (coming to terms with and working through the past) that would increasingly characterize German culture during the next thirty years.

Améry mourned the "German revolution that did not take place" and that did not drive out National Socialism from within, but today it is per-haps possible to suggest that a revolution has indeed taken place—a revo-lution of minds played out on the field of memory. This is a version of the "extravagant moral daydream" in which Améry—futilely, he believed—allowed himself to indulge when he imagined that Germany might one day "learn to comprehend its past acquiescence in the Third Reich as the total negation not only of the world that it plagued with war and death but also of its own better origins" and would "no longer repress or hush up the twelve years that for us others really were a thousand, but claim

them as its realized negation of the world and its self, as its own negative possession. . . . Two groups of people, the overpowered and those who overpowered them, would be joined in the desire that time be turned back and, with it, that history become moral." If this were to take place, Améry writes, time would turn backward, and the "German revolution would be made good. . . . And in the end Germans would really achieve what the people once did not have the might or the will to do . . . the eradication of the ignominy."[4]

It is in light of these thoughts that I analyze in one book Holocaust museums and exhibits in Germany, Israel, and the United States and that it becomes justifiable to speak of common goals and purposes among the Jewish Museum Berlin, Yad Vashem, and USHMM. As I argue, however, the methods and means with which these three museums represent the past and evoke Holocaust memory are at times dramatically different, reflecting the necessary differences in their underlying ideologies of Holocaust remembrance. The book begins with an awareness of the cultural, historical, and political particularities unique to each museum, but also with the conviction that all three museums nevertheless share the fundamental purpose of attempting to commemorate extreme trauma in a way resonant with the context culture and—to use the language of Charles Liebman and Eliezer Don-Yehiya—its "civil religion." In other words, each museum reveals the national Holocaust ideology of its context, including the way that the Holocaust is framed within the country's "civil religion."[5]

This book draws significantly on the work of several scholars within the fields of memory studies and Holocaust studies. It relies in particular on the publications of three scholars who have laid the groundwork for the academic study of Holocaust memorials and museums: Edward T. Linenthal, Oren Baruch Stier, and James E. Young.[6] Even when not directly citing their work, this study benefits greatly from their distinct contributions and remains indebted to their general approaches and methodologies.

The work of Edward T. Linenthal, in particular his in-depth study and "biography" of USHMM, has helped shape this work's understanding of museums as dynamic rather than static institutions that are reflective of manifold—and at times contradictory—interests as well as philosophies of memory and history. Linenthal's exploration of the extent to which a Holocaust museum may help shape a culture's memory and his delineation of the different kinds of memory that a museum may create, based on its methods of display and

the content of its exhibits, has informed this book's theoretical approach from the start.[7]

The influence of Oren Baruch Stier's scholarship underlies many of the concerns as well as the overall method of this work; specifically, this work draws on Stier's focus on the mediation and transmission of Holocaust memory through different concrete forms, on his analysis of how Holocaust memory is shaped by the very forms and media through which the events of the past are communicated, on his unique contribution that memorialization appears in different modes and thus inspires different kinds of memory, and, especially important for this book, on his argument that Holocaust images and artifacts may be used in ritual and religious (or religious-like) ways within Holocaust memorial contexts.[8]

As readers will recognize, this work bears the significant imprint of James E. Young's studies of Holocaust museums and memorials. Several of Young's most salient insights shape this book as a whole, including the idea that Holocaust memory is plural, that each Holocaust memorial site memorializes a unique "Holocaust," and that Holocaust remembrance is culture- and nation-specific. Young's approach toward memorials as "memorial texts" that generate unique meanings and types of memory, furthermore, paves the way for this book's aesthetic interpretation of museum displays and spaces. Finally, this book's concluding chapter on the ritual experiences of museum visitors and the way that these experiences shape memory draws on Young's understanding of the interactive and dialogic relationship between memorials and their viewers.[9]

Drawing on the scholarship of these authors, this book proceeds as follows. Chapter 1, titled "Zakhor: The Task of Holocaust Remembrance, Questions of Representation, and the Sacred," undertakes three tasks: it discusses Jewish approaches to Holocaust remembrance and the role of remembrance in Judaism in general; it outlines issues that bear on contemporary Holocaust representation and commemoration; and it explores the idea of the sacred in Holocaust remembrance in terms of both spatial and temporal experience. This consideration of the sacred addresses the perception that the Holocaust transcends normal, secular historical experience as well as the consequences of such a perception—namely, that it poses particular challenges for museums and exhibits that represent the Holocaust.

Chapter 2, "An Architecture of Absence: Daniel Libeskind's Jewish Museum Berlin," focuses on Libeskind's aesthetics of absence and the

way in which his voids, broken lines, and memorial spaces evoke a sense of a negative sacred. The chapter also analyzes a number of concepts and sources, which Libeskind discusses in his writings, as they manifest themselves in his design, including the concept of an "irrational matrix" of German and German Jewish lives, Arnold Schoenberg's opera *Moses und Aron*, the recovery of a proliferation of names of deported German Jews, and Walter Benjamin's *Einbahnstraße* (*One-Way Street*).

Chapter 3, "Architectures of Redemption and Experience: Yad Vashem and the U.S. Holocaust Memorial Museum," focuses on the architectural narratives developed in Yad Vashem and USHMM. In Yad Vashem's Holocaust History Museum, architect Moshe Safdie develops a narrative rooted in a redemptive, Zionist story of homecoming and renewal in contrast to death and suffering in exile. This redemptive account draws on the symbolism of autochthony and the sacred role of memory in Judaism. The architect of USHMM, James Ingo Freed, in contrast, translates certain concepts of Holocaust experience into the museum in an effort to metaphorically overcome geographic and temporal—and thereby psychological—distance.

With chapters 4, 5, and 6, the book's focus shifts to the exhibits within the three museums as well as memorials and monuments that are part of the larger Yad Vashem complex. Chapter 4, called "The Artful Eye: Learning to See and Perceive Otherwise inside Museum Exhibits," analyzes how museum displays encourage specific modes of perception that in turn evoke particular ways of remembering the past. Exhibits discussed in this chapter include, in addition to a number of smaller photograph and video displays, the *Tower of Faces* in USHMM, the *Hall of Names* in Yad Vashem, a video installation by Michal Rovner in Yad Vashem, and installations in the Jewish Museum Berlin by Via Lewandowsky and Arnold Dreyblatt.

Chapter 5, "'We Are the Last Witnesses': Artifact, Aura, and Authenticity," argues that Holocaust museums and exhibits frame authentic artifacts as witnesses to Holocaust atrocities in an attempt to transform visitors themselves into vicarious witnesses. Artifact exhibits analyzed in this chapter include an exhibit of concentration camp victims' shoes, a Torah ark desecrated during Kristallnacht, and a German railway car from the World War II era in USHMM. Displays of artifacts and victims' personal possessions in the Jewish Museum Berlin and Yad Vashem draw on very different aesthetic techniques and, I argue, promote a radically different kind of remembrance than that of USHMM.

Chapter 6, "Refiguring the Sacred: Strategies of Disfiguration in *String*, the *Memorial to the Deportees*, and *Menora*," examines in close detail three memorials and exhibits at Yad Vashem and the Jewish Museum Berlin—*String*, a video installation evocative of the Torah; the *Memorial to the Deportees*, an outdoor deportation railway car memorial; and *Menora*, a video sculpture that draws on the imagery of Hanukkah menorah candles. I argue that each of these exhibits first destabilizes or ironicizes a conventional trope of Holocaust memorialization—the Torah scroll or book, the deportation railway car, and the candle—and then, through disfiguration, reinvests the trope with sacred meaning.

The book's seventh and final chapter, titled "Rituals of Remembrance in Jerusalem and Berlin: Museum Visiting as Pilgrimage and Performance," suggests that the physical act of visiting a museum may function as a pilgrimage and that the passage of the visitor through a museum's spaces may imitate a rite of passage. As discussed in the first chapter, museum visiting as a mode of Holocaust remembrance takes place not only in space but also in time. Chapter 7 takes the element of time into account as it examines the way that movement and passage may alter consciousness and help shape identity in ways that resonate with a museum's Holocaust narrative.

Museums that both document and memorialize the Holocaust reveal, whether consciously or not, the irreconcilable gap between a reentry into and a recovery of a pre–World War II European, Jewish past. In their best moments, Holocaust and Jewish museums confront this void unequivocally and refuse to fall prey to either a sentimentalizing nostalgia for harmonious coexistence between Germans and Jews, which risks creating a misleadingly idealized, utopian past, or to an attempt to conceal the rift between reentry and recovery through an abundance of evidence that seeks to fill in the cracks of a permanently ruptured and fragmented history.

1 ⇥ ZAKHOR

The Task of Holocaust Remembrance, Questions of Representation, and the Sacred

Forgetfulness prolongs the exile; remembrance is the secret of redemption.

—Ba'al Shem Tov (1698–1760)

These famous words, attributed to the Ba'al Shem Tov, express the sacred duty of remembrance in Judaism. The dynamics of remembrance and forgetting, belonging and banishment, fairly vibrate in these simple lines, while their epigrammatic conciseness and clarity, combined with a symmetry of expression and poetic commingling of physical and spiritual experience, make them inherently memorable and suited to admonish visitors to a Holocaust museum. The former Yad Vashem: The Holocaust Martyrs' and Heroes' Remembrance Authority in Israel chose these words to alert visitors to the duty of remembrance. The quote frames Yad Vashem's Holocaust narrative within the two opposing poles of oblivion and exile on the one hand and remembrance and redemption on the other. These words also imbue the act of remembrance with a meaning that transcends purely secular, historical concerns. Although the new Yad Vashem, which opened in 2005, greets its visitors with a quotation from the book of Ezekiel—"I will put my breath into you and you shall live again, and I will set you upon your own soil" (37:14)—both quotations reveal a common thread running like a leitmotif throughout Yad Vashem's Holocaust narrative: a Zionist vision of redemption and renewed life through homecoming in contrast to destruction and suffering in exile.

Implicitly, the Ba'al Shem Tov's words evoke the moment of revelation at Mount Sinai when Moses and his companions accepted the covenant on behalf of future generations of Jews to come. With no land of their own, the Israelites possessed only time and the promise of a future. The Ba'al Shem Tov speaks toward this future, offering homecoming and redemption to the exiled people of Israel if they will fulfill their sacred duty of remembrance. Within the context of Yad Vashem, these words attain another layer of meaning. Remembrance as a general principle is thus transformed into a specific call for remembrance of the Holocaust, and exile acquires a symbolic dimension: geographic exile may have come to an end with the founding of the State of Israel, but those who deny the ritual of remembrance and thus risk forgetting the past create a new exile in oblivion.

The name "Yad Vashem" itself echoes the meaning of these quoted lines. The words "Yad Vashem" may be translated as "a memorial and a name," and they are taken from Isaiah 56:5: "I will give them, in My House / And within My walls, / A monument and a name / Better than sons or daughters. / I will give them an everlasting name / Which shall not perish." This scriptural promise of immortality through remembrance will be fulfilled by those who visit Yad Vashem. The task of remembrance dictates the narrative of not only Yad Vashem but the other two museums discussed in this book as well: the Jewish Museum Berlin and the USHMM. Each museum's Holocaust narrative, however, is uniquely shaped by the specific cultural and historical context in which it appears so that each museum creates a distinctive form of Holocaust remembrance.

More than sixty years have passed since the defeat of Nazi Germany put an end to the systematic destruction of European Jewry. Over these six decades the great question of whether or not it is possible to represent the Holocaust without inevitably trivializing it has been repeatedly posed and introduced by means of reference to the famous, often decontextualized and therefore misunderstood, claim by Theodor Adorno that to write poetry after Auschwitz is barbaric.[1] In the past several years, however, this question of the possibility of representation has become eclipsed by more current issues concerning the impact of mass media on remembrance and the diminishing number of Holocaust survivors who can provide personal testimony. Particularly striking, however, for even the most casual observer of Holocaust memory discourse, is the veritable explosion of Holocaust museums and memorials around the world, especially across Europe and

the United States, during the past three decades.[2] Serving the twin goals of education and commemoration, Holocaust memorials and museums possess the potential to reach an audience of a size and diversity unrivaled by most other media. The USHMM, for example, reports that since it opened its doors in April 1993 it has received more than thirty-four million visitors—a staggering number that reveals to what extent the museum is shaping Holocaust remembrance in the United States. Given the fact that more individuals will visit the USHMM in any given year than will most likely read Primo Levi's powerful memoir, *Survival in Auschwitz*, for example, or watch Claude Lanzmann's prodigious documentary film, *Shoah*, the question of how museums and memorials shape Holocaust remembrance acquires an urgent significance. As James E. Young has argued, "memory is never shaped in a vacuum; the motives of memory are never pure."[3] In this sense, memorialization practice tells us as much about the present as about the past; a study of contemporary Holocaust commemoration, therefore, as it unfolds in museums and memorials, reveals to us with new clarity the age in which we live as well as times past.

Holocaust Memory Reframed: Museums and the Challenges of Representation addresses the question of how remembering the past illuminates the present. It investigates the ways museums and their exhibits use visual forms in creative, often surprising manners to shape culture-specific Holocaust narratives. Each of the three museums creates a visual language, inscribed in its architecture, exhibits, objects, and spaces, to construct a particular visitor to its unique space. This visitor, like the novelist's "ideal reader," does not exist empirically. Rather, he or she is an ideal composite—fashioned through the language of the museum and made sympathetic to the salient worldview of the museum's host culture. This book begins, in short, by considering the following methodological issue: Holocaust museums and exhibits play an important role in national cultures of remembrance. The Holocaust, however, is widely regarded as possessing significance that goes beyond that of normal history and therefore poses unusual challenges. It raises, for example, aesthetic and ethical questions about how to visually represent extraordinary trauma and rupture. Attempts to memorialize the Holocaust, therefore, must take into account the technical difficulties of representation itself, and this raises the following questions: What are the special representational problems that Holocaust museums and exhibits face? Why do museums engage visually with the Holocaust in such radically

different ways? How do museums employ particular strategies of representation, including mimesis, abstraction, allusion, or fragmentation? What do these choices reveal about different cultural attitudes toward Holocaust memory? And how do certain aesthetic techniques, such as interruption and disfiguration, function in the unfolding of Holocaust narratives in museums?

Although Yad Vashem, the Jewish Museum Berlin, and the USHMM rely on very different strategies in their representations of the Holocaust—which arise, naturally, from different cultural contexts—they share a fundamental task that shapes each of their narratives: they seek to tell the story of the Holocaust in a way that resonates with their national and cultural environments. Both the Jewish Museum Berlin and Yad Vashem resist directly representing the Holocaust. Instead, they rely on aesthetic techniques that break down the illusion of a coherent narrative of remembrance. In contrast, the USHMM adheres to a much more conventional approach, maintaining the illusion that it is possible to offer a comprehensive narrative of the Holocaust.

[margin note: 3 aesthetic approaches]

Although much of the material in museums documenting the Holocaust provides testimony through discursive forms such as survivor testimonies, historical films of Nazi rallies and speeches, text, and statistics, the three museums under examination here operate on another level as well. Certain exhibits, displays, and spaces within the museums go beyond documentation to evoke a sense of the sacred of the type that often surrounds Holocaust sites and artifacts. In this way museums and exhibits seek to involve their visitors in ways that carry them beyond the limits of mere spectatorship and engage them as witnesses. At the same time museums may use visual forms in unexpected ways to emphasize the irrevocable loss and absence at the center of Holocaust remembrance and to illustrate the gap between the construction of a Holocaust narrative and the event itself, which is beyond narrative delineation.

[margin note: ? beyond documentation to sacred ?]

A discussion of how visual museum narratives transcend quotidian representational strategies and thereby shape national Holocaust memory in unique ways requires a brief clarification of contemporary Holocaust memory discourse. The duty to remember underscores every testament to the Holocaust. Scholars today have begun asking in reference to Holocaust representation whether it is possible to have too much memory and whether a surfeit of memory might lead, paradoxically, to forgetting. Critics

of the commercialization of the Holocaust by popular culture contend that Holocaust memory is sacred and as such requires vigilant protection from the threat of desanctification. Steven Spielberg's 1993 film, *Schindler's List*, for example, drew the criticism that it attempts to imagine the "unimaginable" by violating the *Bilderverbot*—the taboo on representation—that surrounds the gas chambers. The problematic overexposure of Holocaust images has become a touchstone in discussions of remembrance. Referring to the way that certain images can come to "encapsulate common ideas of significance and trigger predictable thoughts, [and] feelings," Susan Sontag describes such representative images as the "visual equivalent of sound bites." The idea of the "visual sound bite" reveals how select Holocaust images have been appropriated by popular culture, appearing again and again in films, cartoons, and a variety of other media as instant evocations of suffering. These images evolve into icons; they acquire canonical status and overdetermine Holocaust remembrance. To designate such images as "iconic" is to recognize that their function moves beyond that of the referential and even the symbolic. The most often-reproduced photographs of the Holocaust have come to stand metonymically for the event as a whole. For example, consider the photograph of the little boy in the Warsaw Ghetto who stands at gun point, hands in the air.[4] Photography historian Vicki Goldberg describes this image as a "secular icon," which she defines as a representation that provides an "instant and effortless connection to some deeply meaningful moment in history."[5] These qualities have particularly problematic consequences for Holocaust remembrance, as they give the observer the illusion of a facile grasp of complicated events, which leads in turn to an elision of the past in favor of easily accessible symbols.

The question of how the overexposure of images may negatively affect collective memory of the Holocaust raises the issue of memory itself. The scholarly fascination with memory is uniquely modern, and first began attracting serious academic attention (outside of psychology) in the 1970s, with an upsurge of interest in memoirs and museums.[6] Within the field of memory studies, two distinct conceptions have emerged: memory as private and belonging to the individual, and memory as inherently social and collective. The most famous memory theorist of the twentieth century, Sigmund Freud, investigated the role of repressed memories buried in the unconscious of the individual psyche, moving private memory to the center of his psychology. In contrast to this model stands the concept of collective

memory, whose most influential theorist, Maurice Halbwachs, argues in *Les cadres sociaux de la mémoire* (*The Social Frameworks of Memory*, 1925) that all memory is collective and socially produced. By suggesting that even seemingly private memory is entirely dependent on "frameworks of social memory"—for example, on identity markers such as family, social class, and religion—Halbwachs posits memory as a process shaped by and in society.[7] Theories of collective memory also have a tendency to focus on the role of place in memory formation, particularly sites such as museums and monuments.[8]

It is vital to a discussion of memory today to also consider how mass media contribute to the production of memory. The power of technology to shape memory holds both beneficial and harmful consequences. The increasing autonomy of technological memory—that is, the ability of certain images to bear the weight of remembrance away from their original contexts—can be harmful in its tendency to lead to an image-focused rather than an event-focused remembrance. On the other hand, mass technologies such as photography and film also have the power to create collective memory and to encourage social cohesion among people who do not share social practices or beliefs. The power of technology not only to influence the shape of memory but also to enable new kinds of memory that can transcend group boundaries challenges a more traditional understanding of memory as possessing a basically archival function and of memory institutions, such as museums, as physical containers for memory.[9]

A potentially harmful consequence of the autonomy of technological memory is the repeated reproduction and exposure of certain Holocaust images, which can lead to the loss of their referential efficacy. Barbie Zelizer describes the function of collectively held images as "signposts" that act to "stabilize and anchor collective memory's transient and fluctuating nature in art, cinema, television, and photography, aiding recall to the extent that images often become an event's primary markers."[10] As Zelizer demonstrates, photographs of the liberation of concentration camps became increasingly relied on for their symbolic dimension, to the exclusion of their referential status. Precise captions disappeared, photographs were falsely labeled, and credits vanished. Remembrance became quicker and simpler, but it also began to lose its nuances and complexities. The representations themselves become the object of remembrance, instead of vehicles for the remembrance of the represented events.

The Sacred

Underlying discussions of the autonomy of technological memory is the problem of how overexposure numbs the viewer and weakens the transformative power of images. Those images that at first haunt our memory can gradually blend into the everyday backdrop of life, becoming part of the profane stock of images from history that we carry with us. Through this process images lose their potential sanctity.

There are two distinct approaches to discussing the Holocaust as sacred. The normative approach argues that the sanctity of the Holocaust is an ethical imperative: one ought to regard the Holocaust as sacred; we are commanded to do so. The analytic or theoretical approach, in contrast, asks how the conception of the Holocaust as sacred reveals something about the culture that holds this belief and examines the strategies that the culture employs in its representations. One of the most influential voices from the normative perspective is Emil Fackenheim, who argues that the Holocaust is a part of sacred history—a moment of revelation—and that Holocaust remembrance is a sacred duty, similar to the remembrance of the destruction of the Temple on the Ninth of Av. Unlike Martin Buber, who sees in the Holocaust the temporary eclipse of God (*Eclipse of God*), or Richard Rubenstein, for whom the Holocaust is evidence of the end of the covenant (*After Auschwitz*), Fackenheim finds in Auschwitz "not a Divine silence but a Divine commandment."[11] He names it the 614th Commandment, which stipulates, "namely, that Jews must survive as Jews so as to refuse the Nazis a posthumous victory."[12] In his first major book on the Holocaust, *God's Presence in History* (1970), Fackenheim asks whether Jewish belief in God's presence in history is still possible after the Holocaust. He proposes two categories for Jewish experiences in history: root experiences, which are decisive events for Jewish faith and consist of the exodus from Egypt and the revelation at Sinai, and epoch-making experiences, which challenge Jewish faith. The Holocaust, Fackenheim declares, caused such a rupture that Jews today may no longer look back to the root experiences as they once did to experience the divine presence. The only way to repair this rupture, Fackenheim maintains, is to survive and endure as Jews. The determination to survive *as Jews* despite the Holocaust demonstrates for Fackenheim a divine revelation.[13]

A second important voice in the discussion of the sanctity of the Holocaust is Elie Wiesel. As a public figure, Wiesel is recognized for his Holocaust memoir writing, public speeches and service, and objections to

representations of the Holocaust in popular culture. Wiesel is perhaps the most widely known advocate of the idea that the Holocaust belongs to sacred history; he has declared the Holocaust to be equal to the revelation at Mount Sinai, finding in it a sacredness of the highest order in Judaism. In his piece "Trivializing the Holocaust," printed on the day the extremely popular television miniseries *Holocaust* began, Wiesel writes, "Auschwitz cannot be explained nor can it be visualized. . . . The dead are in possession of a secret that we, the living, are neither worthy of nor capable of recovering. . . . The Holocaust [is] the ultimate event, the ultimate mystery, never to be comprehended or transmitted. Only those who were there know what it was; the others will never know." The survivor appears here as the high priest of a mystery religion, before which noninitiates can only stand in awe. In a second piece for the *New York Times*, titled "Art and the Holocaust," Wiesel describes the play *Ghetto* by Joshua Sobol as "*Hilul hashem*": an act of blasphemy and a profanation. As Peter Novick notes, although not everyone has been willing to follow Wiesel in his framing of the Holocaust in this way, the themes that appear in Wiesel's statements—namely, that the "Holocaust was a holy event that resisted profane representation," that it is "uniquely inaccessible to explanation or understanding," and that "survivors had privileged interpretive authority"—continue to resonate in contemporary American culture.[14]

Rabbi Irving Greenberg, founder of Zachor: The Holocaust Resource Center, which played a key role in placing the Holocaust at the core of American Jewish thought, also views the Holocaust as a sacred event and urges that it be given a central place in a "renegotiated Covenant and in Jewish liturgy." Viewing the Holocaust as a "modern *Akedah*" (binding of Isaac), Greenberg goes so far as to suggest a ritual reenactment of Holocaust experience in imitation of the Passover Seder: "I would suggest, then, that in the decades and centuries to come, Jews and others who seek to orient themselves by the Holocaust will unfold another sacral round. Men and women will gather to eat the putrid bread of Auschwitz, the potato-peelings of Bergen-Belsen." Particularly striking is Greenberg's argument that the Holocaust museum is a "new institution in Jewish history. . . . Just as the synagogue emerged as a major institution after the Temple, so the Holocaust Memorial Museum—not just this one in Washington, but all of them as a type—is a new institution to express Jewish values and beliefs and to advance understanding of the Holocaust as a turning point in Jewish and

world history." In light of such claims and the discourse of sacrality sur-
rounding the Holocaust, Novick argues that in American "folk Judaism," a
"de facto sacralization of the Holocaust" has taken place, characterized by
an unwillingness to adopt a naturalistic "mode of thought when it comes
to the 'inexplicable mystery' of the Holocaust, where rational analysis is
seen as inappropriate or sacrilegious." Within the religion of the Holocaust,
finally, survivors assume a special role, emerging as the "American Jewish
equivalent of saints and relics."[15]

The discourse of the Holocaust as sacred emerges from the religious
community with a distinct theological agenda. But do the museums under
discussion explicitly participate in such notions of the sacred? I argue that
Yad Vashem does explicitly act within this discourse; it directly frames
remembrance as a sacred duty throughout the museum, and the museum's
visual strategies enact a sacred agenda. The Jewish Museum Berlin, in con-
trast, cultivates a sense of the negative sacred without explicit theological
reference, while the USHMM sacralizes the American values that it posits
as a redemptive solution to the problems of fascism and genocide.

The use of the word "sacred" in connection with the Holocaust is a source
of alarm to many. But describing the Holocaust as sacred or as possessing
sacred meaning does not imply designating the Holocaust as an act of God.
Twentieth-century historian of religion Mircea Eliade defines the sacred as
a reality of an entirely different order from that of natural reality.[16] It is this
complete separation from the order of the profane that is the most impor-
tant quality of the sacred for Eliade. For Rudolf Otto, one of the founders of
the academic study of religion in the twentieth century, the sacred evokes
the *mysterium tremendum*: a feeling of terror or awe before the sacred, which
is beyond comprehension and "wholly other."[17]

A second essential point in the discussion of the sacred is its manifes-
tation in space, which Eliade calls "hierophany" and defines as a break or
rupture in the homogeneity of space in the revelation of a sacred reality.
As Eliade argues, "Every sacred space implies a hierophany, an irruption of
the sacred that results in detaching a territory from the surrounding cosmic
milieu and making it qualitatively different." A third point is that even for
the nonreligious, there exist certain places that retain a quality of the sacred.
These places possess an exceptional, unique quality that evokes a feeling of
revelation, as if in these spaces one has experienced a reality that is other
than that of ordinary life.[18] Eliade calls this behavior "crypto-religious." This

distinction is important when considering the evocation of the sacred in contexts that go beyond what is typically considered to be sacred, such as churches and synagogues, or sites of pilgrimage like the Western Wall or the Via Dolorosa.

Finally, it is important to note that the sacred should not be simplistically conflated with the "good." Otto argues that the sacred can be ethically neutral, and although it has come to be associated with the good or moral in common parlance, as well as in philosophical and theological contexts, this use is inaccurate. Similarly, the sociologist Emile Durkheim argues in his seminal *The Elementary Forms of Religious Life* that the idea of the sacred is inherently ambiguous and that there are religious forces of two kinds: the benevolent, and the evil and impure—the bringers of disorder, death, sickness, and sacrilege—before which one experiences fear and horror. The latter category may be termed the negative sacred, as the feelings it evokes are not without a certain "reverential quality." Durkheim, who was raised in a Jewish family and whose father, Moses Durkheim, was chief rabbi of the Vosges and the Haute-Marne regions of France, argues that essentially it is not the innate quality of the thing that makes something sacred but rather the "collective feeling of which it is the object."[19] This is a crucial distinction: it is ritual treatment and collective feeling that creates the sacred. The sacred and the profane are therefore not static categories into which objects and events may be neatly divided; rather, any discussion of the sacred must take into account the process by which an event, object, or representation is sanctified through collective rituals. Durkheimian and Eliadian collective representation and cosmology have been two of the most influential ways of thinking about the sacred in the twentieth century and have had a profound impact on how museums are conceptualized as sacred places and as places of ritualized visits.

The analytic, or theoretical, approach to the question of the sanctity of the Holocaust analyzes how the perception of the sacred plays a decisive role in remembrance and representation. It considers, for example, how the aura of sanctity imposes a certain agenda on museums, and it asks how representations of the sacred are culturally determined. Such an approach also explores how Holocaust symbols are treated in ways that imitate religious objects and that communicate the sacred. For example, Oren Baruch Stier has pointed out that Holocaust symbols may be "structurally similar to religious symbolizations" in terms of the meanings they generate, although

they are representationally distinct. Of particular importance to the potential of certain objects to evoke the sacred is the ritual context into which they are placed—a dynamic that Jonathan Z. Smith calls "emplacement." Nothing, according to Smith, is inherently sacred or profane—these are "situational categories," and a ritual object or action becomes sacred by having "attention focused on it in a highly marked way."[20]

Another essential characteristic of the sacred is its manifestation in time. The temporal and spatial experience of the sacred in museums is central to how this manuscript proceeds. Because the museums under discussion are Holocaust and Jewish museums that reveal distinctly Jewish perspectives, the manifestation of the sacred in time takes place within a specifically Jewish framework.

The Sacred in Space: Museums

The manifestation of the sacred in museum space is not unique to Holocaust museums. As Eliade has argued, sacred spaces need not be religious ones; what is essential is that a boundary separate the ordinary, profane space from the sacred space (as the wholly other). The so-called hierophany in museum space is often signaled through thresholds, passageways, or distinct boundaries, including staircases. For example, entering the *Children's Memorial* at Yad Vashem, to be discussed in chapter 6, visitors must descend between walls of Jerusalem stone into a tunnel, which leads into an underground cavern. During this descent, they experience a series of changes in light, temperature, and physical orientation. The tunnel ritually symbolizes passage from one realm into another as visitors enter the sacred space of memorialization.

Museums have often been considered to be ritualistic and sacred spaces. They have been described as shrines and sanctuaries and have been compared, as Carol Duncan notes, to older ceremonial monuments like palaces or Greek temples. Museums perform a variety of other functions as well, from the scientific to the sociological. Museum scholar Tony Bennett describes the traditional, nineteenth-century museum of Western culture as a "classifying house" that emphasized scientific and instructional qualities in its practices of preservation, object-centered collections, and "show and tell" exhibitions. Such exhibitions were carefully crafted to communicate to visitors "specific cultural meanings and values."[21]

Over the next century, museums began undergoing changes, shifting attention from the traditional collection-centered aesthetic to one increasingly more media based and subject centered. Philosopher Hilde Hein, for example, has examined how modern museums are increasingly involved in the manufacture of experience, that is, in appealing to the visitor's emotional and sensory responses through the manipulation of objects to elicit sensations, emotions, and feelings.[22] With this shift from objects to experience, and from artifacts to representations and simulations, the museum of the late twentieth century has been able to popularize museums and, in the words of Michelle Henning, to compete in the "marketplace of leisure attractions."[23]

As institutions that represent the cultures and nations that house them, museums also play a key role in the construction of collective identity and in the confirmation of national values and beliefs. Tim Cole argues in his discussion of the "nativization and nationalization" of the Holocaust in Yad Vashem, the USHMM, and the Holocaust exhibit of the Imperial War Museum in London that presentations of the Holocaust have become tools of nationalism, even participating at times in the celebratory.[24]

Despite their authoritative and legitimizing status, however, the narratives that museums tell are not monolithic. In recent years there has been a growing emphasis in scholarship on museums as sites of "contests of social remembrance."[25] Museums create collective memory and contribute to the construction of a nation's narrative, but they do not do so in a static sense; rather, the museum is a process as well as a structure.[26] For example, since its founding in 1953, Yad Vashem's memorial landscape has been continuously evolving. Early memorials focused on heroes, ghetto fighters, and partisans, reflecting a desire to portray the courage and resistance of Jews rather than passive suffering. In the 1980s, however, as Natasha Goldman has argued, Yad Vashem's memorials began addressing the suffering of victims and survivors, revealing an interest in integrating their experiences into the Israeli national narrative and in providing a visual framework to give a form to their trauma.[27]

Museums are, therefore, complex institutions that evolve through time and seek to fulfill a variety of tasks. Museums that exhibit the Holocaust face a particular challenge: they seek to simultaneously provide witness, facilitate remembrance, and educate their visitors. They perform yet another function beyond their didactic and commemorative goals, however. As already stated, a perception of the Holocaust as sacred imposes a

particular agenda on Holocaust museums and exhibits. If they are to meet the needs of their visitors, they must reach past the informational and even the emotive to perform an evocative function. In their task of representing what is often considered to be a unique and unparalleled event in history, Holocaust museums and exhibits face the singular challenge of enabling visitors to perceive the sacred.

Museum theorists recognize that the function of the museum may reach beyond the traditional goals of civic pedagogy, instruction, or aesthetic contemplation. George F. MacDonald argues, for example, that museums satisfy the visitor's need for the sacral and that these "sacred needs are tied to the role of museums as pilgrimage sites." Because museums are popular tourist destinations, tourism and pilgrimage appear to overlap when the destinations are sites of death and destruction. John Lennon and Malcolm Foley, in their study on "dark tourism" as one of the earliest forms of tourism, demonstrate that modern pilgrimage is often associated with sites of violent and untimely death. Holocaust museums in particular have often been described as sites of pilgrimage or as secular temples and shrines. Jeshajahu Weinberg, the first director of the USHMM, describes the museum as a place where visitors undergo an experience similar to that of "pilgrims walking together to a sacred place." Similarly, Charles S. Liebman and Eliezer Don-Yehiya, authors of *Civil Religion in Israel: Traditional Judaism and Political Culture in the Jewish State*, argue that Yad Vashem is Israel's "major Holocaust shrine," second only to the "western wall in its sacredness as a shrine of the Israeli civil religion."[28]

The language of shrines and pilgrimage clearly suggests a feeling for the sacred, conjured up in the image of tourists moving in a state of reverence and awe through a Holocaust museum. The most immediately visible sacral aspects of Holocaust museums are often the spaces set aside for remembrance, such as Yad Vashem's Ohel Yizkor (Memorial Tent), a skylit space whose floor is inscribed with the names of twenty-two concentration camps and which also contains an eternal flame and ashes from death camps. Such a depiction of the sacred relies on popular representations that occur repeatedly at sites of mourning and remembrance. These sites instantly evoke what Eliade calls "crypto-religious" sentiments.

On a more subtle level, Yad Vashem, the Jewish Museum Berlin, and the USHMM create narratives of the Holocaust that express beliefs sacred to each of their cultural and political contexts—in short, to their specific "civil

religions." Liebman and Don-Yehiya define civil religion as "the ceremonials, myths, and creeds which legitimize the social order, unite the population, and mobilize the society's members in pursuit of its dominant political goals. Civil religion is that which is most holy and sacred in the political culture. It forges its adherents into a moral community." In the case of Yad Vashem, for example, Liebman and Don-Yehiya point out that the museum and memorial complex plays a crucial role in the Israeli civil religion and "assumes a sanctity not only because it symbolizes six million Jews who died but because it symbolizes the Jewish people and culture of the Diaspora whose suffering and death legitimize the Jewish right to Israel." The myths of civil religion, Liebman and Don-Yehiya maintain, resemble religious myths; they evoke strong sentiments while transmitting and reinforcing basic societal values.[29]

[handwritten margin note: Zionism]

The Sacred in Time: Memory

The words quoted earlier, "Forgetfulness prolongs the exile; remembrance is the secret of redemption," hint at the connection between the sacred time of memory and sacred space. The question of how sacred spaces enframe remembrance has already been addressed. But remembrance itself takes place in time and leads to the question of how museums deal with this temporal dimension.[30] Visiting museums as a practice occurs in both time and space. Guests move through exhibition spaces, but they also traverse the historical time represented within the exhibit. The temporal structures of Holocaust museums and exhibits are mainly chronological and sequential, following a traditional, linear narrative form. The act of museum going, however, repeats itself and thus evolves into a ritual reenactment of a narrative in time. All narratives are temporal, and the framing of narratives within time is influenced by the cultural context in which it occurs. Yad Vashem depends on religious—specifically, messianic—notions of Jewish time, experienced through a narrative of exile, suffering, and redemption. The Jewish Museum Berlin diverges here from Yad Vashem and offers a crucial difference. In the Berlin museum, time is broken and fragmented; this rupture reveals the appearance of the sacred—the negative sacred—moment.

The enactment of a sacred temporal narrative is most clearly visible in Yad Vashem. Visitors enter the Holocaust History Museum, which is a

prism-like triangular structure cutting into the mountain (Har Hazikaron) from one side to the other, at a downward angle. The first exhibit that they see is Michal Rovner's *Living Landscape*, a triangular-shaped video art display and document of prewar Jewish life, projected onto a fifty-foot-high wall (to be discussed in chapter 4). The video reveals ordinary, daily lives within Jewish communities and offers a brief glimpse of a world before it was annihilated. This exhibit sets the stage for the documentation of what was lost; it situates visitors in a moment of idyllic, peaceful time before the inexorable journey through the war and Holocaust began. Yad Vashem's Holocaust History Museum lies predominantly underground and is designed to give visitors the impression of descending deep into the mountain through the techniques of varying triangular cross-sections and a gently sloping floor.[31] As visitors near the end of the permanent exhibition, the floor gradually slopes upward. The museum finally opens outward, jutting forth from the mountain ridge and offering an expansive view of the Jerusalem valley below. The representation of time in Yad Vashem is therefore not restricted to the chronological documentation of events. Time depends on the symbolism of descent and ascent; it is both performative and implicitly messianic.

Traditional notions of time in Judaism emerge from the unfolding of events in the Bible as it chronicles the relationship between God and man. Abraham Joshua Heschel describes time in Judaism as "the presence of God in the world." The Jewish God makes his presence known through his acts in history: he is not so much the God of abstract principles as the Redeemer from slavery and the Revealer of the Torah. The Jewish people, in return, are given the task of remembrance. Yosef Hayim Yerushalmi, author of *Zakhor: Jewish History and Jewish Memory*, states that remembrance is crucial not only to Israel's faith but also to its very existence. Yerushalmi argues, furthermore, that the religious emphasis on remembrance is unique to Israel: "Only in Israel and nowhere else is the injunction to remember felt as a religious imperative to an entire people. Its reverberations are everywhere, but they reach a crescendo in the Deuteronomic history and in the prophets. 'Remember the days of old, consider the years of ages past' (Deut. 32:7)."[32] Insisting on the religious significance of remembrance as uniquely Jewish, Yerushalmi frames remembrance as one of Judaism's defining practices. Of particular importance is the remembrance of God's acts and humankind's reactions to them; this constitutes the sacred memory cultivated in Jewish

liturgy and ritual. The most important of these acts is God's choice of the Jews at Mount Sinai and the covenant that resulted from it: "It is a moment that does not vanish; it is a moment that determines all other moments." This moment occurs within sacred time; it is continuously reenacted with each individual acceptance of the covenant. Through ritual reenactment, sacred moments of the past are experienced as still present. Heschel states that the root of Jewish faith is an "inner *attachment to sacred events*; to believe is to remember."[33] The commitment to remembrance thus emerges as a crucial tenet of Jewish faith and practice and continues to be so to this day.

Concepts of history, memory, and time within Judaism have evolved over the years, and the founding of a Wissenschaft des Judentums (Science of Judaism) in the early nineteenth century encouraged new ways of thinking about history. More recently, the theories of Eliade have affected twentieth-century ways of understanding the sacred. Eliade argues that time, like space, is neither homogenous nor continuous, and it possesses a sacred as well as a profane dimension. Turning to the architectonic structure of sanctuaries, Eliade demonstrates how the temple, as the *imago mundi*, sanctifies at once the entire cosmos as well as cosmic life, meaning time. He explains, for example, the temporal symbolism of the Temple of Jerusalem as part of its cosmological symbolism. Citing Josephus Flavius, Eliade describes how the twelve loaves of bread on the table signified the twelve months of the year.[34] Time therefore underlies the making of the sacred in the Temple space: space and time—*templum* and *tempus*—participate together in the creation of the sacred.

Sacred time, as defined by Eliade, possesses "the paradoxical aspect of a circular time, reversible and recoverable, a sort of eternal mythical present that is periodically reintegrated by means of rites." Following this definition, sacred time is perpetually renewable through festivals and rituals; it is liturgical and mythological, and in space it is visualized as a closed circle, always turning and repeating back to itself. Sacred time is apparent in the renewal and regeneration evoked through the celebration of a religious new year, for example, with which the world returns to its moment of origin and recovers its original sanctity. Eliade points to this annual repetition of cosmogony as an illustration of sacred time as the "time of origins" (*illud tempus*). The basis for all sacred calendars is the ritual reactualizing of the illud tempus, and it is this reactualization through rituals and festivals that plays a central role in Jewish concepts of sacred time.[35] Reactualization is crucially different

from both recollection and commemoration. During the Passover Seder, for example, the past is not merely recollected; it is actually experienced as being present: "For whatever memories were unleashed by the commemorative rituals and liturgies were surely not a matter of intellection, but of evocation and identification. . . . What was suddenly drawn up from the past was not a series of facts to be contemplated at a distance, but a series of situations into which one could somehow be existentially drawn. . . . In the course of a meal around the family table, ritual, liturgy, and even culinary elements are orchestrated to transmit a vital past from one generation to the next."[36]

A final example of sacred time in Judaism can be seen in the resistance to novelty in history. Yerushalmi describes how medieval Jewish chronicles had a tendency to assimilate new events to old and established conceptual frameworks, essentially pouring new wine into old bottles. Major contemporary events were subsumed to "familiar archetypes, for even the most terrible events are somehow less terrifying when viewed within old patterns rather than in their bewildering specificity. Thus the latest oppressor is Haman, and the court Jew who tries to avoid disaster is Mordecai." The chroniclers of the Crusades, for example, relied on the image of the Akedah when describing the Jewish mass suicide in the Rhineland of the twelfth century, during which devout Ashkenazi Jews slaughtered their families and themselves rather than accept baptism. Through a comparison with the Akedah, the martyrs emerged as those put to the supreme test because of their very devoutness. The horror remained vivid, writes Yerushalmi, but no longer absurd, "and grief, though profound, could be at least partly assuaged."[37]

Sacred time in Judaism is not restricted to the past; it reaches into the future as well. As Gershom Scholem argues, messianism is a theory of catastrophe from which emerges a dialectical link between redemption and catastrophe—a notion recognizable in the idea that in the most cataclysmic moment the chance for redemption begins to exist. The legend that on the day the Temple was destroyed, the Messiah was born, as noted by Yerushalmi, is a concrete illustration of this principle. Importantly, Scholem maintains that the influence of messianism within Judaism has occurred "almost exclusively under the conditions of exile." The messianic idea, then, is both the revelation of an abstract proposition—the hope for redemption—as well as a response to the concrete, historical circumstances of life in exile.

By linking the messianic idea with the condition of exile, Scholem points toward a possible continuity between messianism and Zionism. As he notes, it is "little wonder that overtones of Messianism have accompanied the modern Jewish readiness for irrevocable action in the concrete realm, when it set out on the utopian return to Zion."[38]

Arthur Hertzberg and Jacob Katz have made the link between messianism and Zionism more explicit. Hertzberg describes Zionism as the "secularization of the Messianic ideal," and Katz declares, "In [modern Zionism] Jewish Messianic belief was, so to speak, purged of its miraculous elements, and retained only its political, social and some of its spiritual objectives." This is apparent in the way that Zionists will at times rely on messianic language and concepts, identifying their goals with "traditional messianic expectations such as the Ingathering of the Exiles, the centrality of Jerusalem, the confrontational wars to come, peace in nature, or international harmony."[39] The presentation of the Zionist narrative in Yad Vashem relies on messianic imagery to evoke an experience of sacred time. In addition to the visitors' passage through the museum, a visual demonstration of this principle appears in Yad Vashem's *Memorial to the Deportees*, to be discussed in chapter 6.

Temporality in the Jewish Museum Berlin is very different from that of Yad Vashem. Whereas time in Yad Vashem is messianic and teleological through its Zionist framework, triumphantly gesturing toward a redemptive ending, the sense of time in the Jewish Museum Berlin, as depicted through its architecture, is fractured. This sense of time is an extension of the negative sacred in space—a concept to be discussed in the following chapter. Unlike Yad Vashem, whose call to remembrance is rooted in the very stability of place and in a celebration of homecoming, the Jewish Museum Berlin testifies to a permanent displacement in both time and space.

In contrast to Yad Vashem and the Jewish Museum Berlin, the USHMM seeks to create a secular memory that achieves perfection and completion in its temporal narrative. The permanent exhibition begins with the liberation of the Ohrdruf concentration camp by American troops and then skips backward in time to document the rise of National Socialism. From here, the permanent exhibition follows a linear, chronological development, concluding with the testimony of survivors who immigrated to the United States and began new lives. This progression places visitors in a specifically American narrative that begins with a uniquely American perspective. By

concluding with the immigration of survivors to the United States, the exhibit closes its narrative in a circular manner, with a return to its starting principle of the United States as a sanction from persecution. The USHMM thus offers its visitors the illusion of wholeness as it attempts a fully reconstructed narrative of the Holocaust. Temporally and spatially, the museum displays a closed narrative. Visitors begin their journey on the ground floor, ascend to the fourth floor on an elevator, and wind back down to the ground floor once again. This staged, circular experience of wholeness and closure is designed to satisfy its audience and to reassure its participants of the logic and final justice of history. It depicts the tragedy of the Holocaust, finally, as a story that ends with resolution through immigration and that reiterates— even celebrates—democratic principles.

Each of the three museums discussed in this book approaches the task of Holocaust remembrance in a unique way that reflects the context culture's civil religion. The discourse of sacrality, furthermore, which surrounds Holocaust commemoration and the special challenges that this discourse poses, plays a significant role in shaping not only the museums' Holocaust narratives but the very forms of Holocaust memory that the narratives encourage. One of the key questions underlying the analysis of Yad Vashem, the Jewish Museum Berlin, and the USHMM in the following chapters, therefore, is precisely this question of how the perception of the Holocaust as sacred within a particular cultural context impacts the way that a museum frames—and ultimately, commemorates—the Holocaust.

2 ✷ AN ARCHITECTURE OF ABSENCE

Daniel Libeskind's Jewish Museum Berlin

> I have found, among my papers, a leaf, in which I call architecture fro-
> zen music. There is something in the remark; the influence that flows
> upon us from architecture is like that of music.
>
> —Johann Wolfgang von Goethe, letter to
> Johann Peter Eckermann, March 23, 1829

Goethe's famous description of architecture as "frozen music" resonates on a visceral level as one stands before Daniel Libeskind's zinc-clad Jewish Museum Berlin for the first time. Across the building's gleaming surface stretches a series of jagged, disconnected window bands that suggest a fractured Star of David. These fissures in an otherwise smooth surface offer a note of dissonance—a hint of the atonality characteristic of the music of Arnold Schoenberg, whose opera *Moses und Aron* inspired Libeskind in his design. Although radically different in style, the Jewish Museum Berlin, Yad Vashem, and the USHMM share a fundamental quality—namely, the architectural designs of the three museums evoke particular ideas of the sacred that are bound to each culture's dominant ideology of Holocaust remembrance and memorialization.

As discussed in chapter 1, the concept of the sacred in this book is narrowly prescribed. First, the sacred is situational. As such, it appears as the result of a ritual context or treatment rather than as the outcome of an innate, essential, sacred quality.[1] Second, manifestations of the sacred may exhibit their sacred qualities in a civil religious sense.[2] It becomes possible, then, to describe a museum like Yad Vashem as a shrine and a sacred

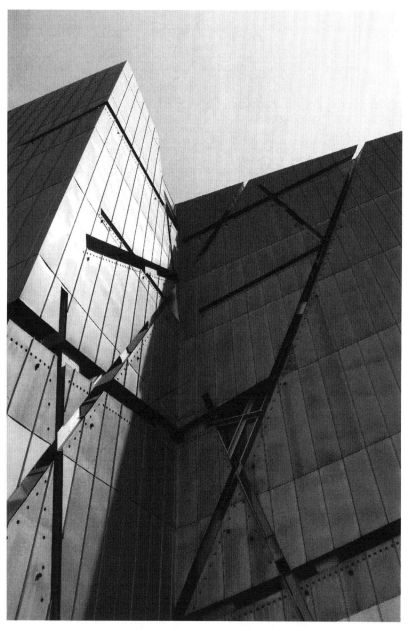

FIG. 2.1 Jewish Museum Berlin with a fractured Star of David on its facade. Photograph by Rony Oren.

destination for pilgrims without claiming the Holocaust to be an act of divine will or revelation. Each museum's architectural evocation of the sacred is tied, furthermore, to its own specific cultural and historical context and is expressive of that culture's civil religion.

The architectural styles of the Jewish Museum Berlin, Yad Vashem, and the USHMM have attracted much attention in the press. The dramatic architecture of new Holocaust and Jewish museums around the world may be viewed as part of a larger trend in museum design. Forced to "vie with theme parks and mass-market entertainment for a slice of the public's leisure time and disposable income," many new museums seek to attract visitors through their unusual architecture as much as through their exhibits and collections. This pattern in museum design has become especially prominent since the opening of two museums with dramatic architecture: Frank Gehry's Guggenheim in Bilbao, Spain (1997), and Richard Meier's Getty Center in Los Angeles (1997).[3]

Architectural critic Michaela Giebelhausen claims that a museum's architecture is not merely an outer shell but rather plays a decisive role in producing meaning: "the architecture *is* the museum: it is precisely the architectural configuration that gives the museum meaning. The architecture determines the viewing conditions both conceptually and physically. It not only frames the exhibits but also shapes our visitor experience."[4] The architecture of the three museums under discussion supports this claim. In each, architecture never functions as a mere frame; rather, steel and stone possess signifying power, while bridges and windows contribute to narratives and evoke particular sensations. Each of the three architects—Daniel Libeskind, Moshe Safdie, and James Ingo Freed—chose an architectural syntax that communicates culture-specific notions of Holocaust memorialization. The architecture of the Jewish Museum Berlin frames its narrative of the Holocaust with the idea of the negative sacred, which is evoked through absence. The museum's architecture gives form to this absence by means of a series of voids that run through the heart of the design. Yad Vashem's architecture, in contrast, evokes the sacred through a dialectic of redemption and catastrophe within a Zionist framework. This dialectic is formalized in the museum's architecture through a series of descending and ascending planes and spaces as well as choreographed views.

A sense of the sacred in the USHMM manifests itself on two levels. First, the sacred is tied to American civic values such as democracy and

religious tolerance. With these values in mind, the museum-going experience is structured in such a way that visitors empathize and identify with both categories of protagonists in the museum—the victims and the American concentration camp liberators. Second, on a more abstract level the sacred emerges through the metamorphosis of the visitor into a Holocaust witness. In Holocaust discourse, as discussed in chapter 1, Holocaust survivors are often treated as sacred figures whose roles as witnesses grant them extraordinary moral insight or wisdom. The architecture of experience in the USHMM engages in certain representational strategies to transport the visitor from the United States to authentic sites of the Holocaust—bridging geographic and psychological distance and thus granting the visitor a portion of the sacred Holocaust witness's privileged insight.

In his book *The Architecture of the City*, Aldo Rossi describes the city as "the collective memory of its people, and like memory it is associated with objects and places. The city is the *locus* of the collective memory."[5] Within this locus of collective memory, museums fulfill a particular cultural function as the bearers of narratives of past and present. While they contribute singular voices and stories shaped by a number of individuals—architects, curators, exhibition designers, and museum directors—they belong to a still greater context. For the architects Daniel Libeskind and Moshe Safdie, the cities of Berlin and Jerusalem are not merely physical but also psychic spaces whose historical narratives play active roles in the museums' creation of meanings. The unique histories of these two cities thus raise particular questions that impact how museums signify. For example, what role does Zionist ideology play in the Holocaust narrative of Yad Vashem—a museum complex whose geographic proximity to Mount Herzl emphasizes nationalist and Zionist meaning? And how do the politics of remembrance in postwar Berlin impact the Jewish Museum Berlin's narrative of the history of Jews in Germany?

Berlin as Ruined Topography

Viewed across the two axes of history and aesthetics, Berlin emerges as a ruined topography at the center of which exists the void as both space and concept. This means both actual voided spaces caused by the ravages of war, urban schemes, and the removal of the Berlin Wall and, in a metaphoric sense,

destroyed communities and families from World War II, the Holocaust, and Berlin's subsequent division. The architectural vision of Daniel Libeskind, as seen in his Jewish Museum Berlin and in other Berlin designs, resonates with the city's ruined topography in a number of ways. Above all, it takes into account the recently reunited city and country as well as the complex, at times successful, and finally tragic past of Jewish life in Germany. Libeskind's architecture puts the void itself on display and externalizes absence through spatial form; the voids at the center of the Jewish Museum Berlin's design illustrate the absence of German Jews, but they also resonate in a more general way with the museum's urban context in Berlin. After all, this city has often been conceptualized through the metaphor of the void. Libeskind's design acts structurally as an echo of this idea of the city as void and appears, as Stanley Allen argues, as if it had erupted "out of the fissured condition of the city." In his important reading of the Jewish Museum Berlin, James E. Young focuses much attention on Libeskind's voids and points out the direct relationship between the museum's architectural voids and the voids of Berlin: "Indeed, it is not the building itself that constitutes his [Libeskind's] architecture but the spaces inside the building, the voids and absence embodied by empty spaces. . . . It is the void 'between the lines' that Libeskind seeks to capture here, a void so real, so palpable, and so elemental to Jewish history in Berlin as to be its focal point after the Holocaust—a negative center of gravity around which Jewish memory now assembles."[6]

Libeskind's building responds to the city in a way that keeps the wound of the past—and the illustration of that wound across the city's surface—visible so that the museum sets out "neither to close the wound nor to maintain it, but rather to live out of it." In this way Libeskind resists the temptation of what Allen calls the "obvious options": "the comforting amnesia that would deny the wound or the aestheticizing logic that would monumentalize the physical gap in a futile attempt to come to terms with that which is unspeakably other."[7]

The use of the void metaphor to describe Berlin has a long history, and it was used already in 1935 by Ernst Bloch to describe life in Weimar Berlin after the disintegration of nineteenth-century bourgeois culture. Fascism and Albert Speer's wrecking crews turned Berlin into a literal void, followed in turn by the *Sanierung* (urban renewal) of the 1950s, when significant portions of old Berlin were destroyed to clear space for more modern architecture. The voids of the no-man's-land and minefields in the center

of Berlin soon became the setting for the Berlin Wall, the later removal of which resulted in the greatest and most visible void of all: a "seventeen-acre wasteland" reaching from the Brandenburg Gate to Potsdamer Platz and Leipziger Platz.[8] Specific empty city spaces or voids would become invested with symbolic meaning, including Potsdamer Platz, which was immortalized by Wim Wenders in his meditative 1987 film *Der Himmel über Berlin* (*Wings of Desire*) as a symbol of Berlin's conflicted memory and history.

After Germany's reunification and the removal of the wall, Berlin quickly became the site of the second *Gründerzeit* (founding epoch). As Dagmar Richter argues, the city was all at once "opened up to a sudden cultural storm from all sides" and became transformed into what Walter Benjamin predicted for Berlin: a "transitional space of all thinkable forces."[9] The series of design projects and architectural competitions after 1990 suggest that Berlin was searching for a new identity to match its new political status and emerging role as a world city. The official ad campaign of 1996 in Berlin was, tellingly, "Berlin wird" (Berlin becomes)—a revision of Berlin journalist Robert Springer's proclamation in 1868: "Berlin wird Weltstadt!" (Berlin Becomes a World City!).[10]

The choice of Daniel Libeskind as the architect for the new Jewish Museum excited much discussion, partly because it would be the first of Libeskind's projects to be realized. Libeskind was born into a Jewish family in Poland in 1946 and later emigrated to Israel and then to the United States. He has designed a wide range of buildings, including museums, concert halls, convention centers, shopping malls, universities, and hotels in Israel, Europe, the United States, Canada, and Korea. Several museums designed by Libeskind have as their subject Jewish history, including the Felix Nussbaum House in Osnabrück, Germany; the Danish Jewish Museum in Copenhagen; and the Contemporary Jewish Museum in San Francisco.

Although Libeskind has designed many different types of structures, one can trace elements of ambiguity, instability, and liminality throughout his various works. As Gavriel Rosenfeld argues, Libeskind's architecture demonstrates a "site-specific orientation," which is "narrative without being historicist" and possesses the following defining traits: "symbolic ground plans, colliding volumes, slashed facades, and contrasting materials."[11] In his design for the Jewish Museum Berlin, these elements are apparent in tilting hallways, transitional staircases, slanting floors, and narrow, slashed windows. Such principles appear in Libeskind's other Berlin designs as

well, including his *City Edge* project proposal for Berlin's Tiergarten district. Inspired by the Berlin Wall, it won Berlin's City Edge competition of 1987. Libeskind's discussion of this project reveals his view of Berlin itself as a liminal, shifting, and ambiguous place, and it is this atmosphere to which his *City Edge* project design responds. By way of introduction to his project, Libeskind describes the Berlin sky as continuously refusing "to come into identity or equivalence." It remains, in other words, in a constant state of flux and process of becoming. Libeskind continues, "one discovers that what has been marked, fixed and measured nevertheless lapses in the dimensions of both the indeterminate and the spherical." To capture this mood of transition and ambiguity in the Berlin landscape, Libeskind employs tilted angles and crossed bars that suggest instability and create an unsettled feeling.[12] The apartment complex portion of his design, furthermore, a ten-stories-high "bar" on stilts, was placed in such a way as to evoke Albert Speer's infamous North-South Axis of the never-achieved capital of the Third Reich, "Germania." By drawing attention to the site's past, Rosenfeld argues, Libeskind "declared his commitment to an architecture of memory."[13]

The titles of some of Libeskind's other designs for Berlin, including *Traces of the Unborn* and *Out of Line*, reveal his interest in the tension between presence and absence and in liminal spaces that fall outside, or in-between, stable boundaries. Libeskind ultimately seeks to build in such a way that Berlin's scars remain exposed and its transitional nature unresolved. The architect draws attention to the ragged edges and wounds of the city—not to repair them but rather to keep them before the eyes of the city's residents and visitors. Architectural critic Hugh Pearman succinctly captures the essence of the *City Edge* project when he writes that this project, "far from attempting to heal the scars of the city as was then fashionable— exploited to the full the weird east-west disjunction caused by the Wall and its minefields . . . surgically slicing through the surviving urban grain."[14]

An architectural principle essential to Libeskind's work and particularly significant to his design of the Jewish Museum Berlin is the cultivation of an active engagement or interpenetration between a building and its site. In Libeskind's conception, each architectural project is a living being that forges connections and relationships with the surrounding streets, buildings, and overall topography. As Libeskind explains, "It's not just that the building fits into its context and is just a passive, inert bit of matter.

A building also has a responsibility to transform the context, give it back something more. Not just taking from its surroundings, but also contributing. Enlivening, transforming."[15] Such a dynamic interaction is a recurrent feature in Libeskind's architecture.

One technique Libeskind uses to visualize this relationship is to draw lines in his sketches between the building he is currently designing and other neighboring geographic sites that he finds significant.[16] The technique plays a fundamental role in Libeskind's conception of the Jewish Museum. Libeskind situated the Jewish Museum in his sketches within an "irrational matrix" of real addresses of influential German and German Jewish cultural figures.[17] The building's site thus emerges meaningfully, rather than accidentally, at the point of intersecting lines within the Berlin landscape.

The urban matrix, furthermore, underscores conceptually the way that Libeskind organizes the Jewish Museum and its surrounding structures around the nexus of a new topography, which places the German Jewish historical narrative at the core of Berlin's (and Germany's) history while simultaneously refusing to reduce it merely to a part of that history. The German Jewish historical narrative thus preserves its autonomy while its role in the German past in general remains acknowledged. Displaying this connection on a concrete level is the physical linkage between structures belonging to the Jewish Museum complex. The Libeskind building and its baroque neighbor, the former *Kollegienhaus* (courthouse) and former Berlin Museum, as well as other museum structures including the Holocaust Tower, E.T.A. Hoffmann Garden, and Paul Celan Courtyard—although appearing from the outside of the museum to be autonomous—are in reality bound together in the form of a "basement story with streets and passageways, junctions and external spaces." This lower story metaphorically reproduces a city landscape: "In a sense, it is a piece of urban tissue, set at a scale level below that of the building and nevertheless reproducing the forms of the outer, larger city." The upper city of Berlin is linked to the hidden, lower city of the museum through "routes" through the interior of the building, the "free-standing prismatic hollow volume [the Holocaust Tower] (which belongs to both worlds) in front of the south face, and via the sunken E.T.A. Hoffmann Garden, which may also be seen to belong to both planes (i.e., both levels and both scales)."[18] This topography of concealed passageways and hidden linkages suggests a close yet not

lines to
addresses

immediately visible connection between the history of Jews in Berlin and a larger, more comprehensive history of the city.

The interpenetration of the Jewish Museum Berlin with its site emerges as well through a series of spatial relationships between the museum and its geographic setting that creates an effect similar to an echo, including the "interaction of inside and outside, the specific and the general, [and] lesser and greater scales." One example of this inside-outside interaction is the possibility of occasional views from the interior of the museum itself out to other parts and spaces of the museum complex, including the Kollegienhaus and the surrounding urban space. These moments of liberated vision (which remain, however, restrained and controlled) are breaks through the otherwise "massive, largely closed external face of the extension" and allow the visitor to experience the Jewish Museum as an extension not only of the Kollegienhaus but also of the city, "as a city within the building, as a city within the head; city and building as an extension of man." Other museum spaces create subtle linkages with the surrounding urban context as well. The visitor's view across the Paul Celan Courtyard, for example, possesses a double dimension: "the open space appears both as an internal courtyard of the building, the confining walls of which are read as the 'rear faces' of the complex and as an integral part of and appendix to the urban space beyond."[19]

Inseparable from Libeskind's concern for context and significance of site is his interest in preserving traces of the past even as he designs new structures. In his unrealized design for Alexanderplatz (1993), *Traces of the Unborn*, for example, he rejects the erasure of the history of Berlin and instead suggests a "gradual improvement of public spaces" that will develop "more like a dream than a piece of equipment." In a description of his design, Libeskind advocates the transformation and metamorphosis of that which already exists: "There is an important need in every society to identify the icons which constitute a particular area, the structures which form the texture of living memory. Thus, in refuting the past and the future alike, the eternal present of transformation is used as a strategy for the creation of unpredictable, flexible and hybrid architecture disseminated both horizontally and vertically." In the case of Libeskind's *Traces of the Unborn* design, such a philosophy means making visible an encounter with traces of East Berlin architecture. In fact, Libeskind has supported the preservation of the architectural existence of the DDR. "Even the prefabricated ill-conceived buildings of the DDR," Libeskind writes, "which have little architectural

merit, should not be singled out for demolition, but should be incorporated in an ecologically responsive manner."[20]

The acceptance of past traces can also be seen in Libeskind's *City Edge* project. Describing Berlin as an "edge city" that possesses multiple histories, the project draws on Berlin's kaleidoscopic, pluralistic quality and seeks to preserve the past by drawing its traces to the fore while making visible that which lies hidden. In his proposal, Libeskind writes, "Underneath the ground, the city traces its own schizoid memory and protects it by insulating and covering the site. What is unforgotten cannot be eradicated, concealed." In a similar vein Libeskind's cultivation of a heterogeneous and pluralistic (or kaleidoscopic) reality in architecture emerges in *Out of Line*, his unrealized design for Potsdamer/Leipziger Platz. This project creates heterogeneity through the concept of site-as-puzzle—derived, as Libeskind writes, from the "symbolic fragments of memory of Potsdamer Platz" as they have been captured in nine different perspectives. In this scheme, which Libeskind imagines as an "illuminated muse matrix" (consisting of the nine muses plus one: the muse of the unexpected), buildings go over, on, and below the streets.[21]

Underlying all of Libeskind's Berlin projects is his search for an "open and ever-changeable matrix which reinforces the processes of transformation and sees the dynamic of change in a diverse and pluralistic architecture. Such an approach . . . treats the city as an evolving, poetic and unpredictable event."[22] The unexpected, Libeskind's "tenth muse," invigorates his projects—particularly the Jewish Museum Berlin—with an imaginative potential that allows the visitor to experience architectural space as something surprising and at times unsettling.

Architecture of Absence: Libeskind's Jewish Museum Berlin

The varied and often passionate reactions that the Jewish Museum Berlin has evoked among its visitors and critics suggest the many conflicting expectations that greeted the museum's opening. W. Michael Blumenthal, director of the Jewish Museum Berlin, described the museum in a speech at its inauguration on January 23, 1999, as a "house of both melancholic introspection and joyful encounter." A year and a half later, on August 16, 2000, twelve months before the opening of the museum, Blumenthal added

to this Janus-like description: "We are creating a museum that shows how firmly Jewish citizens were anchored in German life, what they achieved here and how their community and religious life functioned.... It is meant to be a hospitable place that ... makes the visitor feel at home in a place to which he is happy to return."[23]

A number of critics, in contrast, minimize the educational and pleasure-giving role of the museum and have declared Libeskind's building to be a Holocaust monument that would have been best left empty. Julius Schoeps, for example, director of the Moses Mendelssohn Zentrum in Potsdam, describes the Jewish Museum as a "Holocaust sculpture" rather than a museum.[24] Such a claim questions the very nature of the museum and its ultimate task. Is the role of the museum to teach Germans about German Jewish history? Or is it to promote tolerance and pave the way for a better relationship between Germans and their neighbors of different ethnicities and religions? Or perhaps it should provide a space for memory and mourning after the Holocaust?

It comes as no surprise that a Jewish Museum in the heart of Germany's capital would create a stir. Although Berlin does possess a national memorial to the Holocaust—the Memorial to the Murdered Jews of Europe (Das Denkmal an die ermordeten Juden Europas)—Germany lacks a national Holocaust museum. The Jewish Museum Berlin—although not a Holocaust museum—does at least approach such a task with its Holocaust exhibit and Holocaust memorial spaces, and therefore it assumes a vast responsibility. The story of the founding of the Jewish Museum Berlin, which has been thoroughly documented elsewhere and will therefore be only briefly touched on here, reveals much about the memory politics of post–World War II Germany and sheds light on the challenges that faced both architect and exhibit designers.[25] The year in which the Berlin Senate held a competition to find the architect who would design the new Jewish Museum was 1988—one year before the fall of the Berlin Wall and two years before the formal reunification of the city and country. What began as a West Berlin project thus turned into an opportunity to make a powerful statement about newly reunited Germany's attitude toward the past. Decisions about what kind of a museum to build and questions regarding the museum's autonomy, design, and message were therefore necessarily political.

The new Jewish Museum Berlin would replace the original Jewish Museum on Oranienburger Straße, which opened in the inauspicious year

of 1933, was plundered and ravaged during Kristallnacht and then closed one year later. Fifty-five years after the opening of the original Jewish Museum, Daniel Libeskind would win the design competition with his conception *Between the Lines*, and the resulting museum would soon become one of Berlin's most popular tourist attractions. The new Jewish Museum first opened to visitors during the Long Museum Night in January 1999, and although it was at this point empty, it still drew 350,000 visitors. The often-voiced opinion that the museum should remain empty and act as a memorial to the victims of the Holocaust testifies to the power of the museum's architecture to evoke visceral reactions in its visitors. To many, the idea of filling the museum's dramatic spaces with objects meant stripping the building of its unique ability to evoke the absence of Berlin's missing Jews. However, as Libeskind has made clear in his own writings, the museum was not designed as a memorial but rather to hold exhibitions that would tell a story.

On September 9, 2001, the Jewish Museum Berlin officially opened its permanent exhibition *Two Millennia of German Jewish History*. The declared purpose of the Jewish Museum Berlin transcends, however, a mere documentation of the nearly two-thousand-year history of German Jewry. As W. Michael Blumenthal has stated, the museum "symbolizes a determination to confront the past and to gain a perspective on the societal problems of the present and the future." For Blumenthal, the building of the Jewish Museum signifies not only that the time has come for Germany to face its past but also that Germany is prepared to rise to new challenges, including building a "tolerant and peaceful society." The purpose of the museum, as framed by Blumenthal, is to fulfill a much-needed secular, historical, and educational mission, one that recognizes that "without memory there can be no future."[26] Following this agenda, a new enlightened and tolerant society may be built on the ruins of the past through the vehicle of knowledge, which would serve as a bastion against future intolerance and persecution.

In a speech on January 23, 1999, Blumenthal pointed out that many Germans know "little or nothing of Jews, apart from perhaps the Holocaust." Instead of encountering Jews only as victims, Blumenthal argues, German citizens need to recognize that Jews were at one time "lively and creative citizens, who contributed a great deal to German life." If, he continues, visitors "absorb this history, with all its glories and tragedies, they will learn how important it is to show tolerance to minorities—a relevant topic throughout the world today. They will also learn what price must be

paid for intolerance, not only for the minorities and victims, but also for those who oppress and show intolerance."[27] The purpose of the new Jewish Museum is therefore twofold: first, to educate Germans about the role that Jews once played in German life, and second, to immunize today's Germans against future intolerance toward cultural, ethnic, and religious difference. The Jewish Museum thus possesses relevance for current minority issues pertaining, for example, to questions of citizenship and immigration, and it is projected as an institution devoted to multicultural ideals essential for Germany's future as a diverse and tolerant society.

Furthermore, as K. Hannah Holtschneider points out in her recent monograph, national museum exhibitions such as the one at the Jewish Museum Berlin "are understood and treated by their staff and the public as official and authoritative statements of a nation or a community about the subject matter displayed, as is clear from the political attention and public funding they receive."[28] The Jewish Museum Berlin's promotion of multicultural values and presentation of a new and more tolerant Germany transcends, therefore, the narrow limits of a single perspective and speaks for contemporary German society as a whole.

The Jewish Museum Berlin also plays a major role in Germany's ongoing efforts to come to terms with the past (*Vergangenheitsbewältigung*). One might also suggest that the museum reveals a desire to alleviate the burden of the *Schulderbe* (legacy of guilt) that Germany still bears. Such issues underlie many of the problems that surfaced during the planning stages of the museum, including the question of whether there should be an autonomous Jewish Museum or merely a Jewish department or extension added to the existing Berlin Museum. While an autonomous museum might risk drawing too sharp a line between Jewish Germans and non-Jewish Germans—banishing for a second time German Jewish culture and history from its context—a Jewish extension to an existing German museum might risk integrating Jewish culture and history into its German context to the extent where its unique voice could be silenced. In 1993 a crisis over funding almost led to a cancellation of the Jewish Museum project by the Berlin Senate. Thanks to Libeskind's direct intervention, however, the museum was built, and the completion of the museum made a timely statement about the future path that Germany wished to take regarding its relationship to its Nazi past. As Gavriel Rosenfeld points out, the late 1990s in Germany witnessed an alarming

increase in neo-Nazi violence against Jews and foreigners. In this climate the "Jewish museum project implicitly became a litmus test of Germany's post-unification political reliability."[29]

In public statements administrators of the Jewish Museum Berlin have been careful to avoid giving the impression that the museum is a frightening or guilt-inducing place for Germans. In particular, museum personnel have found it necessary to repeatedly stress that the museum is not a Holocaust museum—a fact emphasized through a three-round advertising campaign that began in 2002. The campaign consisted of nine surprising photographs—such as a fried egg in an open oyster shell at the bottom of the ocean—accompanied by the motto: "Jüdisches Museum Berlin. Nicht das, was Sie erwarten" (The Jewish Museum Berlin. Not what you expect). Peter Chametzky interprets this campaign as "part of a broader strategic project on the part of the JMB's administration to dispel the widespread notion that visitors' experiences will centre on Holocaust remembrance. It assumes that many potential visitors expect a frightful and potentially sickening encounter with shocking *Shoah* details, images, and stories."[30]

One might pose the question as to why so much time and effort has been spent proclaiming what the museum is not instead of focusing on what it is. The answer is twofold: first, Jewish history in Germany is necessarily and justifiably viewed through the lens of the Holocaust as the gravitational center around which all discourse on German Jewish experience turns.[31] Second, Libeskind's stunning *Zickzackbau* is by far the most impressive and memorable aspect of the Jewish Museum Berlin and as such it automatically raises certain expectations. Although Cilly Kugelmann, program director and vice director of the museum since 2002, has stated that Libeskind's design was not meant to function as a symbol of Jewish history but rather as a metaphor for Berlin's history, the broken Star of David that marks the building's facade and a number of other museum spaces—including the Axis of Exile, the Axis of the Holocaust, the Holocaust Tower, the Memory Void, the Paul Celan Courtyard, and the E.T.A. Hoffmann Garden of Exile and Emigration—suggest otherwise.[32] Indeed, these spaces contribute to the sense that the Holocaust is not merely a part of the museum's narrative, but rather that it exists at the very core of it.[33]

Such an impression is reinforced by the fact that the visitor does not enter the museum at the beginning of the permanent exhibition, which documents the history of Jews in Germany. After coming into the museum through the former Berlin Museum and descending a steep flight of stairs

that leads to the Libeskind building, visitors find themselves at the intersection of three axes that function as underground streets and branch off in three directions. From among the Axis of the Holocaust, the Axis of Exile, and the Axis of Continuity, only the Axis of Continuity continues on to the permanent exhibition. The other two axes contain exhibits that focus on persecution, exile, and death during the Holocaust and lead to memorials commemorating victims who either perished or were forced into exile. The permanent exhibition, finally, closes with an exhibit on contemporary Jewish communities in Germany, Austria, and Switzerland—with a demonstration, in other words, that despite the Holocaust Jewish communities in German-speaking countries still exist. The Holocaust thus acts as a framing device for the museum as a whole and as its thematic core; it cannot be reduced to merely one of several topics covered in the exhibition.

Political issues also surrounded the founding of the Jewish Museum. As Paul Jaskot has shown, Cold War politics played a major role in the planning of the Jewish Museum in what was at that time West Berlin, and these politics are reflected in Libeskind's design itself, which carefully integrates the Jewish Museum within "the local and ideological goals of the IBA [Internationale Bauausstellung—International Building Exposition]" while also offering an "effective response to anything the East Berlin government would do to commemorate its Jewish community."[34]

The architecture of the Jewish Museum Berlin illustrates, finally, Giebelhausen's claim that "the architecture *is* the museum." Libeskind's building is not about something but rather is (or performs) something—it is the crystallization of an idea. This idea appears through the languages of the museum, which manifest themselves both horizontally (through the juxtaposition of the Libeskind building with its stylistically distinct neighbor, the former Berlin Museum) and vertically (through a variety of philosophical concepts that Libeskind inscribes into his design). Several architectural theorists, including Robert Venturi and Charles Jencks, have explored the signifying potential of architecture and its communicative and semiotic functions. Venturi not only describes architecture through concepts and terms traditionally applied to language—including allusion, articulation, and irony—he also calls for architects to incorporate into their buildings a "multiplicity of architectural languages."[35] The techniques of eclecticism and hybridity, namely, the mixing of different architectural styles, may be seen in the juxtaposition of the Libeskind building (the Neubau) and the baroque

Kollegienhaus (the Altbau). From the outside, the two conspicuously different structures appear to be merely adjacent. Once within the museum, however, visitors become aware that the two apparently autonomous structures are actually linked underground, and visitors may enter and exit the Libeskind museum only through its neighbor. They form, in this way, a single structure that combines old and new, baroque and modern, while their radically different aesthetics engage in a playful, ironic dialogue.

Approaching the Jewish Museum along Berlin's Lindenstraße, visitors receive two distinct impressions. The first impression reveals the irregularly spaced, jaggedly incised window bands that appear like sudden fault lines and destabilize the smooth zinc facade of the museum while also tracing the image of a shattered Star of David. Structurally, the museum has been described as a "zigzag," a "streak of lightening," and an "unraveling star of David."[36] The second impression emerges from the contrast between the Libeskind building and its neighbor. The former Prussian courthouse and Berlin Museum was designed by Philipp Gerlach (1679–1748) in the baroque style and was completed in 1735 under the reign of Friedrich Wilhelm I. It was renovated several times and its interior was largely destroyed during World War II. Between 1963 and 1969 the building was expanded and the interior redesigned according to plans by Günter Hönow. The building's courtyard turns away from Lindenstraße, and its mansard roof sits atop the three wings of the structure. The middle axes are joined together with a pilaster (a rectangular support resembling a flat column) that contains a portal and balcony. This middle section is topped with a three-cornered pediment that bears the Prussian national coat of arms. To the right and left of the peak of the pediment are the allegorical figures of Justitia (justice) and Caritas (charity).

The striking contrast between the Libeskind and Gerlach buildings might suggest a challenge to inherited ideas about the museum as a unified space and as a sacred archive of history. The Libeskind building itself already "breaks with traditional museum architecture, which generally seeks to consolidate the cultural heritage" of a given culture.[37] Through the juxtaposition of monumentalizing baroque architecture and Libeskind's fragmented, unpredictable architecture, a critique emerges of the traditional, modernist museum project—that of the museum as a repository of stable knowledge and archive of the past.

The museum as an archive has a long history. When architectural critic Lewis Mumford famously described the museum as a reservoir of the city's

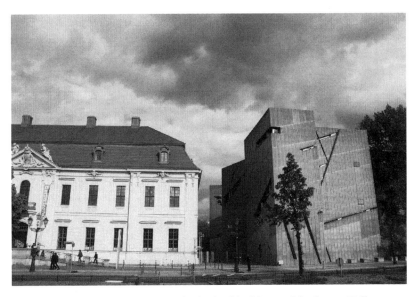

FIG. 2.2 Contrast between the Daniel Libeskind building and the former Kollegien-haus and Berlin Museum. Photograph by Rony Oren.

overpowering accumulation of history, he hinted at this archival function: "Layer upon layer, past times preserve themselves in the city until life itself is finally threatened with suffocation: then, in sheer defense, modern man invents the museum."[38] Traditionally, museums have been cast as temples or shrines that house the sacred and valuable objects of civilizations. Within this paradigm of a shrine, the museum carries an iconic meaning; collections are fetishized—symbolizing the greatness of the civilization—and displays emphasize the objects' uniqueness and authenticity. Spacing and lighting techniques, furthermore, frame museum objects with an aura of sanctity and an eternal significance recalling the Platonic values of beauty and morality.[39] The Kollegienhaus evokes associations relatable to this more traditional museum style, while the Libeskind building cultivates instability and unpredictability through its jagged, fragmented window bands and shattered facade. Through this contrast between two such different visions of the museum, the modernist museum project becomes an object of critical contemplation.

The visual disparity between the Libeskind building and the Kollegien-haus constitutes the first language of the Jewish Museum. Turning to the Libeskind building itself, it becomes possible to identify a number of

aesthetic and philosophical concepts that underlie the architect's design and that communicate with visitors through a texture of languages. Already with the title *Between the Lines* Libeskind suggests a mode of reading or experience that transcends a perfunctory response on the part of visitors. As Libeskind explains, *Between the Lines* is a "project about two lines of thought, organization and relationship. One is a straight line, but broken into many fragments; the other is a tortuous line, but continuing indefinitely. These two lines develop architecturally and programmatically through a limited but definite dialogue. They also fall apart, become disengaged and are seen as separated. In this way, they expose a void which runs through this museum, a discontinuous void."[40]

Through their disharmonious coexistence, the two lines of thought that resist integration reveal a structural tension and an underlying void that establishes the syntax or grammar of the museum as a whole. Other forms of visual communication further inform design. For example, the unexpected shapes of the museum windows evoke the language of graphic design, while the zinc "skin" of the building recalls the painter. The E.T.A. Hoffmann Garden of Exile and Emigration and the Paul Celan Courtyard—two external museum spaces—reference, respectively, the fantastic and uncanny literature of the writer E.T.A. Hoffmann and the poetry of Paul Celan, a poetry that demonstrates the tension between language and silence and points toward the very limits of expression. The E.T.A. Hoffmann Garden is an outdoor garden with a sloping surface and concrete columns out of which olive trees grow. This garden space simulates the experience of uncertainty and instability in exile through its uneven ground. The Paul Celan Courtyard was designed by Celan's wife, Gisèle Lestrange, and bears the name of Kristallsplitter (Crystal Fragments). This name references Germany's infamous 1938 pogrom, Kristallnacht, and the jagged cuts that cover the floor of the courtyard mimic the glass shards of Kristallnacht's broken windows. The white, gray, and black stones of the Paul Celan Courtyard were laid on November 9, 1992—the fifty-fourth anniversary of Kristallnacht. But Kristallsplitter might also reference Celan's 1952 poem "Kristall," as well as the symbol of the crystal itself as it repeatedly appears in the poetry of Celan. Along with other symbols such as glaciers and snow, the crystal points beyond the limits of language to the realm of silence.

In a detailed description of the philosophy behind his design, Libeskind states that three basic ideas inform the construction of his museum: first,

the impossibility of understanding the history of Berlin without grasping the contribution made by its Jewish citizens to intellectual, economic, and cultural life; second, the necessity of physically and spiritually integrating the meaning of the Holocaust into the conscious memory of Berlin; and third, the need to fully acknowledge the erasure of Jewish life in Berlin for Germany and Europe to secure a human future. One of the ways in which Libeskind seeks to illuminate the deep interconnections between German Jewish and non-Jewish German life that once existed in Berlin is through spatial embodiment. On a first, self-evident level, the Jewish Museum and former Kollegienhaus are linked underground to symbolize the foundational relationship between German Jewish and German history—even when that history is not immediately visible. On a more subtle level, as briefly mentioned earlier, Libeskind demonstrates that the Jewish Museum itself exists within an "invisible matrix of connections, a connection of relationships between figures of Germans and Jews."[41]

In early design sketches Libeskind located the site of his future building in a meaningful constellation according to the real addresses of former German and German Jewish cultural, artistic, and intellectual figures. These figures include Heinrich von Kleist, Rahel Varnhagen, Heinrich Heine, Ludwig Mies van der Rohe, Arnold Schoenberg, E.T.A. Hoffmann (who both worked in the former Kollegienhaus and lived nearby), and Walter Benjamin. Using these addresses, Libeskind "plotted an irrational matrix that would yield reference to the emblematics of a compressed and distorted star: the yellow star that was so frequently worn on this very site."[42] The museum's location as conceived by Libeskind, therefore, is neither accidental nor random but rather constitutes a fateful joining of influential individual lives into a significant configuration. It suggests, above all, the interwoven nature of German and German Jewish lives in pre-Holocaust Germany. Among these notable persons, two—Arnold Schoenberg and Walter Benjamin—were forced into exile during the Third Reich. Libeskind designates this irrational matrix the first aspect of his project.

The second aspect of Libeskind's project speaks in the language of the musician—specifically, through the form of Schoenberg's unfinished three-act opera *Moses und Aron* (1927). Libeskind has written that he sought to complete this opera architecturally in his design for the Jewish Museum.[43] Evoking Goethe's description of architecture as "frozen music," Libeskind's intriguing statement suggests a fundamental affinity between Schoenberg's

opera and his own architectural design. One way of understanding this affinity is to examine the opera itself—particularly the passage during the second act that Libeskind cites. As Libeskind points out, Moses breaks off during the opera's second act and cries out, "Oh word, thou word, that I lack!" before he collapses to the ground in despair. The context of these words is the failure of Moses's faith in his people. Returning from a forty-day absence, he discovers that under Aron's leadership the people have resumed their idolatrous ways. He despairs so deeply that he smashes the tablets bearing God's law. A pillar of fire appears in the dark sky and the people, newly encouraged, follow it as their guide. Aron joins them but Moses remains distrustful and is distressed that Aron insists on communicating the idea of God through images and marvels. For Moses, such images render his idea of God powerless by constricting "the Boundless in an image finite!" Crushed by the failure of his vision and convinced that Aron has betrayed his absolute idea of God, Moses cries out the following words:

> Inconceivable God!
> Inexpressible, many-sided Idea,
> will You let it be so explained?
> Shall Aron, my mouth, fashion this image?
> Then I have fashioned an image, too, false,
> as an image must be.
> Thus am I defeated!
> Thus, all was but madness that
> I believed before,
> and can and must not be given voice.
> O word, thou word, that I lack![44]

In the final line, as Libeskind notes, Moses addresses "the absence of the word."[45] This absent word is the one that he could never possess, because it is the word that would express a transcendental idea—an idea that, by definition, is inexpressible through language.[46] Language, or any type of representation, strips Moses's idea of the transcendent and imposes a finite and limited form on that which should remain unnameable.

What is the word that Moses lacks and for which he cries out? Perhaps it is the word that is capable of fully expressing his idea (that is, the presence—or the name—of God). Given the limitations of language and the inability

to pronounce the name of God, what Moses actually longs for is silence. And it is exactly this silence—this absence expressed as presence—that is revealed when, directly after his speech, Moses collapses to the ground in despair. In the first and final scene of act 3 (an act for which Schoenberg wrote words but no accompanying music), Aron appears as a prisoner in chains, and Moses condemns the word that Aron speaks, the images he fashions, and the deed for which he longs. Only his own pure idea, Moses declares, can bring the people closer to God, and this idea, the libretto suggests, expresses itself truthfully only through silence and lack.

Moses und Aron thus enacts, in the words of one scholar, "a succession of enigmatic and paradoxical shards of musical *Unfaßbarkeit* [inconceivability]. The characters, words, and events on stage are a poetic-dramatic rendering of Schoenberg's belief that the margins of comprehensibility are the essential realm of both art and spirit."[47] Libeskind's architecture attempts something similar; it demonstrates spatially the limits of representation by locating at the heart of the museum a series of voids, which cuts through the museum's internal spaces and forms an "impenetrability . . . around which the exhibitions are organized."[48] The museum is thus built quite literally around a structural absence—a negative sacred. Libeskind's *Zickzackbau* echoes Moses's call for the missing word in that it attempts to give presence to an absence—in this case, to make the void and absence of Berlin's missing Jews visible but to avoid doing so through direct representation, which would risk filling the void. In the following description of his design, Libeskind delineates this tension between presence and absence: "The new extension is conceived as an emblem wherein the invisible, the void, has made itself apparent as such. Void / invisible: these structural features have been gathered in the space of the city and laid bare in an architecture where the unnamed remains in the name that keeps still."[49]

Libeskind's reference to the "unnamed" that "remains in the name that keeps still" suggests parallels to the unspoken name, or the absence that is God's name, in Jewish theology. One of the two primary names of God in the Hebrew Bible—the tetragrammaton, which may not be spoken out loud, is replaced in everyday speech with the substitution "HaShem" (the name). As Gershom Scholem explains, according to kabbalistic theory, the nature of God himself lies beyond human knowledge. This attitude, which Scholem defines as "mystical agnosticism," inspired kabbalists to create another term: *Ein-Sof*—"a hypostatization which, in contexts dealing with

the infinity of God or with His thought that 'extends without end' (*le-ein sof* or *ad le-ein sof*), treats the adverbial relation as if it were a noun and uses this as a technical term." Scholem explains the origins of Ein-Sof as follows: "God in Himself, the absolute Essence, lies beyond any speculative or even ecstatic comprehension. . . . In order to express this unknowable aspect of the Divine the early kabbalists of Provence and Spain coined the term *Ein-Sof* ('Infinite')." Scholem points out, furthermore, that Ein-Sof "does not reveal itself in a way that makes knowledge of its nature possible, and it is not accessible even to the innermost thought (*hirhur ha-lev*) of the contemplative."[50] Like God's infinite nature and name, and Moses's transcendent idea, which would be unavoidably bound and limited by its expression through image or word, Libeskind's "unnamed" must remain unspoken if it is to intimate the prodigious absence he seeks to evoke.

Parallel to this void of the "unnamed" appears the third aspect of Libeskind's project: a proliferation of names of German Jews who were deported during the Holocaust. Using the two large volumes of a *Gedenkbuch* (memorial book), which contains the names, birth dates, dates of deportation, and presumed place of death of German Jews, Libeskind discovered the names of the places where Berlin's Jews died—places like Riga, the Łódź Ghetto, and different concentration camps.

While working in Milan on his design for the Jewish Museum Berlin competition, Libeskind and his associates cut from the Gedenkbuch masses of names, which they then glued to the diamond-shaped wooden base of the Jewish Museum model. Their method of constructing a "terrain of unimaginable tragedy," as design associate Donald L. Bates describes the Jewish Museum, was to divide the names in half and, beginning in opposite directions and with the family name "Berlin," to glue the names onto the base. German Jews with the name "Berlin," Bates points out, had adopted the name of their new home as their family name—an act that signified hope and confidence in their future as Jews in Germany. A collage of names therefore underlies the very structure of Libeskind's design, beginning with the names of those who envisioned their new identities through their adopted home. This proliferation of names acts as a counterpoint to the absence that is expressed architecturally through the voids. Libeskind expresses the fourth and final aspect of his design through the language of philosophy—specifically, through a reference to Walter Benjamin's book *Einbahnstraße* (*One-Way Street*) (1928), a collection of sixty short prose texts

that include aphorisms and observations on a variety of subjects. Libeskind explains that he used Benjamin's text "neither as a metaphor nor as an inspiration to build a building, but rather to make a building whose use would open up that unidirectional text to other perspectives. There are sixty stations, stop-gaps along the distorted Star of David, which in the text, as well as in the building of the Jewish Museum, tracing [sic] apocalyptic Berlin." Edward Dimendberg comments on the role of One-Way Street in the Jewish Museum as follows: "As it replicates Benjamin's abrupt transitions in sharp angles, dramatic thresholds, and foreboding dead ends, Libeskind's construction is more closely derived from literature than architectural designs generally are." Following Dimendberg, it appears that Libeskind's design indeed parallels Benjamin's mosaic-like text in the sense that Benjamin's prose-pieces lead the reader into a textual labyrinth with unexpected turns and brief, shifting impressions. In the prose-piece "Innenarchitektur," which is included in One-Way Street and may be translated as "Interior Design," Benjamin describes the Traktat (treatise) as a form whose logic is not discernible from the outside, but rather opens itself to the reader from within.[51]

If there is a logic to One-Way Street, then perhaps it is a logic that each reader must individually discover—and this is a realization that applies to the Jewish Museum as well. Libeskind suggests such an idea when he emphasizes the interactive, dialogic nature of his museum and the role of the human subject within the museum space: "Whatever the reaction to this museum, the expectations and anticipations of the visitors will be connected to their own view of this history. Like a cloud passing in the sky that some see as a face, others as a fish or a monster, this building gives permanence to the figure of hope dressed in the guise of every visitor's response. The Museum is open to many interpretations and many routes, just like the pages of the Talmud, where the margins are often as important as what is being commented on."[52]

The very title of Libeskind's design—Between the Lines—reinforces this notion by implying a mode of reading that transcends the literal. The Jewish Museum demands the active engagement of the reader-visitors who decipher the text of the museum, which itself remains open to interpretation and analysis. In his response to Libeskind's design, Jacques Derrida notes that Libeskind creates architecture that invites participation. In this sense the museum is a performative space in which visitors transcend a merely passive or voyeuristic role as they actively respond to the architecture.

Derrida's reading of the museum text as one that calls for a response recalls Paul Celan's description of his own search for his reader—the "addressable thou"—who would be receptive to his poetry. Libeskind's architecture thus acts—like Celan's poetry—as a "message in a bottle" that is sent out in the hope that "somewhere and sometime it could wash up on land."[53]

The element of the unexpected and the unpredictable—the realm of Libeskind's "tenth muse"—appears in the *Glashof* (glass courtyard) of the Jewish Museum Berlin, erected in 2007. The glass courtyard, which looks out onto the museum garden, evokes the texture of ambiguity and liminality that features prominently in Libeskind's other Berlin designs. The courtyard actively draws on the *sukkah* (hut or tent—literally "tabernacle") for its model, which is also the title that Libeskind gave the design. The glass ceiling of the structure is supported by four bundles of "tree-thick" steel pillars, suggesting a table, while overhead a steel framework imitates the spreading branches of a tree. These beams echo in steel the tree branches spread out on the roofs of the huts erected during the Jewish festival of Sukkot. Light pours through the courtyard roof of transparent glass, creating striated shadows across the floor. Curtain walls allow unobstructed views of the garden and sliding doors open in the summer, transforming the courtyard into an outdoor space.

FIG. 2.3 Glass courtyard, Jewish Museum Berlin. Photograph by Rony Oren.

During the fall festival of Sukkot, the sukkah serves as a space for social gatherings and the sharing of meals. Echoing this social function, the Jewish Museum's glass courtyard houses all kinds of events, including receptions, concerts, and performances. On a more symbolic level the glass courtyard as sukkah brings into ambiguous relation ideas of exile, homeland, liminality, and transition. The sukkah itself symbolizes transitory existence, referring as it does to the Israelites who lived in such temporary dwellings in a state of transition between slavery and arrival in the Promised Land. In this sense the sukkah-modeled glass courtyard emphasizes the fact that the Jewish Museum Berlin is an exilic site and thus undermines the very idea propagated in the museum's permanent exhibition: the possibility of Germany as a homeland for Jews. However, while sukkah huts today (in Israel, for example) are often built with natural materials such as wood and then covered with branches and leaves, Libeskind's sukkah is made of immutable glass and steel. This sukkah is, so to speak, set in stone and suggests a paradox of permanent liminality.

In the Jewish Museum Berlin, the element of the unpredictable emerges in the form of the visitors who respond to the architecture and participate in memory in idiosyncratic ways. Ambiguous spaces that are open to interpretation, such as the Holocaust Tower, articulate questions and conflicts rather than solutions; they encourage visitors to imaginatively engage with the architecture. A definitive meaning is withheld in the sense that these spaces do not dictate an answer to the problem of remembrance but rather return the burden of memory to the visitors.

As already discussed, Libeskind's design plays with the tension between absence and presence—but it also highlights the tension between the abstract and the concrete. Libeskind seeks to give a concrete shape to the abstract relation between Germans and German Jews through a series of individuals (both Jewish and non-Jewish Germans) whom he names as "great figures in the drama of Berlin who have acted as bearers of an immense hope and anguish and are traced into the lineaments of this museum: Heinrich Kleist, Rahel Varnhagen, Walter Benjamin, E.T.A. Hoffmann, Friedrich Schleiermacher, Arnold Schönberg, Paul Celan." Each figure symbolizes for Libeskind an affirmation of the "permanent human tension polarized between the impossibility of the system and the impossibility of giving up the search for a higher order."[54] Libeskind thus frames the Jewish Museum as existing in the tension between the ultimate reality toward

which humans strive and the necessarily limited and limiting means they employ. The cultural figures and their methods through which Libeskind traces this "permanent human tension" include Heinrich von Kleist and "tragic premonition," Rahel Varnhagen and "sublimated assimilation," Walter Benjamin and "inadequate ideology," E.T.A. Hoffmann and "mad science," Friedrich Schleiermacher and "displaced understanding," Arnold Schoenberg and "inaudible music," and Paul Celan and "last words." Libeskind argues that it is the series of encounters between the visitors to the museum and the figures inscribed into the museum that will allow his space to emerge as a "concretized space of encounter."[55] This is how Libeskind seeks to connect museum visitors to the lives and experiences of Germany's Jewish victims—through empathy with those individuals, both Jewish and non-Jewish, who struggled for a higher order against the system. Such a vision transforms a museum from a static container for exhibits into a living and dynamic space where visitors are not merely passive spectators but active participants.

The "system" to which Libeskind refers might be described as the system of rationality and order—in short, that which cannot be renounced in the name of chaos. Culture helps us articulate the search for a higher purpose or meaning, but as Schoenberg shows us in *Moses und Aron*, the system that gives our culture form is ultimately hopeless because it cannot help us to discover the transcendent truth that lies beyond language. To go totally silent, however, is not the answer either, as Libeskind suggests with his highly expressive architectural design. It is within these series of tensions—between ultimate reality and the human effort to reach it, between the fixed system and absolute silence, between presence and absence, between the concrete and the abstract—that Libeskind's architecture exists. The essence of his design may be found, therefore, in the series of marginal spaces or voids that exist at the heart of the Jewish Museum, which—like the edges of the pages of the Talmud—offer a place where personal interpretation and response may emerge. Libeskind's claim, furthermore, that his architecture completes Schoenberg's opera might suggest a mystical reading of his museum. In such a reading, Libeskind's design attempts to reach beyond the silence imposed by Moses and emerges as a prism to the transcendent. "The Name" (HaShem) in Jewish theology would in this way correspond to what Libeskind is doing with his museum in space—representing absence and, in so doing, gesturing toward infinity.

The Negative Sacred and the Void

The most powerful illustration of absence in Libeskind's design is the series of voids that runs throughout the museum. Visitors may enter and experience two of the voids in the Jewish Museum—the Holocaust Tower and the Memory Void. Libeskind uses the term "voided void" to refer to the act of materializing the emptiness of a vacant space so that a void may be entered. The first of these two voids—the Holocaust Tower—is described by Libeskind as ending "the old history of Berlin": "From the burning of books and cultural artifacts, the exhibit of which will be shown in the Museum, to the burning of human beings which will be represented by nothing but the names in a Gedenkbuch—this is what I mean by the 'voided void.' This bespeaks the nothingness of the nothing."[56] The void, Libeskind adds, "refers to that which can never be exhibited in this museum, no matter how many objects are brought to it and stories told in it."[57] It hints at the absence, in other words, of Germany's missing Jews and gives spatial expression to a loss that cannot be expressed through the amassing of objects or evidence.

The Holocaust Tower (Holocaust-Turm), located at the end of the Axis of the Holocaust, is an approximately seventy-eight-foot-high angled space built of raw concrete. The door that opens into the tower is heavy and closes automatically behind visitors, and the space is neither heated nor cooled. The only light filters in from above through a narrow opening, which creates a wintry, bluish gray light within. This dim, cool, empty space inverts conventional spaces of memory and mourning that offer viewers symbols of heroism or martyrdom. Before a conventional memorial, such as the World War II Memorial in Washington, DC, or the *Pillar of Heroism* at Yad Vashem, viewers gaze at a material signifier of memory and are encouraged to project certain predictable values—such as heroism and martyrdom—onto their remembrance of the victims.

In the Holocaust Tower, however, absence prevails as a void that makes itself visible as such. Standing inside the tower, visitors experience the burden of silence and feel drawn into a vacuum. It is a staging of absence and an illustration of loss through the negative sacred that becomes manifest in the Holocaust Tower and in the architecture of the Jewish Museum as a whole. Libeskind resists the temptation to try to make sense of history or to heal the wounds of the past. Instead, the Jewish Museum may be viewed as the architectural expression of two philosophical problems: how to make visible that which has been made invisible and how to recall that which has

been exiled and destroyed. The sense of the sacred that Libeskind's architecture communicates in the articulation of this problem is fundamentally negative. The negative sacred is just as powerful as the (positive) sacred, but in contrast it is associated with dangerous and frightening forces—which Emile Durkheim describes as death, fear, and sacrilege—before which one experiences reverence or awe. Drawing on Robertson Smith, as did Durkheim, Robert Hertz emphasizes in his analysis of the negative sacred those aspects that "violate and disturb the order of the universe." The respect that such aspects impose, furthermore, is "founded on aversion and fear."[58] Libeskind evokes the negative sacred in the Jewish Museum through his intricate structure of five voids, painted in graphite black, which, cutting through the museum both horizontally and vertically, are positioned between the two lines extending through the museum. The Holocaust Tower offers visitors the chance to experience on a visceral level the negative sacred.

The museum's second accessible void is the Memory Void (Leerstelle des Gedenkens), which houses the installation *Shalechet (Fallen Leaves)* by Israeli artist Menashe Kadishman.[59] *Shalechet* consists of more than ten thousand roughly cut, round iron faces with open mouths and empty eye sockets. These faces are cut from heavy, circular iron plates and their open mouths appear to scream in silent pain. Visitors may walk directly on them and feel the rough, heavy iron in unsteady heaps underneath their feet. Varying in size, these iron faces suggest the vast range of Holocaust victims who are rendered an anonymous collective through their pain and deaths. Unlike the Holocaust Tower, this void is "filled," but it is filled with abstract forms that serve only to emphasize the depersonalization of the victims and the way that their humanity was stripped away from them.

The museum voids that remain inaccessible to visitors are still occasionally visible through narrow windows, and as visitors move from one museum space to another they traverse sixty bridges that open into voided spaces—what Libeskind describes as "the embodiment of absence." The inspiration for using voids in his museum design, as Libeskind explains, originated from his visit to the Weißensee cemetery, which was once the largest Jewish cemetery in Berlin. Libeskind was struck by the emptiness of the vast marble tombstones, which had been erected by wealthy families with the purpose of engraving and inscribing them with the names of future generations. Lost to exile or death, there would be no one left to return, Libeskind notes, to bear witness to the emptiness of those stones or to those lost generations. Here, Libeskind came face-to-face with the negative sacred in the form of

tombstones that, instead of testifying to the natural cycle of birth and death and the succession of generations, testify to the destruction of both living generations as well as the future generations of Jews that might have been but were never permitted to be born. In Shabbat liturgy, the sanctity of generations is expressed in the following lines from Psalms 146:10: "*Yimlokh Adonai l'olam, Elohayikh Tziyon l'dor va-dor, Halleluyah*" (Adonai shall reign through all generations; Zion, your God shall reign forever. Halleluyah!) The loss of generations is thus a tragedy that extends beyond individual families and even communities to strike at the very heart of Jewish practice and tradition. The Weißensee cemetery inspired Libeskind to use voids as the medium to express a trauma that exceeds personal tragedy—"a trauma which is structured by the destruction of a community . . . an absence which is structured in the city, in the topography of a country, and in the topography of Europe and the world."[60] Before this landscape of destruction and absence one stands in awe and silence—this is the moment of the negative sacred.

Libeskind's architectural voids, among other techniques, have led many critics to describe his museum as deconstructivist, with an architecture of disintegration and rupture. In a discussion of Libeskind's architectural drawings of 1979, titled *Micromegas*, for example, Gavriel Rosenfeld argues that Libeskind's work challenges "the foundations of western architectural practice" and demonstrates a "radical separation of form and function." Rosenfeld maintains, furthermore, that Libeskind's early work "display[s] a suspicion of modern reason, a rejection of traditional architectural form and function, and a penchant for cryptic poetry," revealing, in essence, an "incipient deconstructivist mentality."[61] Deconstructive architecture as a style is associated with Peter Eisenman, Frank Gehry, and Rem Koolhaas and appears, for example, in the Museum of Modern Art's 1988 exhibition and catalog *Deconstructivist Architecture*. The comparison of Libeskind's museum to the work of such deconstructivist architects has a good deal of merit. Eisenman in particular employs a dialectic of oppositions in his work, using techniques of dislocation and rupture to destabilize his structures. General characteristics of deconstructivist architecture include unclear boundaries, ambiguous spacing, exaggerated or distorted perspective, the idiosyncratic collision of walls, and an aesthetics of fragmentation.[62]

Deconstructivist architecture decentralizes conventional architectural syntax and strips its forms of any aura of familiarity or hominess, creating what Anthony Vidler calls the "architectural uncanny." Vidler analyzes Libeskind's museum through this concept in the following quotation, in

which—ironically—he draws on Heidegger for his analysis: "when confronted by the withdrawn exteriors and disturbing interiors of the Jewish Museum . . . we find ourselves in a phenomenological world in which both Heidegger and Sartre would find themselves, if not exactly 'at home' (for that was not their preferred place), certainly in bodily and mental crisis, with any trite classical homologies between the body and the building upset by unstable axes, walls and skins torn, ripped and dangerously slashed, rooms empty of content and with uncertain or no exits and entrances."[63] Vidler reads Libeskind's building through a philosophical lens and argues that the moments of absence and voids, including voids of memory, the past, and the still-missing Jewish community, are what hold "the visitor in spatio-psychological suspense." Furthermore, they evoke for Vidler the "closest experience" to what he imagines a "religious experience of architecture might be."[64]

Vidler's reference to the uncanny in his reading of Libeskind's architecture is fitting, given the fact that Libeskind names E.T.A. Hoffmann as one of the inspirations for his design. Hoffmann's short story "Der Sandmann" (1817) was an inspiration for Freud's essay "Das Unheimliche" ("The Uncanny") (1919), in which he explores in detail the psychoanalytic nature of the uncanny. James E. Young also draws on the uncanny in his description of the Jewish Museum, in which he depicts the museum as a "haunted house of Jewish memory" that is faced with the task of housing the memory of a people who had once felt at home in Berlin but had been driven away or murdered.[65] In this analysis, Young relies on Freud and stresses the role of repression in forming the uncanny.

The architecture of the Jewish Museum Berlin signifies on a number of levels. It undermines visitors' expectations through its juxtaposition with the Kollegienhaus and hints at a critique of the modernist museum project. The apparent spatial and stylistic separation of the two buildings, furthermore, suggests a separation between German and German Jewish history that turns out to be deceptive, as German and German Jewish history are linked in a fundamental way underground. The Libeskind building itself, finally, appears suspended around an absent core that expresses the trauma of the Holocaust—a trauma made visible through the series of voids throughout the museum. Libeskind's framing of the negative sacred in the Jewish Museum Berlin contrasts sharply with Yad Vashem—to be discussed in the next chapter—where a positive, even redemptive narrative and sense of the sacred prevails.

3 ❧ ARCHITECTURES OF REDEMPTION AND EXPERIENCE

Yad Vashem and the U.S. Holocaust Memorial Museum

While Daniel Libeskind's Berlin architecture resonates with the image of Berlin as a ruined topography and seeks to preserve traces of that ruin, instability, and uncertainty, architect Moshe Safdie's Jerusalem architecture resonates with an image of Jerusalem as a palimpsest or a layered topography. The architect emphasizes structures rich with symbolic meaning in terms of their shape, material, style, and near-organic relationship to the landscape.

Moshe Safdie was born in Haifa, Israel, in 1938. He and his family later emigrated to Canada, and Safdie studied architecture at McGill University. He apprenticed with Louis I. Kahn in Philadelphia and then returned to Montreal, where he was in charge of the master plan for the 1967 World Exhibition, whose central feature was an adaptation of his Habitat '67 project—an icon of urban living famous for its utopian principles. After setting up an office in Jerusalem in 1970, Safdie became involved with the rebuilding of the city. He was particularly active in the restoration of the Old City and the construction of the city's new center. Safdie's realized designs in Israel—in addition to the new Yad Vashem Holocaust History Museum and the *Children's Memorial* and *Memorial to the Deportees*, both

at Yad Vashem—include the David Citadel Hotel, Modi'in, Yeshiva Porat Yosef, Hebrew Union College, David's Village in the Mamilla District, the Mamilla Center and the Mamilla Hotel, Mercaz Shimshon, and the Yitzhak Rabin Center.[1] Highly conscious of Jerusalem's architectural history, Safdie applied this knowledge to his design for the new Yad Vashem. Hence, to understand his approach to that museum, it is necessary to consider the architectural past of Jerusalem.

Jerusalem as Palimpsest and Layered Topography

In his book *The Harvard Jerusalem Studio*, Safdie tells an anecdote about the construction of the Ottoman Wall in Jerusalem by Suleiman the Magnificent. He claims that without the lesson of this anecdote, no discussion of design and architecture in Jerusalem would be complete. In Safdie's retelling: To the left of Jaffa gate are two tombs. According to legend they belong to the architects who designed Suleiman's wall. After the completion of the wall, Suleiman visited and found that the architects had left Mount Zion outside of the wall and therefore beyond the city. He beheaded the architects. "So much for the danger of designing for Jerusalem," Safdie concludes.[2]

As the sacred center for the three major monotheistic religions and a city that has been at least twice destroyed and rebuilt as well as subject to occupation, division, and war, Jerusalem is a city of great religious and historical significance. Its stature, Safdie declares, must be acknowledged by the architect who dares to build in Jerusalem: "One cannot build with indifference in Jerusalem. It requires either an act of arrogance—building boldly as Solomon and Herod did—or of aggression—demolishing the old fabric and building anew as the Romans and Umayyads did; or it demands humility—absorbing the past, reflecting upon it, respecting it, as one considers the present and future."[3]

Safdie's Jerusalem architecture follows the third approach—the path of humility—as he reflects on and acknowledges Jerusalem's palimpsest-like nature and architectural history. Despite the many political and architectural changes in Jerusalem over the years, certain principles or foundational values in Jerusalem architecture persist and have exerted considerable influence on Safdie's design for Yad Vashem. The most important of these is the use of Jerusalem limestone, which for many years was mandated for

all structures built in Jerusalem. The ubiquitous golden-colored limestone contributes to the city's famous soft, glowing tint. Golden and silver domes amplify and reflect this light, inspiring Jerusalem's nickname, "City of Gold." One indicator of the symbolism of Jerusalem limestone in Israeli national mythology is demonstrated through the popularity of the song "Yerushalayim Shel Zahav" (Jerusalem, City of Gold), composed by Naomi Shemer and sung by Shuli Nathan at the Israeli Music Festival on May 15, 1967. Associated with the Six-Day War, which broke out only three weeks later, and with the reunification of Jerusalem under Israeli rule, the song expresses the Jewish longing for Jerusalem after a two-thousand-year exile. Symbolic of an autochthonous relationship to the land, the golden limestone, a natural resource of the region, binds the constructed structures of the city with the underlying earth. Admiring the soft, golden texture of the city, Safdie describes Old Jerusalem as a "mass of intricately carved stone. It is as if nature had deposited a solid layer of limestone three or four storeys high which followed the curves and contours of the landscape. Then, with a chisel, man cut away alleys, passages, stair ramps, courtyards and terraces."[4]

The use of golden-colored limestone was mandated for the city when it was still under the control of the British Mandate (1919–1948). In an effort to preserve Jerusalem's heritage, Sir William McLean initiated the regulation, insisting that all buildings in Jerusalem be at least faced with the limestone. Ronald Storrs, the military and then civil governor of Jerusalem between 1917 and 1926, stated that the motivation behind the regulation was to respect "the tradition of stone vaulting, the heritage in Jerusalem of an immemorial and hallowed past."[5]

Jerusalem, as has been often noted, is a historically and architecturally layered city.[6] Many cities have been metaphorically described as palimpsests, but in the case of Jerusalem it is an especially fitting image, calling forth as it does the image of a city displaying a paradoxical temporality. Safdie describes Jerusalem as a "mosaic of architectural patterns" and points out that one senses architectural contrast and change when contemplating the diverse styles of different periods that are layered on top of one another. For example, as Safdie explains, in the Western Wall the joints of the huge stones of Herod's Temple (about three feet tall by about thirty-three feet long) are covered by the "small rubble-looking stones of Turkish times." The layered construction of Jerusalem means that each new age encounters the last, and must "accommodate [its] . . . ruins, foundations, and remnants."

The Crusader and Ottoman markets, for example, followed in the footprints of the long ago destroyed Roman Cardo Maximus; the southern wall of the city is constructed over the foundation wall of the Omayyad Palace of the seventh century; the Damascus Gate is superimposed onto the Roman gate from 1,500 years ago; and the Al Aqsa Mosque and Dome of the Rock arise from the plateau designed by Herod for the enlarged Temple.[7] Each new age rebuilds, but traces of that which came before remain and create a layered topography.

Given the rich and varied history of Jerusalem, a common concern among architects and city planners has been how to preserve and protect the city's heritage. To give one example, buildings like the Supreme Court are praised as "acutely aware of the need to adapt traditional Jerusalem architectural features and materials into its modernism, and to fit the building conceptually as well as physically into the landscape of the city and its surrounding desert and mountains." Built in 1992 and designed by Ran Karmi and Ada Karmi-Melamede, the Supreme Court is made of Jerusalem limestone and resonates visually with other Jerusalem architecture. With its "arched colonnades, stepped paths, rough stone next to whitewashed walls, and changing vistas produced by jutting corners and angular pathways," the Supreme Court produces "modern echoes of the Old City" and thus offers visual continuity rather than stylistic dissonance. According to Ada Karmi-Melamede, the building possesses a familiar Jerusalem stone alley and an entrance hall reminiscent of Absalom's Tomb.[8]

Institutions and committees were created, furthermore, to address the development of Jerusalem in the years after its reunification. The Jerusalem Committee, for example, was set up by former Jerusalem mayor Teddy Kollek with the purpose of examining the city's actions in shaping future growth, and the Harvard Graduate School of Design's Jerusalem Studios, implemented under Safdie's direction, focused on urban design strategies in Jerusalem. As Safdie points out, certain areas of Jerusalem, such as the Jewish Quarter, were restored and developed, but other parts of Jerusalem have been overlooked, including the neglected area by the Damascus Gate and ritual routes to the Old City by Saint Stephen's Gate and the Mount of Olives.[9]

Safdie's Jerusalem Studios, which operated for five years, recognized the inherently political and problematic nature of building in Jerusalem. The principles that guided the Jerusalem Studios included appreciating the value of tradition in design, promoting the architecture of symbols, and

raising the question of harmony or contrast in new construction. The studios also considered the impact of building technology on style and form, the conflict between new development and traditional cultural values, and the question of how urban design affects inhabitants. These foundational agendas address issues facing all city planners and architects; however, in a city like Jerusalem, with its different religious traditions and politically charged landscape, such issues become particularly significant.

Moshe Safdie's Vernacular Architecture

We see how the studios' guiding principles translate into actual construction when we look closely at Safdie's Jerusalem architecture. First, Safdie believes in preserving continuity in form between the new buildings he designs and the existing environment. In his concern for protecting the heritage of the city into which he integrates his structures, Safdie seeks to be true to the history of place, which means paying careful attention that the materials he uses foster harmony with the environment. Much of Safdie's architecture in Israel relies on contextual references such as Jerusalem limestone and arches. Safdie's Hebrew Union College and David's Citadel Hotel, for example, use traditional rough-hewn golden Jerusalem limestone. The glass and aluminum infill panels of Hebrew Union College, furthermore, "reflect the yellow stone and complete a silver and gold palette that echoes the colors of the city's shrines."[10] Similarly, Safdie's Yeshiva Porat Yosef relies on structures such as concrete arches, arcades, ramped passages, and apertures to echo and create a sense of harmony with the domed shrines. Made of Jerusalem stone and possessing "sand-blasted arches" that match the color of the masonry walls, Yeshiva Porat Yosef was constructed on the site of a yeshiva destroyed in the 1948 war and rises from the Western Wall plaza.[11]

Safdie's guiding values reflect an adherence to "vernacular architecture," which he describes as an architecture that emerges from the realities of the environment and responds naturally to its materials and climate and the needs of the community. In an architectural vernacular, "each architect would use, adapt, and add to the totality of environment." This philosophy expresses an organic principle in which structures are tied to place and land. As Safdie explains, vernacular building systems "evolved in an organic, morphological way. . . . [Man] was very influenced by the materials. If he

had mud he used it in a way that was true to the nature of mud, if he had stone he used it according to the nature of stone."[12]

In describing his own work through the concept of the vernacular, Safdie illuminates how his structures are not universal solutions but rather "organically valid" for a particular place. This concern with harmony between structure and site is a quintessentially Israeli and nondiasporic concept, deriving from ideas of natural presence and autochthony. According to the principle of Safdie's vernacular architecture, constructed structures should respond to their surrounding climate and landscape conditions. Safdie admires much of the architecture of Israel for precisely this reason: he describes hillside Arab villages, for example, which are crafted from the stone of the mountains and whose domes, arches, vaults, shaded passages, and towers are "all in harmony with the landscape and the sun."[13] Safdie imitates such effects in his own projects: the Great Hall and Library, for example, of his Yitzhak Rabin Center in Tel Aviv are roofed by a series of "undulating, curved, shell-like elements, overhanging and shading the glazed walls and reflecting diffused light inward."[14] In this way, the building responds to the intense, bright white light of Tel Aviv with processes of shading and diffusing, much like the patterning of tree leaves.

The principles that characterize Moshe Safdie's body of work share an attention to the local environment and an interest in discovering continuity in terms of the form and material in structures. Turning to the erection of buildings that embody sacred meaning and symbolism, such as the new Yad Vashem and Safdie's unrealized Western Wall Precinct (a redesign of the space in front of the Western Wall into a series of public piazzas, archaeological gardens, and public institutions), an additional principle emerges: the separation of the secular and the sacred. In his Western Wall Precinct plan, Safdie suggests excavating the praying area down to its original Herodian street level, about thirty feet below the current terrain, with a series of public squares terracing upward. He would then partially restore the archaeological ruins of an Umayyad palace and would reconstruct a segment of the Temple's grand stairs. The plan separates sacred and secular traffic through an arcaded street that would run parallel to the wall. This plan reveals other aspects of Safdie's Jerusalem designs as well, such as the preservation and restoration of historic structures and the harmonious integration of new buildings into the city environment. Several of these architectural principles, including the separation of the secular and the sacred and ideas of

natural presence and autochthony, helped to shape Safdie's design for the Holocaust History Museum of the new Yad Vashem as well.

Architecture of Redemption: Moshe Safdie's New Yad Vashem

On August 28, 1953, the Knesset (the Israeli parliament) passed the Martyrs' and Heroes' Remembrance (Yad Vashem) Law 5713–1953. This law heralded the founding of Yad Vashem: The Holocaust Martyrs' and Heroes' Remembrance Authority in Jerusalem, which would become the central institution in Israel dedicated to the study and commemoration of the Holocaust. The law states that Yad Vashem was established to commemorate the "six million members of the Jewish people who died a martyr's death at the hands of the Nazis and their collaborators."[15]

The idea for a Holocaust museum in Israel first appeared in 1942, when reports of the catastrophe enveloping European Jewry reached the Yishuv (the Jewish settlement in Palestine during the British Mandate). Mordechai Shenhavi, a member of the Kibbutz Mishmar Ha'emek, suggested at a board meeting of the Jewish National Fund that a monument be established called "Yad Vashem," which translates as "a monument and a name" and which would be dedicated to the victims and would seek to register all the Jewish victims of the Shoah.[16] The site chosen for Yad Vashem was the western side of Har Hazikaron (Mount of Remembrance), facing away from the city of Jerusalem and adjacent to Mount Herzl, the site of Jerusalem's national cemetery for Israeli and Zionist leaders as well as soldiers. This physical proximity to Mount Herzl forges a link between national heroism, Zionist principles, and the martyrdom of Holocaust victims. The nationalistic assimilation of Holocaust victims by means of geographic configuration also stands out in an idea put forth by Shenhavi in 1950 that all Jewish Holocaust victims be granted Israeli citizenship at the time of their death. Shenhavi's reasoning was that the loss of each Jewish Holocaust victim was the loss of a potential Israeli citizen. Although the idea received considerable attention, it was logistically untenable and in the end the possibility of memorial, or honorary, citizenship remained the only option.[17] The physical location of Yad Vashem, however, fulfills Shenhavi's failed conception in the sense that Holocaust victims are now offered a place of memorialization

that overlaps with Israel's preeminent citizens. Holocaust victims are thus subsumed into a collective Israeli and Zionist identity.

In 1957 the first structures of Yad Vashem opened, consisting of an administrative space, an archive, and a library. The Ohel Yizkor (Memorial Tent), a space for reflection and memory and the site of commemorative ceremonies as well as a basic historical exhibit, were added in 1961.[18] In 1973 a museum containing a more permanent exhibition was inaugurated. Increasingly over the years, Yad Vashem's complex of Holocaust museum and memorials has expanded substantially across its forty-five-acre site. The grounds of Yad Vashem now contain a number of memorials and monuments dedicated to particular groups of victims and heroes, including the *Pillar of Heroism*; the *Monument to Soldiers, Ghetto Fighters, and Partisans*; the *Valley of the Communities*; the *Memorial to the Deportees*; a memorial to Janusz Korczak and the children of the Warsaw Ghetto; and the *Children's Memorial*. By the beginning of the 1990s it became clear that the main exhibition building was inadequate and outdated, and on March 15, 2005, the new Holocaust History Museum was dedicated, designed by Moshe Safdie and Associates and occupying four times the size of the former Yad Vashem.[19]

From the perspective of its founders, Yad Vashem serves as the world's official commemorative institution for the Holocaust. Implicit here is the assumption that Israel is the sole political entity able to appropriate the memory of the Holocaust as "part of its own self-definition and legitimation."[20] One of Yad Vashem's ongoing projects is to collect and register the names of all Jewish Holocaust victims in its *Hall of Names*.[21] That is to say, Yad Vashem functions literally as a repository of memory and an archive that refuses to surrender the past to the effects of time and forgetting. But Yad Vashem also manifests, spatially, a tension between the displacement and exile of the Diaspora on the one hand and Zionist return on the other. Recalling the tradition of returning the remains of those fallen in battle to their homelands, ashes of Holocaust victims are held in Yad Vashem's Ohel Yizkor, and Yad Vashem has been described as a grave for Jewish Holocaust victims. The vast majority of these victims, of course, never even set foot in Palestine, so this is homecoming in a metaphoric sense, reflecting the Zionist principle that Israel is home to all Jews, past and future. Joan Ockman has aptly called Yad Vashem "a place in the world for a world displaced," capturing the dialectic at the heart of Yad Vashem and the challenge of creating a place that is itself a monument to displacement.[22]

A rich literature exists on the instrumentalization of Holocaust memory in Israel for political reasons and on the shifting of memory practices over time.[23] Scholars agree that Holocaust commemoration in Israel's immediate postwar years focused on heroic figures, including ghetto fighters, partisans, and Jewish soldiers. This focus served a vital political and ideological purpose in the young and vulnerable state. The image of the courageous Jewish resistance fighter or partisan was the only acceptable (exilic) counterpart to the new Israeli, the pioneer and Sabra (native-born Israeli) who, in sharp contrast to the Diaspora Jew, was strong and self-reliant, worked in the fields, and was ready to defend the Jewish state. The Sabra embodied the image of the Zionist ideal, and through the figure of the heroic resistance fighter or partisan, a link was made between the Jewish past in the Diaspora and the new Jewish state. As Yael Padan has argued, heroic narratives from the Holocaust were assimilated into the official narrative of Israel, linking resistance in the Diaspora with the Israeli soldiers of the War of Independence as well as of subsequent wars.[24] The ostensibly more passive survivor or victim, on the other hand, was not so easily assimilated to the new Israeli ethos.

Many changes have taken place during the more than fifty years that Yad Vashem has been in existence. The early memorial focus on partisans and ghetto fighters (seen, for example, in Yad Vashem's Wall of Remembrance, a modified copy of Nathan Rapoport's Warsaw Ghetto Uprising Monument), which dominated through the late 1970s, has since been mitigated by a broader commemoration that acknowledges and honors all victims and survivors of the Holocaust. The changing memorials at Yad Vashem thus reveal shifts in Israeli attitudes toward the Holocaust, the survivors, and their trauma.[25] With the appearance of new generations after the immediate survivor-immigrants and with changing political realities, Yad Vashem has sought to establish ties between the soldiers who died in the three Israeli wars of 1948, 1967, and 1973 and all victims—not only resistance fighters—of the Holocaust. This evolution in commemorative practice reflects a broader shift in Israeli society toward deeper sympathy for Jewish suffering during the Holocaust.[26]

The significance of Yad Vashem in Israeli culture extends far beyond its function as an institution of memory. As previously discussed, Charles S. Liebman and Eliezer Don-Yehiya describe Yad Vashem as playing a critical role in the Israeli civil religion. Defining civil religion as that which is "most holy and sacred in the political culture," the authors argue that civil

religion provides a sacred legitimation of the social order and society in which it functions.[27] Similarly, Omer Bartov has argued that in reference to the Holocaust the State of Israel acts as "both the consequence and the panacea": the Holocaust wouldn't have occurred if a Jewish state had already existed, and since the Holocaust did occur, a Jewish state becomes a necessity. Until recently, all visiting foreign dignitaries were taken to Yad Vashem upon their arrival in Israel, and schoolchildren and soldiers still visit Yad Vashem regularly. Yad Vashem not only tells a story about the past, Bartov argues, but concerns itself with the future as well. All Israelis, as Jews, are potential victims, and all Israelis are survivors of a catastrophe, still living on the "brink of an abyss."[28]

As a memorial authority and an institution of memory Yad Vashem promotes recollection, but it also possesses an integrative function, inscribing its visitors into a collective and national narrative. Idov Cohen, member of Knesset, for example, envisioned Yad Vashem as both a "symbolic tombstone for individual mourners as well as a monumental civil religious shrine."[29] The existence of a "shrine" is key to a civil religion; in Israel, "holy sites" such as Yad Vashem are necessary to serve as "physical manifestations" of political (or civil) religion and to be "visited by pilgrims."[30] In this way Yad Vashem fulfills a vital national function in Israeli culture—it contributes toward the formation of a collective identity for its visitors through an ingathering of memory, which it then channels toward a future collective redemption in nationhood.

Holocaust remembrance has changed in many ways from the time of the Yishuv to the present day, and these shifts have led to alterations in the Yad Vashem landscape. Events such as the Rudolf Kastner Trial (1954) and the Eichmann Trial (1961) made the Holocaust front-page news in Israel. Debates within the government, meanwhile, over issues such as diplomatic relations with Germany and reparations for survivors raised questions of how the State of Israel should deal with the traumatic past of many of its citizens. New memorials built during these years reflected the changing narratives of Israeli Holocaust remembrance. The greatest change to the Yad Vashem landscape, however, was the opening of the new Holocaust History Museum.

The new Holocaust History Museum demonstrates the power of evocative architecture as it creates in its visitors an empathetic, visceral identification with the victims of the Holocaust and inspires a redemptive reading of its narrative. A variety of techniques serve these ends, including a carefully

choreographed use of shapes, material, color, and the play between shadow and light. Certain techniques also impact the body and senses of visitors. The longitudinal section of the museum, for example, is modulated with floor and roof planes ramping five degrees downward and then back up again, producing "perspectival distortion" and destabilizing visitors' sense of equilibrium.[31] The tunnel structure of the museum, furthermore, varies in diameter, constricting and widening at different moments of the display's narrative to induce claustrophobia and discomfort at certain points and an expansiveness evocative of redemption and freedom at others. Notably, passage through the museum itself is carefully crafted so that the visitor can see the entire length of the museum but cannot move through the center section directly. Instead, visitors follow a restricted serpentine path through a series of ten galleries.

To enter the Holocaust History Museum, the visitor must first cross a series of thresholds. Approaching the Yad Vashem complex from the main entrance, one encounters an aqueduct-like screen wall, the Gateway Wall, which is made of cast-in-place concrete and which serves as the initial physical threshold of Yad Vashem. The Gateway Wall's verticals widen at their bases and cant a few degrees backward, inducing in the visitor a subtle feeling of instability—what Joan Ockman describes as the "opening notes of a spatial composition that is both symphonic and at times vertiginous."[32] The screen wall bears the inscription, "I will put my breath into you and you shall live again, and I will set you upon your own soil" (Ezekiel 37:14). The dialectical relationship between death and redemption appears already with these words and sets the tone for the visitors' experience of the Yad Vashem complex as a whole.

The Gateway Wall serves another purpose as well; it acts as a demarcation line that separates the sacred site of Yad Vashem from the surrounding city. As discussed earlier, one of the key elements of Eliade's theory of the separation of the sacred and profane in space is the hierophany, which acts as an irruption of the sacred and results in the detachment of a territory from its surrounding milieu—making it qualitatively different.[33] Safdie uses the technique of marking off a special space from its surroundings to emphasize its different, sacred quality, just as he has done in other designs in Jerusalem, such as in the Western Wall Precinct.

At this juncture it bears repeating that Durkheimian and Eliadian theories of collective representation and sacred cosmology have offered

influential ways of thinking about the sacred and sacred space in the twenti-eth century.[34] Furthermore, they have had real impact on conceiving muse-ums as sacred sites and as places of ritualized visits—indeed, of pilgrimages. Since the late twentieth century, and especially in the past decade, both of these intellectual models have been challenged by new ways of conceptual-izing the sacred. New approaches emphasize, for example, the ways in which the sacred spaces of memorials and museums are "contested," that is, fluc-tuating, beset with conflicts, and often highly politicized. These new con-ceptions are beginning to affect how museums are designed; for example, museums increasingly seek to bring to the fore voices formerly silenced and marginalized within national narratives and thus to highlight the "econom-ics of movement between center and periphery and periphery and center."[35] Nonetheless, Durkheimian and Eliadian theories remain foundational even when challenged by current theorists of sacred space and memory. Further-more, for a museum such as Yad Vashem, which seeks to integrate its diverse population of visitors into a collective identity rooted in Zionism, the imagery of a powerful, sacred center is particularly compelling and persuasive.

Past Yad Vashem's Gateway Wall stands a paved stone plaza that leads to the pavilion (the *mevoah*), a large, porous square structure made of con-crete with an aluminum and glass roof and screen walls that recall the initial Gateway Wall. Safdie and Associates describe the pavilion as an "arcaded concrete pavilion roofed by skylights and trellises, which cast ever-changing patterns of shadows. It is reminiscent of a sukkah."[36] Describing the pavilion as a sukkah frames Yad Vashem and its goal of Holocaust memorialization within a narrative of exile and homecoming that continues throughout the Holocaust History Museum. Safdie's reference to the sukkah also recalls the glass courtyard—the sukkah of the Jewish Museum Berlin. Unlike the suk-kah of the Jewish Museum Berlin, however, this sukkah does not exist in exile. It serves, rather, as a liminal or transitional space through which visi-tors pass en route to the Holocaust History Museum, where they enter, in effect, the exilic space of the Holocaust.

Leaving the pavilion, visitors catch sight of the entrance to the Holocaust History Museum jutting forth from the hillside. A bird's-eye view reveals twin concrete protuberances, one at each end of the museum's long linear structure. The south end—the entrance to the museum—is a large closed concrete triangle. It has a solid, dense geometric shape whose blank exterior side possesses a single square opening that serves as a doorway. The triangle

is the dominant shape of Yad Vashem; it appears repeatedly throughout the museum and evokes the image of a halved Star of David as well as the colored triangles used to identify prisoners in Nazi concentration camps. Its partner at the northern end, the exit, is identical except that it is turned inside out, its two sides flayed outward over the abyss where the mountain drops away sharply, and its closed triangular wall is missing. Between the entrance and exit the museum is swallowed up by the mountain, with only its thin top ridge remaining visible. Safdie's breakthrough idea while designing the new Holocaust History Museum was to avoid perching the museum on the hilltop and instead to cut through the mountain, "penetrating it from the south, extending under, emerging, indeed exploding, to the north. Thus the entire new museum would be underground, with a subtle cut across the hilltop—a narrow skylight coming up for light, a reflective knife edge across the landscape that would disclose the museum's presence."[37]

From the outside the cut across the hilltop appears to slit open the ground, leaving an "archaeological scar" that is "symbolically healed by the landscape itself."[38] The healing properties of the surrounding landscape, designed by landscape architect Shlomo Aronson, are evoked repeatedly throughout the Yad Vashem complex—for example, in the dramatic and affirmative exit from the museum overlooking the Jerusalem hills. Taking into account which form would best suit the subject matter of the museum, Safdie decided that the new Holocaust History Museum "must be a wedge-like, prismatic shape, the peak of which cuts through the hillcrest, the triangle resisting the load of the earth above. The spine would be straddled by chambers, with shafts rising from each one, like periscopes through earth and vegetation, for light." The reasoning behind this decision, Safdie explains, has to do with the subject matter of the Holocaust itself: the "story of the Holocaust is too terrible, uniquely cruel and shameless in the annals of civilization," Safdie writes, to be told in the "normal 'galleries'" that all visitors have experienced. The black box style of museums would be ill-suited for such a history, as would traditional architectural constructions of doorways, windows, and halls. This is a dark story, one that comes to light only with much effort and difficulty. Safdie's building, which lies beneath the earth and occasionally pierces the surface for light and air, suggests viscerally the tremendous effort needed to confront the Holocaust. Safdie's description of the shafts rising "like periscopes through earth and vegetation, for light" further evokes the metaphor of a submarine immersed in

darkness beneath the heavy weight of water.[39] This is a narrative that must continuously struggle to reach the surface.

The new museum's underground construction was inspired by very old places buried deep beneath the earth's surface, like the Cappadocia in Turkey with its "underground cities" and the "subterranean chamber" of Beit Guvrin in the hills southwest of Jerusalem.[40] Safdie appears to be hinting at a sacred autochthony by carving his museum into the side of a mountain, a practice that represents a long-standing and widely pervasive artistic idea. Northern Israel's Beit Shearim, for example, is an entire necropolis carved out of a hillside, and India's Kailash Temple, built in the eighth century, was dug out of a single mountain. Safdie's structure exhibits a similar idea—the rock and earth of Har Hazikaron are regarded as sacred within the Zionist civil religion of Israel, and the museum taps into that physical space and ideological value.

Safdie's choice of material for the structures that belong to the new Yad Vashem is also meaningful. He built the entry screen, the pavilion, the Holocaust History Museum, and the auxiliary structures in cast-in-place concrete to create an aesthetic of abstraction and to communicate the sense of an "archaeological remnant." "Only concrete," Safdie writes, "could achieve a sense of the symbolic extension of the monolithic bedrock, free of joints, mortar, or any other embellishments."[41] Such an aesthetic resonates with the symbolism of autochthony, which is explored in the discussion of Yad Vashem's *Hall of Names*. The use of concrete signifies in other ways as well. Concrete, the stuff of bunkers, recalls the many concrete Israeli monuments that commemorate Israeli soldiers, and thus it forges a link between Holocaust victims and fallen Israeli soldiers. As Mooli Brog demonstrates, between the beginning of the 1960s and the start of the Six-Day War almost one hundred monuments were built, of which about half were dedicated to soldiers who died in the War of Independence. Concrete was the material favored for such monuments; it was "considered the symbol of extensive building and construction in the developing country—basic infrastructure, strong and exposed, and, in this sense, representative of the Israeli image: entrenched with firm roots, powerful and with a direct manner." Monuments and memorial sites erected during the 1980s were mostly constructed from exposed concrete as well.[42]

Concrete also distinguishes Yad Vashem visually from other structures built of the golden limestone typical of Jerusalem. The use of concrete thus creates the visual impression of something alien and foreign in contrast to

the warm facades of other Jerusalem tourist sites and thereby evokes a sense of displacement and exile. It is worth noting that building the new museum with concrete meant breaking with Jerusalem's zoning laws, and Safdie, therefore, had to receive special permission to use the unfinished concrete. The Ohel Yizkor, which was built as part of the original Yad Vashem complex, as already mentioned, was built of boulders and concrete, representing "Israeli memory testifying to the symbolic integration of the dead from the Holocaust with that of the fallen soldiers."[43]

Exiting the pavilion or sukkah, visitors cross a bridge that descends toward the mountain and leads to the entrance of the Holocaust History Museum. Upon entering the museum through the square door of the concrete exterior where it overhangs the mountain, they turn abruptly to the left and confront the museum's south face, an extruded fifty-foot-high triangle that is the prism's structural end. Onto this concrete wall is projected a video installation (part of the permanent exhibition) titled *Living Landscape* by Michal Rovner. This installation consists of black-and-white archival film footage and fills the "giant triangle with images of a bygone civilization": a montage of scenes from Jewish life prior to Nazi persecution. Safdie writes that through this "scroll-film" visitors are offered a window to the past (to the south), which is completed at the end of the visit with a window to the future (to the north), over the hills of Jerusalem on the museum's terrace.[44]

After viewing Rovner's video installation, visitors turn 180 degrees and descend a ramp to begin the chronological exhibit. They may be struck by the starkness of the interior of the museum. Plain, unadorned concrete walls slant inward and form a long, narrow triangle whose tip reaches up toward a narrow slit above. The triangular structure of the museum pulls the eye upward toward the light that filters through the narrow skylights, even as visitors are viscerally weighted down with the grayness of the concrete walls. As Safdie explains, "I was determined to cast the entire museum monolithically, jointless, unadorned—without any exterior waterproofing or cladding, nor any interior insulation or finishes. I wanted just the basic structure—concrete walls and floors, and glass to let the light in from above."[45] There is little color inside the museum; gray concrete walls blend into black-and-white photographs and documentary films. Visually speaking, this is a world depicted in shades of gray.

The switchback path through the museum prevents direct progression as it zigzags between ten exhibition chambers or galleries holding

permanent exhibits designed by Dorit Harel. Ruptures or trenches in the prism floor ("seizures") make it appear as though the floor had been "ripped apart" by an earthquake.[46] These ruptures or channels force a diagonal movement through the storyline of the exhibits and contain various displays that signify turning points in the Holocaust narrative. The tunnel itself is nearly six hundred feet in length and acts on visitors viscerally, constricting to its narrowest spaces and pitching slightly downward during the part of the Holocaust narrative that describes the Auschwitz exterminations. As Gavriel Rosenfeld notes, the "triangular interior space contracts from that of an equilateral triangle at the beginning to a narrower isosceles triangle in the middle."[47] The space widens again toward the end of the permanent exhibition, which concludes with the fulfillment of the Zionist dream and the Yad Vashem narrative: the founding of Israel. In the background, a 1930s recording of a children's choir from Mukacevo, Czechoslovakia, singing "Hatikva" (the national anthem of Israel) plays. Most of the children singing in the recording later died at Auschwitz. This choir appears visually at the entrance to the museum in Rovner's video installation as well so that the children's choir both opens and closes the Holocaust narrative.

An example of exhibit architecture that partakes of Yad Vashem's redemptive narrative appears in a permanent display on the massacre of Jews in Ponary Forest, outside of Vilna. From 1941 to 1944, between seventy thousand and one hundred thousand people, mostly Jews, were murdered by SS, German Police, and their Lithuanian collaborators in Ponary Forest. Their bodies lay buried in mass graves until September 1943, when Jewish prisoners were forced to dig up the corpses and burn them in an attempt to hide all traces of the mass killings. Approaching this exhibit, visitors first encounter a museum case with photographs and video testimony from the few survivors of the massacres. Beyond this case is a deep recess or pit, symbolic of the mass graves. Leaning over the edge, visitors peer downward into the excavated gap. The recess is irregularly shaped; it has four sides, but the left side is longer and canted. At the bottom of the recess lie piles of stones—a larger pile in the right corner and a smaller pile in the upper left. These piles of stones are reminiscent of the Jewish ritual of placing stones on graves in remembrance of the dead. In the ceiling above the pit is a square opening through which traces of natural light filter. The skylight lets in very little light and therefore fulfills a primarily symbolic function, suggesting a

theological illustration of the passage of Jewish souls or perhaps a sense of redemption through homecoming to Israel.

In Jewish eschatology the concept of redemption is tied to the coming of the Messiah, who will usher in the messianic age of peace and prosperity. Within the ideology of Zionism, this messianic concept is transformed into the secular goal of returning to the Jewish homeland and achieving peace and prosperity through the cultivation of land. In the exhibit on Ponary Forest, however, the vertical language of the architecture maintains a hint of the original eschatological meaning.

A staging of Yad Vashem's redemptive narrative that relies on architecture as well as on photography is the *Hall of Names,* a circular hall that appears at the end of the Holocaust History Museum. The *Hall of Names* functions both as an archive, housing the *Pages of Testimony* collection, and as a memorial to Jewish Holocaust victims. The *Pages of Testimony* project was begun in the mid-1950s and continues today to work toward collecting the names, short biographies, and photographs of all Jewish Holocaust victims; currently, there are more than two million pages, and the *Hall of Names* possesses enough space for six million. Yad Vashem describes these pages and photographs as symbolic tombstones, and the project will be complete only when every Jewish victim has been remembered. The documentation of faces and names is an act of remembrance and therefore already a sacred ritual in Judaism. But the *Hall of Names* also reaches beyond its function as a repository of memory.

In the center of the *Hall of Names* are two large cones, one extending downward through the mountain's bedrock and ending in a base filled with water, and the other rising up over thirty-two feet toward the ceiling and skylight. Inside of the upward-extending cone are some six hundred photographs of Jewish Holocaust victims, accompanied by fragments from the *Pages of Testimony.* The victims' photographs are reflected in the water at the base of the downward reaching cone. The cone reaching upward toward the light that filters in through a skylight suggests transcendence through homecoming—both in the sense of a return to God after death and in a homecoming to Israel through Zionism. The second cone, descending through Jerusalem stone and ending in water, suggests autochthony and makes explicit the connection between redemption through Zionism and the land of Israel itself. The sacred moment in this structure emerges through a link between transcendence and redemption on the one hand and the autochthonous depths of Israel on the other.

As a structure that evokes sacred meanings through a spatial (vertical) technique, the *Hall of Names* encourages a reading that draws on the theoretical lens of Eliade's work. Above all, Eliade's description of the consecration of temples provides insight into the *Hall of Names* and its performance as a sacred space. Eliade's theory is here most relevant because the *Hall of Names* preserves at its heart a powerful symbolism of the sacred center—a space that claims to transcend the conflicts and politics of the periphery that contemporary readings of museum exhibits emphasize. In addition, the explicit verticality of the *Hall of Names* and its linkage of three spatial realms may best be illuminated through Eliade's famous analysis of the axis mundi. In Eliade's analysis of sacred spaces the axis mundi is the universal pillar and center of the world.[48] This vertical element holds a vital function in that it links together and thus acts as a meeting place for all three cosmic regions of underworld, earth, and heaven. The axis mundi acts, furthermore, as a hierophany and thus reveals a sacred reality. An axis mundi appears in the *Hall of Names* through the connection between Jerusalem stone and water at the bottom of the lower cone (symbolizing the depths of the underworld), the space between the two cones at ground level where visitors stand (the earth), and the tip of the upper cone, which stretches up toward the skylight (the heavens). This architectonic structure, and the way that it ritually integrates visitors into a sacred narrative within Yad Vashem, is discussed in chapter 7. It is important to note here that the *Hall of Names* partakes of a sacred symbolism of autochthony by both visually and spatially linking Yad Vashem's *Pages of Testimony* project (and thus the memorialization of Holocaust victims) to the autochthonous depths of Israel and—via an axis mundi—to an eschatological vision of redemption.

At the end of the ritualized journey within Yad Vashem, visitors ascend the gradually slanting floor and exit the "gloom of the subterranean passageway" onto a balcony framed by cantilevered wings. This balcony offers an expansive view, overlooking the Jerusalem hills, forests, and villages. This is an affirmative journey, redemptive in the end with the visitors' reintegration into present-day Jerusalem—the spatial center of the realized Zionist dream. This "cathartic opening" has been described as a biblical tabernacle, a pair of wings, and the "exultant blast of a horn or trumpet."[49] In earlier plans the flayed sides of the viewing platform were to be shaped as spread hands, but this idea was abandoned in favor of the subtler yet equally evocative opening.

The exit from the new Holocaust History Museum gives rise to a variety of associations. Emerging from the narrative of death and victimization (with the final exhibits dedicated to the founding of the State of Israel, the struggles of survivors to rebuild their lives, and the *Hall of Names*), the two outwardly curving edges of the stagelike viewing platform frame the view of Jerusalem as a final and climactic exhibit: the redemptive ending to the catastrophe of exile in the State of Israel. Here, then, is the triumphal note that Safdie sought to avoid by tunneling his museum underground, and this note is all the more powerful in its visceral evocation. After spending several hours within the museum where gray concrete and muted light underscore the material of the exhibits, the sudden exit into the bright white light of Jerusalem evokes feelings of relief, expansiveness, and physical as well as cognitive well-being. The *Hall of Names* enacts on a smaller scale, then, the sacred narrative of Yad Vashem's Holocaust History Museum in general, with its entrance dug into the side of a mountain to evoke a symbolism of autochthony and depths and with its exit staged on a viewing platform over Jerusalem to imply transcendence and redemption.

Architecture of Experience: The USHMM as a Case in Contrast

The permanent exhibition of the USHMM in Washington, DC, opened in April 1993—fifteen years after the President's Commission on the Holocaust was formed in 1978, with Elie Wiesel acting as chair of the commission as well as chair of its successor body, the United States Holocaust Memorial Council. In contrast to the Jewish Museum Berlin and Yad Vashem, the architecture of the Hall of Witness—the entry hall and main floor of the museum—moves beyond the evocative and even the metaphoric as it crosses over into direct representational strategies. The USHMM demonstrates a postmodern sensibility in architectural design that is illustrative of a general trend in American Holocaust museums. Architects of Holocaust museums with such a sensibility produce, as Rosenfeld argues, "historically informed designs defined by narrativity and didacticism; indeed, most [architects of Holocaust museums in the United States] embraced the idea of '*architecture parlante*' ('speaking architecture') by making their buildings visually disclose their underlying function and identity." They do this by

alluding to the Holocaust in different ways—for example, through the use of "concentration camp iconography in their exterior form." Such iconography might include shapes that resemble guard towers, chimneys, or barbed wire. The Holocaust Memorial Center of Michigan, for example, displays a facade that references elements of concentration camp construction as well as striped prisoner uniforms.[50]

As the well-known architectural critic Herbert Muschamp puts it, James Ingo Freed, the architect of the USHMM, chose to make the "container one with the contained," and to this end he drew on two distinct vocabularies in his design, which Muschamp describes as the "two faces of the State." The first of these faces is the architecture of the "'Empire of Reason' that shapes official Washington, from the roots of Enlightenment to the glazed space frame of the twentieth century." Freed does not use this architectural "vocabulary of the *res publica* uncritically," however. As Muschamp points out, although the front entrance to the museum on Fourteenth Street displays a neoclassical limestone screen that "recalls the historicism of Postmodernism," Freed also "intends it as a criticism of Postmodernism's complacent fetishizing of classical manners to cover up our inner life. He has separated the classically symmetrical entrance from the building because he wants it to be just that: a screen, a façade with no true relationship to what is going on inside."[51] For this reason Freed describes his screen as a "pure façade, a pure fake," and "a lie."[52] Freed understands, Muschamp concludes, that "the story his building tells is about the use of official masks of high ideals to veil inner horrors."[53]

The second face of the state and its corresponding vocabulary, on which Freed relies, is also drawn, Muschamp continues, from the history of architecture—but this time an unwritten history—the "history of the ghettos and the death camps." Daniel Libeskind and Moshe Safdie do not attempt to reference ghettos or concentration camps in their architectural techniques, but Freed does translate certain concepts of Holocaust experience and architecture into the architecture of the USHMM, as Muschamp notes.[54] The Hall of Witness, for example, refers visually to ghettos and concentration camps, although it stops short of succumbing to the Disneyland aesthetic of reconstruction. As Freed acknowledges, the museum "must not be a reconstruction because that would devalue the Holocaust; a reconstruction would be a Disneyland—clean, cute, no tension. There is

how do museums avoid aestheticization?

a profound risk of aestheticization with this particular subject, of leaching out the raw power."[55]

The assumption behind Freed's representational strategy in the USHMM is that his technique enables visitors to overcome geographic and temporal distance and to experience new levels of identification with the victims as well as a more thorough understanding of the Holocaust itself. The architecture of the USHMM may therefore be described as an architecture of experience, as it seeks to lead visitors into a vicarious encounter with the sites and spaces of the Holocaust. In short, the representational strategies of *witness* the Hall of Witness seek to transform visitors into Holocaust witnesses— figures of privileged ontological status. The building should thus help them to engage with history more directly and to achieve a level of insight that would otherwise be impossible.

The sacred narrative of the USHMM differs both from Yad Vashem's dialectic illustration of destruction and redemption and from the Jewish Museum Berlin's evocation of the negative sacred. The permanent exhibition of the USHMM frames its Holocaust narrative within a sacred symbolism that reflects the American civil religion. Arthur Hertzberg, the well-known Judaic scholar, rabbi, and activist, succinctly described the USHMM as "the national cathedral of American Jewry's Jewishness."[56] Implicit in this statement is both Hertzberg's recognition of how the Holocaust has been sacralized in Jewish remembrance and the way in which that remembrance exhibits a uniquely American quality.

Throughout the museum's permanent exhibition, the ideals of democracy, freedom, pluralism, and individual rights are sacralized and set in absolute opposition to the ideals of fascist Germany. The USHMM promotes its American civil religion through a variety of means, ranging from the inscription of quotations from founding fathers on museum walls to visual and auditory references to American troops as concentration camp liberators. Several times throughout the permanent exhibition, for example, and beginning already with the elevator ride to the beginning of the exhibition, visitors view images of concentration camps quite literally through the eyes of American GIs. This technique in particular helps the visitor to identify with the American troops as one of the two categories of protagonists portrayed in the museum—liberators and victims. The following pages focus on Freed's architectural philosophy for the museum and the representational

liberators / victims

strategies he draws on in the Hall of Witness, a six-thousand-square-foot, five-story-high atrium-style space.

In a short film about the architecture of the museum produced by Freed's wife, the artist Hermine Freed, architect James Ingo Freed insists that his building is not symbolic but rather suggestive and metaphoric, as well as a "distillation of other things." He states quite clearly that any references to the Holocaust in his architecture should remain on the level of suggestion and intimation. In his own words, the museum's architecture should possess the "flesh and blood of the Holocaust somehow, somewhere, but not [be] directly visible."[57] At the core of Freed's architectural philosophy for the USHMM is the idea that his architecture should without direct communication nevertheless give rise to certain ideas and feelings. One of his methods is to cultivate abstraction. Through abstraction, Freed seeks to suggest without stating and to leave the exact meaning of the architecture open to personal interpretation: "We consciously didn't want to force the one reading that we knew. . . . Whenever the architecture became too concrete, whenever the metaphor became too insistent, we had to soften. We wanted an evocation of the incomplete. Irresolution, imbalances are built in. . . . to make evident the need for interpretation."[58] For example, Freed uses the concept of "metaphoric play" to describe his use of steel strapping on brick walls in the Hall of Witness. With this concept he suggests that steel strapping could represent a number of things in addition to the fact that such strapping was used on the brick ovens and crematoriums of the camps to prevent explosions from excessive internal pressure. For example, other possibilities might include the constraints of history, the enslavement of a people, and the compression of physical torture. Most important, Freed emphasizes, is that one single interpretation never force itself but instead "linger like a suggestive stain in one's consciousness."[59]

Abstraction also plays a role in a second principle underlying Freed's design: the principle of irresolution. Freed strongly believes that the ideas and feelings—and even vicarious memories—that the architecture evokes in visitors should never be resolved. Rather, they must remain a bit raw and should be "sufficiently ambiguous and open-ended so that others can inhabit the space, [and] can imbue the forms with their own memories." Freed conceives of abstraction in architectural design, therefore, as a vehicle for a certain kind of memory—a memory that remains open, fluid, and above all highly personal and subjective. Freed envisioned the Hall

of Witness as a highly evocative space—at once visceral and tactile—and therefore capable of affecting visitors on a perceptual and emotional as well as on a cognitive level. The USHMM architecture, Freed writes, should be an "architecture of sensibility." He agrees, furthermore, with Elie Wiesel's statement that this is a "building that should disturb."[60] It should not be a place where visitors feel "at home" but rather a place that induces feelings of discomfort and unease.

Despite Freed's claim that he was not interested in "resuscitating the forms of the Holocaust," the architectural techniques on display in the Hall of Witness reveal direct representational references to Holocaust sites. The "other things" mentioned earlier, which Freed sought to distill into his design, include impressions he received while visiting concentration camps, ghettos, and synagogues; images he gleaned from viewing films and photographs of the Holocaust; and, finally, his own memories of a childhood spent in Essen, Germany, where he personally witnessed the burning of the town's synagogue. Certain images, Freed writes, had a "residual, lingering presence" in his mind—above all, images of brick and steel. Steel strapping and bracing on brick crematoriums and ovens, moreover, remained with him as indelible images of the Holocaust in material form. For instance, Freed notes that the addition of heavy steel to a raw wall was emblematic of concentration camps, and this technique appears throughout many of the brick walls in the Hall of Witness in the form of V-shaped wedges and brackets or steel strapping that clamp the brick. Crisscrossed strapping, which Freed didn't actually see in the camps he visited, nevertheless "speaks of the Holocaust" to him, as it seems to brace the brick walls against a powerful pressure building irresistibly from within.[61]

A particularly powerful image that Freed encountered was the black shooting wall in the courtyard of Block 10 of Auschwitz, where tens of thousands of people were executed. This wall, Freed explains, is a space he could not get out of his mind, and although he did not seek to replicate the wall directly in museum architecture, he maintains that he nevertheless communicates the idea of the wall to visitors through the architecture in the Hall of Witness—perhaps through its many blank brick surfaces that lack any embellishments or windows.[62] Additional images that resurfaced obsessively in Freed's mind and that he incorporated into his museum design include gates that lie or deceive, such as the Auschwitz gate with its slogan "Arbeit Macht Frei" and the entrance to Birkenau (a one-way train station),

as well as bridges, particularly pedestrian bridges, like the one in the War-saw Ghetto, which was designed to separate non-Jews traveling through the ghetto from the Jewish residents. The steel-framed, glazed glass-block floor bridges that connect the floors of the permanent exhibition refer visually to the gates and bridges that Freed saw in Europe at the sites of former con-centration camps and ghettos. A series of brick towers along the north side of the museum evoke watchtowers and sentry boxes typical of concentra-tion camps. In the Hall of Witness, boarded and blocked-up windows do not offer views outside; rather, they suggest openings into dark depths and recall Freed's description of the windows in Josef Mengele's infamous labo-ratory at Auschwitz, which concealed rather than illuminated.

Inverted triangles are also essential to Freed's design and appear throughout the museum in windows and on floors, walls, and ceilings, while industrial-looking lamps, made of metal and mounted high on brick walls, suggest concentration camp lamps through spacing and design. Cer-tain architectonic techniques also refer directly to specific sites. Exposed steel diagonals in the Hall of Witness, for example, resemble the tower of Majdanek, while a second-floor brick gate has an arch shaped like the gate to Auschwitz-Birkenau.

Other architectonic techniques that do not refer directly to the architec-ture of camps and ghettos nevertheless evoke feelings of confinement, anxi-ety, pressure, and alienation. For instance, instead of using welding, Freed relies on bolts, which suggest an enormous pressure building and contract-ing behind the brick walls and requiring heavy steel to hold it at bay. Simi-larly, a skewed and twisted glass and steel skylight drops to the third floor and reaches diagonally across to the opposite side of the Hall of Witness. The steel and glass are wrenched and buckled, suggesting distortion and hinting at the great force that would be necessary to twist and mangle such thick glass and steel. The steel railings and bracing, black grating, bolted and industrial-looking steel trusses, arched brick entryways, barriers, and exposed beams that appear throughout the Hall of Witness are evocative of a functional, industrial aesthetic, indicative of a "modernist attitude toward the showing of structure and the perfection of things" that in this case led to the "perfection of the death factory."[63] As critics like Jeffrey Ochsner have noted, Freed's architecture is marked throughout by "the forms and details of nineteenth- and early-twentieth-century industrial architecture— the architectural language found in the death camp buildings." This

architectural language, furthermore, conveys a sense of "ominous foreboding" through a combination of "massiveness, austerity, and industrial detailing."[64] These forms and details contribute to a sense of inexorable purpose and to the machinery of modern technology—both of which, for Freed, are evocative of the Holocaust and its dehumanization of victims.

One of the most revealing comments that Freed makes about his design is that the museum's architecture is a "kind of artifact."[65] The word "artifact" *artifact* captures the essence of Freed's architecture in the Hall of Witness, which seeks to overcome the psychological and physical distance between visitors and the Holocaust—both the Holocaust as event as well as the Holocaust as space and geography—by exploiting the special status granted to artifacts as the bearers of traces. Artifacts possess an aura of authenticity as traces of a lost time and place. Because they appear to be unmediated remnants of an authentic past, they possess an almost mystical power to bridge time and space and to act as witnesses. Museums often emphasize this mystical quality of artifacts through boutique lighting, framing, and isolated placement, all of which imbue artifacts with an air of sacred significance. The architecture of the Hall of Witness acts as an artifact in the sense that it gives visitors the feeling that they are moving through spaces that bear the traces of authentic Holocaust sites. The artifact as trace possesses a particular power because it points back to an authentic presence in time and space. The images that burned into Freed's memory appear repeatedly as echoes—or afterimages—in the brick and steel, glass and stone of the Hall of Witness. If the hall's architecture affects visitors as Freed hopes, then they should experience a hint of the dread and anxiety that visiting authentic Holocaust sites inspires.

Responses to Freed's design span from enthusiastic support to censure. Herbert Muschamp, for example, points to the potential problems of Freed's architectural vocabulary when he argues that although Freed did not literally reproduce forms evocative of Holocaust sites, he nevertheless "absorbed them, tracing their contours as if he could distill their meaning in a ritual of recollection." The museum's "highly expressive, symbolic vocabulary," Muschamp continues, "veers perilously close to the rage for simulation that has loomed large on the architectural landscape in recent years. . . . It was natural to fear that Mr. Freed's embrace of symbolism might produce a Holocaust theme park."[66] *critique*

Two of the more critical voices responding to Freed's design belong to Thomas Laqueur, who objects that Freed's infelicitous description of the

building as "broadly holocaustal" is "an oxymoron if ever there was one" and who criticizes the elevators for "whisper[ing] ever so coyly of the gas chamber," and to Mark Godfrey, who describes the Hall of Witness as a story "being told through the conventions of Hollywood . . . and through the devices of theater." While it is true that Freed never directly replicates structures from concentration camps or ghettos, his architectural references to structural techniques of camps and ghettos come at times a bit too close to simulation. This becomes clear in the following report by Edward Linenthal:

> The building itself can be perceived as a "code," a collection of Holocaust symbols that need to be identified and "read." In 1992 . . . museum staff taking donors and other VIP's on tours of the unfinished building occasionally used a four-page guide to the "architectural symbolism and other features of the . . . museum," which decoded the symbols in a straightforward manner: "the curved entranceways leading off the Hall of Witness are reminiscent of the shape of the crematoria doors, while the massive brick towers on the north side of the HOW [Hall of Witness] represent chimneys."[67]

Such a decoding practice reveals that the USHMM might function, despite the intentions of its architect, as what Susanna Sirefman declares "unabashedly didactic architecture"—a didacticism that Sirefman finds to be "entirely appropriate." A coded reading reinforces for this visitor, however, the perception that the architecture tries too hard to mean too much and does so, furthermore, far too literally. "The brashness of this site, its immodesty, its lack of any hint of the elegiac . . . its sheer excess, left me profoundly saddened and unexpectedly empty. There is too much here on the Mall and also too little," writes Thomas Laqueur of the USHMM, capturing well the sense of the monumental in the Hall of Witness that precludes any possibility of contemplation or mourning.[68]

Common to the caveat of Muschamp and the outright objections of Laqueur and Godfrey is a pronounced leeriness before architecture that seeks on any level to evoke Holocaust sites through direct representation. References to Hollywood and theme parks reveal a suspicion of an increasing trivialization—or what Elie Wiesel calls the "de-sanctification"—of the Holocaust.[69] This suspicion is hinted at in the rather cynical dubbing of 1993 as the "Year of the Holocaust," due to the fact that 1993 marked both the opening of the USHMM and the release of Steven Spielberg's *Schindler's*

List. Tim Cole states it succinctly, "The 'Holocaust' is being bought and sold. . . . The 'Holocaust' is being consumed." While the Holocaust as iconic symbol is not restricted to a single nation, there is little doubt "that at the end of the twentieth century the 'Holocaust' is being made in America."[70]

In contrast to the Hall of Witness, which functions as the core of the museum, the Hall of Remembrance acts as the memorial portion of the USHMM and is a much more conventional space. Partly free-standing and with classic proportions, the hexagonal-shaped hall (evoking perhaps the six million Jewish victims, perhaps a Star of David) appears at the end of the permanent exhibition on the second level. This space houses the eternal flame of remembrance and is where visitors may light a memorial candle in a niche beneath one of the engraved names of concentration and death camps. The floor of the Hall of Remembrance is of verde antica marble, a stone that is "by nature cracked, disintegrating in an unpredictable fashion." The corners of the six walls are "broken away so that the walls become free-standing plaques or tablets" rather than a closed form, and the cracks at the corners are filled with glass slots and act as skylights—inspired by Freed's memory of a synagogue in Poland. Over each portal are triangular openings, echoing other triangle shapes throughout the museum. Descending the stairs into the center of the room, visitors arrive at an empty center—a void that symbolizes loss and the task of remembrance. In contrast to the voids of the Jewish Museum Berlin, however, this space is tamed and domesticated through its geometrically balanced shape, soothing light colors, and natural light. Although Freed originally desired bricked-up windows in the Hall of Remembrance, he compromised and settled on a classical recess resembling a window and done in an "aclassical manner, to clash with the coursing of the stone."[71]

The walls of the Hall of Remembrance are engraved with epitaphs, and a high center skylight in the dome ceiling floods the room with light. Freed describes the Hall of Remembrance as "betwixt and between"—a ritual term referring to liminal space.[72] The space is liminal because it exists between the world of the Holocaust, depicted in the exhibition, and the contemporary outside world, visible through the slim openings at the corners of the walls. Free from references to the camps or ghettos, this space resembles traditional Holocaust memorials.

In design the USHMM differs radically from both the Jewish Museum Berlin and Yad Vashem. Cultivating an architecture of experience means

that the museum's architecture moves beyond the mere suggestiveness claimed by the architect in an attempt to overcome psychological and geographic distance. All three museums, however, share one fundamental characteristic: they move far beyond a mere functional housing of exhibits as is typical of the black box style of museum. In the Jewish Museum Berlin, an architecture of absence emerges through a series of voids that fracture space along a linear trajectory. These voids evoke a sense of the negative sacred as they stage absence and irrevocable loss. The architecture of Yad Vashem tells an ultimately redemptive story that reflects a Zionist ideology of Israel as a national homeland for all Jews. At the heart of Yad Vashem's architectural narrative is a dialectic between a past of exile, destruction, and catastrophe in the Diaspora and a future of homecoming, life, and redemption in Israel.[73] Through the suffering and deprivation of the past, a new and hopeful future is made possible.

The architectural techniques of the Jewish Museum Berlin, Yad Vashem, and the USHMM arguably rate among the most memorable aspects of the three museums, being spatial and tactile as well as visual. In addition to the way that architecture evokes unique concepts of the sacred and contributes to Holocaust narratives, it also serves as the frame for the exhibits and determines the parameters of the visitor's ritual movement within its spaces. The unique architectural designs and techniques of Yad Vashem and the Jewish Museum Berlin are explored in more detail in chapter 7 with a particular focus on visitors' experience within museum spaces.

4 ❧ THE ARTFUL EYE

Learning to See and
Perceive Otherwise
inside Museum Exhibits

The third floor of the permanent exhibition of the USHMM displays a large, rectangular photo mural that dominates an entire wall. A photograph of four Jewish Auschwitz survivors from Salonika, Greece, appears in the center of the mural. Three of the men grasp a vertical pole with bare arms, while the fourth leans his cheek upon his open palm. The men stare into the camera with expressions of defiance and sadness; their faces are creased with deep lines. Surrounding these men on all four sides are seventy-two smaller, identically sized rectangular photographs of bare forearms. These arms represent, metonymically, seventy-two Holocaust victims. Some arms end in closed fists, others with outstretched or gently curved fingers.

Without faces or names (the twin pillars of selfhood), this presentation renders the seventy-two victims anonymous. Yet each arm does reveal a kind of identity; the infamous serial number tattoos of Auschwitz—for these inmates, the only form of identity left to them—mark the skin of each limb. Surrounded by disembodied arms and the faceless victims they represent, the four men from Salonika illustrate the painful fact that they, the few, are the exception: they are the survivors who once again possess a personal

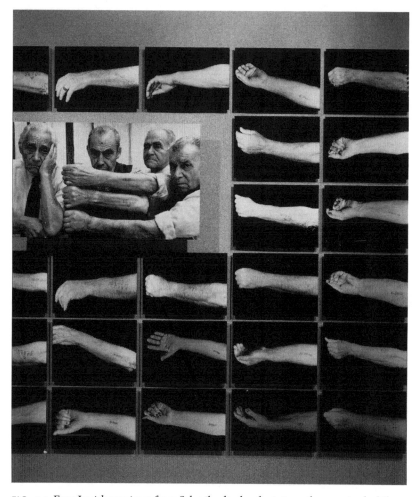

FIG. 4.1 Four Jewish survivors from Salonika display the tattoos they received while imprisoned in Auschwitz. Pictured from left to right are Sam Saporta, Mois Amir, Mr. Robisa, and Barouh Sevy. © U.S. Holocaust Memorial Museum. Courtesy of Frederic Brenner. Photograph by Arnold Kramer.

identity—a face and a name. The mural poignantly depicts the tension between anonymity and identity, between the Nazi effort to eradicate the Jewish people along with their entire culture and history, and the Holocaust museum's attempts to rescue the victims from oblivion. But the mural's self-conscious aesthetic presentation—the artfully created contrast between

aestheticizat [handwritten margin note]

appendage and human being—raises questions not only about *what* we see, but *how* we see. If the photograph of the four survivors appeared on its own, without the surrounding seventy-two arms, would we see it differently? Does the presentation force us to view these victims, reduced as they are to depersonalized fragments of their former selves, as their captors did—that is, as so many objects in a series? What does it mean to gaze past these tattooed arms, representing a multitude, to concentrate on the faces of the few? The photo mural ironically reduces human beings to mere body parts and thus imitates the very way of seeing that the museum as a whole dele-gitimizes. Does this presentation, finally, encourage us to think about what it means to look repeatedly at atrocity photographs?[1] This last question is particularly relevant in regard to the USHMM, where, as Philip Gourevitch rightly points out, violence dominates the museum aesthetic and where video monitors behind privacy walls (imitating a "peep-show format") engage in a "constant recycling of slaughter."[2]

Violence [handwritten margin note]

Thousands of images and objects, including photographs, artifacts, documentary films, video testimonies, and artworks make up the per-manent exhibitions of Yad Vashem, the Jewish Museum Berlin, and the USHMM. The three museums weave images and objects into layered nar-ratives of rich symbolic meaning and draw on a variety of aesthetic and spatial techniques to tell detailed stories of the Holocaust. This chapter investigates how museum displays encourage specific ways of seeing and remembering. Two particular concepts underlie this discussion: aesthetic differentiation, which draws on the writings of Hans-Georg Gadamer and David Freedberg, and Mieke Bal's concept of the grammar of museum exhibition space. The theoretical matrix within which this chapter may be situated is the scholarly engagement with issues of Holocaust displays and aesthetics. While non-Holocaust works on museum exhibition practice—including those of Svetlana Alpers, Barbara Kirshenblatt-Gimblett, and Eilean Hooper-Greenhill, for example—provide a larger and more gen-eral background for such work, scholarship that focuses specifically on the aesthetics of Holocaust display offers a more immediate context. Monographs by Isabelle Engelhardt, K. Hannah Holtschneider, Laura Levitt, Andrea Liss, Katrin Pieper, and Oren Baruch Stier—to name only a few—engage directly with many of the issues of Holocaust representa-tion and display that underlie the concerns of this chapter.

display theory [handwritten margin note]

Strategies of Display: Framing and Exhibition Techniques

Framing and exhibition techniques help shape how museums create meaning. An isolated object in a glass case, lit from below in the "boutique" style, for example, encourages a different reading from an object stacked with a multitude of similar objects behind a simple railing. In the former, spatial and lighting techniques declare that this object is extraordinary and unique, deserving of our undistracted attention. In the latter, the display suggests that this object contributes to an overall idea or narrative—it is one of many and together with other objects has meaning.

Display thus strongly influences how visitors encounter and interpret objects—a single object may appear as evidence of a crime, as an artifact bearing the trace of its former owner, or as a precious art object. For example, a single shoe of a murdered child, enclosed within a glass case like a precious object in Yad Vashem's permanent exhibition, evokes a very different reaction than a display of victims' shoes in the USHMM, which consists of heaps of shoes stacked in such a way so as to conjure up in the mind's eye a storehouse of unprocessed evidence. While the child's shoe focuses the visitor's thoughts on a single life lost, the USHMM's heap of shoes evokes images of mass destruction and emphasizes the extent of the loss rather than the victims themselves.

The isolated child's shoe, furthermore, evokes empathy, while the piles of shoes overwhelm, rendering the viewer helpless and despairing. The limitations of the language used here to describe visitor response—the language of empathy and despair—has been addressed by David Freedberg, who argues that the "lack of adequate discursive terminology for the processes whereby we respond to the visual imagery that affects us powerfully makes us fall back on the more emotive and sentimental categories of spontaneity, instantaneity, and helplessness."[3] The language of affect in this context also reveals the challenge that all three museums face: how to visually depict the trauma and loss of the Holocaust to encourage empathy and remembrance rather than merely exhibit violent and often exploitative images.

The Poetics of Exhibition, the Museum Effect, and Attentive Looking

Cultural theorist Mieke Bal has argued that particular exhibits demonstrate what she calls a grammar of exhibition space. This concept derives

from Bal's larger argument that certain exhibitions are "frequently struc-
tured and sometimes even presented in terms derived from other media,"
such as poetics, narratology, theater, and film. Bal asks us to consider, for
example, "the situation of walls imposing frames like the rules of grammar"
and encourages us to explore how an asymmetrical space and its hangings
may be simultaneously in harmony and disharmony with the "grammar" of
their setting. The frame of an exhibit, in other words, may "deviat[e] from
the rule the building has established" and create tension.[4]

Yad Vashem's permanent exhibition draws on certain display techniques—
such as canted angles, asymmetrical hangings, and the deliberate expo-
sure of wires used for suspension—that deviate from the dominant gram-
mar of conventional museum practices. Such conventional practices avoid
distracting the viewer's gaze from objects of interest and prefer symmetri-
cal hangings, perfect angles, and transparent rods to create the illusion of
weightless suspension.[5] Hanging images in Yad Vashem's gallery on the
Nazi occupation of foreign lands, for example, are suspended at angles
that conflict with the degree of slant of the wall, creating the impression
that the images are asymmetrical and unstable. A second example appears
when visitors exit Yad Vashem's exhibit on death marches and pass a large
photograph, canted at an extreme angle, of an emaciated victim with his
face twisted in pain. While the general "grammar" of Yad Vashem's Holo-
caust History Museum favors symmetrical spaces and hangings, this pho-
tograph disrupts symmetry and violates visual expectations, unsettling
the viewer and creating unease. Such displays deviate from the building's
grammar and foster disharmony as well as feelings of uncertainty.

Even a museum's walls or use of wires may deviate from a building's over-
all grammar. In a Yad Vashem gallery devoted to deportation, for example,
walls huddle closer together than in other galleries and do not fully extend
upward. Cage-like, they evoke the feeling of entrapment. Exposed wires also
appear in Yad Vashem's display on the Nazi hierarchy in charge of German-
controlled territory in the east. Above a photographic exhibit of Nazi func-
tionaries, an intricate spider web of intercrossing wires stretches across the
ceiling, suggesting spatial restriction and metaphorically demonstrating
how the Nazi machinery ensnared its victims in an elaborate trap. An echo
of this wire structure appears in Yad Vashem's display on partisans, but here
the wires fulfill a positive structural function as they physically support
the display on the partisans and their heroic activities. A cage in the cen-
ter of the supporting wires contains a display on the Jewish underground.

Visually, the cage suggests safety and protection—it tells the story of heroes rather than victims.

The way that curators and exhibition designers arrange objects also contributes to a museum's particular story. As Bal argues, "exposition as display is a particular kind of speech act. It is a specific integration of constative speech acts building up a narrative discourse." Within this narrative discourse the ways that objects come together produce meaning: "connections between things are syntactical; they produce, so to speak, sentences conveying propositions." Bal points out, furthermore, that juxtaposition can constitute a speech act.[6] Objects, artifacts, and photographs grouped together by type and juxtaposed with similar objects appear as cultural evidence. In contrast, isolated, elevated, or individually lit objects, such as the child's shoe mentioned earlier, resemble works of art or sacred objects. Installation techniques that draw the viewer's visual focus thus play an important role in consecrating objects as artistic or sacred.[7] The process of focusing visitor attention, or the "museum effect," channels the visitor's diffuse gaze into an act of "attentive looking."[8]

In Yad Vashem, for instance, a traditional, mirrored rectangular display case stands independently, separated from other exhibits. It holds a small wooden chain depicting scenes from camp life, carved by Holocaust victim Moshe Scheiner. This isolated display enhances the object's visibility and aesthetic qualities and frames the chain as an art object. Similarly, poems of a ghetto resident appear as if they were antiquities, top-lit in a glass case in the wall. The display presents the poems as a single precious object among the machinery of deportation and death closing in around Europe's Jewish communities. On one level the carved chain and poems tell stories (they depict scenes from camp life and reveal continuing artistic activity in the ghetto). On another level their framing suggests that survivors and their artistic responses to the Holocaust are held sacred by Yad Vashem and that visitors should also perceive them as sacred. To recall Jonathan Z. Smith's discussion of the sacralization of objects and places, any object may be presented and perceived as sacred. Emplacement and ritual treatment, not any inherent quality, determines the sacred.[9]

Color also plays a key role in how museum displays create meaning. The predominance of plain gray concrete throughout Yad Vashem creates a visceral feeling of cold, bare surfaces and of deprivation. The "unfinished surfaces," as Steven Erlanger puts it, "stir a dreadful sense of normal

life dehumanized, of metal, bone and ash."[10] The occasional appearance of color surprises—a sudden burst of vivid green from large, panoramic color photographs of trees overlaid on glass in the partisan exhibit, for example, breaks through the dominant visual field of gray and expresses the freedom and life that survived within the forests, in contrast to the restrictions and lack of liberty in camps and ghettos.

Contrasting Images of Remembrance: The USHMM's *Tower of Faces* and Yad Vashem's *Hall of Names*

Within Holocaust exhibits one may find, contrary to expectation, aesthetically striking and even beautiful photographic displays. Such displays give rise to the following question: is it possible for an exhibit's aesthetic technique to overshadow the actual content of the exhibit? The photograph's representational power and its potential to stimulate remembrance, for example, may in certain exhibits become eclipsed by the stylistic power of the presentation. Displays of Holocaust photographs in museums have traditionally relied on atrocity photographs—most of which were taken by perpetrators.[11] But over the past few decades museums have been increasingly adding prewar family photographs to Holocaust collections. These family photos add "personal drama to an otherwise incomprehensible event" while also tapping "into our complex and contradictory associations of family, nostalgia and mortality."[12] Displaying family photos in museums also partakes of a long tradition of using portraits to depict ancestral links between the generations. Such practice demonstrates continuity and a pride in ancestry.[13] The USHMM's *Tower of Faces*, however, turns this tradition inside out, as family portraits demonstrate the loss of generations and the irreparable chasm in Jewish history rather than the binding connection between past and present.

David Freedberg explains that the evocative power of the photograph is tied to its peculiar, seemingly magical ability to capture the very essence—the "living presence"—of an absent person: "The reality of the image does not lie, as we might like to think, in the associations it calls forth: it lies in something more authentic, more real, and infinitely more graspable and verifiable than association." This "something" is the power of the photograph to

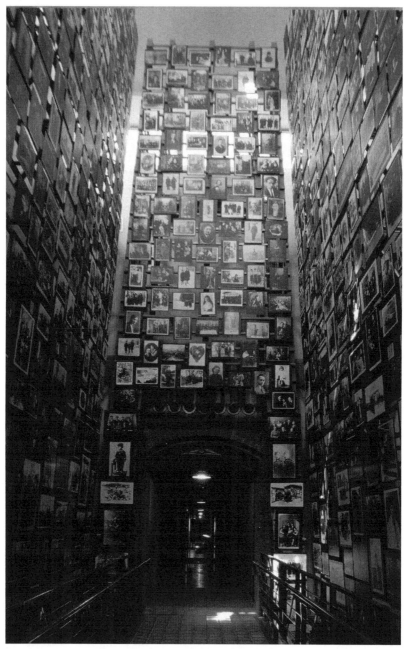

FIG. 4.2 The *Tower of Faces* (the Yaffa Eliach Shtetl Collection) in the permanent exhibition at USHMM. © U.S. Holocaust Memorial Museum. Photograph by Edward Owen.

evoke the presence of the missing person. The photograph can resurrect the deceased or otherwise lost loved one: it "transcends death and peculiarly replenishes the lost being. What is lost or absent seems present, but we cannot know why. . . . It [the photograph] is alive, present, and real."[14]

In his classic treatise on photography, *Camera Lucida*, Roland Barthes also emphasizes the central importance of the power of presence. He suggests that photography offers "an immediate presence to the world" and possesses a power of authentication that exceeds even its power of representation. The photograph, he explains, "is literally an emanation of the referent. From a real body, which was there, proceed radiations which ultimately touch me, who am here. . . . A sort of umbilical cord links the body of the photographed thing to my gaze: light, though impalpable, is here a carnal medium, a skin I share with anyone who has been photographed." Susan Sontag adds that the photograph provides an actual link to the real—it is a "trace, something directly stenciled off the real, like a footprint or a death mask." The photograph-as-trace offers the viewer access to the original object or person in a unique way not to be replicated by other resembling images. To quote Gregory Currie, "By virtue of being traces of things, [photographs] offer us special epistemic and emotional access to the things they are documentaries of."[15]

This sense of the photograph-as-trace resembles what Freedberg describes as the aura of living presence—a power that gives the resembling image its extraordinary ability to resurrect the missing person or object. As Freedberg argues, the aura of "living presence" "can never be wholly dispelled"; indeed, he points out, nothing in experience suggests that this takes place. Furthermore, the aura of living presence or the "imprisonment of presence in representation gives the fixed image its potentiality; then it may be cherished or become a fetish."[16]

The most powerful type of photograph is the human portrait. Its ability to conjure up an absent person makes the portrait the "ultimate retrenchment" of the photograph's cult value. In Walter Benjamin's words, "It is no accident that the portrait was the focal point of early photography. The cult of remembrance of loved ones, absent or dead, offers a last refuge for the cult value of the picture. For the last time the aura emanates from the early photographs in the fleeting expression of a human face."[17] It is from the human portrait, Benjamin argues, that the aura emanates for the last time, as art's cult value (the magical power of a work of art, or the role it would

play in ritual) is displaced by its exhibition value (the value of the artwork in terms of artistic display). This aura—a unique and authentic presence— survives in the portrait photograph, despite its reproducibility, through the depiction of a lost beloved face. Photographic displays like the USHMM's *Tower of Faces* and Yad Vashem's *Hall of Names* cultivate and capitalize on this aura; they draw on the special properties of portrait photographs to offer the visitor an almost mystical connection to the lost victims.[18]

The *Tower of Faces*, a three-story-high, skylit photograph exhibit housed in one of the museum's tower spaces, displays more than one thousand photographs of the former Jewish residents of Ejszyszki (Eish- ishok) in Lithuania.[19] Professor Yaffa Eliach of Brooklyn College, one of the shtetl's twenty-nine survivors and granddaughter of the shtetl's Jewish photographers, collected and donated the photographs to the USHMM. The images themselves depict the richness of ordinary life in a Jewish town before the Holocaust. A sampling of photographs in the *Tower of Faces* includes images of family celebrations and groups of friends, chil- dren bicycling and playing, and portraits of newly married couples.[20] Visitors connect to these photographs in a personal, intimate way; they remind us of the old black-and-white and sepia-toned photographs of our own grandparents and great-grandparents.[21] This familiarity is reassur- ing in one sense. After observing in graphic detail the relentless violence of the assault on Jewish life throughout the permanent exhibition, these photographs offer a welcome opportunity to momentarily escape the hor- ror and to gaze at pleasing photographs of familiar scenes that remind us of images from our own family albums.

But this encounter with the familiar among the unfamiliar is also painful, because it expels us from the numb, abstract space that results from view- ing so many images of vast destruction and mass killing. The photographs of the *Tower of Faces* remind us that each victim was an individual human being. It is this glimpse of familiar humanity buried among so much evi- dence of dehumanization that makes the *Tower of Faces* moving and at the same time uncanny. Here, familiarity and unfamiliarity are joined into a sin- gle moment of disquietude; here, Barthes's famous "punctum" "rises from the scene [of the photograph], shoots out of it like an arrow, and pierces me," leaving in its wake a wound, a prick, or a sting.[22]

Visitors encounter the *Tower of Faces* for the first time on the fourth floor after crossing a glass bridge etched with the names of "Lost Communities"

(destroyed Jewish communities) and after passing beneath a series of brick arches. In the room before the *Tower of Faces*, visitors examine Roman Vishniac's photographs of traditional eastern European Jewry from between 1935 and 1939. They then enter the *Tower of Faces* via a glass-block bridge with steel railings. The text accompanying the photographs does not explain the fate of those pictured but merely relates that the town of Eishishok possessed a lively Jewish population and culture in 1939. The photographs both ascend and descend beyond the visitors' range of vision in the exhibit's chimneylike space. Standing within the *Tower of Faces*, visitors are surrounded on all four sides by a multitude of photographs that creates a dizzying constellation of countless lives.

Visitors return to the *Tower of Faces* for a second time on the third floor, after passing through exhibits on the ghettos and concentration camps. This time, after crossing a glass bridge engraved with the first names of Jewish Holocaust victims, visitors read the following text, labeled "The End of a Shtetl":

> The "Final Solution" began in Eishishok [the Yiddish name of the shtetl] soon after German troops arrived there on June 23, 1941. A Jewish Council was formed. The Jews' valuables were collected and confiscated. Jewish men and women were abused and humiliated. On September 21, the eve of the Jewish New Year, an SS mobile killing squad entered the town, accompanied by Lithuanian volunteers. Four thousand Jews from Eishishok and its environs were herded into three synagogues and imprisoned there. Three days later, on September 24, the Jews were taken from the synagogues to a horse market on the outskirts of town. The next day, the men were led in groups of 250 to the old Jewish cemetery. There, the SS men ordered them to undress and to stand at the edge of open pits, where they were shot by Lithuanian guards. On September 26, the women and children were shot near the Christian cemetery. . . . Nine hundred years of Jewish life and culture in Eishishok came to an end in two days. Today, no Jews live in Eishishok.[23]

After visitors read this text, the photographs in the *Tower of Faces* acquire a different significance: they no longer reveal glimpses into individual lives but rather project the image of a single great catastrophe. The power of human portraits to evoke empathy in their viewers is here eclipsed by the exhibit's aesthetic technique, which transforms each individual into a

fragment in an artfully rendered mosaic of loss. The fact that many of the photographs remain out of sight as they extend upward and disappear into an amorphous sea of faces undermines the viewers' ability to identify with the victims. The display's sheer vastness and its abundant images, which are the very sources of its impressive aesthetic, end up devaluing the individual in favor of an overall impression that is undeniably (and disturbingly) pleasing to the eye. As Thomas Laqueur rightly observes, the *Tower of Faces* leaves one "marveling at the architect's cleverness and slightly repelled by the excess—of design, of space, of evidence."[24] The *Tower of Faces* moves us, without a doubt—but to what end? Does this exhibit encourage empathy and remembrance by bridging the distance between the abstract catastrophe of six million and the concrete tragedy of each life lost, or does it aestheticize these losses by creating a beautiful whole out of fragments?

Compare the *Tower of Faces* to Christian Boltanski's photographic installation *Autel de Lycée Chases* (Altar to Chases High School) (1986–1987), in the Israel Museum, Jerusalem. *Autel de Lycée Chases* consists of six enlarged black-and-white portraits of Jewish children, six desk lamps, and twenty-two rusted tin biscuit boxes, which are stacked to form a platform beneath the photographs. Boltanski took these images from a school photograph of the 1931 graduating class of a Jewish Viennese high school. The portraits of the six children (representative, perhaps, of the six million) are simultaneously illuminated and obscured by the lamps that hang directly in front of them, partially blocking them and hiding them from view.

Despite relying on the familiar genre of photography to nostalgically evoke a lost Jewish world, like the *Tower of Faces*, Boltanski's installation resists the *Tower*'s aestheticizing impulse. Instead, it brings to conscious attention the difficulties inherent in memorializing victims condemned to anonymous deaths. The photographs of *Autel de Lycée Chases* are few and enlarged—an exhibition technique that typically highlights the individuality and uniqueness of those pictured—yet these photographs are unlabeled and the identities of those pictured remain a mystery. The prominent display of the desk lamps with their hanging wires, moreover, which both reveal and conceal the children's faces, suggests a critique of the common practice in museums of manipulating the appearance and implied significance of artifacts through lighting techniques. Not only does Boltanski expose the lighting fixtures, he self-consciously emphasizes them so that the act of exhibiting victims becomes as much a theme of the installation as

victimization itself. *Autel de Lycée Chases* thus refuses to gloss over the risk that exhibition may transform photographs into fetishized artifacts (suggested by both the rusted tin boxes and the lighting technique evocative of artifact presentation), as well as the fact that photographic display itself is an artistic, and therefore contrived, process drawing on exhibitionary strategies to evoke certain responses in the viewer.

The *Tower of Faces*, as already stated, uses family photographs to evoke feelings of intimacy and familiarity within the context of events shockingly unfamiliar. Despite our inevitable failure to comprehend the violence that destroyed Eishishok and its long, rich Jewish history, it is still possible—at least initially—to derive pleasure from the *Tower of Faces*. Laura Levitt describes the *Tower of Faces* as a source of relief for the visitor and argues that this explains why the visitor may repeatedly access it. The *Tower* exhibits, as Levitt notes, a ubiquitous presence through its unique spatial placement: "Even as we linger in other places, we are never far from the Tower. Through cutouts and bridges, we keep finding ourselves near but unable ever to touch these faces. . . . Not only do we literally travel through the Tower more than once, but the Tower also seeps through the rest of the permanent exhibit."[25]

One way to interpret this diffuse quality of the *Tower of Faces* is through the metaphor of memory. The fact that the *Tower of Faces* allows repeated access reveals an anomaly in the otherwise progressive structure of the USHMM's permanent exhibition. Resembling the way that a traumatic memory may resurface in a Holocaust survivor's consciousness, the *Tower of Faces* spatially enacts what Dominick LaCapra describes as the tendency to "compulsively . . . repeat, relive, be possessed by, or act out traumatic scenes of the past." In this vein Andrea Liss argues that the visitor's second encounter with the *Tower of Faces* creates "an echoed experience that functions more in harmony with the layered way in which memories overlap and intrude on the mental time zones of the past and the present, especially involving circumstances of extreme traumatic dislocation. Chronological time stands still in trauma. . . . It is sealed away into a space where psychic time takes over." Such a form of remembrance imitates, according to Liss, the memorial tradition of Yizkor books. Predominantly written in Yiddish and produced by small committees of survivors or community associations, these books document Jewish lives before and during the war. Acting as the "equivalent in words to communal tombstones," to quote Geoffrey

Hartman, the books offer a place for memory to reside. Liss suggests that the *Tower of Faces* shares in this memorial tradition through "its overlapping structure of historical and memorial narratives."[26]

A crucial difference, however, between Yizkor books and the *Tower of Faces* is the fact that the individuals memorialized in Yizkor books are identified by name; their stories are rescued from oblivion so that through these books they may live on. The individuals in the *Tower of Faces*, however, remain anonymous. Although the portraits of the former residents of Eishishok seek to partake of the "cult of remembrance of loved ones, absent or dead," they nevertheless exist in a void.[27] The *Tower of Faces* displays an entire world of lost loved ones' faces, but they are not recognized by the visitor with the cry: "There she is! She's really there! At last, there she is!" as Roland Barthes exclaimed upon discovering an old photograph of his deceased mother. The *Tower of Faces* evokes aesthetic appreciation rather than empathy with individual victims. In the language of Walter Benjamin, the exhibition value of the *Tower of Faces* trumps the cult value of the individual portrait photograph.[28] Indeed, not only do the photographs leave one overwhelmed with the scale of the tragedy rather than encourage empathy, but the chimneylike structure of the display itself emphasizes the anonymity of victims by obscuring so many faces. This anonymity is the decisive difference between the *Tower of Faces* and Yad Vashem's ostensibly similar photographic exhibit, the *Hall of Names*.

The *Hall of Names* plays a central role in Yad Vashem's ongoing Names Project. As mentioned in the previous chapter, this exhibit participates in Yad Vashem's ritual of remembrance and redemption by seeking to rescue all Jewish Holocaust victims from the fate of oblivion through a display of *Pages of Testimony* as well as photographs of the victims.[29] This ritual of remembrance reflects the religious duty of memory that is imparted to all Jews. As Yosef Hayim Yerushalmi has demonstrated, the imperative to remember in Judaism and the resulting practice of remembrance among Jews has traditionally flowed through two channels: ritual and recital.[30] The *Hall of Names* demonstrates the practice of the former through its ritual of remembrance, in which visitors play a vital role.

When visitors enter the *Hall of Names*, stand beneath the upward-reaching cone, and gaze at the photographs of Holocaust victims whose identities are being restored and who are therefore being rescued from anonymity, they become engaged in a ritual of remembrance—that is, they

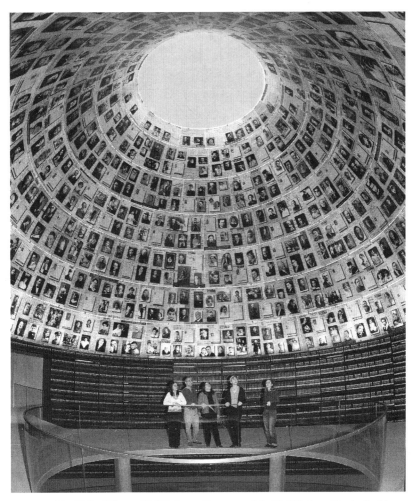

FIG. 4.3 The *Hall of Names*, Yad Vashem. Courtesy of the Yad Vashem Photo Archives. Photograph by Yossi Ben David.

actively participate as they complete the project of remembrance begun with the Names Project. Their engagement in the ritual of remembrance imbues the photographs with a particular power—the power that Freedberg describes as "living presence." Freedberg argues that images acquire their efficacy, their power to evoke the living presence of an absent person or deity, "only following some act of consecration or another, which invests the 'mere' materiality of the . . . image with powers not attributable to the

material object itself." With the phrase "living presence," Freedberg refers to the power of certain images to promote the belief that "the bodies represented on or in them somehow have the status of living bodies."[31] In the context of the *Hall of Names* and the Names Project, the power of living presence strengthens the ability of viewers to empathize and even identify with the victims.

The purpose of the *Hall of Names*, furthermore, resonates with the overall strategy of Yad Vashem's permanent exhibition, which is to restore names and identities to the victims and to relate as many personal stories of the Holocaust from the victims' point of view as possible. Yad Vashem's previous Holocaust exhibition relied heavily on photographs and records that were, necessarily, from the perpetrators' point of view. Given the fact that most of the evidence of the Holocaust was recorded from the perpetrators' perspective, how can we avoid further debasing the victims when we remember them through the very images created by their persecutors? In Geoffrey Hartman's felicitous words, "Our Holocaust museums are full of photos drawn from the picturebook of the murderers. The mind is exposed to images magnifying the Nazis and degrading their victims."[32]

Yad Vashem's new permanent exhibition addresses this problem directly by privileging personal stories and the perspective of the victims. As Yad Vashem director Avner Shalev explains, two main goals guided Yad Vashem's new permanent exhibition: first, to give the perspectives of individual Jews and to tell personal stories of how they coped with the Holocaust; and second, to encourage the visitor to connect and empathize with the victims. Both of these goals rely on restoring to the victims their names and identities and on overcoming the abstraction and anonymity that make it difficult for empathy to develop. For Jewish visitors the museum expresses a third hope that "they should reflect on the continued survival of the Jewish people and its Jewish and human values."[33]

True to these goals, Yad Vashem's permanent exhibition relates more than ninety personal stories and individual testimonies and draws on artifacts, films, survivor testimonies, original artworks, poems, toys, music, letters, and diaries. Throughout Yad Vashem, moreover, names accompany photographs of victims whenever possible, anticipating on a smaller scale the work of the *Hall of Names*. An exhibit on the deportation of Jews to concentration camps, for example, includes small screens that show images of Jews being forced into trucks. From amid the masses

of deportees, certain figures are highlighted and their names flashed for a moment on the screens above their figures—for an instant, they are no longer anonymous victims but individuals. Jews from Salonika forced to do calisthenics; Jews being deported from Stropkov to the camps; Jewish men humiliated by German soldiers, who mockingly cut off their beards; and a Jewish musician (who refused to play in a concentration camp orchestra) committing suicide on an electrified fence—all these figures are rescued from oblivion through an endless cycle of naming, as if Yad Vashem were seeking to reverse the very process by which the Nazis first stripped their Jewish victims of their identities and humanity before taking their freedom and lives.

The *Hall of Names* shares with a number of other exhibits in Yad Vashem, then, this task of restoring to victims their lost identities. Together, they enact a ritual of naming and of remembrance. Accordingly, the final effect of the *Hall of Names* is dramatically different from that of the *Tower of Faces*, despite an initial impression of similarity. The spatial placement of the *Tower of Faces* and the *Hall of Names*, finally, within their museum contexts contributes to their different meanings. As the last exhibit of Yad Vashem's permanent exhibition, the *Hall of Names* marks the final stage of the visitors' journey through a narrative that begins in exile and death and ends triumphantly with the visitors' exit onto a platform overlooking Jerusalem's pine forests. The *Hall of Names* rejoices, in other words, in a successful resolution to the dangers of exile and acts as the final station in a goal-oriented narrative, signifying to visitors that a climax has been reached that will be followed by resolution. The *Tower of Faces*, in contrast, imitates the structure of a traumatic memory that may not be so easily placed within an overarching narrative. Returning to the *Tower of Faces* for the second time, visitors experience the exhibit as part of a cycle of death and destruction that was reenacted many times across eastern Europe in varying permutations and which intimates the inevitable return to tragedy.

Seeing and Knowing in Museum Spaces

While display and framing techniques in museums manifestly reflect decisions made by curators, exhibition designers, and project directors, they

also reveal greater shifts in paradigms of knowledge and cultural values. During the past twenty-five years, a new type of museum has emerged— the "post museum"—in distinction to the modernist museum of the nineteenth century. The latter, rooted intellectually in the Enlightenment and deriving formally from Europe's public museums, frames objects within the same cultural and epistemological structures as maps—that is, as forms that unify knowledge—while claiming to present ideas and relationships in a rational and neutral way.[34] Museums in the modernist style reflect a modernist epistemological framework by relying on a type of spatial presentation that dictates a systematic relationship between viewer and object. For example, identical and uniformly spaced glass cases define appropriate viewing conditions and encourage a balanced, rational perspective. The observer is imagined in this space to be neutral and impartial while objects and images "speak for themselves"; this museum space suggests that visitors have entered a realm of positivist and objective knowledge.[35]

The modernist spatial presentation, moreover, reflects the dominant philosophy of vision within Western modernity. Positing the modern subject as a neutral observer who gazes with a dispassionate, monocular gaze (as if through a peephole) at the world, this point of view, known as Cartesian perspectivalism, places the trope of the window, which "frames and mediates the possibilities of vision," at the center of its discourse. Behind the metaphoric window, which sets up the formal separation necessary for rational perception between "a subject who sees the world and the world that is seen," the observing subject (a disembodied eye) consumes the objects of his or her gaze.[36] This gaze gives rise to a model of mind in which human consciousness is "a mirror of the world we inhabit" and looking and understanding take place simultaneously.[37] As Chris Jenks has demonstrated, the *way* that we think about *how* we think is shaped by a visual paradigm, so that visual ability becomes conflated with cognition. Looking, seeing, and knowing are thus "perilously intertwined."[38]

Much of what appears natural or transparent in museum exhibits— such as the ubiquitous glass display case—reflects a Cartesian perspectival theory of vision. However, as philosophies of vision, which Martin Jay refers to as "scopic regimes," shift, so do techniques of museum display.[39] Indeed, not all museum exhibits continue to demonstrate such assumptions about vision and knowledge, and certain exhibits undermine the model of a pure, peephole-like vision through self-conscious display

techniques. Such exhibits that draw attention to exhibition qua exhibition substantiate the truth of Ron Burnett's claim that seeing is never innocent and vision never takes place within a temporal or historical vacuum.[40] As this chapter illustrates, certain Holocaust exhibits in Yad Vashem and the Jewish Museum Berlin demonstrate this very impossibility of the "innocent eye" by encouraging artful types of vision that reflect social and cultural realities.

The changing views of visitors also play a major role in shifting exhibition practices. As Mieke Bal has argued, while earlier exhibition practices were designed to instruct and entertain the visitor "according to the old adage *utile dulci*" (the useful with the agreeable), the past few decades have seen an important change in how the visitor's role is imagined. In Bal's words, "Through famous exhibitions in the 1980s and 1990s . . . the museum-going public has been confronted with the retreat of the white cube and, in its place, the creation of something like a Gesammtkunstwerk [total artwork] of a specifically designed combination of artistic objects, sometimes with the building and the spaces therein as active participants."[41]

The idea that a museum exhibition may act like a total artwork, that is, an artwork that combines a number of varied artistic forms, aptly applies to creative museums like Yad Vashem, the Jewish Museum Berlin, and the USHMM. All three draw on a variety of techniques to create experiences for visitors that engage all the senses: seeing, hearing, and even bodily sensation. This approach helps to transform visitors into active participants instead of passive spectators. Certain exhibitions, furthermore, demonstrate this new approach by staging "a dialogue between the art and the viewer as thinker in which the art has its own power to speak, and speak back." Although Bal's analysis confines itself to art exhibits, her insights may be applied to other types of exhibits as well. For example, Bal suggests that often-overlooked aspects of exhibition (such as the slant of walls or types of framing devices) reveal a kind of grammar or language that affects how exhibits make meaning and how visitors interpret that meaning.[42] As Bal succinctly puts it, "walls speak, and readers are implicated by the speech."[43]

In contrast to museums that seek to conceal their presentation techniques so that objects and images may "speak for themselves," Yad Vashem often displays its exhibits in ways that draw the viewer's attention to issues of mediation, perception, and representation. Within the permanent

exhibition, for example, Holocaust survivor video testimonies are repeatedly projected directly onto bare walls. Through the projected images viewers may glimpse the texture and color of gray concrete—an unfinished, transitional substance that is also the material of bunkers and numerous war memorials in Israel. By eliminating the formal separation between viewer and object of vision embodied in screens, the direct projection makes viewers aware of their own viewing practices. It draws viewers' attention to their expectation of mediation and to the fact that under conventional viewing conditions they merely perceive the referent—the content of the projected image—rather than reflect on the fact of representation itself. As Freedberg has shown, human perception automatically elides resembling images with their living counterparts, unless "aesthetic differentiation by way of attention and abstraction supervenes."[44]

Abstraction and other strategies of aesthetic differentiation disrupt this naturally occurring elision and make viewers critically aware of the difference between an image and the original object or person it represents—helping to avoid, in other words, what Freedberg, following Hans-Georg Gadamer's *Truth and Method* (1975), calls the slippage from representation to presentation. Such slippage occurs when the image itself becomes the "living embodiment" of what it represents.[45] Aesthetic differentiation appears, for example, in the photo mural of the four Jewish survivors from Salonika discussed earlier. The artfulness of the mural's presentation forces the viewer to consider not only the content but the method of presentation itself and to ask what it means to look at Holocaust images, particularly those that degrade depicted victims. This level of consideration, which focuses on the *how* rather than on the *what* of presentation, enables a more critical, less naive viewing.

By drawing attention to the aesthetic and formal qualities of an image or object, techniques of aesthetic differentiation undermine the idea of the "innocent eye" or the image that "speaks for itself." Aesthetic differentiation thus disrupts the often automatic process by which viewers slip into certain visual habits that hinder a more critical or subtle viewing—and by extension, remembering—practice. Through techniques of aesthetic differentiation, furthermore, exhibits evoke particular types of vision, including double, ironic, broken, and multilayered views. The following paragraphs address an additional form of perception that perceives absence, but first the question arises: why are new ways of seeing necessary?

Iconic Images

One of the visual habits that hinders Holocaust remembrance is a rote response to famous—even canonical—images. Such images are repeatedly reproduced and circulated in books and articles as well as in museum and memorial contexts, and may come to act as tropes for Holocaust remembrance itself.[46] Usually photographs, these images have become ubiquitous in Holocaust remembrance to the extent that they have acquired the ability to reach beyond a merely representational or even symbolic potential, as they stand in for complex ideas and events. Such images may be called "iconic images": they are instantly recognizable and recall to the viewer a series of historical and cultural cues.[47] Capable of evoking in the viewer strong emotional reactions, iconic images are often "accepted as straightforward and unambiguous reality" or as a "moral claim" to be accepted without questioning.[48] As the photography critic Vicki Goldberg has shown, such photographs possess "almost instantly acquired symbolic overtones and larger frames of reference that [endow] . . . them with national or even worldwide significance. They . . . provide an instant and effortless connection to some deeply meaningful moment in history . . . [and] seem to summarize such complex phenomena as the powers of the human spirit or of universal destruction."[49] Signifying beyond what they represent and symbolizing entire realms of experience, iconic images are particularly efficacious as well as problematic in the Holocaust memorial context.

The words "iconic image" also carry a religious connotation. While some might shy away from applying a term laden with religious meaning to an image or object representing the Holocaust, it is exactly this connotation that Oren Baruch Stier finds compelling, because it accurately reveals that there is something about how the Holocaust is approached in contemporary discourse that is "structurally similar to the way the holy—the sacred, the *kadosh* (in Hebrew)—is dealt with, in its classic sense. That is, the ways people speak of, react to, and create in response to the Holocaust—with reverence, with awe, with humility—is as if they are confronted with a sacred mystery."[50] As previously noted, the Holocaust is widely treated in contemporary culture as something outside of, or beyond, normal historical experience and therefore requiring different standards in terms of how it is represented and remembered. But the use of "iconic" in these pages does not promote the sacralization of the Holocaust so much as a recognition that the Holocaust has already been elevated to a sacred status.

Iconic images are potentially problematic because they are ubiquitous. The repeated reproduction and display of certain Holocaust photographs can weaken the referential function of images and limit their ability to initiate productive remembrance. As previously mentioned, Barbie Zelizer describes collectively held (iconic) images as "signposts" that act to "stabilize and anchor collective memory's transient and fluctuating nature in art, cinema, television, and photography, aiding recall to the extent that they often become an event's primary markers" and directing those who want to remember to a "preferred meaning" via the fastest route.[51] The most repeatedly reproduced Holocaust photographs have come to stand in metonymically for the Holocaust as a whole and act as shortcuts to memory.

When photographs cease to mediate memory and actually replace the referent as the object of remembrance, then they become what Stier calls "idols." An idol hinders remembrance by usurping it and thereby helping to erase the "voice of the past."[52] This happens, Stier argues, when the viewer fails to recognize the mediation that necessarily takes place when images are reproduced, displayed, and transmitted. Particularly damaging to Holocaust remembrance is the rote response that iconic images may evoke in viewers when such images are not perceived as references to concrete (and unique) sites and moments in history but are rather seen symbolically and consumed without critical consideration. This leads to a flawed remembrance based on "visual sound bites," a remembrance consisting of a storeroom of images that neatly fill in the gaps of actual historical knowledge.[53]

Bearing these concerns in mind, the following pages focus on how museum displays create different modes of seeing and remembering. By directing viewer attention to certain aspects of presentation, these exhibits prevent viewers from slipping easily into an automatic and effortless relation to the past that leads to less rather than more remembrance. Instead, such exhibits encourage viewers to respond to images in a critical and self-reflective manner and to see and remember in new ways.

Double Vision

One unique way of seeing that makes viewers aware of the role that representation plays in creating memory is double vision. By refusing to allow viewers to engage in a simplistic, automatic relation to the past, double

vision forces them to recognize an image first and foremost as a form of representation. This recognition makes possible a more discriminating practice of vision and remembrance that includes insight into how the passage of time removes traces of the Holocaust and leads to forgetting. An example of the evocation of double vision appears in an exhibit in Yad Vashem on deportation. A large-format, contemporary color photograph of the main arrival gate at Birkenau—an iconic image in Holocaust remembrance—appears mounted on a free-standing glass support. This photograph reveals the camp from an external view. On the other side of the support is an almost identical photograph of the entrance to Birkenau, but this photograph is different in a few respects. First, it reveals the camp from the opposite side so that multiple sets of train tracks appear as they converge at the gate; second, it is an original black-and-white photograph taken from a time when Birkenau was still operational; and, third, the photograph was taken from inside the camp. Neither image is labeled. This lack of referential information, which relies on the fact that such images of Birkenau are iconic and will be recognized by most visitors, as well as the double presentation, demonstrates aesthetic differentiation. The viewers' attention is instantly drawn to the aesthetic or formal qualities of the images and to the details of their presentation.

The striking contrast between two ostensibly identical images slows down the viewer's process of seeing and allows subtle differences between the two photographs to come to light. Viewers are struck first by the difference between the black-and-white image—reminiscent of the black-and-white photographs typical of World War II history books or documentary films—and the vivid color image, which with a flash catapults the site into the present. Viewers then notice that the converging tracks in the black-and-white photograph are littered not only with snow but with piles of objects—presumably, objects that spilled from the overstuffed cattle cars of the train as they were rapidly emptied of their human cargo upon arrival. These discarded heaps of objects and remnants signify metonymically for their lost owners.

In contrast, the contemporary color photograph reveals clean, orderly tracks that bear no trace of human traffic. These tracks are bordered by patches of bright green grass and traffic signs. The entrance gate is neat and well kept up, with no signs of decay; by all appearances, this might be a fully operational stop. Gazing at the photograph, viewers can easily imagine a train pulling in at any moment. The past is sanitized in this photograph; all

traces of suffering and death have been cleared away, the site tidied and sterilized and made into a presentable monument.

The contrast between the two photographs reveals the process whereby history is sanitized and made palatable. The juxtaposition of these images, placed front to back on a single support, forces viewers to consider how they remember Birkenau differently in each photograph and to ask themselves what kind of a progression appears to have taken place in the time that passed between the two photographs. Is this a process of remembrance, whereby a historic site is fashioned into a memorial to victims, or perhaps a process of forgetting, whereby rough traces of the past are smoothed away in the creation of something easier to confront? By leading viewers to contemplate these two images in terms of their presentation and form, this exhibit encourages them to critically contemplate what it means to remember the Holocaust through iconic images.

Ironic Vision

Yad Vashem encourages a second, ironic type of vision in several exhibits, including the display on the Theresienstadt (Terezin) concentration camp. This display consists of a single screen split into two sides; one side shows clips of documentary footage of Theresienstadt. The footage was to have been developed into a film called *Der Führer schenkt den Juden eine Stadt* (The führer gives the Jews a city) and was shot by the Jewish actor and director Kurt Gerron under orders from the German camp authorities. Shortly thereafter, Gerron was deported to Auschwitz and immediately killed. These images of Theresienstadt are documentary only in the sense that they were shot on location in the camp; the scenes themselves were staged. Prisoners are shown taking part in a range of resort-like activities, including attending lectures, playing sports, and listening to music. Juxtaposed with these black-and-white film images on the second half of the split screen are drawings and paintings by Theresienstadt prisoners. The latter present a very different reality of hunger, exhaustion, sickness, and despair. Separating the two sides of the screen is a jagged line, as if two halves of a torn picture had been placed side to side.

The irony of this exhibit emerges from the contrast between the misleading yet objective-appearing documentary images and the truthful yet clearly subjective paintings and drawings. It asks viewers to question their

assumptions about the role that documentary film and photographs play in Holocaust remembrance and to be suspicious of the idea that photographs reveal unmediated reality—particularly given the fact that most Holocaust photographs were taken by the perpetrators. The Theresienstadt exhibit thus admonishes the viewer to maintain a critical and skeptical distance from all images, but especially from those that claim to speak with objective authority. The personal testimony of Holocaust victims, this display reveals, is often more objective and truthful than photographic evidence.

Broken Vision

The first exhibit of Yad Vashem's permanent exhibition, titled *Living Landscape*, demonstrates a third kind of vision, called broken vision. Aptly described by Yad Vashem as "a kind of scroll, a quilt, a moving human landscape," this video installation begins the process of transforming museum visitors into witnesses—a process that is developed throughout the museum, brought to a climax with the installation *String* (discussed in chapter 6) and completed with the visitors' integration into the *Hall of Names*.[54] *Living Landscape* was created by artist Michal Rovner and donated to the museum by the Clore Israel Foundation. In this installation Rovner reports, "the challenge was to recreate the atmosphere of Jewish life. I took different film clips and blended them into one background, just as the Jews blended into the fabric of life in the countries where they lived."[55] The ten-minute black-and-white film montage of refurbished archival photographs and film clips plays on a loop and is projected directly onto the concrete triangular-shaped southern wall of the museum. The fact that this triangle is also half of a Star of David occurs to visitors after they see repeated Stars of David and triangle patterns throughout the permanent exhibition.

In this image from *Living Landscape* a building appears inscribed with the following words in Hebrew: "Law establishes times for the Torah." To the left is a group of children playing violins and (not visible here) a chicken; in the foreground stand two waving children. The figures visible through the windows on the ground floor are bent over books, engaged in Torah study. Such images reveal nostalgic scenes of prewar European Jewish life. In other scenes viewers see waving children superimposed over background maps of Europe and everyday images of busy public life, including the bustle of shopping districts and crowded streets. What is interesting and unusual

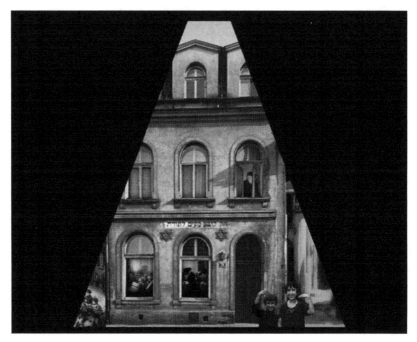

FIG. 4.4 *Living Landscape,* by Michal Rovner, Yad Vashem. © 2013 Michal Rovner and
Artists Rights Society (ARS), New York.

here and what captures the visitor's eye is the triangle shape of the wall
upon which the film is projected. This triangle eviscerates the rectangular
shape of the typical screen in a more conventional museum. The prism of
the projected film's boundaries undermines ordinary perception and forces
us to see otherwise—that is, to become consciously aware that this prism,
this half of a Star of David, is the lens of the present through which our view
of the past is shaped. This is a broken view because it is indelibly stamped
by our knowledge of the approaching destruction that would obliter-
ate these Jewish communities. We cannot view the European Jewish past
without this knowledge, and our perception of this past is therefore filtered
through a sense of nostalgia and impending doom. Even as Jewish history
continues—a continuity emphasized throughout Yad Vashem's Zionist
narrative—our view of the Jewish past is always framed by the devastation
of the Holocaust.

Like Walter Benjamin's Angel of History, whose backward gaze perceives a single catastrophe and its incessant consequences despite the passage of time that propels him forward, viewers experience the Holocaust through broken vision as a great *churban* (destruction) of the Jewish past that continues to shape the present.[56] This backward gaze is our initiation into Yad Vashem's narrative. The ideology of Zionism that frames Yad Vashem's Holocaust narrative throughout speaks convincingly of progress, but exhibits like *Living Landscape* reveal how the Holocaust traps us in a past that continues to shape our understanding of the present.

Multilayered Vision

A fourth type of vision evoked in Yad Vashem is multilayered vision, a way of seeing that initiates the viewer into an awareness of the complexities of vision and remembrance. Directly after Rovner's video installation, visitors encounter a display consisting of photographs arranged in three distinct yet interconnected layers. This exhibit, displayed on both sides of the museum's prism-shaped hall in a mirrorlike arrangement, introduces visitors to the narrative of the museum and to its "layered structure."[57] Physically closest to the viewers, the first layer consists of a glass display case containing possessions of Jewish Holocaust victims, including passports, a watch, and photographs. The second layer is a series of transparent personal photographs, ripped and charred along their edges and affixed to a glass wall with a thickness of approximately one-half inch. These photographs were found in the pockets of victims killed in a camp in Klooga, Estonia, in September 1944 as the Red Army advanced. The third layer is a set of large-format photographs of corpses stacked on a pier of logs—the victims reduced to their final, ignominious state after execution. These final photographs are backlit and visible through the transparency of the second-layer photographs.

This layered exhibit depicts a journey from individual life to anonymous death—a progression that takes place through three layers of perception. The exhibit is not lit for clarity but rather to emphasize a certain semantic structure. The first layer of personal possessions and artifacts testifies to the normalcy of a pre-Holocaust existence that included citizenship and travel. The second layer of charred personal photographs reveals the beginning of destruction and the violence and damage inflicted on individuals, families,

and communities. The final layer exposes the horrible end of individual lives: not only the loss of life itself but the desecration of the body. In its entirety the display suggests that the truth of the victims' experience will not be revealed through a static peephole gaze and an objective distance between viewer and object. Rather, the type of vision called for is more complex and nuanced; it is inscribed with memory and mourning and relies on an understanding of the victims as individuals rather than as statistics. As such, this vision is highly subjective and empathetic. It calls for remembrance that is empathetic as well, as it seeks to recall to viewers the victims' lives as well as their deaths.

The Perception of Absence

The types of vision discussed thus far have all appeared in Yad Vashem. The final type of perception to be discussed, the perception of absence, appears in the Jewish Museum Berlin. One of the greatest challenges facing the Jewish Museum Berlin is the question of how to represent absence. Two of the Jewish Museum Berlin's most interesting acquisitions, both of which appear in the Holocaust exhibit of the permanent exhibition, engage with this problem. The first reveals to visitors the role of absence in Holocaust remembrance as it focuses their perception on that which is not visible. Via Lewandowsky's *Ordnung des Verschwindens* (*Gallery of the Missing*) (2001) is an imagined archive consisting of three black glass sculptures, 120 soundtracks, and infrared headsets. A literal translation of the German title, and the translation chosen by the artist, is *Order of Disappearance*. Visitors cannot see into these sculptures—the black glass effectively blocks vision—but they can hear through the headphones acoustic descriptions of missing objects and may imagine the objects described. Some of these objects might have been included in the museum's Holocaust exhibit had they not been stolen from their owners, lost, or destroyed. Placed in close proximity to the black walls of Libeskind's voids, these sculptures echo the architecture's strategy of evoking absence and loss.

The *Gallery of the Missing* returns the burden of memory, to use James E. Young's phrase, to the visitors, and emphasizes the necessarily incomplete nature of Holocaust remembrance. Underlying this exhibit is the belief that absence can be effectively represented (or gestured at) and can play

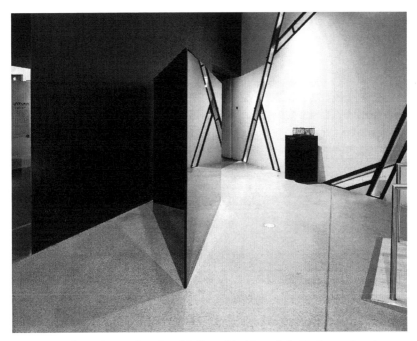

FIG. 4.5 *Ordnung des Verschwindens* (*Gallery of the Missing*), by Via Lewandowsky, Jewish Museum Berlin. © VG-Bildkunst. Photograph by Volker Kreidler.

an active role in remembrance. The *Gallery of the Missing* demonstrates to visitors that remembrance cannot be passive; instead, visitors must actively contribute to the project of memory. In its evocation of absence, this installation partakes of strategies characteristic of the countermonuments described by Young, which, he explains, negate "the illusion of permanence traditionally fostered in the monument" and challenge the idea of a fixed, unyielding memory that may be regarded as "eternally true." Finally, and most important, the countermonument insists that viewers, not the monument, do the actual work of memory. It leaves behind, in Young's words, "nothing but the visitors themselves standing in remembrance, looking inward for memory."[58]

The second exhibit in the Jewish Museum Berlin that evokes a perception of absence is Arnold Dreyblatt's installation *Unausgesprochen* (*Unsaid*) (2008). This exhibit consists of a barrier of eight steel-framed, vertical glass panels. Each panel is approximately three feet wide and ten feet high. Four

data projectors behind the glass panels project onto alternately opaque and transparent surfaces. When the electric current is switched off and the glass is opaque, the glass panel acts as a writing surface upon which letters appear. When the electric current runs, the panels become transparent and the words disappear. The emerging words and sentences, which materialize across the glass, letter by letter, are portions of historical documents selected from museum archives, including last letters and diaries of victims from concentration camps and ghettos as well as official letters from bureaucratic offices concerning preparation for deportations and transports to the east. The startling juxtaposition between the personal words of victims on the one hand, and the official language of institutionalized persecution on the other, as well as the shifting absence and presence of sentences, draws the viewers' attention to the act of representation itself.

The four pairs of panels of *Unsaid* are thus constantly moving between opaque and transparent states, creating a shifting, vibrant pattern. At any given time between one and four panels may be displaying words, and the sequence of active and inactive panels is always at variance. In certain

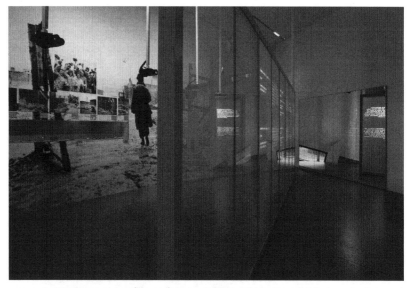

FIG. 4.6 *Unausgesprochen* (*Unsaid*), by Arnold Dreyblatt, Jewish Museum Berlin. © Arnold Dreyblatt, 2008. Photograph by Jens Ziehe.

moments entire sections of the wall seem to disappear. Presence yields to absence and absence to presence, without an apparent pattern that may be predicted. Similar to the way in which the *Gallery of the Missing* is located to form a connection between the sculpture and the museum's voids, the glass barrier of *Unsaid* is carefully situated in space to resonate with Libeskind's architecture; it is built across a line in the floor that crosses the space at an angle. This line echoes in muted form the two lines that run throughout the Libeskind building, intersecting the architectural space and exposing between them a series of voids. In this way, Dreyblatt's installation engages in a dialogue with Libeskind's architecture and its evocation of absence.

Both the *Gallery of the Missing* and *Unsaid* draw attention to the fact that the most powerful trace of the Holocaust in Germany is not to be found in the ruins of concentration camps or in remnants and artifacts put on display in museums but rather in the absence of Germany's lost Jewish citizens. The *Gallery of the Missing* gives expression to this lack and literally speaks of that which no longer exists. *Unsaid*, similarly, plays with absence and presence as words of witness—the private testimony of victims—as well as the words of persecution appear and disappear in unpredictable, shifting patterns. Both displays emphasize the ephemeral nature of witness. The acoustic and visual testimony in both are fleeting and, after a brief appearance, recede again into absence. Finally, both displays force museum visitors to play an active role in remembrance, rather than remaining mere spectators or voyeurs of the past.

The *Gallery of the Missing* and *Unsaid* are welcome disruptions in an otherwise unremarkable segment of the museum's permanent exhibition titled *Verfolgung—Widerstand—Vernichtung* (Persecution—Resistance—Extermination). Entering this exhibit, visitors are immediately struck by an impression of scarcity. The exhibit lacks a substantial display on the concentration camps, including the conditions of hunger, thirst, cold, and heat that tormented prisoners; the selections; the medical experiments; and the diseases that ravaged camp populations. Life and death in the ghettos is also neglected in the exhibit.

In the Holocaust exhibit of the Jewish Museum Berlin, the censorious words of Edward Rothstein come to mind: "There may be worse Jewish museums in the world than the Jüdisches Museum Berlin. . . . But it is difficult to imagine that any could be as uninspiring and banal, particularly given its pedigree and promise." The problem, perhaps, is that the Jewish

Museum Berlin imitates the identity museum genre. Identity museums chronicle the history of a particular ethnic group, including its high and low points, its "travails and triumphs," with a focus on survival and an exhibition "culminating in the institution's own prideful displays." As Rothstein rightly points out, though, in this case, "of course, the Holocaust interrupts the uplift."[59] The effect of this "interruption" of the Holocaust on the narrative of the museum as a whole is decisive. Indeed, how can the Holocaust be folded into a conventional narrative without necessarily relativizing the extent of the crimes committed?

The attempt to fit the Holocaust into a greater story and to maintain a semblance of continuity throughout the German Jewish narrative is bound to fail precisely because of the radical disruption of the Holocaust, which eradicated forever the mythic idea of the German-Jewish symbiosis.[60] This concept was, as Amos Elon explains, a most dubious and "always suspect" concept that was primarily dreamed of by Jews before the Holocaust. This was, in other words, a "love affair that only one partner was interested in and believed in."[61] It was also a love affair that did not die with the birth of National Socialism. Martin Buber, for example, in the words of Amos Elon, "rhapsodized about a German-Jewish symbiosis as late as 1939: it had been abruptly interrupted by the Nazis, he [Buber] claimed, but it might be resumed again in the future." Elon points out, however, that after the Holocaust the dream was no longer salvageable, and it was only nostalgically resuscitated by "penitent Germans . . . guilt-stricken and rueful over 'their' loss."[62] Although the museum stops short of succumbing to a resurrection of this discredited concept, the exhibition nevertheless tends toward a "dull homogeneity" and an "assimilated blandness in which antipodes unite in ersatz tolerance."[63]

The desire to preserve some appearance of a narrative thread connecting successful examples of Jewish assimilation in pre–World War II Germany with the remnants of Jewish life in post–World War II Germany explains, perhaps, the museum's disproportional concentration on Jewish response to Nazi persecution as well as Jewish and non-Jewish German resistance. The documentation of Jewish life in the years immediately predating National Socialism highlights Jewish engagement in sports, schools, hospitals, synagogues, and Zionist groups. Such displays emphasize both the integration of Jews in German society as well as efforts to maintain Jewish identity. In the Holocaust exhibit itself, displays focus on Jewish efforts at

Berlin

self-help and resistance. The exhibit emphasizes, simply put, how Jews did not passively or fatalistically accept persecution and murder—refusing to go "like sheep to the slaughter."[64] Within the relatively limited section of the permanent exhibition dedicated to the Holocaust appear displays on the 1943 Rosenstraße protest; the rescue of a Jewish family hidden in Berlin; the Herbert Baum Resistance Group; Otto Weidt's Workshop for the Blind; the Kulturbund Deutscher Juden (Cultural Federation of German Jews, founded 1933); Jüdische Winterhilfe (Jewish Winter Relief); preparations of German Jews to emigrate to Palestine through Zionist organizations; and leisure activities that Jews continued to engage in after 1933.

The generally optimistic narrative of Jewish life in Germany throughout the permanent exhibition expresses a "spirit of reconciliation" that disintegrates when it confronts the reality of National Socialism.[65] The main theme running throughout the permanent exhibition is the cultural, economic, and political contribution of Jews to German culture. German Jews are presented as learned, urban, and patriotic; they appear largely as members of a bourgeois and intellectual elite (Bildungsbürgertum) and, above all, as cofounders of the German nation.[66] The degree to which German Jews felt at home in German culture—if not always in Germany—has been succinctly expressed by Amos Elon: "Through no fault of their own, their true home, we now know, was not 'Germany' but German culture and language."[67] In the Jewish Museum Berlin, however, German Jews are retroactively rehabilitated and integrated into Germany's multicultural society. This is common in memorial spaces, which are often self-serving in attributing national identity to the victims who were denied that identity during their actual lifetimes.[68] Although persecution and exclusion are indeed thematized, the exhibition demonstrates a notably positive tone that refuses to portray Jews as victims in any fundamental or existential way. German Jews are presented, rather, as the very bearers of German culture.[69]

The baffling leap from the sections of the museum that demonstrate successful Jewish assimilation—such as the "German Jews–Jewish Germans" segment—to the Holocaust leaves the visitor disconcerted. The chronological and progressive narrative becomes exposed in this moment as a failed fiction and the great questions of "why" and "how" are swept aside by a focus on response, resistance, and self-help. The natural and justified objection that no Holocaust museum or exhibit can adequately answer the questions of "why" and "how" does not absolve the Jewish Museum Berlin

from the fact that it fails to pose them—nor from the fact that it fails to convincingly acknowledge the violent caesura that shattered the German Jewish narrative up to that point—a caesura, in contrast, that Libeskind's architecture does acknowledge. With this in mind, Edward Rothstein's criticism that the incongruity between the architecture of the museum and its permanent exhibition results in a "strain" that is "almost bipolar" is fitting.[70]

Critics of the Jewish Museum Berlin have argued that the museum collection has not only had to "fight against the architecture" but has actually triumphed over it, sabotaging the significant memorial possibilities of Libeskind's design.[71] Susannah Reid, for example, argues that "other than in a few cases, the exhibitions are fully independent of the architecture, and the empty building's powerful emotional impact has unfortunately largely disappeared." Calum Storrie agrees, adding that the "greater emotional narrative" of the Libeskind building is often "lost amongst the cacophony of stories being told by objects, graphics and audio-visual material."[72] With the exception of the *Gallery of the Missing* and *Unsaid*, which succeed both as artistic engagements with Holocaust memory and in terms of achieving resonance with the museum's architecture, the Holocaust exhibit of the Jewish Museum Berlin remains shrouded in inarticulateness and even muteness.

In light of the fact that framing and display techniques shape to a significant extent museum visitors' perception of objects and images, it becomes possible to speak of a visual language, or poetics, of exhibition in museums. Within this language, a number of aspects of presentation—like parts of speech—contribute to the overall meaning of an exhibit. Particular techniques of display, furthermore, such as the use of color, asymmetrical hangings, juxtaposition, and isolation, contribute to the making of meaning. Alternative modes of vision, including double, ironic, broken, and multilayered, as well as the perception of absence, reveal how museum exhibits may draw on creative visual and acoustic techniques to encourage a critical and nuanced interaction between viewers and the object of their gaze, as well as a more thoughtful and self-reflective approach to Holocaust remembrance.

5 ⇥ "WE ARE THE LAST WITNESSES"

Artifact, Aura, and Authenticity

Flying Spice Box, an oil painting by Israeli artist Yosl Bergner (1966), depicts an ornate spice box hovering against an ominously dark sky. Beneath the spice box lies a dusky, low-hanging sun and ruined landscape with a border of crumbling stone walls. The spice box plays a special role in the Havdalah ceremony that marks the end of Shabbat and transitions its participants back into ordinary time. As part of this ceremony, a sweet-smelling spice—often stored in a special spice box—is passed around the table so that each person can share in its scent. The elaborately carved spice box in Bergner's painting represents Jewish custom and, by extension, the Jewish family who used this box in its weekly Shabbat ritual. Here, the spice box appears in flight—fleeing ravaged, war-torn Europe and searching for a new home and future—and suggesting, as Ziva Amishai-Maisels notes, an "'inanimate' rendering of the Wandering Jew as a survivor."[1]

Many artists depicting the Holocaust draw on relics and objects—above all, on objects of a personal or ritual nature—to anthropomorphically symbolize Jewish victims. Joseph Richter's pencil drawing *The Lublin Railway Station* (1943), for example, portrays a brief stretch of train track that separates vaguely heaped-up, unmarked mounds (most likely impromptu graves) from discarded possessions that lie about on the ground, including prayer shawls (*tallits*), a child's doll, crutches, Torah scrolls, and caps. The possessions refer metonymically to their absent owners—victims of

the latest round of deportations—and, at the same time, to their mortal remains.

Whether it is through a single, valued object like a spice box or through a heap of possessions plundered from Holocaust victims, many artists and curators rely on objects to represent missing Jewish figures. This chapter focuses on the roles that artifacts play in museum exhibits and on a single type of vision called "witnessing vision"—a way of seeing that responds to authentic artifacts within displays that are presented as witnesses to atrocities. Philosopher Giambattista Vico argues that objects are "manifest testimony" and carry greater authority than mere texts or mimetic representations.[2] Objects act as witnesses and bear testimony in the sense that they testify to the time and place whence they came. They belong to a different world, and thanks to their authentic presence, or "aura," we can come closer to that distant, vanished world through them.

Paul Williams suggests that by presenting authentic artifacts as witnesses to atrocities, museums "humanize" the artifacts within a "rhetorical strategy" of exhibition and, in a sense, grant them their own "lives." The idea that an artifact may act as a witness suggests a nebulous or even mystical view of objects in museum settings. As David Freedberg argues, however, there is nothing "vague, mystical, or unanalytic" about the aura of an image (or, in this case, an artifact); rather, the "aura is that which liberates response from the exigencies of convention."[3] In other words, the aura of an artifact does not exist without the individual who perceives it and who experiences, in response, something meaningful—the aura emerges in this way from real, concrete conditions of presentation and spectatorship and is neither magical nor mysterious.

Authentic artifacts, like those on display in the USHMM's permanent exhibition, are physical remnants of a distant time and place. Within the museum context, artifacts usually fall into one of the following three categories: objects that are "particularly rare or revelatory," objects that exhibit typicality and therefore "represent a category of experience," and objects that possess remarkable provenance.[4] In memorial museums, however, artifacts often belong to more than one category. They may, like eyeglasses and toothbrushes, exhibit typicality but simultaneously possess a remarkable history by virtue of having belonged to Holocaust victims imprisoned in a notorious concentration camp or ghetto. Discovered at the actual sites where key events of the Holocaust took place, such as the Warsaw Ghetto or

the Auschwitz-Birkenau extermination camp, otherwise quotidian objects like bowls or spoons acquire an aura of fatefulness because they seem to bear the very traces of the Holocaust itself; they possess, in short, a unique and powerful presence. Through their genuineness or authenticity, they claim to bridge the geographic and temporal distance between contemporary museum visitors and the sites and victims of the Holocaust.

Although artifacts are by definition constructed objects, two unique exhibits in the USHMM display natural objects that resemble artifacts in their evocative power: a tree stump from Palmiry Forest, where approximately seventeen hundred civilians were executed, and tree trunks from the Rudniki Forest near Vilna, where Jewish partisans fought. The tree stump from Palmiry Forest marked the site of a mass grave where victims were buried. Behind the stump hangs a large photograph of blindfolded men who were photographed moments before their death. Set off from the surrounding space; enshrined in its own small, recessed room; and lit from below, the stump evokes the image of a *matzevah*, a headstone or memorial. The tree trunks from Rudniki Forest are also isolated and displayed as precious objects. Through their spatial placement, the permanent exhibition awards the tree trunks and stump a special status; they are presented as witnesses to events that took place deep in the woods—to crimes designed to leave no eyewitnesses as well as to acts of heroism. In the presence of these objects, to use Edward Linenthal's words, visitors may reach out and "touch the Holocaust."[5] By encouraging witnessing vision, displays of authentic artifacts thus transform visitors into vicarious witnesses.

Both the spice box of Bergner's painting and the discarded possessions of Richter's drawing appear to us as witnessing objects. The former is a witness to the destruction of the Holocaust that left in its wake a ravaged landscape and the imperative for surviving Jews to seek out a new homeland, and the latter are witnesses to the horrors of deportation. This technique of framing artifacts as witnesses and encouraging witnessing vision appears most elaborately developed in the USHMM.[6] The museum's permanent exhibition contains approximately one thousand authentic artifacts; its overflowing displays, crammed full of photographs, objects, and texts, exemplify the idea of the museum as a storehouse or repository of memory.[7] From among the truly vast number of artifacts on display—including sacred objects such as Torah scrolls, a stained glass window from the Krakow synagogue, and a pile of prayer shawls as well as prosthetic limbs, Zyklon B canisters,

and anti-Semitic posters—a few large artifact exhibits stand out for their power to transform visitors into vicarious witnesses. These exhibits include a collection of Holocaust victims' shoes on loan from the State Museum at Majdanek; a desecrated Torah ark (*aron ha-kodesh*)—vandalized during Kristallnacht—from a synagogue in Nentershausen, Germany; and a German railway car from the World War II era, procured from the Polish government and of a type used for deportations.

The Aura of Artifacts and the Ritual of Remembrance

Broadly speaking, objects in the traditional, nineteenth-century European museum were seen as carrying meanings that were objective and transferable to viewers through their inherent qualities. Following this model, viewers needed only to be empty vessels to benefit from their instruction. Museum objects typically possessed traceable life histories, and their display was governed by the dynamics of painstaking collection and rational observation. Most often presented in glass cases at a respectful distance from viewers, these objects dictated certain ways of seeing and knowing.[8] Museum objects, moreover, radiated authority as authentic traces of the past. They could effectively "freeze time," creating through their presence a state that transcends historical time and fixes the memory of a culture in a particular, chosen vision.[9]

Today, however, objects are no longer automatically assigned the natural-seeming authority they were granted in the past; instead, they are recognized as relying on exhibit designers to shape their presentation and on viewers to interpret their multidimensional meanings. As David Lowenthal aptly puts it, "Relics are mute; they require interpretation to voice their reliquary role."[10] Objects in museums today, furthermore, are primarily valued for their potential to enrich an exhibition's storyline rather than for their inherent, unique value. When objects and artifacts are called on as corroborative evidence to supplement a museum's narrative instead of acting as mirabilia and unmediated traces of the past, their individual meanings become subsumed to a more general purpose.[11]

It is becoming increasingly apparent that the great collecting phase of objects has largely passed, and new types of museums have assumed

prominence, including the theme museum—a prominent example of which is the Beit Hashoah—Museum of Tolerance in Los Angeles. Such museums structure their exhibits around a single narrative focus or historical idea, which replaces artifacts as the driving force behind the exhibition. As a result, objects lose their preeminence as the primary source of authority. This demonstrates a shift in emphasis from the value of the object's provenance to its representative value. Increasingly, viewers no longer revere the object for its authentic presence so much as for its ability to provide a sense of context. Its power to act as a trace of distant times and places—its seemingly mystical potential to bridge distances and to cultivate empathy—is thereby marginalized. This shift suggests that museum objects have undergone a process of "de-mystification" or "de-sacralization," in the sense that the artifact no longer exhibits an aura that arises from its unique presence in time and space.[12]

In the language of Stephen Greenblatt, the representative value of an object lies in its ability to provide "resonance," which he defines as the "power of the object displayed to reach out beyond its formal boundaries to a larger world, to evoke in the viewer the complex, dynamic cultural forces from which it has emerged and for which as metaphor or more simply as metonymy it may be taken by a viewer to stand." Furthermore, Greenblatt uses the word "wonder," which is roughly synonymous with "aura," to refer to "the power of the object displayed to stop the viewer in his tracks, to convey an arresting sense of uniqueness, to evoke an exalted attention." "Wonder" refers to a state of enchanted looking, which occurs "when the act of attention draws a circle around itself from which everything but the object is excluded, when intensity of regard blocks out all circumambient images, stills all murmuring voices." Curators often draw on certain presentation techniques, such as "boutique lighting," in which a pool of light seems to emerge from the object itself, and spatial isolation, to evoke a sense of wonder.[13]

Despite a countervailing trend over the past few decades, Holocaust museums and exhibits continue to present artifacts as authentic relics, framing them to emphasize that they are the traces of lost times and persons and thereby lending them an aura or sense of wonder. Through these techniques, Holocaust museums and exhibits create a new ritual function for artifacts within the context of remembrance. As Yosef Hayim Yerushalmi has shown, ritual is one of the two channels through which Jewish remembrance has traditionally flowed. In the ritual of remembrance, Yerushalmi

demonstrates, explanation alone cannot suffice to connect to the past those individuals who are alienated from it. For this connection to take place, evocation becomes necessary. Yerushalmi refers in this context to the evocative practices of Jewish rituals, for example, the Passover Seder, where language and gesture encourage the merging of historical and liturgical time and thus enable the fusion of past and present. During this ritual, memory is no longer simply a matter of recollection but rather "reactualization." Through the collective, ritualized practice of the Seder—for example, lifting up a piece of unleavened bread, declaring it the bread of affliction, and saying the words, "next year in Jerusalem"—the participants symbolically reenact and take part in the narrative of slavery, deliverance, and redemption.[14]

Using the Seder as a model, Irving Greenberg proposes that such ritual reenactment might be imitated in the context of Holocaust remembrance. In his words, "in the decades and centuries to come, Jews and others who seek to orient themselves by the Holocaust will unfold another sacral round. Men and women will gather to eat the putrid bread of Auschwitz, the potato-peelings of Bergen-Belsen. They will tell of the children who went, the starvation and hunger of the ghettoes, the darkening of the light in the Mussulmen's eyes." Greenberg maintains that the Holocaust is both "normative and revelatory." Through its reenactment Jews of future generations will be able to "experience the normative event in their bones—through the community of the faith" and thus "will live by it."[15]

In the context of visiting Holocaust museums like the USHMM, which demonstrates, in the words of Herbert Muschamp, the "sanctity of the temple," the ritual of Holocaust remembrance adopts a different form; it relies on the presence of authentic artifacts to overcome the psychological and cognitive distance that time, space, and experience engender between Holocaust victims and museum visitors.[16] The ritual of remembrance in the USHMM seeks to transform visitors into Holocaust witnesses who not only empathize but also identify with the victims.[17] The powerful presence of the Holocaust artifact in the USHMM thus replaces the language and gesture of traditional Jewish ritual as the evocative catalyst for sacred remembrance.

Walter Benjamin's canonical essay, "The Work of Art in the Age of Mechanical Reproduction," defines the power of authentic presence, or "aura," as the "unique existence" of a work of art "at the place where it happens to be." The aura, in short, is an object's "presence in time and space," and it emerges based on the fact that the object exists in an original, singular

state. It is for this reason, Benjamin explains, that the aura of the work of art "withers in the age of mechanical reproduction." An object's aura evokes, furthermore, due to its authentic presence and distinctive nature, "the unique phenomenon of a distance, however close it may be." Stephen Greenblatt picks up on this phenomenon of distance as well when he writes that the viewers' act of gazing, induced by wonder, isolates the object in question and shrouds it in a veil of silence and awed attention.[18]

Both Benjamin and Greenblatt describe art objects rather than artifacts in their discussions of aura and wonder, and important differences naturally exist between the two. The aura that Holocaust artifacts exhibit is not that of the artistic treasure, which reveals a unique genius or an exceptional level of craftsmanship. Rather, Holocaust artifacts exhibit a power that exudes tragedy and fatefulness. Despite obvious differences, art objects and Holocaust artifacts share essential characteristics that justify extending the concept of the aura from the former to the latter: in both cases the aura arises from the objects' unique presence in time and place and fulfills ritual functions. As previously noted, Holocaust artifacts in museums play a key role in the ritual of remembrance and depend on their provenance as authentic objects with ties to the sites and experiences of the Holocaust—they function, in short, as a trace. Art objects also rely on their unique "presence in time and space" and exhibit a ritual function—be it one that lies in the distant past. In Benjamin's words, "the earliest art works originated in the service of a ritual—first the magical, then the religious kind. It is significant that the existence of the work of art with reference to its aura is never entirely separated from its ritual function. In other words, the unique value of the 'authentic' work of art has its basis in ritual."[19] Art objects and Holocaust artifacts, therefore, exhibit a certain affinity, and the concept of aura may be extended to fateful objects as well as artistic masterpieces.

The authentic presence of Holocaust artifacts possesses, in addition, a sacred dimension that strengthens their efficacy within rituals of remembrance. Visitors tend to grow silent or at the very least to speak in hushed tones in the presence of certain artifacts—for example, before the exhibit of victims' shoes in the USHMM. This silence suggests a reverence before something sacred and reveals the assumption that Holocaust artifacts possess a quasi-religious significance. On the most basic level, this has to do with the common perception in contemporary culture that the Holocaust transcends ordinary historical experience and possesses a revelatory power.

*If holocaust is
sacred, its
artifacts
are sacred*

Artifacts bearing the traces of an event widely perceived as sacred are therefore themselves perceived as sacred.

Oren Baruch Stier addresses the sacred nature of Holocaust artifacts on another level as well. He argues that Holocaust artifacts may be read as "sacred relics, with all the symbolic impact such relics traditionally invoke. Their role as symbols, within particular contexts, may be structurally similar to religious symbolizations, especially in the meanings they generate." They resemble, Stier maintains, fetishes or totemic objects—items, in other words, that are "invested with religious significance." Stier's argument depends on a notion of the sacred as situational rather than essential. Holocaust artifacts may hold sacred meanings because they do so among those who engage with them, not because they are inherently sacred. These sacred meanings are generated, furthermore, through a series of concrete actions—namely, through the "dis- and re-placement" of artifacts as they are removed from their original settings and "re-placed" within memorial and museum environments, which sometimes exhibit a sacred aura themselves. Such environments highlight and enhance the artifacts' symbolism.[20]

Through their responses to an object's aura, visitors also play an essential role in creating sacred meanings. In the presence of an authentic object, museum visitors experience feelings such as awe, pity, empathy, and even identification. Often in the case of Holocaust artifacts, it is precisely the mundane nature of the objects that makes them poignant and capable of evoking such strong feelings. The intimate familiarity of a pair of wire-framed spectacles, a shaving brush and razor, and a crudely carved spoon combine with the viewers' knowledge of the objects' insurmountable strangeness—that is, the experiences to which they allude—to call forth a sense of the uncanny.

A "Terrible Immensity" of Authentic Objects

Authenticity imbues Holocaust artifacts with the power of presence and truth and grants them the metaphysical validity of a trace. Edward Linenthal reports that while on a trip to Europe with Michael Berenbaum in 1988, the USHMM exhibit designer Ralph Appelbaum was "stunned by how much material evidence of the Holocaust" remained etched "like scars" on the European landscape.[21] A scar is a trace of a past wound—a mark of damage

or harm that persists despite the passage of time and apparent healing—and is thus a particularly apt description for the traces of the Holocaust that mar Europe after World War II. In this sense of the word, a trace is a visible mark or object left behind that indicates the former presence of another object— such as a footprint in snow or a layer of rubble in the Warsaw Ghetto.

Artifacts that have been removed from their original environments and integrated into new, artificial environments such as in the USHMM may also act as traces, but in a different sense. In this case artifacts offer a bridge between the artificial site of memory in Washington, DC, and the authentic sites of memory in Poland, Germany, and Austria. Linenthal describes this bridge as "shrink[ing] the geographical distance . . . [making] permeable the boundaries between Holocaust and American space." The personal possessions of victims, for example, may act as traces by metaphysically embodying their former owners. These objects bear the scars of the past and offer museum visitors an otherwise inconceivable access to places and times that are, in the words of Walter Benjamin, "'somewhere beyond the reach of the intellect, and unmistakably present in some material object (or in the sensation which such an object arouses in us).'"[22]

The preference in the USHMM for authentic artifacts over reconstructions reflects more than a desire to bridge the distance between the contemporary United States and World War II Europe. Jeshajahu Weinberg, the first director of the USHMM and a driving force behind its creation, and Rina Elieli declare that a "recent upsurge in the activities of Holocaust deniers" was a major reason behind the decision to include in the permanent exhibition only "authentic material." Weinberg and Elieli explain that by drawing exclusively on authentic artifacts and photographs, with very few exceptions, "the Museum itself would constitute historical evidence of the Holocaust." In the rare case where this principle could not be followed, great pains were taken to preserve the overall commitment to authenticity. For example, certain large artifacts could not be brought to the USHMM, including the last fragment of the Warsaw Ghetto wall, the Auschwitz gate inscription "Arbeit Macht Frei," and a gas-chamber door from Majdanek. In these instances, a team of specialists traveled to Poland to make fiberglass castings of the objects so that the reconstructions would be as close to the originals as possible.[23]

The commitment to the principle of authenticity permeates the USHMM from its architecture in the Hall of Witness to the numerous

artifacts on display in the permanent exhibition. These range from concentration camp uniforms and prayer shawls to posters from DP (Displaced Persons') camps and telegrams from passengers on the SS *St. Louis*. To obtain the objects, a delegation of commission and museum staff members scoured Europe and brought back with them a wide variety of Holocaust artifacts from a number of sites, including former concentration camps and ghettos. Filling the museums' halls with authentic artifacts from the original sites, museum staff sought to transform the museum itself into a quasi-authentic site of the Holocaust.

The permanent exhibition of the USHMM displays a near veneration of authentic artifacts and echoes to a significant extent the display strategies of memorial museums like the Auschwitz-Birkenau Memorial Museum and the State Museum at Majdanek. Both the Auschwitz and Majdanek museums exhibit personal possessions that were plundered from victims upon their arrival in the camps, including utensils, shoes, eyeglasses, brushes, suitcases, Torah scrolls, and tefillin, as well as items that prisoners used every day, such as uniforms, wooden clogs, and bowls. Other artifacts on display include objects used by camp functionaries and tools used to torture and execute prisoners, such as helmets, boots, whips, clubs, Zyklon B canisters, and gallows. Especially disturbing is the display of urns, hair, and ashes—for example, in the Auschwitz-Birkenau Memorial Museum—which demonstrates the machinery of death within the camps. The USHMM, it should be noted, does not display actual human hair or remains.

Martin Smith, director of the exhibition department, and Ralph Appelbaum persuaded Jeshajahu Weinberg that the museum needed to acquire as many artifacts as possible for its permanent exhibition. Weinberg believed that the USHMM needed a "terrible immensity" of artifacts and a "Grand Canyon of memory, not just valleys."[24] Through its practice of accumulation, the museum imitates the archive. The artifacts on display are too numerous to list in their entirety, but a few examples include fence posts from Auschwitz-Birkenau, a hospital door from the Łódź Ghetto, a gate from the Tarnow Jewish cemetery in Poland, one of the milk cans used to preserve part of the Oneg Shabbat archive in the Warsaw Ghetto, and twenty Zyklon B cans—including actual Zyklon B crystals encased in a glass cylinder. Together, these artifacts compose a narrative of industrial killing, suffering, resistance, death, and survival.

Not only does the permanent exhibition reproduce the concentration camp museums' principle of displaying only authentic objects, it also partakes of what Jeffrey Feldman calls a "Holocaust museum aesthetic."[25] This "aesthetic," for lack of a better word, is characteristic of Holocaust museums like the State Museum of Auschwitz-Birkenau and consists of heaping up *stacks* the plundered possessions of victims into great mounds according to the *of object* type of object. This display technique had by the 1990s established a "canon *object* of Holocaust victims' objects," which commonly includes suitcases with name tags, shoes, eyeglasses, hairbrushes, letters, photographs, and clothing.[26] The State Museum of Auschwitz-Birkenau donated to the USHMM a number of such items, including nine kilograms of human hair (which is not on display) and the twenty Zyklon B cans mentioned earlier.[27] Many of these objects are displayed in small stacks in glass cases at the entrance to the USHMM's exhibit on concentration camps, which is located on the third floor.[28]

"We Are the Last Witnesses": The Shoe Exhibit in the USHMM

Entering one of the large tower spaces on the third floor of the USHMM, visitors encounter a vast and imposing collection of Holocaust victims' shoes on loan from the State Museum at Majdanek. The Majdanek museum possesses hundreds of thousands of shoes plundered from victims; because the Majdanek concentration camp also served as a storage facility for victims' possessions from other camps, the shoes currently on display there belonged to victims of the killing centers of Belzec, Sobibor, and Treblinka II as well as Majdanek. The shoes were discovered, along with other evidence of atrocities, by the Soviet army at liberation on July 24, 1944.

Arranged into two piles of unequal size on either side of the visitors' path, the shoes stand out in the open in a dimly lit space that is noticeably warmer than the rest of the permanent exhibition. While the shoes cannot be touched due to a simple railing, one cannot fail to perceive the musty smell of decaying leather. The ceiling and walls in this space, in contrast to other museum spaces, are of gray concrete. Blending together into a great mass, the shoes add to the permeating grayness of the room. The exhibit is simple and spare with minimal text, and the visitors' gaze moves seamlessly

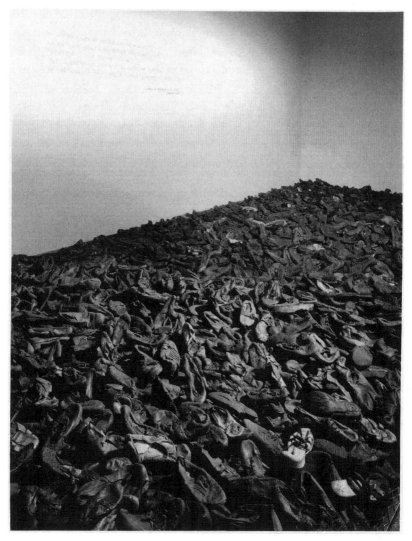

FIG. 5.1 Shoes confiscated from Majdanek prisoners, USHMM. © U.S. Holocaust Memorial Museum. Photograph by Edward Owen.

to the shoes without lingering on any framing devices. Such a presentation allows no distractions to surface between the viewers and the shoes—the effect is to pull visitors into the exhibit and to render invisible any reminders of the constructed nature of the display that might interfere with the viewers' engagement with the shoes themselves.

The visitors' initial experience of the shoes is therefore neither intellectual nor cognitive but rather sensory and visceral. The noticeable warmth of the room, the dim lighting, the smell of old leather, and the overwhelming visual impression of the two mountains of shoes are sufficiently strong that visitors first feel and then consider. Particularly significant is the number of shoes and their apparent similarity—the passage of time has worn down differences of color, shape, and material.[29] The way that the shoes are heaped together and the difficulty of distinguishing individual shoes from the mass reminds visitors of a photograph they saw at the very beginning of the permanent exhibition, immediately upon stepping out of the elevator: a large, back-lit, black-and-white photograph of a pile of human remains at the Ohrdruf concentration camp. In the background of the photograph stand a number of American soldiers and General Dwight Eisenhower; they are inspecting the carnage left behind by the Germans. Looking at this photograph, visitors identify with the soldiers' gaze and thus become witnesses to the evidence of the crimes as well as to the soldiers' own primary act of witnessing.

After this priming, the visual similarity of the shoes—particularly their multitude and anonymity—with the remains of the victims in the photograph is striking. The shoes resemble relics and signify metonymically for the final remains of the victims. Strengthening this connection is an excerpt from the third stanza of the poem "I Saw a Mountain," written by Yiddish poet Moishe Shulstein and inscribed on the wall above the shoes. Shulstein wrote this poem about what he calls the "Jewish shoes in Majdanek"—a fact revealed in the first stanza of the poem, which does not appear on the wall.[30] The featured portion of the poem reads as follows:

> We are the shoes, we are the last witnesses.
> We are shoes from grandchildren and grandfathers,
> From Prague, Paris and Amsterdam,
> And because we are only made of fabric and leather
> And not of blood and flesh, each one of us avoided the hellfire.

"I Saw a Mountain" appears twice, in Yiddish and English, on opposite walls of the exhibit. Through the poem the shoes speak to us, the viewers, with a collective human voice. The words encourage us to see the shoes as material witnesses bearing testimony to the suffering of the victims. Their aura of genuine presence and the traces they bear of their former owners,

empty shoes *evoke nostalgia + loss*

who wore them and touched them and held them in their hands, evokes empathy. As the recipient of the shoes' poetic testimony, visitors become witnesses to the witnesses—a secondary witnessing that mirrors the visitors' encounter with the Ohrdruf photograph.

Paul Celan famously declares in his poem "Ash-Aureole" ("Aschenglorie"): "No one bears witness for the witness" ("Niemand / zeugt für den / Zeugen").[31] These words speak to the solitude of the witness, who bears the burden of testimony in isolation. The *appointment* to bear witness," however, as Shoshana Felman argues, is an "appointment to transgress the confines of that isolated stance, to speak *for* others and *to* others." Celan extends this ability of the witness to speak not only for others but to others as well in his acceptance speech for the Bremen Literature Prize in 1958. In this speech Celan describes a poem as "essentially dialogue" that "can be a message in a bottle, sent out in the—not always greatly hopeful—belief that somewhere and sometime it could wash up on land, on heartland perhaps. Poems in this sense too are underway: they are making toward something. Toward what? Toward something standing open, occupiable, perhaps toward an addressable Thou, toward an addressable reality."[32] The victims' shoes, together with Shulstein's "I Saw a Mountain," act in just this way as they seek a living witness for the "last witnesses." Visitors themselves may thus become the hoped-for and sought after "addressable Thou."

The display strategy in the shoe exhibit hinges on the power of the shoes' concrete presence in time and space. This power bridges the gap between viewers and victims and thereby evokes empathy and transforms viewers into witnesses. The shoes, however, in contrast to those displayed in the State Museum at Majdanek, have been subjected to what Stier describes as a displacement on two levels, by virtue of the fact that they have been removed from their original environments and placed into a new setting. One might argue, as does Linenthal, that these artifacts are "domesticated" and rendered "'safer' to view" due to such displacement.[33] This possibility raises the question of whether the shoes in the USHMM are therefore in some sense "less authentic" than the shoes in Majdanek. Is an object authentic on its own terms—that is, measured purely in terms of the object itself, or is authenticity a question of resonance between an artifact and its environment as well? Is the display of shoes at the State Museum at Majdanek significantly more powerful than its admittedly diminished echo in the USHMM thanks not only to the former's comparatively vast size (filling

one of the barracks) but also to the method of its presentation—to the fact that the shoes at Majdanek are exhibited in what appear to be the very wire cages that held them before liberation?[34]

Omer Bartov confronts this question when he decries the USHMM's fixation on artifacts as creating a "false sense of reality" and in effect "trivializing the genocide." Bartov suggests that the quality of authenticity does not lie in the provenance of an artifact but rather hangs on the question of whether or not the artifact teaches us something about the reality of the Holocaust:

> Walking through a clean, somewhat rickety freight car, staring at a pile of old shoes, inspecting the symmetrical wooden bunks of a concentration camp . . . does not bring us "closer" to the filth and stench, brutality and fear, death and cruelty which were the Holocaust; it makes us merely empathize with what is *not* the thing itself, but merely its nicely reordered reproduction. These "authentic" artifacts are no more related to the reality of the Holocaust than are the reconstituted Puritan settlements in New England. . . . The similarity is as deceptive (and heart-wrenching) as is that between a busy barber shop and the mounds of rotting victims' hair in the museum's cellars.[35]

(criticism)

In Bartov's estimation the strategy of displaying authentic artifacts to create an affective connection between viewers and victims and to bridge the distance between "there" and "here," "then" and "now," fails, and museum visitors remain alienated from the events of the Holocaust.

The shoe exhibit, however, is problematic for another reason—namely, that it relies on metonymy for its display strategy, which carries serious implications in terms of Holocaust remembrance. Even more alarming than the possibility of a display failing in its efforts to bring the Holocaust "closer" is a display that, paradoxically, succeeds too well and thereby perpetuates the illusion that by accumulating enough authentic evidence, an exhibit can make the Holocaust "knowable." Elie Wiesel writes in this regard, "Ask any survivor, he will tell you; he who has not lived the event will never know it. And he who went through it, will not reveal it—not really, not entirely." The ostensible purpose of the USHMM commission and staff members' efforts to locate and bring back to the museum vast amounts of authentic artifacts was, as Linenthal reports, to "collect artifactual material that imported the material reality of the Holocaust into the United States."[36] If the "material reality" of the Holocaust can be packed into boxes and imported, like

a collection of precious objects carefully arranged on a bed of Styrofoam peanuts, the following questions spring to mind: In what sense are these objects "reality"? Why do we perceive them as such? How does the way we perceive them affect how we remember?

Metonymy, simply defined, is the process by which one entity refers to another related entity. Metonymic concepts, as George Lakoff and Mark Johnson have shown, are grounded in real-life experiences; they "structure not just our language but our thoughts, attitudes, and actions." The tradition of portrait photography, for example, is based on metonymy, and we engage in metonymic thinking and understanding whenever we perceive people in terms of their face.[37]

The shoe exhibit echoes on a smaller scale the overall strategy of presentation in the USHMM's permanent exhibition. Authentic artifacts act as metonymic fragments brought together in the hopes of creating a coherent vision of the past that is accessible and comprehensible. Like multicolored pieces of stone or tile that create a meaningful mosaic, the exhibition promises that in the end it will yield a complete and intelligible narrative. This perpetuates the illusion that a direct relationship exists between what one sees in the museum and what the objects and images represent. The permanent exhibition suggests, in other words, that the Holocaust can be presented in a coherent way and made comprehensible if enough evidence is collected and put on display—an idea without credence in contemporary Holocaust remembrance scholarship. If the past is a foreign country, to quote L. P. Hartley's famous words, then the Holocaust remains terra incognita. Elie Wiesel, well known for his declarations that the Holocaust is a mysterious realm knowable only to the witnesses (that is, to the survivors and victims), addresses exactly this point when he writes, "The truth of Auschwitz remains hidden in its ashes. Only those who lived it in their flesh and in their minds can possibly transform their experience into knowledge. Others, despite their best intentions, can never do so."[38] The mystery of the Holocaust, Wiesel concludes, "is doomed to remain intact."[39]

The permanent exhibition in the USHMM, however, attempts to bridge this chasm between what one sees and knows about the Holocaust and the unknowable depths of the victims' experiences. An excess of evidence presumes to fill the void. As Thomas Laqueur convincingly concludes, "the history of the Holocaust probably is not like any other history. Indeed, the museum [the USHMM] is predicated on the idea that it is not. And yet it is

designed to say that with enough objects, linearly arranged, the ineffable is made manifest. . . . The thousands of pictures and objects in the Holocaust Museum are all there as if they could speak clearly, manifestly—as if there were no depths. In Washington, a plenum claims to speak for loss."[40]

The presentation of artifacts leads to another problem: piles of authentic artifacts, particularly the former possessions of victims, signify metonymically for the remains of the victims themselves. The USHMM's shoe exhibit as well as displays of artifacts on loan from the Auschwitz-Birkenau Memorial Museum, including toothbrushes, hairbrushes, shoe daubers, and scissors, illustrate this principle. Gazing at heaps of objects, displayed according to type and en masse, we glimpse in them the traces of their former owners. Repeatedly seeing photographs of human remains stacked in mass graves or on funeral pyres, museum visitors begin to perceive the piles of objects as the tortured remains of the victims themselves. Above all, these artifacts testify to the Germans' cruel method of processing their victims as objects. Metonymic representation contributes unwittingly to the further dehumanization of victims by reducing them to a heap of indistinguishable, anonymous objects.

A brief comparison of the shoe exhibit at the USHMM with the shoe exhibit at Yad Vashem reveals to what extent placement and presentation strategies affect perception. Yad Vashem's minimalistic shoe display appears in the museum's fifth gallery, which focuses on the Warsaw Ghetto uprising and Auschwitz-Birkenau. The shoes on display lie in a glass case that is divided into four panels and has been installed into the floor in the center of a spacious, open room. Visitors walk directly on the glass and thus over the shoes. The shoes are not labeled; this display relies on the fact that most visitors to Yad Vashem will be familiar with the infamous heaps of shoes discovered in extermination and concentration camps.

By means of its unusual placement, Yad Vashem's shoe display instantly draws the viewers' attention to the fact of presentation itself; instead of encouraging viewers to look past the framing of objects and to focus exclusively on the objects themselves, as in the USHMM's shoe exhibit, the viewers at Yad Vashem first note the startling presentation and only then contemplate the shoes. This strategy establishes distance between the gazer and the gazed-upon artifact. With a seemingly paradoxical gesture, Yad Vashem both frames the shoes behind glass like precious objects and places them underfoot, a choice that undermines and throws into doubt the

preciousness of the shoes. After all, what sacred objects are placed in such a way that visitors may stroll over them as though they were simply part of the floor? Visitors do not hesitate to stride back and forth over the shoes; after a few glances, the display becomes simply part of the space to be crossed on the way to the next exhibit. In contrast to the shoes in the USHMM, which are humanized, granted voices, and presented as sacred Holocaust witnesses, the shoes in Yad Vashem are buried and their internment is exposed to every passing eye—thereby rendering them both mundane and extraordinary.

Desecrated Torah Ark

One of the most powerful and visually impressive displays in the USHMM's permanent exhibition appears in its fourth-floor segment, devoted to the series of state-sanctioned, Nazi-instigated pogroms against Jews that took place November 9–10, 1938. The Nazis cynically called the night of November 9 "Kristallnacht"—the Night of Broken Glass. Primarily known for the destruction of Jewish property and, above all, of synagogues, Kristallnacht also had its fatalities: ninety-one Jews were killed and more than thirty thousand Jews were arrested and sent to concentration camps, among whom as many as one thousand were murdered. During the pogroms, sites and objects of sacred significance for Jews were particularly singled out for destruction: hundreds of synagogues were set on fire by storm troopers or smashed to pieces with hammers and axes; Torah scrolls and prayer books were desecrated, torn, stomped on, and burned; Torah arks were defiled and damaged; and in the Jewish cemetery in Leipzig (a city where three synagogues were set aflame), vandals went so far as to violate graves and uproot tombstones.[41] Tens of thousands of Jewish businesses and homes were attacked by Nazi officers, SS men, and rioters. As historians have pointed out, Kristallnacht marked a major turning point in National Socialist policy toward the Jews and was an important step leading to the later implementation of the "Final Solution."[42]

The USHMM's exhibit emphasizes the fact that the perpetrators of Kristallnacht directed their fury in particular against sacred Jewish sites and objects. In addition to various images of the havoc and ruins left in Kristallnacht's wake, which appear on video monitors, the exhibit displays two large black-and-white photo murals of the Alte Synagoge (Old

FIG. 5.2 The damaged lintel above a Torah ark from a synagogue in Nentershausen, Germany, which was destroyed during Kristallnacht. The damaged Hebrew verse on the lintel reads, "Know before whom you stand." © U.S. Holocaust Memorial Museum. Courtesy of Jüdisches Museum der Stadt Frankfurt.

Synagogue) in Essen, designed by Edmund Körner and completed in 1913. The synagogue's forecourt, which is flanked by covered passages, echoes the former courts of the Temple of Jerusalem.[43] One of the two photo murals of the Essen synagogue portrays the synagogue before Kristallnacht in all its beauty and splendor, with a magnificent interior. The second photo mural reveals the synagogue after it was attacked, plundered, and burned. Although its internal spaces were devastated and ruined, the external structure of the synagogue survived intact. Also on display in the Kristallnacht exhibit are a defaced Torah ark from a synagogue in Nentershausen and desecrated Torah scrolls from synagogues in Marburg and Vienna, enclosed in a glass case.[44] Both the ark and the scrolls were damaged during that fateful night of November 9.

A Torah ark (*aron ha-kodesh*) is a sacred cabinet that holds a synagogue's Torah scrolls. Within the synagogue the ark should be placed at one end

so that it faces the entrance and is turned in the direction of Jerusalem (for example, placed along the eastern wall) so that Jews engaged in prayer before the ark will also face the holy city. During the Middle Ages, Torah ark designers modeled the arks after the tabernacle that the Israelites built during their forty-year sojourn in the desert, following the exodus from Egypt and before reaching the promised land. A kind of mobile tent or sanctuary, the tabernacle was used by the Israelites for worship and sacrifice. Detailed instructions for building the tabernacle, given by God and passed on by Moses to the Israelites, appear in the book of Exodus. The purpose of the tabernacle, as described in Exodus 25:1–8, is to provide a sanctuary where God and the Israelites may meet: "The LORD spoke to Moses, saying: . . . And let them make Me a sanctuary that I may dwell among them. Exactly as I show you—the pattern of the Tabernacle and the pattern of all its furnishings—so shall you make it."

Protected within an inward-slanting glass case, the Torah ark in the USHMM's Kristallnacht exhibit stands next to the photo mural of the ruined Alte Synagoge. Gazing at the damaged lintel of the ark, visitors may see how repeated strokes of an ax bit into the wood with deep, angry cuts. Standing before the ark, visitors witness the violence and brute force required to make such profound wounds, which disfigure the following words inscribed in Hebrew on the lintel: "Know before whom you stand" (da lif'nei mi attah omed). These words are often inscribed on Torah ark lintels, including the ark in Essen's Alte Synagoge. The exhibit's photo mural testifies to the fact that even after the Alte Synagoge had been ravaged and violated, its once gorgeous interior reduced to ashes and rubble and its sanctity defiled, the ark's lintel survived and continued to proclaim its message: "Know before whom you stand."

The words "know before whom you stand" come from the Talmud, specifically, from Seder Zera'im, tractate Berakhot (Benedictions). The passage in which these words appear reads as follows: "Our Rabbis taught: When R[abbi] Eliezer fell ill, his disciples went in to visit him. They said to him: Master, teach us the paths of life so that we may through them win the life of the future world. He said to them: Be solicitous for the honour of your colleagues, and keep your children from meditation, and set them between the knees of scholars, and when you pray know before whom you are standing and in this way you will win the future world."[45]

Abraham Joshua Heschel explains that benedictions such as this one appear in the present tense because they are spoken before an eternally

present God. The universal and constant presence of God thus under-
lies the meaning of the lintel's message. In Heschel's words, "What are all
prophetic utterance if not an expression of God's anxiety for man and His
concern with man's integrity? A reminder of God's stake in human life; a
reminder that there is no privacy? No one can conceal himself, no one can
be out of His sight. . . . Living is not a private affair of the individual. Living
is what man does with God's time, what man does with God's world."[46]

Inscribed into the Torah ark's lintel, the words "know before whom you
stand" exhort those who appear before the ark in prayer to show reverence.
But they also admonish all those present to remember that they are always
in the presence of God. All *mitzvot* (commandments), Heschel explains,
"are means of evoking in us the awareness of living in the neighborhood of
God. . . . They call to mind the inconspicuous mystery of things and acts,
and are reminders of our being the stewards, rather than the landlords of
the universe; reminders of the fact that man does not live in a spiritual wil-
derness, that *every act* of man is an encounter of the human and the holy.
All mitzvot first of all express reverence. They are indications of our aware-
ness of God's eternal presence, celebrating His presence in action." "Know
before whom you stand" thus goes to the very heart of one of the essential
questions of Judaism: "How must man, a being who is in essence the like-
ness of God, think, feel and act? How can he live in a way compatible with
the presence of God?"[47] Given the import of the words inscribed on the lin-
tel and their deep significance in Judaism, the mutilated wood and blotted
out letters demonstrate an attempt not only to extinguish Jewish life but to
erase all traces of Jewish belief and tradition as well. The anger and hatred
that erupted in Kristallnacht appear here in tactile form; the lintel literally
bears the traces of that night and viewers react to it viscerally. If permitted,
we might run our fingers over the scarred, splintered wood and touch the
damage left by the ax.

Visibly shaken by the palpable rage captured in the traces of the cuts,
many visitors pause longer than usual before this ark. The Torah ark
exudes an aura of fatefulness; it appears before us as a witness to the atroc-
ities of Kristallnacht—a witness still bearing its wounds. Standing before
the ark, visitors become witnesses as well; the act of destruction appears
to be taking place before their very eyes—this is the power of the trace,
which can revive the past and, as Greenblatt memorably puts it, evoke the
wonder that "blocks out all circumambient images, stills all murmuring

voices."[48] Like the synagogue congregants who once faced this ark in reverent prayer and who strove to live in accordance with these words, and the vandals who stood defiantly before it while committing sacrilege, it is now the museum visitors' turn to appear before the ark as witnesses to both these histories. It is the visitors to whom the admonishing words of Rabbi Eliezer ("know before whom you are standing and in this way you will win the future world") are now directed and to whom the responsibility of memory falls—not only for the sake of the victims but—as Rabbi Eliezer points out—for the sake of the future. In this case, it is the assault on Judaism itself, on Jewish religious tradition and practice that demands to be remembered.

The USHMM's Authentic Railway Car

On the third-floor entrance to the museum's permanent exhibit on deportations, the USHMM's authentic German railway car, courtesy of the Polish government, is the star artifact of the *Final Solution, 1940–1945* section. The railway car is surrounded by large-format black-and-white photographs of deportations and of the assembled deportees who have just arrived at concentration camps. Although visitors may walk around and thus avoid the railway car if they choose, the layout of the museum space encourages visitors to pass through if they do not want to miss part of the exhibit. Although this specific railway car was not necessarily used for deportations, as the exhibit carefully points out, it is authentic in the sense that it is a German railway car from the World War II period and was one of the types of railway cars used for deportations.[49]

Edward Linenthal tells a fascinating anecdote in which he relates that the Polish government spruced up the railcar with a fresh coat of red paint before shipping it off to the United States, clearly having missed the point that the USHMM wanted the railcar precisely because it looked authentic when spotted in a Warsaw depot by Jacek Nowakowski, Martin Smith, and Ralph Appelbaum.[50] The new layer of paint, along with eight other layers, were subsequently removed, and the car was restored to its original appearance.[51] The railcar now appears convincingly discolored and appropriately worn for a World War II artifact, with its reddish-brown facade revealing patches of unevenly faded wood.

As visitors approach the railway car, the ground drops away over a large open space to the left, separated by railings. At the bottom of this space are authentic railroad tracks from Treblinka, and sitting on the tracks is the railway car. Lying around the tracks are suitcases—artifacts from the Auschwitz-Birkenau Memorial Museum. The luggage is scattered about as if discarded in a hurry, suggesting a reconstructed environment. Visitors may even read a few of the names on the suitcases, for example, Ilse Knapp and Frieda Fischl. These names, marked clearly in large letters, reveal the calculating deceit of the perpetrators and the piteous hope of the deportees, who were misled into believing that they would be permitted to reclaim their belongings later. For this visitor, at least, the labeled suitcases with their personal names and hope for the future presented the most poignant aspect of the railcar exhibit.

Upon entering the narrow train car, visitors may examine in close proximity the wooden planks and the thin cracks between them that served as the only, insufficient source of oxygen. They may imagine the extreme temperatures, suffocation, and crowding that the deportees suffered during their long journey. Although railings within the car itself set up clear boundaries for the visitors' experience, and visitors may not actually walk on the wooden floor but rather on a sheet of metal, this railway car is open and accessible, in contrast to Yad Vashem's *Memorial to the Deportees*, which is discussed in the next chapter. Similar to the shoe exhibit, the railway car first impresses visitors on the sensory level and, again like the shoes, through the sense of smell. Here, it is the faintly stuffy, not unpleasant odor of old wood that creates a visceral impact.

We first encounter objects, Eilean Hooper-Greenhill explains, through our senses and bodies, and we initially learn from objects tacitly—on an emotional, reactive level. Our response to objects on this level, she maintains, remains largely unarticulated.[52] In the case of the USHMM's railway car, the presentation of the car and the emphasis placed on its authenticity—namely, the description of the car's provenance, the train tracks from Treblinka, and the scattered, labeled suitcases, forges an affective connection between visitors and victims based on empathy and even identification. The display suggests that visitors may now imagine what the victims experienced by virtue of the fact that they have walked through this space and have been transformed into vicarious witnesses. There is no reason to lead visitors on a stroll through the railway car other than to encourage such a leap

of imagination, and although it is of course absurd to suggest that spending a few moments by choice within a clean, uncrowded, and well-ventilated railway car can help visitors imagine the suffering of deportation victims, it is precisely such a conceit that underlies many reconstructed environments in museums.

The railway car exhibit is presented to help museum visitors feel empathy with the victims. This in turn should encourage visitors to seek a deeper understanding of the past and to dedicate themselves to remembrance. As an affective experience that is, as Dominick LaCapra argues, "bound up with a transferential relation to the past," empathy is "arguably an affective aspect of understanding which both limits objectification and exposes the self to involvement or implication in the past, its actors, and victims." An experience of empathy, however, may be sufficiently powerful that it encourages the illusion and self-deception of full identification with victims. The desirable degree of empathy, LaCapra suggests, "involves not full identification but what might be termed empathic unsettlement in the face of traumatic limit events, their perpetrators, and their victims."[53] Empathic unsettlement allows viewers to become emotionally involved with the past and to feel implicated in that past so that they may develop feelings of responsibility in terms of preventing another genocide in the future.

The shoe exhibit, desecrated Torah ark, and railway car exhibit seek to bridge the gap in time, space, and experience that exists between victims and museum visitors. They do this by emphasizing the authenticity and aura of the objects and thereby forging an affective connection based on empathy and identification. Such exhibits seek to transform passive spectators into involved and concerned Holocaust witnesses. But some of the techniques used in the service of this goal are problematic. As seen in the examples of Bergner's *Flying Spice Box* and Richter's *The Lublin Railway Station* as well as in the shoe exhibit, artists and museum curators often anthropomorphize objects and artifacts and use them to refer symbolically or metonymically to Holocaust victims. The inherent flaw of such a strategy—particularly when metonymy is the presentation technique of choice—is that such presentation further objectifies and dehumanizes the victims in our memory. Standing before a great heap of shoes, visitors remember the victims in the very state to which they were reduced by their oppressors—as objects themselves to be processed and discarded. Furthermore, the technique of amassing vast amounts of artifacts in an effort to create a coherent narrative

of the Holocaust and to stave off Holocaust deniers is also fraught with difficulties: such an approach can perpetuate an illusion of comprehensibility and threatens to fill in the gaps of knowledge with an excess of objects.

An Alternative Approach to Artifacts: The Jewish Museum Berlin and Yad Vashem

The Jewish Museum Berlin avoids the display technique of metonymy, although it does display a number of authentic artifacts in its exhibits. In an interview with Jason Oddy, Daniel Libeskind explains why the USHMM's exhibition strategy would not work in the Jewish Museum Berlin: "The Void is a physical space which is part of the city, and it is also a reminder that however many objects you bring to the Museum, however many stories you tell in the Museum, essentially the only way to connect with Berlin is across the Void."[54] True to this idea, the Jewish Museum Berlin does not attempt to fill the void with an immensity of artifacts, nor does it try to assemble enough fragments to piece together what appears to be a comprehensive narrative. The vast majority of artifacts on display in the Jewish Museum Berlin are personal possessions of Jewish victims; displays, furthermore, are careful to identify by name the persons to whom the artifacts once belonged.

Holocaust artifacts appear in the Jewish Museum Berlin in two spaces: first, in the Axis of the Holocaust and the Axis of Exile; and second, in the permanent exhibition's Holocaust segment. All objects on display in the axes were once owned by Jewish Germans—there are no reconstructions or replicas. Loaned or donated to the museum by survivors or by the families of victims, these items are now displayed in a series of glass cases in such a way that each object receives the full weight of the viewers' attention. Each glass display case holds only a few selected objects, and, most important, objects are accompanied by the names and histories of their former owners so that each artifact is granted an individual identity. Artifacts thus contribute to an ambitious battle being waged in the museum as a whole against anonymity. Although more modest than Yad Vashem's *Hall of Names*, the approach to Holocaust remembrance in the axes is similar through its focus on restoring to those lost individuals—both the dead and exiled—a presence through identity.

Exhibits in the axes, furthermore, frame their objects to highlight their special status as traces. For example, objects are carefully arranged so that a respectful space is preserved around each item, and the fate of each individual offers a dramatic narrative deserving undivided attention. Descriptions of objects are phrased to emphasize their aura of having once been the treasured possessions of victims. For example, the description of a handkerchief in one of the glass display cases states that not only did the handkerchief belong to a German Jew preparing to go into exile but that it is still folded today exactly as the mother folded it for her son before she placed it into his suitcase. The son never took his suitcase, never unfolded the handkerchief; the aura of the handkerchief arises from the fact that no hand has unfolded it since—it waits, intact, for her son. Here at last is the personal, elegiac tone that was missing in the USHMM's artifact displays.

Many of the objects in the Jewish Museum Berlin's axes testify to the emotional bond that tied German Jews to German culture and language. This choice of objects contributes to the museum's overall narrative of a long and often mutually beneficial relationship between German Jews and Germany. For example, in the Axis of Exile there appears in one glass case an emigration pack containing works of Goethe and Gabriele Reuter, which a German Jew took with him to Palestine. Even when driven from his homeland, this Jewish man included among his most treasured possessions volumes of German letters. This display thus testifies to the strength of the German-Jewish bond that survives even a cataclysm like the Holocaust.

Among the multitude of objects displayed in the axes, the most common are those of an expressly personal nature that exhibit proper names: self-portraits, letters, family photographs, and postcards, for example. Everyday objects appear as well, including a sewing machine, a typewriter, a pocket watch, a porcelain coffee set, walking sticks, and a violin. More unusual and fateful objects include an anonymous letter written in 1943, in which a German denounces to the Gestapo a Jewish woman who is hiding in her building, and a purse that fell off a deportation transport. Most of the objects displayed, however, reveal glimpses into the normalcy of German Jews' lives before World War II. They unveil to us a multitude of lost worlds and offer a tribute to the victims' lives rather than to their deaths.

Displays in both the Axis of the Holocaust and the Axis of Exile, furthermore, tell personal stories. One display in the Axis of the Holocaust, for example, tells the story of Steffi Messerschmidt, a singer and accordionist

from Berlin, who died in Auschwitz. A second display focuses on the life of Charlotte Ochs and includes a number of photographs of her as a young girl and a woman, as well as her last letters to her children before she died in Theresienstadt. In a third case appears a collection of candy bowls, a menorah, and Torah scrolls that belonged to members of the Jacobsohn family, who were later killed in Łódź. Beside the objects appears a photograph of the family store now hung with swastika flags, having been appropriated by supporters of the Nazi regime once the rightful owners had been deported. This photograph acts as a reminder of a fact that is otherwise not given much attention in the Jewish Museum Berlin; namely, that individual German citizens as well as the Nazi regime profited financially during the years of the Third Reich by stealing vast amounts of Jewish property and possessions. Thus not only did the Germans murder, they also inherited—an act famously condemned in I Kings 21:18–19, when God says to Elijah: "Arise, go down to meet Ahab king of Israel, which *is* in Samaria: behold, *he is* in the vineyard of Naboth, whither he is gone down to possess it. And thou shalt speak unto him, saying, Thus saith the LORD, Hast thou killed, and also taken possession? And thou shalt speak unto him, saying, Thus saith the LORD, In the place where dogs licked the blood of Naboth shall dogs lick thy blood, even thine."

The Axis of Exile tells personal stories as well: here, visitors can look at photographs of the Berlin family Naftalies, whose son Manfred was sent on a *Kindertransport* (Children's Transport) to England and became the family's sole survivor after the rest of his family died in Auschwitz. The majority of the Jewish Museum Berlin's authentic artifacts appear in the axes. A few artifacts are displayed in the permanent exhibition's display on the Holocaust as well, including objects discovered in Belower Wald, a forest through which prisoners from Sachsenhausen were driven on a death march. Ordinary objects, such as utensils, which were dropped or abandoned by prisoners appear particularly significant, as if they might communicate a last message from the victims. The museum also exhibits a few objects that directly reference victims' experiences in concentration camps and ghettos, including a blanket from Bergen-Belsen, a letter from Auschwitz, and money from the Theresienstadt Ghetto.

Through its display of artifacts, the Jewish Museum Berlin reveals a surprising affinity with Yad Vashem. Although Avner Shalev (chief curator and director of Yad Vashem) declared authenticity—"a rich, three-dimensional

authenticity, anchored in artifacts and bracketed by photographs, documents, texts, and contemporaneous artwork"—to be the "calling card" of the museum's permanent exhibition, Yad Vashem's artifacts serve a greater purpose that transcends the ability to provide evidence. In Shalev's words, "the artifact was to be a means of personification. Looking at the crumbling eyeglasses that Tula Meltzer's mother handed her as they stood in the 'selection' at Birkenau, while listening to Tula's testimony, visitors gain insight into the intensity of family relations."[55]

Artifacts in Yad Vashem, therefore, are meant to serve a purpose similar to that displayed in the axes of the Jewish Museum Berlin. These objects seek to restore names and identities to anonymous victims and to counteract the abstraction of six million with the stories of individuals. Like the Jewish Museum Berlin, furthermore, and in contrast to the USHMM, Yad Vashem assiduously avoids stacking up objects—such as victims' personal possessions—in a way that might metonymically suggest the remnants of victims. Together, the Jewish Museum Berlin and Yad Vashem demonstrate an alternative method for displaying artifacts that renounces the USHMM's "terrible immensity" and "Grand Canyon of memory."

Authentic artifacts in the USHMM claim to be the remnants and remains of the Holocaust and—at times—suggest the Holocaust victims themselves. The sheer quantity and excess of collected objects in the permanent exhibition resembles a chorus of raised voices proclaiming the authenticity of the museum's narrative, recalling the lines, "We are the shoes, we are the last witnesses." The danger of such a strategy lies in the fact that by claiming to offer the remnants of the past to the spectator, the museum creates the illusion of also offering a comprehensive narrative of the past. It suggests that if enough details and fragments are collected and displayed, a coherent truth concerning the past will emerge, visible and knowable. The USHMM's permanent exhibition attempts, in other words, to archive the unarchivable—it shows too much, and ends up silencing the elegiac tone one expects and hopes for in a Holocaust museum.

The overwhelming proliferation of authentic artifacts in the USHMM has led some critics to challenge the very idea that artifacts can bring us closer to the Holocaust. They argue that due to the constructed and artificial nature of the artifacts' presentation in a museum, their presence is inherently false. Quatremère de Quincy, art historian and reigning figure of the Académie des Beaux-Arts from 1816 to 1839, for example, as Didier

Maleuvre demonstrates, claimed that removing an object from its natural historical context and placing it into the new, artificial context of a museum exhibition meant "wrenching the past away from itself, dismembering and classifying it" in such a way that the object became "inauthentic."[56] Are all displays of artifacts doomed to such a fate? Or can artifacts like those on display in Yad Vashem and in the axes of the Jewish Museum Berlin, for example, triumph over such inauthenticity by helping to restore to victims their identities and a hint of the richness of their lives?

A final issue to consider is the question of whether it is ethical to display Holocaust artifacts that encourage viewers to remember the victims through the implements of their destruction as well as through their mortal remains. Is this necessary to present a true historical picture? Or does it merely take us one chilling step further in the direction of a cabinet of macabre curiosities? For example, the display of Zyklon B cans and crystals in the USHMM may demonstrate important facts about the implementation of the "Final Solution" and the methods of its factory-like efficiency, but it also risks creating a form of remembrance that is transmitted through a series of gruesome and dehumanizing images.

James E. Young has expressed his doubt about the value of collecting and exhibiting victims' possessions in Holocaust museums for the reason that they "in a perversely ironic twist . . . force us to recall the victims as the Germans have remembered them to us: in the collected debris of a destroyed civilization." If we agree with Young that it may be the "ultimate travesty" that "a murdered people remains known in Holocaust museums anywhere by their scattered belongings, and not by their spiritual works, that their lives should be recalled primarily through the images of their death," can we really justify—even for the sake of historical accuracy—encouraging a remembrance based on the very objects and tools that reduced the victims to the ignominious state in which we constantly encounter them in photographs and video footage?[57] Exhibits in Yad Vashem and the Jewish Museum Berlin show us that it is possible to display Holocaust artifacts in a way that does not reduce the victims to the symbols of their deaths but rather uses artifacts to enrich the narratives of victims' lives and to renounce an aesthetic that further objectifies and dehumanizes them.

Underlying the presentation of authentic artifacts in Holocaust museums and exhibits is the concept that there is nothing so sacred in Holocaust remembrance as the testimony of a witness. As Elie Wiesel counsels, "Let

us tell tales so as not to allow the executioner to have the last word. The last word belongs to the victim. It is up to the witness to capture it, shape it, transmit it and still keep it as a secret, and then communicate that secret to others. The difficulty lies in the transmission." Holocaust museums and exhibits take on this difficult task of transmission on a grand scale; they must find ways to reach out to museum visitors and involve them directly in remembrance, transforming them from passive spectators and even voyeurs into empathetic participants of the unfolding narrative. They must do this, furthermore, without betraying the "last word" or "secret" of the victims, that is, without showing "too much"—for even the survivor, as quoted earlier, "who went through it, will not reveal it—not really, not entirely. Between his memory and its reflection there is a wall—and it cannot be pierced."[58]

The USHMM's preferred method for communicating what Wiesel calls the "last word" and the "secret," that is, the personal testimony of the victims, is to bridge the gap in time, space, and experience through artifacts. The artifacts' aura of unique presence should allow visitors to "touch the Holocaust" and to empathize, perhaps even identify with, the victims. Framing artifacts as the last witnesses to the atrocities of the Holocaust, the USHMM seeks to initiate visitors into a way of seeing that turns them into vicarious witnesses. If the USHMM's abundance of evidence and metonymic strategy of presentation ultimately threaten to "pierce the wall," and if its exhibition succumbs to the illusion that what we see mimetically reproduces the "truth" of the Holocaust—that an excess of objects can fill unknowable depths—then we might pose the following question: what strategies of representation can museums and memorials draw on to avoid such risks? The following chapter explores select memorials and exhibits at Yad Vashem and the Jewish Museum Berlin, namely, *String*, the *Memorial to the Deportees*, and *Menora*, which demonstrate just such a type of representation—a unique method drawing on a postmodern technique called disfiguration.

6 ⇥ REFIGURING THE SACRED
Strategies of Disfiguration in *String*, the *Memorial to the Deportees*, and *Menora*

We have seen that Holocaust museums and exhibits draw on a number of unique framing and display strategies to evoke particular kinds of vision and remembrance. One technique not yet discussed—and one of the more unusual strategies for encouraging a critical encounter with symbols of Holocaust remembrance—is the disfiguration of memorial objects or images. Drawing on aesthetic techniques indicative of a postmodern sensibility, disfiguration also helps to prevent the monumentalization of Holocaust memory. In contrast to chapters 4 and 5, which broadly examine objects, images, and display techniques, this chapter focuses exclusively on disfiguration as it appears in three exhibits: *String*, a video installation at Yad Vashem; the *Memorial to the Deportees*, an outdoor memorial at Yad Vashem; and *Menora*, a video sculpture in the Jewish Museum Berlin.[1]

Any contemporary discussion of alternative memorials—that is, memorials that deviate in their form and aesthetics from traditional memorial strategies—draws on the work of James E. Young, whose studies of Holocaust memorials in Germany describe a new kind of Holocaust monument—the countermonument.[2] Countermonuments call into question the memorializing work that monuments normally undertake. While Young's work on countermonuments lays the groundwork for the current discussion, above all by providing a basic conceptual framework with which to view and analyze how certain monuments deviate from more conventional memorial spaces, the concept of disfiguration used here ventures into

new territory, with a focus on how sacred meaning emerges from particular aesthetic strategies.

Holocaust Representation, Postmodern Aesthetics, and Sacred Meaning

Both Yad Vashem and the Jewish Museum Berlin turn to methods of disfiguration to dismantle traditional, modernist visual habits and to evoke new and even sacred ways of seeing and remembering. A problem for all Holocaust museums and exhibits is how to relate narratives of the Holocaust without relying too heavily on either abstraction or figuration. Ethical and aesthetic questions haunt both of these strategies. Those who have been critical of abstraction typically object to the elevation of formal and aesthetic concerns above the duties of remembrance and communication. They criticize aesthetic priorities that discourage direct emotional or empathetic involvement with the horrific subject matter. Critics of figuration, on the other hand, object to the overexposure of certain images and symbols, the risk of violating the Bilderverbot (prohibition of images) that concerns particular kinds of suffering, the trivialization and exploitation of the Holocaust, and the creation of harrowing depictions that alienate viewers. In light of these concerns, particularly inventive Holocaust displays rely on an aesthetic strategy that exists between these two poles of representation, thereby avoiding the Scylla of evasion and aestheticization on the one hand and the Charybdis of reductive representation on the other. A number of Holocaust exhibits in Yad Vashem and the Jewish Museum Berlin practice such an alternative strategy, engaging in a process of disfiguration through postmodern techniques and thereby imbuing Holocaust memorial symbols and forms with sacred significance.

A second, related issue in Holocaust representation is the question of the appropriateness of postmodern aesthetics for the subject matter. Holocaust artists have often relied on postmodern aesthetics; this may be due to the fact that the postmodern sensibility is uniquely suited to the representation of trauma, loss, fragmentation, and irresolution. Edith Wyschogrod has aptly described this: "The holocaust is itself intrinsic to postmodern sensibility in that it forces thought to an impasse, into thinking a negation that cannot be thought and upon which thinking founders." Within the realm of

architecture, for example, Holocaust museums of the past few decades have begun drawing on the more daring, at times controversial, strategy of developing their own "ritualized iconography and symbolism"—that at times refers directly to the spaces and experiences of the concentration camps. In architecture, as Gavriel Rosenfeld argues, the rise of postmodernism gave architects the "tools to grapple with Auschwitz's architectural legacy."[3] More generally, postmodern aesthetic techniques draw attention to the process of memory itself and self-consciously recognize the roles of mediation and transmission in Holocaust memory. In this sense, postmodern art practice tends toward the nonnarrative, the polyvalent, the enigmatic, and the ambiguous; it cultivates gaps, silences, and absences appropriate for the evocation of traumatic memories—themselves subject to repression and forgetting.[4]

It is difficult to clearly differentiate between modern and postmodern aesthetics, particularly since many postmodern aesthetic techniques such as self-consciousness, parody, irony, and ambiguity arguably represent the continuation or intensification of trends already prominent in modernist works. For example, certain issues raised in modernist art—such as the relationship between high and popular art or the fragmentation of experience—and techniques like eclecticism appear in postmodern art as well but in more radical forms. The distinction between modern and postmodern aesthetics may therefore be more a question of degree than of kind. Keeping this caveat in mind, there are nonetheless certain aesthetic techniques that may be characterized as largely postmodern. Craig Owens proposes in his well-known article, "The Allegorical Impulse: Toward a Theory of Postmodernism" (1980), six postmodern art strategies including appropriation (the use of photomechanically reproduced imagery to challenge the uniqueness of an image), site specificity (installations or artworks rooted in a specific context), impermanence (the use of ephemeral materials to undermine art's elite status), accumulation (producing works in a series), discursivity (combining visual imagery and written commentary in one piece), and hybridization (combining in an eclectic way materials, genres, and period references as a challenge to the "purity" of art).[5] Although the postmodern is an elusive and fundamentally unstable category with no single, clear definition, the postmodern idiom is still useful for the analysis of aesthetic technique in Yad Vashem and the Jewish Museum Berlin. This is particularly true when examining exhibits that undermine conventional methods of representation and partake of the strategies outlined by Owens.

String, the *Memorial to the Deportees,* and *Menora* engage in such practice, but they also move beyond the strategies described by Owens to evoke a sense of the sacred. In discussions concerning Holocaust representation, the sacralized has often been linked to a modernist aesthetic and the desacralized to a postmodern aesthetic. As Dora Apel explains, such an approach contends that the postmodern approach is effectively a mode of self-consciousness that "always places the Holocaust in relation to the circumstances of its representation in the present" and that "recognizes the altered ideological contexts of the present, the fragmented and conflicted nature of experience and subjectivity, and the difficulty of retrieving knowledge from the past." In contrast, transcendental or timeless truths are viewed as corresponding to a modernist aesthetic.[6]

Such an argument, however, problematically reduces the categories of the sacred and the profane to a simple dichotomy of the unknowable, which exists outside of history, and the relativized and contextualized, which exists within history. But looking closely at select exhibits and memorials at Yad Vashem and the Jewish Museum Berlin, it becomes clear that Holocaust exhibits may call on postmodern aesthetics for a sacred purpose. Sacredness, as previously noted, emerges through specific practices such as ritual and emplacement. Postmodern theologians describe the sacred as being beyond conceptualization or systemic delineation; they argue, in effect, that postmodern theology moves beyond modern theologies, which are—in the words of David Tracy—"principally determined not by the reality of God but by the *logos* of modernity."[7]

This and similar concepts, which characterize the works of postmodern and deconstructive theologians such as Mark C. Taylor, Carl Raschke, and Charles Winquist, also appear in the works of certain literary and art critics and serve as useful tools in the discussion of aesthetic strategies. The writings of Jacques Derrida, for example, exhibit such ideas and are philosophically committed to remaining open toward the presence of otherness. One particularly intriguing theological implication of Derrida's deconstructivist writings is what John D. Caputo describes as the "messianic turn" inscribed into the structure of deconstruction. The messianic, according to Derrida, is a "structure of experience, apparently universal, that opens us to an unknown future. . . . The postmodern condition is essentially, that is, structurally, messianic: constitutionally open to the coming of the other and the different."[8] This concept of the messianic will

prove particularly helpful for an analysis of Yad Vashem's *Memorial to the Deportees*.

Disfiguration and Refiguring the Sacred

In his book *Disfiguring: Art, Architecture, Religion*, theologian Mark C. Taylor proposes a theory of disfiguration that enriches a reading of Holocaust exhibits and memorials. Taylor traces three alternative strategies of disfiguration through three epochs (modernism and two contrasting versions of postmodernism) in twentieth-century art and architecture. Disfiguration, Taylor argues, emerges as a third way between the two dominant tendencies of abstraction and figuration. While figuration produces meaning through identifiable forms, abstraction "removes every vestige of form and figuration in order to reach the formlessness of the unfigurable or unrepresentable." Figuration is well suited to the communication of concrete ideas and concepts, but abstraction proves to be an effective vehicle for the depiction of the artistic *via negativa*, or negative theology, with its evocation of sacred darkness, mystical nothingness, and an apophatic, ineffable divinity. As depicted in the works of the painter Ad Reinhardt, the erasure of form and figure through abstraction may leave behind a "trace of original oneness."[9]

Taylor's third method of disfiguration, however, posits a figure beyond these two poles of abstraction and figuration. Through this method the figure is "neither erased nor absolutized" but rather used with and against itself "to figure that which eludes figuring": the unfigurable. Disfiguring, paradoxically, figures the very impossibility of figuration. In Taylor's words, "disfiguring figures the unfigurable in and through the faults, fissures, cracks, and tears of figures." These "torn" figures, working with and against themselves, mark the trace of something other—an unnameable other "that *almost* emerges in the cracks of faulty images." Taylor calls this unnameable other "altarity."[10] The disfiguring techniques of architects and painters like Peter Eisenman and Anselm Kiefer, who attempt to figure the unfigurable, demonstrate for Taylor the aesthetic possibility of refiguring the sacred in a postmodern age.

Taylor's theory of disfiguration and its potential to refigure the sacred lends itself as a valuable lens for viewing select exhibits in Yad Vashem and

the Jewish Museum Berlin. As discussed earlier, Holocaust museums and exhibits face the challenge of presenting the Holocaust, an event widely perceived as sacred, in a way that preserves this sense of sanctity. At the same time museums and exhibits partake of strategies that often undermine that very agenda. For example, museums often rely on famous, even iconic photographs and interactive, high-tech exhibits to attract visitors. This latter strategy in particular has elicited the criticism that Holocaust museums and exhibits are succumbing to a "Disneyland aesthetic."[11]

Scholars, as well as artists, have long struggled with the question of how (or even if) the Holocaust can be represented. Lawrence Langer, a seminal voice in discussions of Holocaust representation and memory, has argued that depicting the Holocaust demands artistic disfiguration, while Alvin Rosenfeld supports a distinction between authentic and inauthentic representations. Recent works on Holocaust representation by Berel Lang, Michael Rothberg, Brett Ashley Kaplan, and Michael Bernard-Donals, among others, demonstrate the continuing debates on this topic, although the terms and dimensions of that debate continuously shift. Cultural critic Andreas Huyssen expresses a persistent and wide-spread belief when he claims, "No matter how fractured by media, by geography, and by subject position representations of the Holocaust are, ultimately it all comes down to this core: unimaginable, unspeakable, and unrepresentable horror."[12]

Questions concerning the moral and ethical risks of abstraction in Holocaust art were already being raised as early as December 1944 in *Le Spectateur des Arts*. A number of figurative artists, including Marc Chagall, Ben Shahn, and Leonard Baskin, share a suspicion toward abstract representations of the Holocaust. Chagall, for example, queries, "If it is possible mechanically, cold-bloodedly, heartlessly to paint pictures that seem to say, 'It's all the same'; if you fail to see emanating from these pictures simple pity, if they contain only formal relationships that are rotten with calculated, hollow cold-bloodedness, although they are sometimes superficially beautiful; then we must ask if this same art can appreciate fully the catastrophe of millions of men condemned to crematoriums." Similarly, Ben Shahn argues that abstract art is "socially and humanly non-committal," and Leonard Baskin describes it as an "indication of man's inability to communicate: a decadent, cowardly art produced by a decadent, post-Buchenwald and post-Hiroshima society."[13] Artists who reject abstract depictions of the Holocaust believe that the Holocaust needs to be expressed in human (that

is, figurative) terms and should involve spectators emotionally. They view abstraction, in short, as a retreat from humanity into cold intellectualism and aestheticism.

Those who argue in favor of abstraction and against figuration, interestingly, also refer to the emotional response of viewers. Jean-Paul Sartre, for example, argues that abstraction in art is the only means for coping visually with subjects like the Holocaust (with the exception of Picasso's *Guernica*). In his introduction to the catalog of a 1961 show that included Robert Lapoujade's abstract, colorful *Hiroshima*, Sartre writes, "Non-figurative art . . . evokes the total meaning of the human situation. . . . The painting *exhibits* nothing. It lets horror seep down *but only if it is beautiful*." Ygael Tumarkin, an Israeli painter and sculptor, agrees with Sartre. He claims that abstraction is the only valid means through which an artist can approach the subject of the Holocaust and still create art, while figuration would result in a "sadistic nightmare." Only through abstraction, Tumarkin maintains, "can one come to grips with the subject from a distance safe for artist and spectator alike."[14]

A great deal of variety exists in figurative representations of the Holocaust, as artists draw on a wide range of styles and aesthetic principles. However, as Ziva Amishai-Maisels demonstrates in her comprehensive study of Holocaust art, a common thread in the form of certain tropes, metaphors, and symbols suggests continuities between otherwise disparate works. Similarly, Holocaust museums and exhibits also rely on recurring symbols that reflect the memorial iconography of earlier Holocaust memorials. Although Jewish symbols such as menorahs and Stars of David became increasingly common in Holocaust memorial iconography during the 1960s, the first symbols used in memorials were taken from "iconic features of the Nazi camps," including barbed wire, fence posts, colored triangle badges, smokestacks, and railroad cars and tracks.[15] Contemporary Holocaust museums and exhibits draw heavily on iconic concentration camp imagery while also incorporating Jewish symbols, including the Magen David, Yizkor candles, the Torah, and menorahs. The memorial at Treblinka, for example, includes a twenty-six-foot obelisk with a menorah carved in its top. Relying on Taylor's theory of disfiguration, the following analysis demonstrates that particular exhibits employ disfiguring strategies in their treatment of Holocaust symbols, thereby evoking a sense of the sacred for contemporary viewers.

String, Yad Vashem

Because this most striking display "disfigures" the Torah, it is necessary to first look at the significance of the Torah scroll in Holocaust memorialization. Rescued Torah scrolls from destroyed European Jewish communities, particularly those burned or otherwise damaged, have played a significant role in Holocaust commemoration in Israel since the 1950s. The Holocaust Cellar (Martef ha-Shoah) on Mount Zion near King David's Tomb is one of the earliest Holocaust commemoration sites in Israel and illustrates the use of Torah scrolls in Israeli Holocaust remembrance. The Holocaust Cellar was established in 1949, as part of the Sukkot festival, and was inaugurated on the fast day of Tisha B'Av, which marks the destruction of the First and Second Temples, as well as other tragedies of Jewish history, such as the expulsion of the Jews from Spain in 1492. In honor of the cellar's founding, Torah scrolls from a number of destroyed European Jewish communities, along with other ritual objects such as Hanukkah candelabra and Torah crowns, were brought to Jerusalem as part of a symbolic procession and were placed in the renovated cave on Mount Zion. Along with these ritual objects, Holocaust victims' ashes were also brought from abroad.[16]

During the following years Torah scrolls would become increasingly central to the Holocaust Cellar's commemorative practice. The cellar's *Scrolls Room*, for example, which contains rescued Torah scrolls from across Europe, was established in the early 1950s. As Doron Bar points out, the *Scrolls Room* exhibit emphasized—through banners, for example—the "contrast between the destruction of the European Jewry and the establishment of the State of Israel."[17] A Zionist narrative thus underlies Holocaust memorialization in the cellar and echoes the redemptive Zionist narrative staged through Yad Vashem's architecture, as described in chapter 3. Torah scrolls play a central role in this Zionist-framed remembrance by simultaneously offering material evidence of the dangers of diasporic life for Jewish existence and by demonstrating the continuity of Jewish tradition in contemporary Israel—thereby providing a teleological link between the catastrophe of the past in exile and the redemption of the present in the State of Israel.

The use of Torah scrolls in Israeli memorial practice developed further in later years. During Purim in 1951, for example, the Ministry of Religious Affairs opened a new room in the Holocaust Cellar that displayed seventy scrolls (*megillot*) from the book of Esther, which had been gathered from different destroyed Jewish communities across Europe.[18] The book of

Esther ("megillat Esther") provides the scriptural basis and liturgical instrument for the celebration of Purim, which commemorates the deliverance of the Jewish people from King Ahasuerus's evil adviser Haman, who had hatched a plot to destroy all the Jews in the Persian Kingdom. Through the brave actions of Mordecai and Queen Esther, the Jews of Persia were saved from mass extermination. The inclusion in the Holocaust Cellar of megillot that tell the story of the Jews' narrow escape from genocide illustrates the principle described by Yosef Hayim Yerushalmi and discussed in the introduction, whereby Jewish chroniclers recorded contemporary disasters through the framework of familiar archetypes. The scrolls in the cellar thus contribute to Holocaust remembrance by framing the Holocaust through the almost-catastrophic exilic narrative known to all Israeli Jews and observed every year by Jews around the world. Two years later, in 1953, fragments of scorched Torah scrolls that had been rescued from the historic Rashi Synagogue in Worms, Germany, were placed in the Holocaust Cellar as well. The desecration of Torah scrolls during the Holocaust, furthermore, was a prominent focus of Holocaust commemoration ceremonies in the cellar throughout the 1950s.[19] In this way, rescued Torah scrolls played an important role in rituals of Holocaust remembrance in the years immediately following the founding of Israel.

Torah scrolls were also instrumental in Israeli efforts to emphasize the continuance of Jewish life and tradition after the Holocaust by forging a link between pre- and post-Holocaust Jewish communities. For example, in 1949 the Ministry of Religious Affairs began distributing Torah scrolls rescued from ravaged European Jewish communities, which had been collected and held in Mount Zion, to synagogues across Israel. During the 1950s Torah scrolls that were restored in Mount Zion's Scribal House were sent to different Jewish communities in the Diaspora. The inscription of Torah scrolls to commemorate Holocaust victims offers a second example of such efforts. As Doron Bar notes, during the week of *parashat va-yikra* (one of the weekly Torah readings from the book of Leviticus), in the month of Adar 1951, Israeli children traveled to Mount Zion to participate in the inscription of a Torah scroll dedicated to the memory of children killed in the Holocaust. These Israeli children, who were treated as symbols for the future of Israel and Jewish life in general, thus became intimately bound together with those children whose deaths spelled the destruction of a Jewish future. The symbolic importance of the first post-Holocaust generation

of children born in Israel—above all, of those children born to Holocaust survivors—has been described by Dina Wardi in her study of how the birth of Jewish children after the Holocaust "became a symbol of victory over the Nazis." Wardi names the post-Holocaust children born to survivors "memorial candles" due to their symbolic contribution to the effort to "repair the broken links between the parents and their extended families and communities," many of whom perished in the Holocaust.[20] The function of Israeli children as "memorial candles" may be seen in this highly programmatic inscription of Torah scrolls in honor of their lost brothers and sisters.

Today, Torah scrolls continue to appear in Holocaust museums and exhibits. The USHMM, for example, displays damaged Torah scrolls from the Holocaust era in a large glass case in its exhibit on Kristallnacht and the destruction of synagogues in Germany. This exhibit includes Torah scrolls from synagogues in Marburg and Vienna that were ravaged and plundered during Kristallnacht. One of these scrolls, as Oren Baruch Stier notes, is open to the Ten Commandments, "so that the dictum 'Thou shalt not murder' is visible."[21] Yad Vashem also displays rescued Torah scrolls in its exhibit on Kristallnacht and the destruction of synagogues, and Torah scrolls that belonged to the persecuted Jacobsohn family in Germany, as mentioned earlier, appear in the axes of the Jewish Museum Berlin.

Torah scrolls continue to play a central role in Israeli Holocaust remembrance in a more general sense as well and may even offer a link between the Holocaust and more recent tragedies. In 2003, for example, Yad Vashem was presented with a Torah scroll inscribed in honor of Israel's first astronaut, Colonel Ilan Ramon, who died in the *Columbia* space shuttle disaster in January of that year. Ramon, the son of a survivor from Auschwitz, had requested and taken with him on his space flight a Holocaust artifact from Yad Vashem—a copy of a drawing titled *Moon Landscape* by Petr Ginz, who died at the age of sixteen in Auschwitz. The scroll accompanies IDF (Israel Defense Forces) delegations to Holocaust sites in Poland and remains at Yad Vashem between trips. In the words of Yad Vashem chair Avner Shalev, "there is powerful symbolism in the new custom of IDF officers visiting Holocaust sites in Europe, accompanied by a Torah scroll dedicated to an Israeli hero and son of a Holocaust survivor. Col. Ramon . . . was widely regarded as an embodiment of the rebirth of the Jewish People in Israel. We are honored to be entrusted with this special Torah scroll, which . . . bears noble witness to the past, present and future of the Jewish People."[22] The

FIG. 6.1 Torah scrolls, Yad Vashem. *Left*: A Torah scroll from a synagogue in Leipzig, Germany, rescued from the fires on Kristallnacht. It was hidden in the attic of the city's university library together with other scrolls. Yad Vashem Artifacts Collection. Gift of the Association of Former Leipziger in Israel, Tel Aviv. *Right*: A damaged Torah scroll, one of a collection of Torah scrolls from Jewish communities throughout Bohemia and Moravia that were looted by the Nazis. Yad Vashem Artifacts Collection. Loaned by Westminster Synagogue, London, England.

link between Holocaust remembrance and the continued existence of Jewish life and tradition, mentioned earlier in the context of the inscription of a Torah scroll by Israeli children, appears here in Shalev's remarks as well.

The display of Torah scrolls in museums rescued from burning synagogues is particularly poignant in its emphasis on an individual's act of bravery and devotion in the face of danger. A singed, torn, or otherwise damaged scroll testifies to both the spiritual and symbolic importance of the scroll to the person or persons who rescued it as well as to the continued reverence toward the Torah that is alive in Jewish communities today. Torahs bearing traces of fire and ash, moreover, recall the mishnaic requirement to save a Torah scroll endangered by fire, even on the Sabbath.[23] The restoration and distribution of rescued Torah scrolls, furthermore, as discussed earlier, illustrates survival and the persistence of Jewish tradition and community under the most extreme of circumstances. Before destroying synagogues

throughout Germany and eastern Europe, the Germans would often dese-
crate and destroy the sacred objects that they found within, including Torah
scrolls. This was part of the larger Nazi effort not only to wipe out all Jewish
communities but to humiliate and eradicate the Jewish culture as well. In
1941 in Slobodka, Ukraine, for example, German troops filled the town syn-
agogue with dead cats and forced Jewish inhabitants to tear up Torah scrolls
and then strew the pieces across the corpses of the animals. What this event
reveals is the fact that destruction was not enough—the Torah, as the book
most sacred to the Jewish people and therefore emblematic of Jewish belief
and culture as a whole, had to be desacralized and stripped of its power.
Attempts to desecrate sacred Jewish objects appear in anti-Semitic cartoons
as well, such as those found in Julius Streicher's infamous *Der Stürmer*. In
one cartoon, for example, a Jewish man prays before an altar topped with a
bag of gold that is marked with a Star of David. Beneath the altar, at his feet,
lies a discarded Torah scroll.[24] Wealth and greed, the cartoon claims, are
what are truly sacred to the Jew; the Torah is merely a prop that is discarded
when the real sacred object—money—appears.

It is true that National Socialism did not invent the act of burning or des-
ecrating the Torah. Indeed, Torah scrolls were often trampled underfoot
or burned—along with the synagogues that held them—by mobs during
pogroms throughout European history. Torah scrolls were not officially
burned by the church, however, as was the case with the Talmud, which
was publicly burned a number of times in Italy and France between the
thirteenth and sixteenth centuries.[25] The destruction of Torah scrolls dur-
ing the years of National Socialism, however, is unparalleled. It is impos-
sible to know how many Torah scrolls were desecrated and destroyed by the
Germans throughout Germany and its occupied territories, but the number
is certainly in the thousands. After the war was over European synagogues
often found themselves without intact Torah scrolls. Donations helped
address this problem: in 1946, for example, the Joint Distribution Commit-
tee presented thirty-three Torah scrolls that had been donated by American
Jews to Jewish communities in France.[26]

Beginning already during the war years and continuing into the post-
Holocaust period, individuals and institutions such as the Czech Memo-
rial Scrolls Trust labored to rescue and restore Torah scrolls from destroyed
European Jewish communities. The mission of the trust has been to collect,
repair, and redistribute Torah scrolls to synagogues, museums, schools, and

other Jewish institutions, so each scroll may be "restored to its rightful place in Jewish life."[27] The importance of restoring each Torah scroll physically so that it is perfectly intact reflects the view of the Torah as a "living texture, a live body . . . a living structure from which not even one letter can be excised without seriously harming the entire body. The Torah is like a human body that has a head, torso, heart, mouth. . . . It can be compared to the Tree of Life, which has a root, trunk, branches, leaves, bark, and pith, though none is distinct from another in essence and all form a single great unity."[28]

The Czech Memorial Scrolls Trust describes its successfully accomplished mission as "the epic journey of 1,564 Torah scrolls from war-torn Czechoslovakia to London and thence to destinations throughout the world." The purpose of the trust has been to reestablish a link between Jewish life in the past and present as well as to restore the scrolls to their proper sacred, ritual contexts. The scrolls, according to the trust, connect contemporary Jewish communities and destroyed European communities, offering an "intimate link with the individual historic congregations which were destroyed under the Nazis."[29] This is a crucial point: each rescued Torah scroll restores to a lost Jewish community its identity. A recovered Torah scroll thus ensures the continued existence of a destroyed community, even if only through its symbolic, memorial function in a museum.

In addition to the meaningful role that the Torah plays in Holocaust commemoration, the Torah (in scroll or book form) has also often appeared in Holocaust art—for example, in depictions of European Jewry's reactions to persecution.[30] Marc Chagall's *Solitude* (1933) and *The Crucified* (1944); Emmanuel Mané-Katz's *Holocaust* (1941–1945); Hyman Bloom's series *Jew with a Torah*, begun in the 1940s; and Ludwig Meidner's *Jews with Torah Scrolls* (1943–1944) are only a few examples. As the canonical text and spiritual basis of Judaism, the Torah symbolizes religious devotion and the continuity of Jewish tradition. In many Holocaust-themed paintings, Jews carry Torah scrolls to signify their piety and dedication to Judaism. In Chagall's *The Falling Angel* (1933/1947) and *White Crucifixion* (1938), for example, Jews fleeing danger clasp Torah scrolls, signifying the efforts of individuals to preserve Judaism through the crisis of the Holocaust.

Uri Tzaig's video art display, *String*, is located in Yad Vashem's Facing the Loss gallery at the end of the permanent exhibition and directly before the *Hall of Names*. This display destabilizes and ironicizes the static Torah scroll as a symbol in Holocaust remembrance and employs a disfiguring strategy

to evoke remembrance that is open to sacred meaning while also taking into account individual experience. *String* is a two-part video art installation projected onto blank, concrete walls in the gallery's darkened room. In one corner appears the projected image of a virtual book with yellowed, torn pages that turn as if by an invisible hand. On these pages the viewer can glimpse words in handwritten script.

Although Tzaig's video art display does not explicitly name the virtual book as Torah, the second part of the display suggests such an idea. A second projected image appears on the adjacent wall—a large block of jumbled

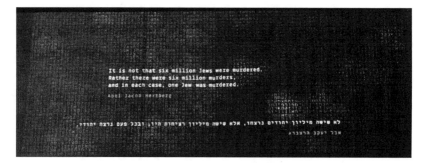

FIG. 6.2 First part of *String*, by Uri Tzaig, Yad Vashem. © Uri Tzaig.

FIG. 6.3 Second part of *String*, by Uri Tzaig, Yad Vashem. © Uri Tzaig.

Hebrew letters. From within the block of letters, particular letters stand out distinctly against their black background as they are infused with light from within. The letters repeatedly combine to form quotations in Hebrew and English. The illuminated letters bring to mind the image in the Tanakh and in rabbinic writings of the Torah as fire. More specifically, the display resonates with a description of the Torah as "written in black fire on white fire" prior to the creation of the world.[31]

Uri Tzaig, the creator of *String*, selected the displayed quotations from original manuscripts, letters, diaries, and other writings by Holocaust survivors and notable Jewish figures, including Primo Levi, Victor Frankl, Jean Améry, Janusz Korczak, Yitzhak Katznelson, and Tosia Altman. Original cello and harp music by Amir Lloyd accompanies the visual exhibit. Describing his video installation, Tzaig declares that the two halves of the display "symbolize the human spirit that survived even in the inferno. After looking at the most distressing materials—pictures that depict hell itself—I decided to use the faceless, written word, which represents structured thought and human faith. The letters are like the strings of a musical instrument, and this room will serve as a sound box for these strings, preserving the human beauty that managed to survive."[32]

The irony of *String* emerges through a stark juxtaposition between the concrete wall on which the images are projected and the torn, fragile-looking pages of the book, which emphasize the vulnerability of the printed medium. *String* plays on this tension: the book projection undermines and disfigures the idea of the permanence of the Torah through its virtual medium (this book is a mere play of light). But it also surprises by casting the light onto a concrete wall—a strong material signifying permanence. Concrete, furthermore, carries additional symbolic meaning in Israeli culture, as many Israeli war memorials are constructed of this material.

An interpretation of the second part of *String*, the large floating block of letters, benefits from a consideration of Gershom Scholem's writings on the Kabbalist tradition. In Kabbalah, or Jewish mysticism, the Torah is regarded as the "complete mystical name of God." As the articulation of divine energy and the direct word of God, but also a concrete, written record, the Torah possesses two aspects: "a literal reading formed by its letters that combined to make words of the Hebrew language, and a mystical reading composed of the divine Names of God." Following this line of thought, the Torah contains within it, in concentrated form, "all that was allowed to develop more

expansively in the creation itself." The Torah is, therefore, infinite. As Scholem quotes from the *Otiyyot de-Rabbi Akiva*, "many lights shine forth from each word and each letter" and "the Torah has 70 faces." The Torah is then, in essence, a living organism that possesses inexhaustible meanings. These reveal themselves "differently at different levels according to the capacity of its contemplator." As Scholem explains, a belief has existed since the sixteenth century that the number of possible interpretations of the Torah was "equal to the 600,000 children of Israel who were present at Mount Sinai—in other words, that each single Jew approached the Torah by a path that he alone could follow."[33]

As the direct word of God and as the manifestation of divine speech, the letters of the Torah are themselves sacred: the Torah, in short, consists of letters whose "soul" is God himself and which are "nothing less than configurations of the divine light." Of particular interest in a discussion of *String* is the fact that, as Scholem writes, "since it was agreed that it [the Torah] assumed different forms in the celestial and terrestrial worlds, the question arose of how it would appear in paradise or in a future age." Implied here is the idea that the content of the Torah shifts and changes according to the unfolding divine narrative. Scholem offers the example of Adam's sin, which caused the "corporealization of its [the Torah's] letters" to take place in a particular sequence. The Kabbalists of Safed maintain that the Torah "contained the same letters prior to Adam's sin but that in a different sequence that corresponded to the condition of the world at that time. . . . In its primordial existence, the Torah already contained all the combinational possibilities that might manifest themselves in it in accordance with men's deeds and the needs of the world. Had it not been for Adam's sin, its letters would have combined to form a completely different narrative. In messianic times to come, therefore, God will reveal new combinations of letters that will yield an entirely new content."[34]

The words of the Torah, then, are not static and fixed but—like any living organism—subject to change as the divine narrative unfolds. Adam's sin, finally, illustrates the insertion of human will into divine drama; it demonstrates how human will can change the divine narrative and thus the content of the Torah. As the Ba'al Shem Tov taught, the holy Torah was "originally created as an *incoherent jumble of letters*," a totality of all possible combinations of the Hebrew alphabet. "In other words," Scholem continues, "all the letters of the Torah . . . were not yet combined to form the words we now read. . . . These words, on the contrary, were not yet present, for the events

of Creation that they record had not yet taken place. Thus all the letters of
the Torah were indeed jumbled, and only when a certain event occurred in
the world did the letters combine to form the words in which the event is
related. . . . As soon as something happened, the corresponding combina-
tions of letters came into being. *If another event had occurred in its place, other
combinations of letters would have arisen.*[35] From within the infinite jumble of
letters of the Torah in its original state there emerged, gradually, the divine
narrative and the deeper level of divine intention underlying events.

The Torah, to put it in a different way, may be regarded within Kabbalah
as both reactive and predictive, as it demonstrates not only God's will mani-
festing itself through history but also the intervention of human will into
the divine narrative. *String* suggests that this dynamic process, whereby the
letters of the Torah reveal new combinations and new content "in accor-
dance with men's deeds and the needs of the world," is still going on and
that the Holocaust, like Adam's sin, causes the letters of the Torah to rear-
range themselves into a new narrative. The personal experiences, sufferings,
and memories of Holocaust survivors are thus inscribed into the divine nar-
rative and are sanctified as part of the unfolding Torah—this amounts to a
refiguring of the sacred.

In contrast to other displays of rescued Torah scrolls, for example in the
USHMM, where scrolls appear as precious, fragile objects encased in glass,
String ironicizes the use of the static, material Torah scroll as a symbol in
Holocaust remembrance. It does this by replacing the actual artifact with a
virtual image, thereby undermining the Torah as a symbol of fixed, abiding
permanence. The display draws on a number of techniques characteristic
of postmodern aesthetics, including the use of words as a central artistic
element, the highlighting of tension between the fragment (the letter) and
the whole (the word, phrase, and sentence), and self-conscious attention
to issues of mediation and impermanence in the process of representation.
String thus not only sets in motion an ironic destabilization but also engages
in an act of disfiguration. The fragile pages of the virtual book appear as
flickering light projections, while meaningful constellations of words
appear and disappear, dissolving after their brief existence to be replaced
by new quotations that emerge from the mass of letters. These images bear
the trace of that which, according to Mark C. Taylor, "eludes figuring": the
unnameable other that appears through torn or faulty (here, destabilized
and ironicized) images and that reveals a space for the sacred.

The unnameable other that eludes figuring is the expression of individual suffering and experience through personal testimony, which emerges from the jumbled block of letters. For example, one quotation reveals an individual's struggle for a new beginning and hope for the future through the realization of the Zionist dream: "Even though my written Hebrew is broken and questionable, I cannot but write in Hebrew, the language of the future, because I will use Hebrew as a Jew standing proud in the Land of Israel!" A second quotation, from Yitzhak Katznelson's "The Song of the Murdered Jewish People," mourns the loss of eastern Europe's Jewish communities: "Rising over Lithuanian or Polish towns, the sun will never find a radiant old Jew at the window reciting Psalms, or going to the synagogue."

Through *String*, the sanctity of individuals and their suffering and experiences come to light and are inscribed into the sacred narrative of Jewish history. The duty to remember that experience is passed on to visitors, who act as witnesses to the revelation of personal testimony. Leaving *String*, visitors pass into the final room of the Holocaust History Museum, the *Hall of Names*. Here, as we shall see in chapter 7, they becomes integrated into Yad Vashem's sacred narrative of exile and redemption through Zionism. This is a narrative that depicts exile as the precondition for the Holocaust and Israel as the redemptive solution to that catastrophe. The visitors' participation in Yad Vashem's Zionist narrative in the *Hall of Names* completes the act of witnessing that is initiated with Michal Rovner's *Living Landscape* video installation and which was made intensely personal with Uri Tzaig's *String*.

Memorial to the Deportees, Yad Vashem

In addition to rescued Torah scrolls, authentic German railway cars from the World War II era play a significant role in Holocaust museum displays. Yad Vashem's outdoor transport memorial, the *Memorial to the Deportees* (1995), employs dramatic aesthetic techniques to invest the symbol of the deportation railway car with new, surprising meaning. This new meaning draws on two powerful shaping forces in Jewish history whose ideas and principles have often influenced and also challenged one another in a variety of ways: Zionism and messianism. Themes of anticipation, the interruption of history and narrative, and the paradox of new beginnings through destruction and catastrophe underlie the *Memorial to the Deportees*.

Due to their crucial role in the deportation and killing of Holocaust victims, railway cars have emerged in Holocaust memory discourse as central symbols of suffering and inhuman treatment, and they are repeatedly evoked in Holocaust memoirs, poetry, and art as well as in museums and memorials. Leo Haas's drawing *The Transport from Vienna* (1942), for example, depicts exhausted figures spilling out of railway cars. Some of the victims appear in bent-over and huddled-up postures, while others lay prostrate or sit on the ground. In the lower right-hand side of the drawing is a guard wearing an overcoat; he stands imperiously with legs spread, straddling a man who lies helpless beneath him. A second example is Teo Otto's *Deported to the Death Camps* (1944), in which an old man with beard and prayer shawl comforts a small girl. Behind him appears a raised bayonet and railway cars. In these images, railway cars signify dehumanization, inexorable fate, and death.

Given their symbolic and evocative power, authentic Holocaust-era railroad cars have increasingly emerged as prized artifacts in museums in Europe and the United States. The German Museum of Technology in Berlin (Deutsches Technikmuseum Berlin), for example, offers an exhibition on the transport of Jews from the German Reich to ghettos and death camps between 1941 and 1945 and includes in this exhibition the display of a typical, closed freight wagon (*Güterwagen*).[36] A reconstructed railroad car appears as well at the memorial at Neuengamme concentration camp (KZ-Gedenkstätte Neuengamme), near Hamburg. The Illinois Holocaust Museum and Education Center in Skokie, Illinois, installed in 2007 an early twentieth-century German railcar of the type used for deportations, an acquisition that the museum's web page describes as an "anchor artifact" and declares to be the "centerpiece" of the museum.[37] Similarly, the Holocaust Museum Houston in Texas displays in its permanent exhibition an authentic World War II–era German railroad cattle car, and a number of other Holocaust museums and centers, including the USHMM, the Dallas Holocaust Memorial Center, the Virginia Holocaust Museum in Richmond, and the Florida Holocaust Museum in Saint Petersburg position railroad cars from the World War II era as highlights of their collections.

In a comparative study of Holocaust railway car exhibits, Oren Baruch Stier argues that railway cars, as "literal vehicles of suffering, appropriately transformed into vehicles of memory," are particularly powerful and resonant artifacts.[38] The *Memorial to the Deportees*, however, departs from the

more conventional use of railway cars in Holocaust exhibitions by conjuring up feelings of weightlessness, anticipation, and expectation. In contrast to the exhibition at the USHMM, for example, which presents an authentic German railway car as part of a historical narrative within the traditional symbolism of death and suffering, Yad Vashem's railway car memorial breaks away from such symbolism by suggesting the possibility of redemption and rebirth through catastrophe. Perched above the Jerusalem hills on violently severed tracks, defying gravity and anticipating a moment of release, the *Memorial to the Deportees*' railway car offers a messianic moment in which history is torn asunder and a new beginning becomes imaginable—a beginning rooted in the Jews' return to Israel.

The intellectual and cultural histories of Zionism and messianism are too vast to be explored in any detail here. A few points, however, concerning the complex relationship between the two will prove helpful to a discussion of the *Memorial to the Deportees*. Aviezer Ravitzky has shown that two polar concepts exist at the heart of messianism (as depicted in traditional Jewish sources): exile and redemption. Ravitzky argues that after the destruction of the Temple, "Jewish existence could not be conceived in any other terms."[39] During the nineteenth and early twentieth centuries, and especially during the Zionist reawakening, which flourished in the mid-nineteenth century, a number of important figures—including Rabbi Yehuda Chai Alkalai, Rabbi Zvi Hirsch Kalischer, Rabbi Abraham Isaac Kook, and Rabbi Shalom Dov Baer Schneersohn—emerged with different positions vis-à-vis Zionism and its relationship to messianism. The year 1840 (5600 in the Jewish calendar) was awaited with particular anticipation by many Jewish communities, as the year that would "mark the onset of the arrival of the Messiah."[40] Simply stated, Zionists sought a solution to Jewish exile that would be achieved through human initiative. They desired a "human, worldly redemption for their people" through a normalization of conditions and through national salvation. The goal of Zionism, as Ravitzky succinctly puts it, was to "render the 'Eternal People' a historical people, temporally and spatially bound; to transform the 'Chosen People' into a 'normal people,' like other nations."[41]

Zionism had deep connections to other movements that were at this time transforming Jewish life and consciousness, including the Enlightenment, reform, and secularization. In contrast, messianism was based on two traditional principles: first, the passivity of the Jewish people and an absolute acceptance of a divinely imposed exile, and second, the quest

for perfection through the coming of the Messiah in a utopian vision of redemption. Diverse Jewish communities held a variety of messianic beliefs, from belief in a "purely natural, historical, worldly" redemption to a vision of a "radical change in the nature of the cosmos and man" that would suddenly break forth through the arrival of the Messiah. To give one example, the Lubavitcher Rebbe, Rabbi Shalom Dov Baer Schneersohn, a Hasidic leader during the earlier years of the Zionist movement, held fast to the original messianic vision that the Jewish people must not violate their oath to remain in exile and must therefore "wait patiently until the End of Days"—that is, until the Messiah revealed himself. Rabbi Schneersohn thus condemned Zionism as an attempt to prematurely "force the end" of Jewish exile and to transfer "initiative from divine to human hands"—a violation of the messianic concept.[42]

The "Harbingers of Zion," in contrast, including Rabbi Yehuda Chai Alkalai (Serbia, d. 1878) and Rabbi Zvi Hirsch Kalischer (Prussia, d. 1874), initiated an alternative, more modern, and activist view of messianism. Alkalai and Kalischer supported Jewish immigration to Eretz Yisrael and the agricultural settlement of the land as a first step in the process of redemption—a process, moreover, that would gradually unfold through the help of natural, human acts. Rather than a sudden bursting forth of "full-blown perfection" that would emerge from the "depths or in the wake of cataclysm," this redemption would develop naturally until it would be completed with a final, miraculous, divine revelation.[43] In their view, immigration—the ingathering of the exiles—to Eretz Yisrael would not be forcing the end but rather preparing for the arrival of the Messiah. Alkalai, for example, called for the rebuilding of Jerusalem and for the return of twenty-two thousand Jews to Eretz Yisrael.[44] The Harbingers of Zion were, therefore, closer in their ideology to the views of Rabbi Abraham Isaac Kook, a supporter of national revival who envisaged Zionism as "paving the way to ultimate religious and national fulfillment." For Kook, the State of Israel would be the "pedestal of God's throne in this world," and Zionism the means for restoring "assimilated, alienated Jews to their people, to the Holy Land, and the holy tongue."[45]

The complicated relationship between Zionism and messianism is revealed in the following concern posed by Gershom Scholem: "Can Jewish history manage to re-enter concrete reality without being destroyed by the messianic claim which [that reentry is bound to] bring up from

its depths?"[46] In time Zionism would, of course, be carried out in secular fashion—that is, through human will rather than divine intervention—and would bear the traces of Theodor Herzl's vision of a Jewish state. Many Jews in the earliest days of Zionism, however, were attracted to Zionism not in spite of but precisely because of their messianic beliefs.[47] This relationship between messianism and Zionism may still be seen today in some of the more extreme political positions toward the State of Israel—be it in the form of radical rejection of the state or fervent, prosettlement support.

A variety of positions concerning Zionism exist in Israel today, from the radical anti-Zionists (Neturei Karta, for example), who regard Zionism as a "demonic, antimessianic eruption" and the radical religious Zionists (Gush Emunim), who regard the "history of Zionism and the State of Israel as a clearly messianic process" to Haredi Jews, for whom a "state of exile persists despite the existence of the Jewish state. . . . Even the Jews living there are still in exile, 'the exile of Israel in the Holy Land'" and the post-Zionists, who call into question some of the most basic tenets of Zionism.[48] With the exception of the post-Zionists, messianism plays a major role in the Zionist or anti-Zionist ideology of all of these positions.

The *Memorial to the Deportees* reveals through its semiotics a link between Yad Vashem's Zionist narrative and the messianic ideas often present in early Zionist thought. Designed by Moshe Safdie, the architect of Yad Vashem's Holocaust History Museum, the *Memorial to the Deportees* consists of an authentic Holocaust-era railway car donated by Polish authorities and a replica of a Polish railway bridge whose tracks are suddenly, violently broken off. The railway car's position, poised above the hills of Jerusalem, echoes the dramatic exit from the Holocaust History Museum itself. Safdie describes the memorial as follows: "Half the bridge cantilevers into the air as if the other half was destroyed, blown away, its steel beams twisted. At the tip of the cantilevered bridge hovering over the valley above the treetops is the railway car, suspended for a journey into the abyss."[49]

Inscribed on the viewing platform adjacent to the memorial, which Safdie describes as echoing the memory of a railway station, is the testimony of Holocaust survivor Avraham Krzepicki in both Hebrew and English:

Over 100 people were packed into our cattle car. . . . It is impossible to describe the tragic situation in our airless, closed car. Everyone tried to push his way to a small air opening. I found a crack in one of the floorboards into which I

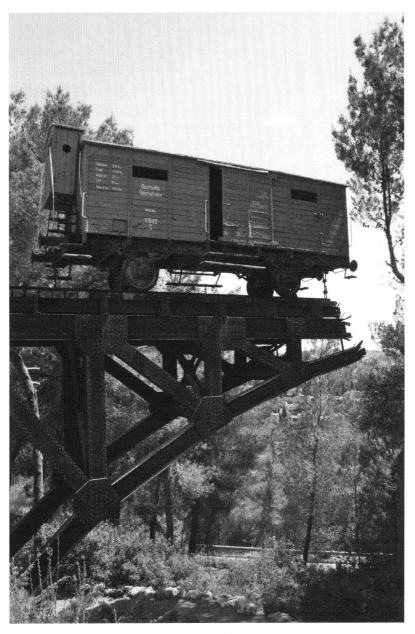

FIG. 6.4 *Memorial to the Deportees*, by Moshe Safdie, Yad Vashem. Photograph by Jennifer Hansen-Glucklich.

pushed my nose to get a little air. The stench in the cattle car was unbearable. People were defecating in all four corners of the car. . . . After some time, the train suddenly stopped. A guard entered the car. He had come to rob us. He took everything that had not been well hidden: money, watches, valuables. . . . Water! We pleaded with the railway workers. We would pay them well. I paid 500 Zlotys and received a cup of water—about half a liter. As I began to drink, a woman, whose child had fainted, attacked me. She was determined to make me leave her a little water. I did leave a bit of water at the bottom of the cup, and watched the child drink. The situation in the cattle car was deteriorating. The car was sweltering in the sun. The men lay half naked. Some of the women lay in their undergarments. People struggled to get some air, and some no longer moved. . . . The train reached the camp. Many lay inert on the cattle car floor. Some were no longer alive.

This statement is signed, "In a cattle car to the death camp. Testimony of a survivor." The inclusion of personal testimony from a Holocaust survivor who experienced deportation in a cattle car such as the one displayed in the memorial adds to the authenticity of the memorial and allows viewers to imagine in concrete terms the suffering that took place in the car. This technique of personalizing suffering through appended testimony is a conventional memorial strategy and is not unique to Yad Vashem.

What is unique to the *Memorial to the Deportees* is the fact that the traditional figure of the Holocaust-era railway car that sits solidly on its tracks, heavy with the weight of history and symbolic of deportation, suffering, and death, is destabilized and refigured as a redemptive, messianic symbol of freedom and release. The memorial is counterintuitive: a train car of great weight is suspended in the air, defying gravity and expectation. It perches on the edge of its tracks; the path of the memorial's railway car is suddenly and violently interrupted and the tracks are ripped away, leaving the railway car exposed, facing the open hills, and ready to take off in flight. The physical setting of the memorial, separated from the historical exhibit on the Holocaust and erected outdoors among the hills of Jerusalem, frames the railway car's imminent flight within a Zionist narrative rooted in the sanctity of the homeland. The refiguring of the sacred emerges in this messianic moment of interruption in which an alternative narrative—one of freedom and redemption through Zionism—breaks through.

The interrupted moments crystallized in the *Memorial to the Deportees* express more than a single moment of destruction or of breaking away from the past: they are messianic in the sense that they open themselves to the possibility of otherness—the otherness of an alternative narrative or interpretation. This alternative narrative is a messianic Zionism: it is the power of human will asserting itself and changing the course of history through Zionism, illustrated through the interruption of the train tracks that open up over the Jerusalem hills. Importantly, this moment of interruption is a moment of violence, which reflects one of the foundational conceptions of the messianic redemption as a cataclysmic event whose "dreadful 'birth pangs'" and "apocalyptic suffering and catastrophe" would signify the coming of the Messiah.[50] In this context, the suffering and catastrophe of the Holocaust appear as the "birth pangs" that preceded the redemptive founding of Israel. As Gershom Scholem points out in his study of messianism, the chance for redemption appears at the moment of deepest catastrophe.[51] The view over Jerusalem and the interrupted journey of the cattle car point to the moment of messianic redemption—a paradoxical moment of openness and utopian potential arising out of destruction and rooted in human action rather than divine will.

Beneath the memorial, heaped onto a low and accessible horizontal beam that is part of the memorial's steel arch support, is a collection of small stones and pebbles left behind by visitors to the memorial. Following the Jewish tradition of placing small stones on a gravestone, the visitors to this memorial have left these small remembrances in honor of the victims of the deportations. These stones reveal a final, more conventionally sacred meaning for visitors: the chance to mourn those denied a burial and grave of their own.

The Children's Memorial, Yad Vashem, and Menora, Jewish Museum Berlin

A third symbol that appears repeatedly in Holocaust museums, memorials, and visual art is the candle used in a ritual Jewish context, including Yahrzeit (memorial), Shabbat, and Hanukkah candles. The use of the Shabbat candle as a symbol of Jewish tradition was given poignant expression in Steven Spielberg's 1993 film, *Schindler's List*. The opening sequence of the film reveals a Jewish family preparing for their Shabbat meal by lighting candles

and praying. This sequence emphasizes the timelessness of the Shabbat tradition; in an otherwise almost exclusively black-and-white film, the flames of the Shabbat candles in this sequence appear in color. As the family members in the scene fade out, only the candles remain in an empty room. The prayer ends and the candles burn down to their wicks; in the final shot of the sequence, the camera tilts up and follows the trail of the candle's smoke, which blends into the smoke of a train. Through this sequence of shots, Spielberg depicts the Shabbat tradition through the nostalgic lens of loss. The Holocaust, foretold through the smoke of the train with its associative links to deportation and death, appears here as the destroyer of Jewish life and custom—the smoke of the train quite literally replaces the last traces of the Shabbat candles.

In the years immediately following the Holocaust, survivors mourned the dead in conventional ways by lighting memorial candles and reciting the Yizkor prayer. Memorial spaces within Holocaust museums, for example in the USHMM's Hall of Remembrance, offer visitors the chance to light a memorial candle for the victims. The use of Shabbat and memorial candles in Holocaust remembrance is straightforward and unsurprising; candles appear often in Holocaust memorial spaces and in Holocaust exhibits commemorating destroyed Jewish communities. In artistic works depicting the Holocaust, candles in both burning and extinguished states first appeared during the period of National Socialism in the works of Picasso and Corrado Cagli. The symbolic use of extinguished candles to signify death was already well established through the *vanitas* still-life tradition, in which "a skull and an extinguished candle often appear beside books or objects of worldly pleasure, to symbolize the omnipotence of death."[52] Audrey Flak's *World War II (Vanitas)* (1976–1977) is an example of a work that incorporates an extinguished candle as well as other distinctive elements, including Margaret Bourke-White's famous Buchenwald photograph *Survivors behind Barbed-Wire* (1945), to signify a Holocaust theme.

To codify candles as Holocaust-specific objects, artists often combine them with other symbols more clearly evocative of the Holocaust. Richard Milholland's series *1940–1945* (1973), for example, combines broken, extinguished candles with barbed wire, a symbol strongly evocative of the Holocaust. Milholland's *1940* depicts two candles (one extinguished and scarred) bound with barbed wire in front of slats of wood on which the word "Jude" is written. The word is almost completely concealed by a scrap of paper or

cloth bearing a Star of David. A piece of wood covers a gaping hole—a broken window, perhaps. Amishai-Maisels suggests that the candles represent Jewish victims "caught in the toils of Nazi persecution and interned in the camps."[53] Milholland's series progressively traces an intensifying level of destruction during which the wood, the Star of David, and the writing are burned and the candles are more deeply scarred, cut by the barbed wire, burned, and finally hanged. In this series, candles are anthropomorphized to signify the fate of Jewish victims.

Often playing a symbolic role in Holocaust museum exhibits, candles are essential to both Moshe Safdie's *Children's Memorial* at Yad Vashem and Michael Bielicky's video sculpture *Menora*, located at the entrance to the Memory Void in the Jewish Museum Berlin. The *Children's Memorial* at Yad Vashem (1987) is dedicated to the approximately 1.5 million children who died in the Holocaust.[54] Echoing the autochthonous symbolism of Yad Vashem's Holocaust History Museum, the *Children's Memorial* is located underground, in a hollowed-out cavern. To enter, visitors walk through a natural rock archway of Jerusalem stone and descend a ramp that is carved into the hill's bedrock beneath cypress trees and leads into the underground chamber.

Safdie has written that with the *Children's Memorial* he wished to create a place for memory and contemplation, where visitors could pause and reflect after experiencing the main museum. At the entrance to the *Children's Memorial* visitors enter a dark room and encounter a display of large-format photographic portraits of children, whose faces emerge ghostlike from the darkness. Reflected in mirrors, the photographs shift and vanish. In the background, visitors hear the names of child Holocaust victims being read out loud, along with the victims' ages and countries of origin. This voice becomes louder as one moves into the second room of the memorial.

The memorial's second room is much larger and completely dark. Its walls and ceiling are covered with five hundred angled mirrors, which reflect the light of five memorial candles and create the impression of millions of flickering stars. Safdie's intention was to have visitors "surrounded in all directions by flames of the memorial candle, the souls of the children." Describing the model on which his memorial is based, Safdie writes, "It was like a miracle. As if thrown into space, floating between galaxies, each twitch in movement of the flame multiplied to the right, to the left—a strange dance of the souls." Symbolizing the souls of the lost children, the lights of

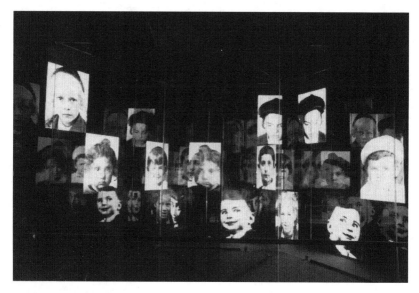

FIG. 6.5 *Children's Memorial*, by Moshe Safdie, Yad Vashem. Courtesy of the Yad Vashem Photo Archives.

Safdie's reflected memorial candles are transformed into "millions of flames extending into infinity," creating "a space expanded rather than limited."[55]

Upon leaving the memorial, visitors exit toward the north, emerging from the hillside and looking over the mountains and forest. "This would represent," Safdie writes, "a return to life and an optimistic future."[56] Aboveground and marking the space over the underground memorial is an octagonal amphitheater with a series of stone pillars. Some pillars are buried in the earth and others are broken, as if to symbolize the way that the children's lives were suddenly cut short.[57]

The use of candles in the *Children's Memorial* draws on the conventional imagery of the Yahrzeit candle in Jewish tradition. Lit by mourners on the anniversary of a loved one's death, the Yahrzeit candle should burn for twenty-four hours. The burning wick in the candle symbolizes the soul within the body, but the act of lighting a Yahrzeit candle has a deeper religious resonance as well, drawing as it does on Proverbs 20:27: "The soul of man is the candle of God." The burning candle signifies in this way the immortal soul as well as the divine spark that resides in each human being. The *Children's Memorial* thus reveals a traditional use of memorial candle

imagery in Holocaust remembrance. More unexpected is the use of a menorah in Michael Bielicky's video sculpture *Menora*.

The use of menorahs, especially Hanukkah menorahs, in Holocaust remembrance points to the greater political and military significance of Hanukkah in Israeli nationalist and Zionist ideology. Hanukkah celebrates the Jewish revolt begun by the Maccabees (or Hasmoneans) in Modi'in against the Seleucid rule of Judea and the Hellenizing Jews (167–158 BCE). The result of the uprising was the Hasmonean victory and subsequent control of Jerusalem and the Temple Mount, which allowed Jews to again worship in the Temple. The miraculous story of the Temple's menorah, which burned for eight days on one day's quantity of ritual oil and purified the defiled Temple, inspires the lighting of the menorah for eight days during the Hanukkah celebration. The heroism and victory of the Maccabees, as Maoz Azaryahu and Aharon Kellerman argue in their examination of Zionist mythical geography in Israel, "featured prominently in modern, national-oriented Jewish historical consciousness" and led to Modi'in, the alleged burial site of the Maccabees, being regarded "as a symbolic place at an early stage of Zionist history." Many even argued that Modi'in should be turned into a "major national shrine."[58]

The poet and Zionist Jacob Vitkin Zerubavel, for example, proposed in 1912 that Modi'in be promoted "as the site that pioneering secular Zionism could identify with in its struggle." He recognized in the Maccabees a model of self-sacrifice and bravery that complemented his idea of Zionist renewal; he saw, in short, a direct connection between Modi'in and the new settlement project. Although the promotion of Modi'in as a Zionist shrine was not to be realized, Azaryahu and Kellerman note that Hanukkah pilgrimages to Modi'in began already at the end of the nineteenth century, and Hanukkah was "in the formative stage of Zionist culture . . . reinterpreted in national and historical terms as commemorating 'political activism and national awakening' rather than the renewal of worship in the Temple (which was the traditional Jewish view)."[59]

The celebration of Hanukkah was in this way bound together ideologically with Zionist principles. Beginning in 1948 the president of Israel would use a torch from the annual Hanukkah torch run from Modi'in to Jerusalem, organized by the "Maccabee" sports organization since 1945, to light Hanukkah candles. As Eliezer Don-Yehiya points out, this gesture carried symbolic weight, and although Hanukkah candles "symbolized continuity

with Jewish tradition, the lighting of the torches symbolized the motif of renewal and of change from that tradition. In contrast to the small, modest candles used in private homes, the torches . . . illuminate the movement of national revival."[60]

The connection between Hanukkah and the Holocaust is not as immediately evident as the one between Hanukkah and Zionist ideology. But a connection does arise through the framing of Israel as the redemptive solution to the problem of exile, which made the Holocaust possible. Hanukkah, therefore, insofar as it possesses Zionist significance, becomes an opportunity to affirm the existence of the State of Israel as the antidote to the exile that led to the catastrophe of the Holocaust. As Doron Bar explains, Hanukkah was commemorated in the Holocaust Cellar in such a way that it was "given a different emphasis and . . . associated with . . . [the Holocaust's] memory." During a Hanukkah ceremony in 1949, for example, the day of Kibbutz ha-Galuyot (Ingathering of the Exiles of Israel) was commemorated by lighting a menorah brought from a European Jewish community. An exhibit was also opened at this time that displayed Hanukkah menorahs and Torah scrolls that had been gathered from destroyed Jewish communities. The exhibit was opened for symbolic purposes next to King David's Tomb on Mount Zion. During the following Hanukkah in 1950, Holocaust survivors lit candles in one hundred Hanukkah menorahs rescued from Jewish communities in Europe. Finally, during the 1950s, while the Ministry of Religious Affairs was overseeing the restoration and distribution of rescued Torah scrolls, it also initiated the Wandering Candelabrum Enterprise. The goal of this initiative was to deliver Hanukkah menorahs that had been procured from Europe and then used on Mount Zion to different settlements and *maabarot* (temporary resettlement camps for new immigrants) throughout Israel.[61] The gift of rescued Hanukkah menorahs to transit camps set up to provide temporary housing for new Israelis demonstrates the perceived connection between Zionism and Holocaust remembrance—a connection ritualized through the medium of Hanukkah menorahs.

Michael Bielicky's video sculpture *Menora* demonstrates how the conventional imagery of menorah candles may be disfigured to create new meaning. Bielicky, a new media artist, has worked in a wide variety of media including photography, video installation, and new media projects. His 1995 project *Exodus*, for example, tracked Moses's journey through the desert using GPS, and his 2004 work *Falling Stars* projected giant video images of

constantly renewing, shifting constellations of media celebrities ("stars") on the *Volksbühne* (People's theater) in Berlin. The child of Holocaust survivors, Bielicky was born in the former Czechoslovakia and fled with his family in 1968, at the age of fifteen, to Germany. A professor of media art and digital media at the Zentrum für Kunst und Medientechnologie (Center for Art and Media) in Karlsruhe, Bielicky creates data visualization projects, including projections on buildings that interrogate concepts of news, media, and public spaces.[62]

Bielicky's work stages an encounter between the spiritual and the technological. Sculptures like *Sephirotbaum* and *Menora* carry religious names and invoke traditional as well as Kabbalistic Jewish customs. At the same time, they bear small video screens and thus bring traditional ideas and images into dialogic tension with new forms of technology and perception. As a child of seven or eight, Bielicky was deeply affected by the magical experience of developing photographs. In a 2009 interview Bielicky related the story of how Rabbi Judah Loew used a magic lantern to transform his poor home in the Jewish ghetto of Prague into a castle in honor of Emperor Rudolf II's visit. The story of this "medieval virtual reality," as Bielicky describes it, reveals the visual mood and culture in which he was steeped as a child.[63]

In Bielicky's video sculpture *Menora*, traditional menorah candles and extinguished memorial candles have been replaced by video screens with images of flickering flames. The installation is profoundly ironic. In the Hanukkah story burning flames symbolize miraculous permanence: despite the lack of sufficient oil, the candles burned for eight days and nights. Here, the flames of the candles have been replaced by a more "permanent" and modern medium—the play of transmitted signals that express themselves as light and figure. These flames are clearly and self-consciously artificial. As mere images of flames, they are mediated through screens and possess no natural light or warmth. No longer dependent on a sacred miracle for their power, these flames are made possible through technology and controlled by human will rather than divine intervention. Intriguingly, the source of the flame images remains hidden from view: the transmitter is concealed, and the installation thus maintains a hint of mystery.

The miracle of Hanukkah—the burning oil that defied natural laws—has been demystified and subjected through *Menora* to a modern, technological explanation. *Menora*, therefore, ironicizes the use of the menorah

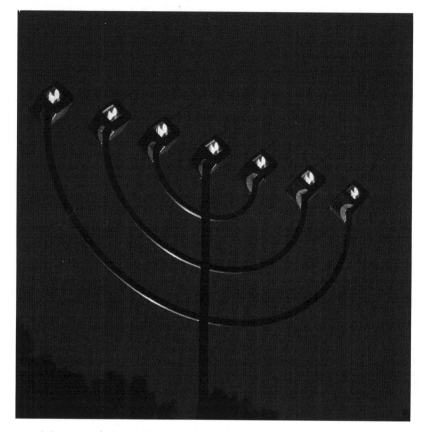

FIG. 6.6 *Menora*, by Michael Bielicky, Jewish Museum Berlin. © Michael Bielicky. Photograph by Luc Bernard.

and its candles as a commemorative cue to suggest miraculous permanence. While the menorah and candle flames are clearly coded as sacred, television screens and video are simply part of mundane, daily life and speak to the realm of the profane. The use of contemporary media to render images of flames and the juxtaposition between the sacred and the profane in this installation undermine and disfigure the sacred symbol. What opens up through this disfiguration is a glimpse of the fluidity of the sacred. *Menora* reveals that the sacred cannot be imprisoned in static forms and that objects are not intrinsically sacred; rather, the sacred is refigured through this exhibit as a shifting evocation, invested in forms through ritual, placement, and contexts of remembrance. Moreover, for those cognizant of the connection between Zionism, Hanukkah, and the Holocaust in the immediate

post–World War II period in the new State of Israel, the ironic treatment of the sacred Hanukkah myth in the context of Holocaust remembrance is significant on another level as well. It is not only the miraculous myth of Hanukkah that is ironicized. Indeed, the entire ideological fabric connecting the heroic Maccabee revolt to the destruction of European Jewry and the establishment of Israel—that is, the fulfillment of the Zionist dream—as a solution to the age-old problem of Jewish exile is put into question.

Beyond their refiguring of the sacred, Uri Tzaig's *String*, Moshe Safdie's *Memorial to the Deportees*, and Michael Bielicky's *Menora* accomplish something more: all three resist the monumentalization of the past and Holocaust memory. They avoid the process whereby objects are removed from history and turned into fetishes of the past. As Didier Maleuvre argues in *Museum Memories*: "To decree that the museum piece is an object henceforth removed from historical becoming turns that object into a sacrament of history, a history so absolute as to be above historical being itself. The museum artifact is crowned with a historical aura of such sacredness that history itself, in its becoming, cannot touch it." In such a manner, Maleuvre argues, the museum confers upon its artifacts the "sanctity of an eternal judgment" so that "objecthood is invested with the aura of fate." In other words, the museum raises its objects into a realm above and outside of history. This temporal disjunction and rupture transforms artifacts into monuments, which appear as the "damaged, *inauthentic*" images of what they once were. Torn from their original contexts and supplanted anachronistically into the present, the objects' ceremonial character keeps intact the "historical caesura" at their core. The objects are no more than ruins committed to the "holding tank of commemoration," appearing to us through a veneer of loss. Monumentalized objects expose, finally, what Maleuvre calls the "alienated status of memory in modern times"; that is, they reveal that our reliance on ceremonial forms to remember the past is a symptom of our estrangement from an authentic culture or environment of memory.[64]

In contrast to the display of monumentalized ruins of the past in the USHMM, as discussed in the last chapter, *String*, the *Memorial to the Deportees*, and *Menora* do not appear as ruins or monuments in a conventional sense. They do not escape the realm of history to become sacraments—rather, they remain rooted in the here and now as they wait for their actively engaged viewers to unveil their meanings. *String* draws on unique visual techniques to refigure Holocaust testimony as sacred and to

create an interactive experience through which viewers will acquire personal memories of individual victims. In this way, viewers become bearers of memory. The *Memorial to the Deportees* challenges the conventional presentation of deportation railway cars (like the one in the USHMM) by placing its railway car into an environment radically different from its original one. Through the technique of interruption, the memorial opens itself to new, sacred meanings and an alternative interpretation. *Menora*, finally, disfigures a popular symbol of Holocaust remembrance to challenge the very idea of an object's inherent sanctity and to ironicize the reliance on symbols in Holocaust commemoration.

String, the *Memorial to the Deportees*, and *Menora* are not the only memorial forms drawing on creative techniques to prevent the monumentalization of Holocaust memory. From the split screen of Yad Vashem's Theresienstadt exhibit to the Jewish Museum Berlin's *Gallery of the Missing* and *Unsaid*, exhibits and displays in these two museums actively resist an ossification of memory. Instead, Yad Vashem and the Jewish Museum Berlin enable their objects and memorials to remain open to alternative interpretations. Aesthetic techniques that draw on a postmodern idiom are useful in this context thanks to their ability to challenge representations of permanence and narrative closure, their engagement with self-reflexivity and irony, and their cultivation of ambiguity.

7 ⇥ RITUALS OF REMEMBRANCE IN JERUSALEM AND BERLIN
Museum Visiting as Pilgrimage and Performance

The traditional pilgrim has been the individual who embarks on a hajj to Mecca or who journeys to the banks of the Ganges River, the Dome of the Rock, or the cathedral in Santiago de Compostela. Such travelers understand their journeys in religious terms, and it was this religious understanding that made their journeys "pilgrimages" rather than simply travel. This understanding has been broadened in recent years to include tourists and their journeys to places that deviate from traditional sites of pilgrimage. Ritual studies scholar Catherine Bell succinctly defines pilgrimage as an activity that possesses a "fundamental ritual pattern of transformation by means of a spatial, temporal, and psychological transition."[1] According to this definition, the moniker "pilgrim" might include an Israeli student who travels on a youth voyage to visit the death camps of Poland, a young Jew taking part in a Taglit Birthright Israel tour, a devoted Elvis fan who journeys to Graceland, a Trekkie who attends Star Trek conventions, or a veteran who participates in American Veterans' motorcycle tours.[2] To quote seventeenth-century English poet Abraham Cowley, "Curiosity does, no less than devotion, pilgrims make." There is now a certain fluidity in the concept of pilgrimage, and pilgrims encompass many facets, as they undertake

journeys of spiritual, intellectual, and psychological significance and seek to transcend ordinary experience.

One may even include museum visitors as pilgrims when certain conditions are met. This chapter mines the works of contemporary experts on pilgrimage, including Catherine Bell and Jonathan Z. Smith, to identify the criteria that help us understand Holocaust museums and exhibits as pilgrimage sites. In particular, this chapter examines the embodied and empirical aspects of visitors' ritualized movement in time and space within Yad Vashem and the Jewish Museum Berlin as well as the way in which museum visiting itself may function as a pilgrimage.

This is an important exercise because visitors to Yad Vashem and the Jewish Museum Berlin are encouraged to engage in certain ritual behaviors and to emerge from their experiences with a transformed identity or consciousness. These museums possess the power to initiate their visitors into a new sense of communal identity and to create a particular social self that resonates with their Holocaust narratives. One of the key criteria I have identified for determining whether or not a museum possesses ritual characteristics typical of sites of pilgrimage is a sacred quality that manifests itself spatially. This sacredness, however, as discussed by Smith in his seminal work, *To Take Place*, is not essentially but rather situationally significant. Smith argues that human attention and behavior imbue ritual objects and actions with sacred qualities: "A ritual object or action becomes sacred by having attention focused on it in a highly marked way. From such a point of view, there is nothing that is inherently sacred or profane. These are not substantive categories, but rather situational ones. Sacrality is, above all, a category of emplacement. . . . A sacred text is one that is used in a sacred place—nothing more is required." According to Smith, it is human engagement in ritual action that creates the sacred.[3]

A second criterion is that the visitors' experience of the museum possesses what Bell calls "ritual-like qualities." Bell agrees with Smith's approach to the sacred and adds two additional characteristics of ritualization. The first is that participants involved in a process of ritualization acknowledge that this process possesses a "special or privileged status" and "extra significance." The second is that participants perceive that a "more embracing authoritative order," characterized by greater "values and forces," underlies their ritual experience.[4] Yad Vashem exhibits this greater value in redemption through Zionism, while the Jewish Museum

What is a person's attached perception to the space

Berlin celebrates the multicultural society with its religious and ethnic tolerance.

A third criterion is the element of performance, which, as Bell points out, helps to effect "changes in people's perceptions and interpretations." An important part of the performative aspect of ritual has to do with framing—a concept first used by Gregory Bateson (1904–1980).[5] A frame separates and distinguishes the sacred from the profane, and the transcendent from the concrete. Carol Duncan argues, for example, that like temples and shrines, museums are "carefully marked off" from surrounding spaces in a ceremonial way and are "reserved for a particular form of contemplation" or "quality of attention." Architecture is one of the primary forms through which museums may engage participants on the level of performance by housing performative actions and practices, such as ritualistic visiting or commemorative ceremonies. Religion scholar Lindsay Jones offers a model for such work when he analyzes the "ritual-architectural events" that take place within certain spaces. He points to three aspects of architectural experience that justify such an approach—first, that our experience of architecture is largely collective rather than individual; second, that it is characterized by a range of wanderings and labyrinthine adventures; and third, that it is primarily a "synesthetic, integral" experience and only secondarily an "intellectual and interpretive" one.[6]

Most important, such an approach acknowledges the visitors' collective and social experience in space. A collective experience leads to the formation of group social memories, which reflect the dominant ideology of the museum. This ideology is "literalized" in the museum space so that visitors are drawn into performing its content through their spatial experience. Through this performance, visitors emerge transformed; they have been "shaped," as Jackie Feldman puts it, by the spaces through which they have moved, and they have experienced a collective transformation with other tourist-pilgrims.[7]

Ritual thus possesses the power to effect changes in consciousness. Choreographed passage, for example, initiates participants into social identities that reflect particular memorial narratives. A common way to designate a change in experience and consciousness is the manipulation of space and the creation of ritual passage. The movement of participants through marked-off spaces of significance was first analyzed in terms of ritualized transition by Arnold Van Gennep (1873–1957), author of the influential

study *The Rites of Passage* (1909). Van Gennep's singular contribution was the three-stage sequence of rites of passage, including rites of separation, rites of transition (liminal rites), and rites of incorporation. As he demonstrates, changes in spatial location or "territorial passage"—for example, passing through gates, doors, and arches—orchestrate real changes in social identity.[8]

Drawing on Van Gennep's three-stage sequence, Victor Turner (1920–1983) later focused on the transitional stages in rites of passage—the periods of ambiguity and liminality that he describes as "betwixt and between"—and the way in which these periods grant the ritual subject a new identity.[9] For Turner, each ritual possesses a "dominant symbol," which "encapsulates the major properties of the total ritual process." As the "smallest unit of ritual which still retains the specific properties of ritual behavior," symbols—and particularly dominant symbols—refer to "axiomatic values."[10] This chapter argues that rituals in Yad Vashem and the Jewish Museum Berlin are shaped by the dominant symbols underlying their narratives. The museums, furthermore, choreograph the ritual movement of their visitors to initiate them into social identities that resonate with their Holocaust narratives. In Yad Vashem the dominant symbol underlying its narrative is the homeland as an autochthonous space, and in the Jewish Museum Berlin this symbol is the past as a void and open wound.

Zionism and Pilgrimage on Har Hazikaron

The vehicle for Yad Vashem's Zionist narrative of redemption is the story of the traumatized Holocaust survivor who begins a new life in the State of Israel. The stark dichotomy between exile, suffering, and death in the Diaspora and redemption and renewal—indeed, rebirth—in the Jewish homeland underlies Yad Vashem's narrative. Through organized movement the museum seeks to create a ritual participant who will adopt its sacred narrative and Zionist ideology. Visitors to Yad Vashem experience the tragedy of the Holocaust but emerge triumphant in the knowledge that Israel alone can prevent another such crime against the Jewish people by bringing to an end the unnatural state of exile. Yad Vashem may display an overtly nationalistic agenda, but it does not merely glorify the state, repudiate the past, and engage in the rallying cry "Never Again!" Rather, Yad Vashem draws on ritual techniques and symbols to create a narrative that sanctifies the very

what about for Jews?
non
Rituals of Remembrance in Jerusalem and Berlin 187

process of homecoming and initiates visitors into a more elevated—and stronger—state of being.

Visitors' journeys through Yad Vashem draw on several aspects of the ritual process. Framing, for example, first appears with the separation of Yad Vashem as a sacred site from the profane space of its urban surroundings by means of architectural structures, including a screen wall at the entrance to the complex. Visitors cross a boundary and leave behind routine reality— this is the stage of ritual separation described by Van Gennep and Turner. The screen wall at Yad Vashem serves a second function: it initiates visitors into the Zionist narrative. As mentioned in chapter 3, the screen wall bears the following inscription: "I will put my breath into you and you shall live again, and I will set you upon your own soil" (Ezekiel 37:14). The lines preceding this verse (Ezekiel 37:11–12) read as follows: "And He said to me, 'O mortal, these bones are the whole House of Israel. They say, "Our bones are dried up, our hope is gone; we are doomed." Prophesy, therefore, and say to them: Thus said the Lord GOD: I am going to open your graves and lift you out of the graves, O My people, and bring you to the land of Israel.'"

In this passage, God instructs Ezekiel to prophesy over the dry bones of the House of Israel that lie about the valley of Jerusalem. Ezekiel speaks the prophecy, and God restores life to the bones; he commands sinews and flesh to grow on them and breath to enter them so that they come to life and stand on their feet as a "vast multitude." The words of Ezekiel 37:14 promise the Jewish people not only rebirth but an end to exile as well—a return to their own soil. With this verse Yad Vashem introduces the narrative of redemption and rebirth through Zionism as well as the dominant symbol of autochthony and homeland—expressed in the word "soil"—at the very moment of the visitors' arrival. All that is to follow within Yad Vashem's museum and memorial landscape appears here first in these words.

Beyond the screen wall and the pavilion (the *mevoah*), museum goers encounter a bridge of steel and wooden planks that give the sensation of fragility. The bridge leads to the side of the museum, where the building overhangs the mountain, and to a simple rectangular doorway, which visitors enter. Tilting downhill, this bridge literally enacts a descent into the mountain—a symbolic transition into the museum's Holocaust narrative. One sees here, in architectural form, Victor Turner's liminal phase, the "betwixt and between," in its first step.

FIG. 7.1 Entrance to Yad Vashem's Holocaust History Museum. Photograph by Rony Oren.

After entering the museum visitors face the south wall of the structure, a plain concrete expanse upon which Michal Rovner's scroll film is projected. Turning away from the film, visitors face the length of the museum's prism-shaped tunnel, the entirety of which is visible but not directly accessible due to its switchback-style that necessitates a winding horizontal path. The channels or ruptured canals in the floor that hold exhibits marking turning points in the Holocaust narrative block a more direct route through the museum and act as physical boundaries that enforce the museum's prescribed passageway through a series of galleries.

This controlled passage invariably leads to crowding and to a forced sense of communal experience. Crowding, so it seems, diminishes individuality. Visitors' perception, furthermore, is repeatedly manipulated through lighting and spatial techniques, fulfilling a condition of ritual as an event that produces real changes in perception. The museum is naturally but meagerly illuminated through a narrow strip of skylights at the apex of the triangular prism of the building. Weak shafts of natural light filter through these skylights and create an impression that one is moving through top-lit underground chambers, giving the museum a geologic or archaeological character.

Certain skylights give the impression of a negative image. A square skylight, for example, placed above the exhibit depicting the liquidation of the Warsaw Ghetto is almost completely blocked out with a concrete plate. The skylight appears at the top of a slanting concrete tower—a chimney-like space. The effect on visitors gazing upward is of a dark square blocking out the sun; around the square appears a thin rim of light that uncannily illuminates the concrete angles. This counters and destabilizes expectation and further alienates visitors from routine, quotidian perception. Throughout Yad Vashem, furthermore, there are no windows of any kind that might allow visitors a glimpse outside—this is a totally closed off and separate world, a microcosm in which they are hermetically contained. These conditions correspond to Turner's liminal stage, which he describes as similar "to death, to being in the womb, to invisibility, to darkness . . . to an eclipse of the sun or moon."[11]

The visitor also experiences changes in perception through subtle modulations in the museum's nearly six-hundred-foot longitudinal section, which constricts to its narrowest diameter at the exhibit on Auschwitz-Birkenau and thus echoes in space the theme of imprisonment, without, however, succumbing to the ill-conceived and ultimately trivializing attempt to reproduce the concentration camp experience. Here, restricted space merely deepens a resonance between visitors' sensory and cognitive experiences. Additional modulations appear in the floor and roof planes, which slant downward and then upward again, destabilizing visitors and creating a "haptic sense of down and up, dark and light, contraction and expansion, weight and suspension." As visitors approach the exhibit on Auschwitz, for example, the floor pitches downward five degrees to its lowest point. Yad Vashem's manipulation of visitors' proprioception illustrates Catherine Bell's argument that the ritual-like nature of performative activities (such as museum visiting) lies partially in its "multifaceted sensory experience."[12]

Specific spaces within Yad Vashem are particularly efficacious in terms of engaging visitors in a movement crafted to transform consciousness and to create a new social identity. As described in chapter 3, the architectonic structure of the *Hall of Names* creates an experiential connection between the recovery of Jewish victims through remembrance (a sacred act in Judaism) and the land of Israel. Visitors enter the *Hall of Names* on a platform that circles between the upper and lower cones. At the base of the lower cone, which is made of Jerusalem stone and descends into the bedrock of

the mountain, lies a dark pool of water that creates a ragged black circle and contains the diminutive, wavering reflection of the six hundred photographs contained in the upper cone. Visitors stand in the direct center of the circle against the glass barrier that prevents access to the downward-reaching excavated hole, alternately gazing upward at the photographs of victims and downward into the pool of water. They are thus encased by the two halves that, although separated by a space of approximately ten feet, are mirror images of each other and appear as two parts of a whole that belong together.

Visitors thus appear as mediators between the two halves and become spatially integrated into what Mircea Eliade famously describes as the axis mundi: the symbolic, mythical center of sacred space. As Eliade has shown, foundations of temples were traditionally built to descend deep into lower regions of the earth, thereby drawing on the symbolism of the center for their sacred language. The Temple of Jerusalem, for example, was supposedly built at the "navel of the Earth," from which the entire world unfolded.[13] Like the Temple, the *Hall of Names* draws on the symbolism of the center and, in particular, on the symbolism of autochthony through the basic elements of stone and water. The *Hall of Names*'s overall spatial configuration is symbolic of incorporation, in Van Gennep's language, as it integrates visitors into the narrative of Zionism through the link between autochthony and redemption (made possible through remembrance).

The *Hall of Names* presents Israel as the homeland of all Jewish Holocaust victims as well as a site of rebirth through Zionist return. A quotation inscribed on the wall at the entrance to the *Hall of Names* reads, "Remember [Zakhor] only that I was innocent / and, just like you, mortal on that day, / I, too, had had a face marked by rage, by pity and joy, / quite simply, a human face." The credit to these lines is "Benjamin Fondane, *Exodus*. Murdered at Auschwitz, 1944." The *Hall of Names* fulfills the command to remember: around the hall's outer edge, surrounding the platform on which visitors stand, are enormous shelves that hold binders containing the 2.5 million *Pages of Testimony* (brief biographies of Jewish victims) that have been thus far collected. The Hebrew word "Yizkor" (he shall remember) is inscribed on the binders. The visitors will notice that many of the shelves are empty; this space is reserved for the remaining 3.5 million names of Jewish victims yet to be collected. The *Hall of Names* thus shows visitors that the process of remembrance will continue indefinitely. The commemoration of Holocaust victims in the *Hall of Names* brings together religious and

Zionist strains of thought, and redemptive remembrance is framed both literally and metaphorically within a Zionist narrative.

Integration into a new Zionist identity reaches its completion as visitors exit the museum onto an outdoor terrace overlooking the Jerusalem hills, which are dramatically framed by the last great arch or doorway of the visitors' passage. This arch, similar to Yad Vashem's Holocaust History Museum as a whole, is fashioned from plain concrete; its sides slant inward and narrow toward the top and the arch frames the Jerusalem landscape like a painting. Gazing upward through a series of four concrete slats, visitors may view the open expanse of sky that was merely hinted at through skylights within the museum. It is here that the Zionist sacralization of land comes into its full visual and sensory power. Suddenly free of the dim lighting and tight spaces of the museum, visitors ascend the gently upward-sloping floor and emerge into full light. In this moment the visitors' integration into the Zionist ideology is complete.

Moshe Safdie explains his reasoning behind this dramatic exit as follows:

Years before, designing the *Children's Memorial* had given me an inkling of the power of emerging into light. It meant that life prevailed. For the new museum,

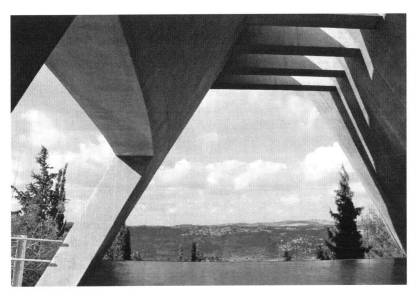

FIG. 7.2 Exit from Yad Vashem's Holocaust History Museum. Photograph by Rony Oren.

cutting through the mountains and bursting northward, dramatically cantilevering the structure over the Jerusalem pine forest to provide views of the hills beyond took this life-affirming experience to another level. To stand on the extended terrace, the side walls of the prism curving away from the site seemingly into infinity, and see the fresh green of the recently planted forest with its great sense of renewal and the urbanizing hills beyond is to understand that, indeed, life prevailed. We prevailed.[14]

Discursive emphasis on the "fresh green of the recently planted forest" and the landscape's "sense of renewal" sacralizes nature. Safdie echoes here a central Zionist theme that redemption will take place through land cultivation. The words "urbanizing hills," meanwhile, praise the process of building up the Israeli state and investing in its future, including welcoming new Israeli citizens who have made aliyah. With the words, "we prevailed," Safdie verbalizes the triumphalism of the physical exit and underscores the assertion that Jewish life continues, not in exile but in Israel. In contrast to existence in exile, which culminated in the Shoah, life in Israel will continue "seemingly into infinity." It was Safdie's intention, as Lisa Alcalay Klug puts it, to take visitors on a teleological journey "from darkness to light, from descent to elevation."[15] The final, expansive visual impression expresses the heart of Zionist ideology, which includes the recovery of the preexilic Jewish homeland and the rebirth of the Jewish people.

In addition to choreographed passage, symbolic objects within Yad Vashem's exhibits also contribute to the enactment of ritual. For example, the final gallery of the permanent exhibition focuses on Holocaust survivors reestablishing their lives after the war and emphasizes themes such as the United Nations resolution that led to the founding of Israel, the country's Declaration of Independence, the emigration of survivors to Israel, the kibbutzim, and the history of Zionism. Hanging across the gallery space are two large cloth banners that were used during memorial ceremonies in DP (Displaced Persons') camps in Germany. The mention of Amalek creates a link between the Holocaust and biblical tales of Jewish suffering and persecution; it inscribes the Holocaust into a specifically Jewish narrative. It also recalls Yosef Hayim Yerushalmi's argument, discussed in the introduction, concerning the Jewish custom of subsuming contemporary tragedies to familiar archetypes.

Nearby in the same gallery appears a chuppah, the canopy beneath which a Jewish couple stands during their wedding and which symbolizes

FIG. 7.3 Cloth banners used during memorial ceremonies in DP camps, Germany: "Remember what Amalek did to you!!!" and "Jews! Do not forget the victims among the Jewish people. Your participation in the unveiling of the memorial stones honors all 6,000,000 Jewish martyrs." Yad Vashem Artifacts Collection.

the home that the couple will build together, as well as open hospitality and the presence of God. The meaning of the chuppah in this context lies in its promise of a future; it symbolizes the creation of a new home in Israel for Jews and the presence of God in that home. Within this gallery visitors can hear the Israeli anthem "Hatikva" (The hope) playing; the song's words express the two-thousand-year-old Jewish longing for Jerusalem. The displays of the final gallery close the circle of Yad Vashem's narrative of passage from persecution and suffering to rebirth through aliyah. To be reborn in the homeland, the survivors of the Shoah had to go through a trial. The architecture of Yad Vashem imitates this trial with its ritual passage that begins by descending into a mountain and ends with the visitors' triumphant emergence onto a platform overlooking Jerusalem. Architectural structures as well as the manipulation of light, space, and objects contribute to evoke the three ritual stages and conclude with an incorporation of visitors into the museum's Zionist narrative.

The incorporation of an individual into a particular narrative and its underlying social community through ritual possesses, as Van Gennep argues, a political dimension; rites of passage carry political implications

when they act as the means for both changing and reconstituting groups, including religious associations as well as political or territorial communities. If rituals are capable of presenting a coherent worldview and ethos (such as Zionism) while contributing to the "processes of adaptation and renewal that constitute communities," then the political implications are significant—particularly in sites of contested memory.[16] The values that these rituals reinforce or even create, and the memories that they sanctify, may translate into real consequences for a country's political culture. In Israel, where the memory of the Holocaust has been much contested, reinterpreted, and influenced by political concerns and where Holocaust memory plays a major role in forging national identity as well as shaping political agendas, narratives of the Holocaust help to shape how communities conceive of themselves and their national histories.

The Museum as a Site of Pilgrimage

Religious temples and shrines are common destinations for pilgrims; recently, however, Holocaust sites have also emerged as popular sites of pilgrimage. David Martin Gitlitz and Linda Kay Davidson name three types of "shrines" to which Holocaust pilgrims travel: the places where killing and destruction took place, including ghettos, concentration camps, and death camps; monuments to the victims; and museums. As Gitlitz and Davidson demonstrate, commercially organized tours to Holocaust sites consistently describe their participants as "tourist-pilgrims"—travelers who leave behind the mundane time and geography of the present to "cross over to the land of our collective past" and engage in "pilgrimages of memory."[17]

A journey to a Holocaust site may function as a pilgrimage in a structural sense—that is, by imitating certain characteristics of traditional pilgrimage. Catherine Bell acknowledges the structural aspect when she writes that visits to historical sites like Auschwitz-Birkenau adopt the style of "religious pilgrimages." This applies even when such sites present the past in secular and historical rather than overtly sacred terms. Markers common to conventional pilgrimage destinations, such as clearly marked boundaries, arches, gates, or doorways, separate sacred from profane space and signal to visitors that they have entered a sacred space. Movement within enclosed spaces, furthermore, is carefully staged so that progression cannot be varied.[18] Finally, the journey is often accompanied by a defining narrative.

Holocaust museums often employ conventional strategies to establish sacredness, including burying beneath their structures soil from concentration camps or ashes of martyrs and keeping eternal flames as vigils. Through such strategies they create what Sybil Milton has called "secular shrines rooted in contemporary needs."[19] Ashes of Holocaust victims are buried in front of an eternal flame in Yad Vashem's Ohel Yizkor (Memorial Tent), for example. It is important to note that the Hebrew word "*ohel*" is biblical and distinct from the modern, secular word for hall: "*ulam*." The choice of a biblical word reveals a conscious decision to frame the physical site as sacred.

Yad Vashem and the Jewish Museum Berlin, however, move beyond such facile strategies for framing their visitors' journeys as pilgrimages. While no clear consensus exists on how to differentiate pilgrimage and tourism, most definitions agree that pilgrimage involves the subject's perception that the destination in question possesses sacred or sacred-like qualities separating it from ordinary life.[20] As Luigi Tomasi argues, while the form of pilgrimage has changed dramatically over time, the meaning has stayed the same: pilgrimage is "the typically human desire to seek out the sacred, though what symbolizes or articulates 'the sacred' today may be different from the past," since "every age has its own mode of relating to the sacred." At this juncture we might recall the perspicacious words of Herbert Muschamp: "In a century of shifting, elastic morality, the Holocaust stands out as something very close to firm. For a civilization that cannot agree on a standard of absolute good, Auschwitz asserts itself as an absolute evil. Perversely, it offers the foundation of a moral universe. It is an ethical base line, humanity's nadir." Although not sacred in a traditional sense, like the tomb of a holy man or a temple, Holocaust sites emerge as sacred because they offer something akin to a moral absolute, albeit in the form of a negative assertion as it is expressed in the ubiquitous "Never again!" motto of Holocaust memorial sites. This absolute moral imperative—a rare commodity in a postmodern world that shies away from absolutes, if not in practice at least in theory—fills what George Steiner has called the "vacuum" and the "central emptiness left by the erosion of theology."[21]

Despite a wide range of perspectives, contemporary works on pilgrimage invariably begin with discussions of Victor Turner's writings, the most important and influential on the subject to date.[22] Turner argues that pilgrimage sets itself apart from the everyday, stable, structured systems of social relations and offers the participant the possibility of social and

psychological transformation through liminality and communitas. Typical of liminal experience is a rearrangement of thought patterns that contributes to the development of a new social identity.[23] Although certain elements of Turner's theory of communitas have been challenged in recent scholarship, his basic approach and its political and social implications remain relevant for an analysis of museums.[24] The type of communitas present in the liminal stages of museum going falls into the category of what Turner calls "ideological" because it contributes to the creation of an idealized model of society.[25] In Yad Vashem this idealized society is the Jewish homeland framed by the Zionist ideal; in the Jewish Museum Berlin it is a multicultural society, tolerant of religious and ethnic difference. Although Yad Vashem and the Jewish Museum Berlin demonstrate different ideologies behind their Holocaust narratives, both rely on spatial and psychological techniques to effect ritual patterns of transformation in the consciousness of visitors.

Yad Vashem as a Site of Pilgrimage

Charles S. Liebman and Eliezer Don-Yehiya have defined civil religion as that which transmits the central values and worldview that dominate a society at a given time. The Israeli civil religion, they demonstrate, has established the Holocaust as the central and "primary political myth of Israeli society"; it is this myth, furthermore, that provides Israel with "legitimacy and the right to its land, Israel." In other words, the suffering of the Jewish people in exile and the final cataclysm of the Holocaust demonstrate the need of the Jews for their own state and provide the justification for national self-determination. The question of legitimacy goes hand in hand with Holocaust commemoration in Israel due to issues of contested space and land ownership, which underlie national consciousness and collective memory and influence memorialization practices. As Don Handelman and Lea Shamgar-Handelman point out, while citizens see themselves as emerging in natural, historical, or mythical ways from a particular landscape—and thereby belonging to it—such feelings and sensations of collective memory and identity are constructed and shaped through state practices. One of the key ways in which a state lays its claim to land is through the "placement and commemoration of national death"—for example, through cemeteries and memorials. Violent death plays a particularly important role in this context,

as it is often cast as a form of a "national sacrifice" that individuals make in the service of something greater.[26]

In the case of Israel, this "something greater" is the Jewish homeland. The decision to build Yad Vashem in close proximity to Mount Herzl's national cemetery, where Israeli heroes and soldiers are buried, establishes an "intimate link" between individual victims (both of the Holocaust and subsequent wars) and the national collectivity.[27] Landscape thus gives birth to national memory; here, again, the symbolism of autochthony and the land of Israel (Haaretz) unites the catastrophic past and the redemptive future into a sacred narrative.

As Israel's official institution of Holocaust commemoration, Yad Vashem embodies this narrative and acts as a sacred site within Israeli national geography. It emerges, therefore, as a major site of pilgrimage. Liebman and Don-Yehiya argue that Israel's current civil religion, the "New Civil Religion," maintains certain traces of Zionist socialism, which was the dominant civil religion of the Yishuv period and acted as a "religious surrogate."[28] This civil religion seeks to integrate and mobilize Israeli Jewish society and to legitimate the primary values of the political system, grounding them in a transcendent order of which the Jewish people and Jewish tradition are basic components. Essential is the idea of the Jewish people as a *national* group sharing a common history and fate, dispersed throughout the world but looking to the State of Israel as the place of its future reunification.

A second important aspect of Israeli civil religion is the concept of the Jewish people as "a people that dwells apart, / Not reckoned among the nations" (Numbers 23:9)—in other words, as a people that is isolated, vulnerable, and dependent on its own resources. In this context, the Holocaust acts as a symbol of Jewish history; in Liebman and Don-Yehiya's words, the Holocaust is the "tragedy that may befall a people that dwells alone."[29] The Holocaust demonstrates, simply put, the disastrous consequences of Jewish reliance on foreign nations for protection. The past thus legitimizes the Jewish people's right to its own land on religious as well as moral grounds.

The civil religion of Israel as depicted in Yad Vashem incorporates into its narrative the dialectical link between destruction and redemption. This connection appears in the more extended memorial landscape of Jerusalem as well. As Doron Bar argues, the decision to place the Holocaust Cellar (Martef ha-Shoah) on Mount Zion carries symbolic meaning for geographic reasons. The Ministry of Religious Affairs viewed Mount Zion

as a "symbolic continuum of Mount Moriah" (the eastern-lying site of the Akedah). Mount Zion, furthermore, is regarded as the burial site of King David—an important figure for nonexilic Jewish history and especially for the Zionist concept of kingdom. The location of the Holocaust Cellar, therefore, binds together Holocaust remembrance with both King David's tomb and the site of the Akedah. The ministry's choice of Mount Zion as the site for the Holocaust Cellar thus "emphasized the link between destruction and redemption in the history of the Jewish people."[30]

As a religious surrogate, the Yishuv's civil religion of Zionist social-ism assimilated into its ideology certain elements of traditional Judaism through a secularized model. Zionist socialism secularized, for example, the Jewish concept of messianism, "transforming it into a vision of sociopo-litical redemption to be realized by natural rather than supernatural means." The natural means of redemption was the return of the Jews to their own land and thus an end to the unnatural state of exile. The three dominant values of Zionist socialism reveal this vision. The first is *Haluziut* (pioneer-ing), which epitomizes the forces of renewal and change. Haluziut paves the way for national redemption, furthermore, by acting as the bearer of the national mission and capturing the spirit of the Jews of the future—a type of Jew that Yosef Haim Brenner called "a new type among the children of Israel." This new Jewish role model was physically strong and bound to the land, and in every way embodied the idealized vision of a child of the earth. The second value of Zionist socialism, which emerges from the first, is labor—a quasi-ritualistic act requiring absolute devotion and the basis of national redemption and personal fulfillment.[31]

The third and final value of Zionist socialism, and an essential value for an analysis of Yad Vashem, is the redemption and sanctification of the land, which includes the sanctification of agricultural labor as well as the bond between humans and nature.[32] This value emphasizes life on the land as redemptive and renewing; a recurrent metaphor in Zionist-socialist lit-erature is that of the uprooted plant returning to the soil of the homeland, striking roots and blossoming anew. Today, redemption through the sancti-fication of the land continues to play a central role in Israeli Holocaust nar-ratives, as demonstrated in Safdie's final triumphant exit from Yad Vashem onto the viewing platform over Jerusalem's pine forests. Underlying Zion-ist socialism and appearing throughout Yad Vashem's memorial complex as a reflection of Israel's New Civil Religion are the diametrically opposed

symbols of exile and redemption. These symbols emphasize that the antithesis to an exilic way of life (beset by danger and persecution) is life in the Jewish homeland.[33]

The mythical geography of Zionism and its connection to pilgrimage are essential aspects of Zionist socialism that persist in Israel's civil religion today. One of the goals of Zionist socialism was the recovery of preexilic Jewish history through a rediscovery of mythical sites from the period of the Second Temple (Second Commonwealth), which could serve as both a model and a legacy. This focus on preexilic sites, as Maoz Azaryahu and Aharon Kellerman argue, aimed at "establishing a territorial base for nationhood. . . . It also produced a new geography of national memory that represented the Zionist myth of return in the landscape of the emerging homeland." Pilgrimage to these sites evoked images and sensations of *Yisraeliut* (Israeli nativism) through a historical and mythical connection to the land, conflating, in short, Jewish history with Zionist revival. The recovery of mythical sites was particularly important due to their preexilic nature; they were, therefore, symbolic of what Zionists view as the natural—rather than exilic—condition of the Jewish people. Through the veneration of these sites, the history of exile was rejected and a history "directly linked to the territory of the newly arising homeland" was strengthened.[34]

Organized pilgrimage to sites significant to Zionist socialism, including Tel-Hai, Modi'in, and Massada, began in the 1930s under the leadership of Shmaria Guttman and colleagues in the leftist pioneering youth movements. Pilgrims journeying to Massada, for example, would cross the desert, climb the mountain, and, upon reaching the top where the infamous mass suicide took place, read the text by Josephus describing Massada's last moments. This act of climbing the mountain, furthermore, ritually enacts aliyah. An important shift occurred in 1949 with the establishment of the national cemetery on Mount Herzl as the "symbolic epicentre of the restored Israeli nationhood." This symbolic function deepened with the building of Yad Vashem in the immediate vicinity shortly thereafter.[35] Named for Theodor Herzl, father of modern political Zionism, the cemetery is the burial site for soldiers as well as national figures, including Herzl, Levi Eshkol, Golda Meir, Yitzhak Rabin, and Hannah Senesh.

The shift to Mount Herzl as the sacred center of Jewish national geography was completed in ritual form toward the end of 1949, during a Hanukkah ceremony and its accompanying "beacons of heroism" run, in which

runners carrying beacons kindled at different symbolic locations, each representing a heroic moment in Jewish history and Zionist restoration, "converged at Herzl's tomb."[36] Sites where the deaths of nationally significant figures are commemorated—such as Herzl's tomb—play important roles in claims of land ownership and belonging and are therefore particularly significant in nations where space is contested.[37] The decision, therefore, to place Yad Vashem on Har Hazikaron, at the foot of Mount Herzl, meant inscribing Yad Vashem and its Holocaust narrative into the very heart of Israel's sanctified landscape.

The cultural significance of pilgrimage to sacred sites continues in Israel. In June 1997, for example, the Israeli Ministry of Education declared that every Israeli pupil should visit at least once the Western Wall, Yad Vashem, Mount Herzl, and Massada. Such sites, as Azaryahu and Kellerman have shown, become incorporated into Israel's sacred geography through ritual activities as well as through symbolic architecture.[38] Yad Vashem has emerged as a site of pilgrimage through both of these conditions. The central ceremonies commemorating Holocaust Remembrance Day (Yom Hashoah) take place at Yad Vashem, and foreign dignitaries are taken to Yad Vashem upon arrival in Israel. Students and army recruits visit Yad Vashem as well; for soldiers the visit is particularly important, acting as it does as a rite of passage and a necessary initiation for those responsible for defending Israel.

A path connecting Yad Vashem and Mount Herzl emphasizes the link between these two sites and visually depicts the way in which Yad Vashem partakes of Israel's geography of national mythology. The path, built by those in youth movements, opened in April 2003 to mark the sixtieth anniversary of the Warsaw Ghetto uprising, and an inauguration took place on April 22, 2004, to dedicate the *Netzer Aharon*, the "last offshoot" memorial. The *Netzer Aharon*, designed by Micha Ullman, commemorates those soldiers who were the last survivors of families ravaged by the Holocaust and who died in one of Israel's wars.[39]

At the inauguration fifteen hundred youths marched from the *Valley of the Communities* past the *Memorial to the Deportees* and up the hill along the new path toward the Mount Herzl cemetery.[40] This march, Jackie Feldman writes, acted as a ritual procession that consecrated the path: "The physical climb (*aliyah*) embodies the act of immigration (*aliyah*) of the Jews on their way from Holocaust-land to homeland." A teleological narrative is thus played out through the path; through this march Yad Vashem's

Zionist narrative is integrated into the contours of the landscape, and a link is forged between those who died in the Holocaust and those who died in Israeli wars—both categories of victims having sacrificed, the path suggests, their lives for the state.[41]

As Yael Padan has argued, furthermore, the political (or civil) religion of Israel depends on "holy sites" to serve as the "physical manifestations" of that religion and to give Israelis a place they may visit as pilgrims as well as a place where they may experience a sense of collective identity.[42] Yad Vashem fulfills each of these purposes; its physical proximity on Har Hazikaron to Mount Herzl and the national cemetery—a proximity strengthened by the connecting path described earlier—inscribes the memorial complex into Israel's nationalist narrative. Yad Vashem's location also frames the memorialization of Holocaust victims within the dialectic of destruction in exile and redemption through homecoming. Ascending Har Hazikaron and journeying through Yad Vashem, tourist-pilgrims undergo a quasi aliyah; they are initiated into a narrative rooted in the landscape and in the symbolism of autochthony, which leads them—if the journey is successful—into a state of mind that recognizes Israel's legitimacy as the redemptive solution to the problem of exile. The landscape of Yad Vashem promises renewal and rebirth, and in the language of Turner, the initiate is welcomed into an idealized society—a communitas—of new beginnings based on ancient promises, including the one that greets visitors at Yad Vashem's front gate: "I will put my breath into you and you shall live again, and I will set you upon your own soil" (Ezekiel 37:14).

Rites of Passage in the Jewish Museum Berlin: Encountering the Void

The Jewish Museum Berlin, in contrast to Yad Vashem, is not conspicuously separated from its urban context; the city streets that lead tourists to this museum are bustling with passersby and traffic. The act of separation—the first stage of Van Gennep's theory of ritual experience—does not take place until visitors enter the museum itself. The museum must therefore rely on a range of techniques to communicate to visitors the idea that by crossing its threshold, they are entering a space qualitatively different from the surrounding urban context.

In the Jewish Museum Berlin the greater value underlying its Holocaust narrative is a multicultural society that embraces religious and ethnic tolerance; the dominant symbol framing the ritual narrative of the museum's architecture (but not the narrative of its permanent exhibition) is the past as a void and open wound. The ritual experience of visitors within the architecture of the Jewish Museum Berlin initiates an encounter with absence, dislocation, and voided space. Unlike Yad Vashem, whose ritual narrative is rooted in an almost mystical symbolism of autochthony, sanctified land, and presence, the ritual narrative of the Jewish Museum Berlin is essentially negative and rooted in absence.

A second important contrast between Yad Vashem and the Jewish Museum Berlin lies in the kind of narrative structure that is presented. Yad Vashem presents a clearly teleological narrative that achieves its climax with a visceral moment of insight into the Zionist idealization of the Israeli landscape. A coherent narrative in the Jewish Museum Berlin, however, is repeatedly disturbed and disrupted through architectural technique—namely, through sudden twists and turns, slanted halls, and, most important, voided spaces. As Eric Kligerman points out, the Jewish Museum Berlin is "interspersed with pitfalls that break off any linear act of . . . walking" as its unsettling design prevents visitors from immersing themselves in the permanent exhibition.[43] Such spaces, furthermore, suggest gaps in the presentation of German Jewish history itself; that is, voided spaces—like the Holocaust Tower, for example—not only interrupt the historical narrative but also reveal an already dislocated history beset by caesurae, false turns, setbacks, and broken beginnings.

Jackie Feldman has persuasively argued that "the challenge of memorial places is to shape the experience of visitors in ways that make the absence of particular presences into the presence of absence—to conjure up familiar spirits of the past while exorcising others."[44] This argument holds especially true for the Jewish Museum Berlin. This is a structure erected, quite literally, around an absence that can never be made whole and that prevents any totalizing or monumentalizing reading.[45] One of the most insightful responses to Libeskind's structure, at least in the mind of this reader, is Mark C. Taylor's unexpected essay "Point of No Return," in which he offers a subtle, at times paradoxical, reading of the museum's voided architecture. Taylor describes Libeskind's extension as a "museum haunted by emptiness," due to the fact that one-third of the structure consists in fact of voided

space. But Taylor goes further and challenges the very limits of concepts such as emptiness, form, and presence:

> This void remains void . . . useless, nonfunctional, excessive. . . . The line of the supplement is neither direct nor straight, but zigzags in a play of Z's and reversed Z's that recalls, without representing, the unnameable point of no return, which sometimes is named *zim zum*. The aberrant line of Z's plotting the course of Berlin's deviant history is not unbroken, but is faulted, fissured, fragmented . . . torn, frayed, rent by a void which is not itself whole. Forever rent, emptiness rends every structure constructed to contain it. From the outside, the addition to the Berlin Museum appears to be a continuous building. But appearances are deceptive, for the structure is inwardly divided. The broken line of the void cuts the convoluted line of the museum to form what are, in effect, seven separate structures. While intricately related, these parts, Libeskind explains, never have and never will form a totality.[46]

As Gershom Scholem explains, *tzimtzum* (or *tsimtsum*), in Lurianic Kabbalah, is the "self-limitation of God"—a moment of contraction, exile, and self-banishment during which he "becomes more and more hidden" by withdrawing into himself. This self-contraction "ushers in the cosmic drama"; it creates a "pneumatic, primordial space" and "makes possible the existence of something other than God and His pure essence."[47] It is at once a moment of negation and creation—a withdrawal into absence that gives birth to presence. This metaphor of the tzimtzum (Taylor's "*zim zum*") captures the tension underlying the visitors' passage through the Jewish Museum Berlin's architecture—a passage experienced as a tension between withdrawal and creation, absence and presence. This tension points, finally, toward that "unnameable point of no return"—the moment of emptiness that, as Taylor writes, "like God . . . has no name." Yet might this emptiness yield—instead of simply nothing—"something else . . . something other . . . which, though no thing, is not nothing?"[48] Here it is worthwhile to recall the name of Libeskind's design, *Between the Lines* and to suggest that what lies "between the lines," that is, between the two lines of thought that traverse Libeskind's design, is indeed emptiness, but the emptiness of tzimtzum and therefore an emptiness pregnant with potential and open to creation.

Fissure and fragmentation, Taylor further notes, characterize the Jewish Museum Berlin in terms of its overall structure. The museum lacks a sense of

totality or the ability to form a coherent whole; its individual structures—the E.T.A. Hoffmann Garden, the Holocaust Tower, and the Paul Celan Courtyard—remain divided from one another and prevent the emergence of a unified structure or system. This architectural dynamic corresponds to Berlin's "deviant history," which is itself characterized by fragmentation, caesura, and rupture. Refusing to present an architectural totality prevents the permanent exhibition from (falsely) persuading visitors that German Jewish history constitutes a comprehensive, intact, linear narrative.

The dominant concepts that shape visitor experience within the Jewish Museum Berlin are the void, absence, loss, and rupture at the heart of the German Jewish past as well as the pedagogical and ethical possibilities of the visitors' recognition of this void in the interest of creating a better Germany. While voids and absences are inscribed into the architecture of the museum, the ethical imperative to cultivate a multicultural society tolerant of religious and ethnic difference appears didactically in the final exhibits of the permanent exhibition.

Physical passage through the Jewish Museum Berlin displays distinct ritual elements even if the visit cannot be reduced to a ritual in a strict sense (as in Yad Vashem). The reason for identifying and discussing ritual elements—however fragmented—is that these contribute, I believe, to Libeskind's stated purpose of initiating visitors via passage through the museum's spaces into subjects who are not merely cognitively but viscerally aware of the irrevocable trauma of the Holocaust. The ritual movement in space—both signifying and effecting changes in visitor consciousness—occurs in several places in the Jewish Museum Berlin. In its basic design the plan for the Libeskind building, derived from the geometry of a Star of David, is labyrinthine in structure.[49] Its mazelike nature, however, is not immediately discernible upon entering the museum, which visitors do through the former courthouse that now houses the Jewish Museum café, bookstore, and guest reception areas. With its straight lines and predictable angles, the former courthouse acts as the stable and safe initial space. The real "encounter" between the visitors and the building, in Libeskind's sense of the word, begins once they have descended a flight of stairs that is set at an angle to the former courthouse and leads down more than thirty feet into the lower level of the museum. This descent recalls Turner's stage of separation—a state of transition into liminal space and a departure from traditional expectations.

At the bottom of the steep staircase visitors find themselves in the subterranean section of the museum as they enter gray intersecting corridors that evoke city streets. The corridors are illuminated by lighting bands that run the length of the ceiling and cause perspectival distortion so that the corridors appear to narrow in the distance toward a vanishing point. Each of the slightly rising and tilting "underground roads," or axes, corresponds to one of the aspects of German Jewish experience during the years of National Socialism. The axis that leads straight ahead, inclining gently upward, is the Axis of Continuity. This axis leads visitors via a staircase to the permanent exhibition. The other two corridors, the Axis of Exile and the Axis of the Holocaust, lead to alternative destinations. These corridors do not carry single names in imitation of streets but rather a multitude of names, which is echoed upstairs with the display of the *Gedenkbuch* (memorial book) of German Jewish Holocaust victims. The Axis of Exile, which bears the names of cities in which German Jewish émigrés sought refuge (such as Chicago, Copenhagen, and Zurich), leads to the E.T.A. Hoffmann Garden of Exile and Emigration. The Axis of the Holocaust, inscribed with the names of concentration camps and ghettos such as Theresienstadt, Bergen-Belsen, and Auschwitz, leads to the Holocaust Tower, which Libeskind describes as "the end of the Museum. The end of all museums [since] the Holocaust represents the extermination of all values."[50]

Passages such as these produce a special condition in which, as Van Gennep puts it, the ritual actor "wavers between two worlds."[51] The transitional spaces of two staircases and three axes suggest parallels with Victor Turner's liminal stage—the ritual moment when initiates are suspended in a "limbo of statuslessness" and are temporally trapped in a "moment in and out of time."[52] One hovers in a liminal state, becoming, so to speak, a tabula rasa and thus inhabiting an unstable state of being. Cut off from their past but not yet incorporated into a new grouping or identity, visitors experience disorientation.

Though more subtly than in Yad Vashem, ritual passage in the Jewish Museum Berlin still alters the consciousness of its visitors. Having descended the staircase and entered the space where the three corridors branch off, visitors begin to experience disturbances in perception. As Janet Ward notes, Libeskind's building enacts a process of "diagonal fissuring," splitting space into fragmented and dislocated pieces. The tilting axes or corridors are designed to rise and fall slightly at varying angles—just

enough to jolt visitors with a sense of instability and disorientation. In original design plans, spatial distortion was much more extreme, as space itself was negated to the point of causing what John Knesl calls an "enormous *angst*." In the Jewish Museum Berlin, Knesl argues, "space is reduced to a sluice, an ever-tightening passage occluded by fragmentary cross walls trying in vain to open up, to make some space. Also in section and elevation, space is squeezed to almost nothing between the ground floor and the consistently held horizontal roof line. . . . Inclined walls destabilize the perception of verticality. . . . Walls move in on the repetitious horizontal planes, taking away their breathing space. . . . The space around the body is cut up by these aggressive planes and lines, the body is squeezed, the walls close in from all sides."[53]

Although not realized in real space to the same degree as in the original plans, the halls of the Jewish Museum Berlin are still narrow, labyrinthine, and diagonal so that visitors are uncertain of where to begin or where to end. This method diametrically opposes that of Yad Vashem in terms of the structure of its initiatory passage. What is rigidly controlled and enforced at Yad Vashem is here left open and indeterminate.

As indicated earlier, the Axis of Exile ends in the E.T.A. Hoffmann Garden of Exile and Emigration. This outdoor garden contains forty-nine concrete columns in a rigid grid-like pattern. Forty-eight of the columns are filled with earth from Berlin, signifying the birth of Israel in 1948, and the forty-ninth column, standing for Berlin, is filled with earth from Jerusalem. The columns are placed at a ninety-degree angle to the paved ground, which is itself tilted at two angles and composed of varying sizes of stone. The columns are each twenty-three feet high and stand three feet apart. Olive trees—biblical symbols of peace—grow from the tops of the columns, creating an upside-down garden of paradoxical expectations. The columns incline slightly in a single direction, creating a slightly dizzying, labyrinthine effect. As visitors step onto the sloping surface of the garden floor, the pitched angles create a sense of visceral instability. The sensations of disorientation and unsteadiness should mirror the experience of being suddenly cast into exile, where everything familiar and comforting is at once inverted and destabilized. The ramp leading to the garden itself is built of Jerusalem stone, and the inside glass wall of the border contains sand from Israel's deserts.

By evoking feelings symptomatic of the experience of exile, the E.T.A. Hoffmann Garden acts as a liminal space. Shifts in visitors' perception

also take place through architectural techniques that break up and disrupt vision. At the top of the staircase leading to the permanent exhibition, natural light enters through windows in contrast to the artificial light of the axes below. Two cruciform windows at ground level produce sensations of isolation and claustrophobia due to the fact, Richard Patterson notes, that the "glazing of these openings is flush with the inner face of the wall and this, along with the narrowness of their shape, requires one to peer at the exterior."[54] Gazing outward in this way means really gazing inward and catching glimpses of the exterior wall of the museum itself.

Within the permanent exhibition, Libeskind's design continues to startle visitors with its sharp angles, sudden twists and turns, and eccentric window bands that trace in light jagged edges and angles on walls, suddenly ending and beginning again and creating unusual geometric patterns. In contrast to the windowless Yad Vashem, the windows here allow traces of uneven light to infiltrate, hinting perhaps at the possibility of temporary escape from tight, isolated, even claustrophobic spaces while simultaneously denying a substantially orienting gaze. As Bernhard Schneider argues, "Neither in the window or slit through which we gaze . . . do we find the points of reference familiar from conventional buildings, by which we judge distances and dimensions, and see an obvious conformance between inside and out. Thus our perception of space and structure, and of our own vantage point, is no longer a matter of course—it becomes a new experience."[55] Additional windows that are directed inward toward the core of the museum—cut into the exterior walls of the voids—reveal only the darkness of inaccessible spaces and contribute to an overall sensation of entombment.

As visitors leave the main exhibit on the Holocaust they pass through two halls that include exhibits on Anne Frank, a video of Holocaust perpetrators entering the Frankfurt am Main courthouse where the Frankfurt Auschwitz Trial took place, and a videotaped interview with Hannah Arendt. These exhibits are spare and include large blank expanses of unused wall space that suggest the erasure or inaccessibility of the past. Triangles appear throughout museum spaces—for example, in the angles caused by crisscrossing beams overhead. These triangles break up the visual space of the museum and force viewers to psychically confront unsettling shapes and angles. Accustomed to more traditional museum spaces that reassure by means of predictable angles, straight lines, and square or rectangular windows, visitors experience anxiety or uncanny feelings as a result of these unusual angles.

The ritual technique of framing as an aid in the creation of a complete and condensed—if artificial—world is used ironically in the Jewish Museum Berlin in contrast to Yad Vashem, where framing contributes to the presentation of a cosmic drama enacted through a unified and sustained architectural narrative. Framing in Yad Vashem helps visitors understand the redemptive ritual of homecoming. In the Jewish Museum Berlin, however, framing performs an ironic function by setting up and then undermining expectations. When entering Yad Vashem, visitors are confronted with a series of structures: these are logically consistent and build on one another in a progressive manner. The screen wall, for instance, naturally yields to the pavilion, sharing as they do the same concrete material and style of spaced columns. The pavilion transitions, in turn, to the Holocaust History Museum, which is also built of exposed concrete but is closed and dense compared to the airy and open structures of its preceding counterparts. This progression of linked structures clearly sets up a microcosmic ritual space that is internally consistent—a world within a world that follows a designated aesthetic.

In contrast, when approaching the Jewish Museum Berlin, visitors encounter radical disjunction in terms of style and structure. They cannot enter the Libeskind building directly; the zinc-clad cement and steel facade is closed and impenetrable. Ambiguity replaces consistency, and the striking visual contrast between Libeskind's extension and the former courthouse undermines the possibility of a unified framework. Entering through the former courthouse enacts a process of distancing; it presents a double frame around the story of German Jewish history. This double frame points to what visitors cannot fail to notice throughout the museum: the fact that two distinct narratives are being related in this space—the first through the architecture, which tells a story of absence and loss, fragmentation, and disorientation; and the second through the exhibits, which suggest continuity and comprehensibility. Although the exhibits are conventional in their chronological narrative, movement throughout the exhibits does not follow a straight narrative path but rather zigzags through irregularly shaped rooms with sharp turns in the path. Ritually speaking, the uncertainty created through the structure of the double frame, along with the already mentioned triple-axis division of the lower level and the zigzagging movement, contribute to feelings of disorientation characteristic of the liminal stage.

Within the narrative of the exhibits, symbolic objects play an important role for the incorporation of visitors into a positive, future-oriented

multicultural ideology. The museum's final exhibit, for example, appears in a green-carpeted, green-walled room filled with poles, on top of which sit white boxes lit from within. The exhibit is titled *Jüdische Kindheit und Jugend in Deutschland, Österreich, und der Schweiz seit 1945* (*Jewish Childhood and Youth in Germany, Austria, and Switzerland since 1945*). Each of the boxes displays photographs of Jewish individuals and families who live in German-speaking countries. Using the supplied headphones, visitors can listen to their stories in German or English. Written in large letters on the first box are the words, *So einfach war das* (*It was as simple as that*). The message of this exhibit is that life continues for Jews in German-speaking countries and that a better future is already in progress. The Jewish German, Austrian, and Swiss individuals in this exhibit are citizens who are successfully integrated into their countries.[56] Their narratives appear to offer a resolution to the problem of how to retroactively integrate Jews into German-speaking countries. An awareness of this problem repeatedly surfaces throughout the permanent exhibition. Well-known and easily recognizable Jewish personalities (such as Moses Mendelssohn) are displayed prominently on red columns at various points throughout the museum, for example. These figures are framed as models for the success Jews could achieve in German culture and society at different stages throughout history.[57] They act as points of stability, anchoring the vagaries of history in positive images of an ostensibly symbiotic German-Jewish relationship.

A second example of a symbolically significant object in the permanent exhibition is the baptismal bowl (*Taufschale*) engraved with the name of Moses Mendelssohn's grandson, which appears in an exhibit on Mendelssohn and the Enlightenment. The display does not adequately explain that the Enlightenment was actually a time of crisis for some Jews because it led to conversions and thereby to the loss of Jewish community and tradition. Within the museum's narrative about German Jews, the baptismal bowl—like the red columns—contributes to a largely positive model of multicultural integration and assimilation. As part of a ritual trajectory aimed toward the incorporation of visitors into a vision of tolerant multiculturalism, the baptismal bowl points backward and suggests that here already can be found hints of a successful model.

The final phase of ritual incorporation appears in its most direct form in the Jewish Museum Berlin's final exhibit on contemporary German-speaking Jewish communities, as already discussed. This exhibit completes

the process by which visitors are initiated into a political and social consciousness based on the tolerance of ethnic and religious diversity, the support of minority rights, and the promotion of Germany as an emerging multicultural society. This agenda is furthered through additional exhibits at the end of the permanent exhibition. These ask visitors to engage with questions of contemporary minority issues in Germany, including laws concerning citizenship rights for the children of Turkish immigrants. There are two problematic aspects to the presentation of this agenda: first, the museum's permanent exhibition suggests that the first traces of such a model of successful multiculturalism may already be glimpsed in the pre-Holocaust relations between non-Jewish and Jewish Germans, and second, this model implies a solution—and thus a sense of closure—regarding the past. The permanent exhibition thus neglects to adequately address both the extent to which Jewish assimilation and integration failed and the fact that this failure resulted in a loss that—despite all efforts—can never be made whole again.

Undermining the permanent exhibition's agenda is the museum's architecture, which intentionally preserves the open wound of the past and resists incorporating visitors into a closed, comprehensive narrative with an optimistic outlook. The agent that the architecture seeks to create is one who remains aware of the catastrophic past and who refuses a totalizing solution to or "correction" of that past. Visitors encounter, for example, voided spaces; disoriented, they are forced to deal psychically with visual irregularities that disrupt normal, reassuring perception. They confront ironic framing as well, which undermines traditional expectations. The Jewish Museum Berlin's architecture and its permanent exhibition, therefore, conflict in terms of the subjects they seek to create and the social identities into which they seek to integrate their visitors.

Antipilgrimage to the Jewish Museum Berlin

The Jewish Museum Berlin emerges as a site of pilgrimage due not only to its quasi-sacred agenda of memorializing the dead but also to its physical proximity to other memory sites that commemorate Germany's victims. In contrast to Yad Vashem, which is associated geographically with a site that evokes images of national heroism and sacrifice, the Jewish Museum Berlin appears within an emerging "memory district" in Berlin that is dedicated

to national guilt and the commemoration of Germany's own victims—the first such space in a national capital. This memory district consists of the Jewish Museum Berlin; *Das Denkmal an die ermordeten Juden Europas* (*Memorial to the Murdered Jews of Europe*), designed by Peter Eisenman; and the new Topographie des Terrors (Topography of Terror Documentation Center). Karen Till argues that such a centralized memory district turns memory itself into a tourist destination and offers its tourists "public acts of atonement, mourning, and healing."[58]

The shift toward a centralization of memory in Berlin began after the reunification of Germany; until then, memorials were regionally based and historically situated. The establishment of centralized memorials to Germany's victims in Berlin has been beset by conflict and debate since discussions began, including arguments over the *Neue Wache*, rededicated in 1993 as the *Central Memorial of the Federal Republic of Germany for the Victims of War and Tyranny* and featuring a Käthe Kollwitz sculpture that, due to its pietà theme, was viewed by some critics as unsuitable for the memorialization of Jewish victims.[59] Debates became particularly intense over what would become Eisenman's *Memorial to the Murdered Jews of Europe*, a project spearheaded by journalist Lea Rosh. The first design competition for the memorial resulted in the submission of designs so bizarre that Henryk Broder described them as "a quarry for anthropologists, psychologists, and behaviorists" interested in examining the "condition of a confused nation that wants to create a monument to its victims in order to purify itself."[60]

The difficulty in finding suitable symbols with which to memorialize the victims of Germany's violent past is partly due to the fact that since the war, Germany has been forced to deal with what Jürgen Habermas describes as a "double past"—the psychological burden of two totalitarian regimes that still needs to be worked through. The reunification of Germany thus became not just a political and economic event but also a struggle over symbols. This process unfolded with the nation's *Erinnerungslandschaft* (memory landscape), which includes not only architectural landmarks and monuments but also more mundane spaces like public squares.[61] Within this Erinnerungslandschaft, specific sites of memory such as the *Memorial to the Murdered Jews of Europe* and the Jewish Museum Berlin have emerged as sites of pilgrimage (or antipilgrimage). Visitors and pilgrims journey to these sites to experience an encounter with the darkest hour—the very nadir—of German history and to mourn the victims. Such centralized

institutions of memory contribute to the effort to shape national memory, while also serving as destinations for visitors and pilgrims, but the process of deciding what Germany's national memory should look like is still necessarily contentious.[62]

The memorialization of the victims of National Socialism became increasingly popular during the 1970s and 1980s and shifted from a general focus on victims of fascism to the commemoration of Jewish victims. Artists who create countermonuments like Horst Hoheisel, Jochen Gerz, and Esther Shalev-Gerz, seek to distinguish their memory projects from traditional memorials and monuments, which suggest redemption and permanence. As James E. Young has argued in his analysis of countermonuments, such monuments are "brazen, painfully self-conscious memorial spaces conceived to challenge the very premises of their being."[63] Countermonuments seek to change the way that the past is remembered; they employ techniques such as negative forms and the representation of absence and rely on audience participation to complete their memorial acts. An individual's journey to a countermonument might be considered a kind of antipilgrimage in the sense that although the trip emerges from a desire to experience a sacred reality with a significance that distinguishes it from everyday life, the purpose is not—as is the case with traditional pilgrimage—to acquire spiritual, emotional, or physical healing or benefit. The meaning of the countermonument, furthermore, is fundamentally ambiguous, self-reflective, and often ironic in contrast to monuments that exhibit static, unequivocal meaning, such as Berlin's *Brandenburger Tor* (Brandenburg gate) or *Siegessäule* (Victory column).

The Jewish Museum Berlin, whose architecture suggests a countermonument sensibility, emerges as a split being—a Janus figure with one face directed backward like Walter Benjamin's Angel of History toward the unmanageable ruins of the past, while the other looks forward toward a future that Jörn Rüsen describes as "committed to the categorical consequence of the Holocaust"—namely, that it should never happen again. The model of such a society, in which another Holocaust could conceivably never again take place, is the tolerant, multicultural, multiethnic society depicted in the museum's permanent exhibition. The Jewish Museum Berlin therefore illustrates what Caroline Pearce calls the "dialectic of normality" in Germany's memory culture: a conflict between the perceived need for remembrance and the desire for a normalization of the past.[64] Visiting the

museum, therefore, cannot be viewed exclusively as an act of atonement or mourning. But neither is it simply a search for a usable past through a coherent narrative. Pilgrimage to the Jewish Museum Berlin is conflicted and, like the museum itself, torn between two different psychological needs: mourning and atonement on the one hand, and closure and normalization on the other—leading to the question of whether one is perhaps a condition for the other.

The sitedness of the Jewish Museum Berlin, furthermore, and its physical and conceptual ties to the city, strengthens its potential as a place of (anti-)pilgrimage. Stanley Allen has written that the Jewish Museum project "erupts out of the fissured condition of the city," suggesting an almost inevitable relationship of the building to its environment.[65] As already described, the Jewish Museum Berlin is located at the intersection of two lines of a Star of David that Libeskind formed using the addresses of influential German and German Jewish figures. The site of the museum thus emerges as symbolic and almost mystical, a fitting place for pilgrimage or, perhaps, antipilgrimage.

A final way in which the Jewish Museum Berlin emerges as a site of pilgrimage is suggested by Libeskind when he describes the museum as a potential bridge between atonement and normalization: "A museum for the city of Berlin must be a place where all citizens, those of the past, of the present, and of the future, discover their common heritage and individual hope." Idealistically, Libeskind describes a broadly humanistic purpose behind his design and a hope that the museum will make tangible for "all citizens" a common origin. The museum, he continues, "must be rethought to transcend the passive involvement of the viewer: it must actively confront change."[66] Citizens who visit the museum, therefore, will be transformed by the discovery of their common humanity and will overcome apathy through empathy—a change in consciousness and a transformation of a psychological nature that are characteristic of pilgrimage.

In Germany and Israel, where memory of the Holocaust has been often contested, reinterpreted, and influenced by political concerns and where Holocaust memory plays a major role in forging national identity, narratives of the Holocaust are ritually defined with real consequences for how communities conceive of themselves and of their national histories. As Tony Bennett has shown, it was common in the late nineteenth and early twentieth century for museums to be referred to as "machines for progress"

producing "progressive subjects."[67] Yad Vashem and the Jewish Museum Berlin are not completely estranged from this model in their efforts to create particular social entities, through rituals of movement and pilgrimage, who will adopt the perspectives of the museums' Holocaust narratives and will contribute toward a future that corresponds to their particular social and political needs.

Yad Vashem's Zionist narrative establishes a dramatic contrast between death and destruction in exile and redemption and rebirth in the State of Israel. The ideal future, as presented in Yad Vashem, will unfold in the Jewish homeland—a sanctuary for all Jews and a refuge against any possible future genocide. In the Jewish Museum Berlin two competing narratives emerge: through the architecture, a narrative of a loss of such cataclysmic proportions that it has left a deep and irreparable scar on the German landscape and consciousness, and through the permanent exhibition, a presentation of a multicultural society that embraces religious and ethnic difference. In the latter narrative the image of Germany's future appears as a beacon of tolerance and good intentions—a vision of lessons learned and a new devotion to the very values that National Socialism sought to obliterate. In the former the future remains obscure and amorphous; the void of Jewish absence is a moment of negation but, recalling the mystical tzimtzum, this absence might perhaps also hint at the possibility of creation—a birth of presence in some new form and at some indefinite point in the future. This, perhaps, is one of the ideas engendered in the E.T.A. Hoffmann Garden of Exile and Emigration, with its simultaneous reversal of expectations and insistence on continued life, albeit in surprising configurations. Libeskind's extension, finally, does not offer an answer in terms of what form such a new presence might take—this is one of the strengths of Libeskind's design. It is enough at this juncture to even hint at such a possibility; indeed, in light of the past, this is already a great deal.

CONCLUSION
"Now All That Is Left Is to Remember"

In his article "On Sanctifying the Holocaust: An Anti-theological Treatise" (1987), Israeli philosopher Adi Ophir warns readers that in Israel a "religious consciousness built around the Holocaust may become the central aspect of a new religion" and that this religion may become the "core of Jewish identity in the future, overshadowing the role of traditional Judaism or of contemporary Zionism." Ophir identifies the most important of the four "commandments" of this new religion as the commandment that dictates duty toward remembrance: "Remember the day of the Holocaust to keep it holy, in memory of the destruction of the Jews of Europe." Ophir writes in this connection, "Absolute Evil must be remembered in exquisite detail. And already scattered throughout the land are institutions of immortalization and documentation, like God's altars in Canaan one generation after the settlement. Already a central altar has arisen which will gradually turn into our Temple, forms of pilgrimage are taking hold, and already a thin layer of Holocaust-priests, keepers of the flame, is growing and institutionalizing; only, instead of rituals of sacrifices, there are rituals of memorial, remembering and repetition, since the sacrifice is completed and now all that is left is to remember."[1]

Ophir is not, of course, arguing against memory and in favor of forgetting; rather, he is concerned with what he describes as the dangerous mythologization and sanctification of the Holocaust. He proposes, instead, that we remember the Holocaust as a human—rather than transcendent—event and advocates Holocaust remembrance as a mode of understanding and prevention rather than as a ritual directed backward toward a past

revelation of "Absolute Evil." Underlying Ophir's argument is the question of where to "place" the Holocaust—"as a revelation whose place is in the past, or as a possibility whose place is in the present?"[2]

Twenty-five years have passed since Ophir wrote his antitheological treatise, but the challenge his words pose has become only increasingly relevant. We must ask ourselves: Is the recent proliferation of Holocaust memorials and museums across Europe and the United States and the ever-growing corpus of Holocaust-inspired films, books, and artistic works a sign that we have succumbed to an obsessive and unremitting ritual of mourning? Or does it reveal a conscious determination to keep the past alive in the present, and to use the Holocaust as a kind of negative moral compass and caveat for the future? Architectural critic Herbert Muschamp writes that the "Holocaust has filled a theological void; for a secular culture, unable to turn to religion for an authoritative standard of absolute good, history has provided us with as close as we are likely to come to as a standard of absolute evil. In this sense, at least, the Holocaust museum cannot escape the sanctity of the temple."[3] The Holocaust appears as the nadir of modern civilization—the extremity and incomprehensibility of which invests it with revelatory significance and establishes it as a kind of boundary that marks the very limits of human experience.

Institutions of immortalization and documentation—altars erected to the past—have formed the subject of this book. We began with the following problem: Holocaust remembrance has become increasingly visible over the past several decades, and this high visibility may have contributed to its trivialization. At the same time, a widely held perception persists that the Holocaust is an extraordinary event, transcending mere secular and historical significance. In light of this paradox, Holocaust museums and exhibits face a special challenge, and in response they call on unique aesthetic and spatial strategies to restore a sacred significance to representations of the Holocaust. These representations are nationally and culturally specific; they reflect the civil religions and corresponding Holocaust narratives that underlie their contexts. Yad Vashem's Holocaust narrative, I have shown, is framed within a dialectic between catastrophe and suffering in exile and renewal and rebirth through Zionism in Israel. The Jewish Museum Berlin, in contrast, exhibits a conflicted Holocaust narrative, torn between a symbolism of irreconcilable loss and absence (depicted in the museum architecture) and a positive, multicultural, forward-looking narrative (promoted in the permanent exhibition). The USHMM, finally, displays a Holocaust

narrative rooted in an American perspective and framed by the values of democracy, tolerance, and individual rights.

This book has also demonstrated that a basic difference exists between the representational strategies of Yad Vashem and the Jewish Museum Berlin on the one hand and the USHMM on the other. While Yad Vashem and the Jewish Museum Berlin avoid representational techniques such as mimesis and metonymy due to the fact that these contribute to the illusion of a coherent and comprehensible Holocaust narrative, the USHMM seeks to fill the rupture of the Holocaust with an excess of objects and artifacts. On a deeper level, however, all three museums display a similar purpose in their efforts to commemorate unspeakable trauma and to do so in a language that resonates with what is sacred within each of their national and cultural contexts.

As it concludes, this work raises more questions than it answers. Is it possible to speak consistently about an aesthetics of Holocaust display and remembrance in German, Israeli, and American museums? The aesthetic strategies of disfiguration, interruption, destabilization, and irony are prominent in Yad Vashem, while the techniques of perceptual disruption, voided spaces, and undermined expectations dominate in the Jewish Museum Berlin. In contrast, a reliance on metonymy, mimesis, and remnants characterizes the USHMM. Would other Holocaust museums and exhibits within these three countries support these findings?

A second question that remains open concerns the relationship between national context and museum narrative. This book stresses the ideological and sociocultural values that appear to be most dominant in each country's Holocaust narrative as they manifest themselves visually in the selected museums. I argue that Zionism, a sanctification of the land, and an aesthetics of autochthony, for example, frame Yad Vashem's Holocaust narrative. But the Zionist perspective is only one of many found in contemporary Israel, where ideological positions range from a post-Zionist intellectual elite to the biblical chauvinism of religious settlers. The permanent exhibition of the Jewish Museum Berlin, in contrast, retroactively embraces Germany's once rich and culturally productive German Jewish population. The museum celebrates a cosmopolitan, multicultural tolerance of religious and cultural minorities through the prism of this past. However, competing nationalistic and xenophobic elements have not been silenced once and for all. The USHMM, finally, portrays the United States as a sanctuary for the Third Reich's Jewish victims and casts American soldiers in the starring

role of concentration camp liberators. But there too, the record of American support of Europe's Jews during the crucial early years of National Socialism is far from ideal—a fact cursorily and inadequately acknowledged in the permanent exhibition. Furthermore, many members of this country's marginal populations continue to suffer from racism, economic exploitation, bigotry and prejudice, throwing into question the supreme confidence of the values intoned throughout the museum.

The Holocaust narratives privileged in these three museums, therefore, express specific perspectives and do not reflect in any comprehensive way the range of attitudes or views on the Holocaust within Germany, Israel, and the United States. Acknowledging this fact, *Holocaust Memory Reframed: Museums and the Challenges of Representation* seeks to examine how a rich variety of visual forms draw on different aesthetic techniques to evoke particular kinds of Holocaust remembrance. The natural question that follows such a focus on memory is the underlying purpose of remembrance itself. Remembering merely for memory's sake is perhaps not enough, unless it leads to a deeper understanding of the past. Memory must also allow us to universalize and to learn from the lessons of the Holocaust, namely, that the Holocaust was a human event and the threat of its recurrence continues to exist. Hence, we should reflect on not only *what* we are remembering but *how* we are remembering, and we should ask ourselves, finally, to what purpose we remember. We must view memory practice with the critical eye it deserves and maintain an attitude to the Holocaust that neither sanctifies it nor simply historicizes it.

It may be useful to recall Jean Améry here: Améry describes the historicization of the Holocaust as demonstrating the "immensity and monstrosity of the natural time-sense." This natural consciousness of time, Améry writes, which is "rooted in the physiological process of wound-healing," is "not only extramoral, but also *anti*moral in character" because it leads to a statement that is at once true as well as "hostile to morals and intellect": "What happened, happened." Améry insists, however, against the callous pragmatism of such a sentiment, that "man has the right and the privilege to declare himself to be in disagreement with every natural occurrence, including the biological healing that time brings about." The moral person thus "demands annulment of time . . . a moral turning-back of the clock" as a form of resistance against the relentless forward momentum of time, which threatens to sweep away the moral truth of the crimes of National Socialism as it succumbs to the storm called progress.[4]

NOTES

INTRODUCTION

1. Améry, "How Much Home?," 42.
2. Benjamin, "Philosophy of History," 257–258.
3. Améry, "Resentments," 79.
4. Ibid., 79, 78.
5. Liebman and Don-Yehiya, *Civil Religion in Israel*, ix.
6. See Linenthal, *Preserving Memory*; Linenthal, "Boundaries of Memory"; Linenthal, "Locating Holocaust Memory"; Stier, *Committed to Memory*; Stier, "Different Trains"; Stier, "Torah and Taboo"; Young, *Texture of Memory*; Young, *Art of Memory*; and Young, *At Memory's Edge*.
7. For a general overview of Linenthal's method, see *Preserving Memory*, ix–xvii, as well as 255–272.
8. Stier, *Committed to Memory*, 19–20, 25–26, 31–41, 120–125.
9. Although these points are culled from a number of Young's works, including *Texture of Memory* and *At Memory's Edge*, the preface to *Texture of Memory* offers a succinct overview of Young's basic approach to Holocaust memorials and museums. See in particular viii–ix.

1. ZAKHOR: THE TASK OF HOLOCAUST REMEMBRANCE, QUESTIONS OF REPRESENTATION, AND THE SACRED

1. Adorno, "Cultural Criticism and Society," 34. To avoid perpetuating the very tendency I criticize, I offer here the immediate context of the quotation: "The more total society becomes, the greater the reification of the mind and the more paradoxical its effort to escape reification on its own. Even the most extreme consciousness of doom threatens to degenerate into idle chatter. Cultural criticism finds itself faced with the final stage of the dialectic of culture and barbarism. To write poetry after Auschwitz is barbaric. And this corrodes even the knowledge of why it has become impossible to write poetry today. Absolute reification, which presupposed intellectual progress as one of its elements, is now preparing to absorb the mind entirely. Critical intelligence cannot be equal to this challenge as long as it confines itself to self-satisfied contemplation."
2. Consult, for example, the "Global Directory" for a list of Holocaust museums around the world.
3. Young, *Texture of Memory*, 2.
4. This iconic photograph appears on the front cover of this book.

5. Hansen, "*Schindler's List*," 130–131; Sontag, *Regarding the Pain*, 86; Goldberg, *Power of Photography*, 135, quoted in Brink, "Secular Icons," 137–138.

6. K. Klein, "Emergence of Memory," 127.

7. Halbwachs, *Cadres sociaux*; Halbwachs, *On Collective Memory*, 38.

8. See Nora, *Realms of Memory*.

9. For a discussion of the creation of new group memories through technology, see Landsberg, *Prosthetic Memory*, 11–18.

10. Zelizer, *Remembering to Forget*, 6–7.

11. The basic approaches of Buber and Rubenstein in *Eclipse of God* and *After Auschwitz*, respectively, are summarized by D. Patterson in *Open Wounds*, 8.

12. Fackenheim, *Jewish Return into History*, 19–24, quoted in D. Patterson, *Open Wounds*, 8, 18.

13. Fackenheim, *God's Presence in History*, 3–34, 67–103, quoted in Eisen, "Midrash," 371–372.

14. Wiesel, "Words from a Witness," 43; Wiesel, "Trivializing the Holocaust: Semi-Fact and Semi-Fiction," *New York Times*, April 16, 1978; Wiesel, "Art and the Holocaust: Trivializing Memory," *New York Times*, June 11, 1989; Novick, *Holocaust*, 211–212. Molly Haskell, for example, sharply criticizes the miniseries *Holocaust* and declares it a "desecration against, among others, the Hebraic injunction banning graven images." See Haskell, "Failure to Connect," 79–80, quoted in Novick, *Holocaust*, 212.

15. Greenberg, "Cloud of Smoke" and *Jewish Way*, chap. 10, quoted in Novick, *Holocaust*, 199–200; Greenberg, "Cloud of Smoke," 54; Greenberg, *Image of God*, 229; Novick, *Holocaust*, 200; Leon Wieseltier, quoted in Miller, *One, by One*, 231.

16. Eliade, *Sacred and the Profane*, 10. The choice of Mircea Eliade's writings as a lens through which to analyze the commemoration of the Holocaust is one that this author recognizes as fraught with irony, given Eliade's well-known support of the fascist and antisemitic Romanian Iron Guard of the 1930s. The relevance of Eliade's theories for the subject matter, however, justifies this choice.

17. Otto, *Idea of the Holy*, 12–13, 25–26.

18. Eliade, *Sacred and the Profane*, 20–21, 26, 24.

19. Otto, *Idea of the Holy*, 5–6; Durkheim, *Elementary Forms*, 412–413, 416.

20. Stier, "Different Trains," 83; Smith, *To Take Place*, 104.

21. Duncan, *Civilizing Rituals*, 7; T. Bennett, *Birth of the Museum*, 3, 6.

22. For a discussion of Hilde Hein, see Henning, *Museums*, 91.

23. Henning, *Museums*, 81.

24. Cole, "Nativization and Nationalization," 143.

25. Zolberg, "Contested Remembrance."

26. Macdonald and Fyfe, *Theorizing Museums*, 4.

27. N. Goldman, "Israeli Holocaust," 103.

28. G. MacDonald, "Change and Challenge," 165; Lennon and Foley, *Dark Tourism*, 3; Weinberg and Elieli, *Holocaust Museum*, 18; Liebman and Don-Yehiya, *Civil Religion in Israel*, 151.

29. Liebman and Don-Yehiya, *Civil Religion in Israel*, ix, 9, 7.

30. The following discussion draws on theories by Mircea Eliade, Gershom Scholem, and Yosef Hayim Yerushalmi—the classic reference points for discussion of these topics. For more recent scholarship on the topic, see, for example, the edited volume *Religion, Violence, Memory, and Place*, particularly the chapter by Friedland and Hecht titled "The Powers of Place," as well as Spiegel's chapter, "Memory and History."

31. Goldstein, "View to Memory," 11.

32. Heschel, *God in Search*, 312; Yerushalmi, *Zakhor*, 9.

33. Heschel, *God in Search*, 214, 213.

34. Eliade, *Sacred and the Profane*, 68, 75.

35. Ibid., 70, 80–81.

36. Yerushalmi, *Zakhor*, 44.

37. Ibid., 36, 38–39.

38. Yerushalmi, *Zakhor*, 23; Scholem, *Messianic Idea*, 2, 4–5, 35.

39. Hertzberg, *Zionist Idea*, 18, and Katz, "Jewish National Movement," 269, both quoted in Myers, "Messianic Idea," 3, 8.

2. AN ARCHITECTURE OF ABSENCE: DANIEL LIBESKIND'S JEWISH MUSEUM BERLIN

1. Smith, *To Take Place*, 103–104; Durkheim, *Elementary Forms*, 416.

2. Liebman and Don-Yehiya, *Civil Religion in Israel*, ix.

3. Barreneche, *New Museums*, 6.

4. Giebelhausen, "Architecture *IS* the Museum," 42.

5. Rossi, *Architecture of the City*, 130.

6. Allen, "Libeskind's Practice of Laughter," 21; Young, *At Memory's Edge*, 165.

7. Allen, "Libeskind's Practice of Laughter," 21.

8. Bloch, *Erbschaft dieser Zeit*, 212–228, quoted in Huyssen, "Voids of Berlin," 62; Huyssen, "Voids of Berlin," 62–65.

9. Richter, "Spazieren in Berlin," 73, quoting and translating Benjamin, "Die Wiederkehr des Flâneurs," 419.

10. Roper, *German Encounters*, 40.

11. G. Rosenfeld, *Building after Auschwitz*, 179.

12. Belloli, *Daniel Libeskind*, 18; Taylor, "Point of No Return," 131.

13. G. Rosenfeld, *Building after Auschwitz*, 185–186.

14. Libeskind, "Gabion," 4.

15. Ibid., 7.

16. Ibid.

17. Libeskind, *Space of Encounter*, 26.

18. Schneider, "Daniel Libeskind's Architecture," 124.

19. Ibid.

20. Belloli, *Daniel Libeskind*, 10.

21. Ibid., 18, 26.

22. Ibid., 10.

23. Blumenthal, Inauguration speech; Blumenthal, Speech.

24. Quoted in Roger Cohen, "A Jewish Museum Struggles to Be Born: Berlin's Efforts to Honor Lost Millions Are Mired in Dissent," *New York Times*, August 15, 2000.

25. The founding of the Jewish Museum Berlin is described in detail in Pieper, *Musealisierung*. See also Weinland and Winkler, *Jewish Museum*, and Jaskot, "Daniel Libeskind's Jewish Museum."

26. Blumenthal, quoted in Fehrs and Krüger, *Discovering*, 1.

27. Blumenthal, Inauguration speech.

28. Holtschneider, *Holocaust and Representations*, 2.

29. G. Rosenfeld, *Building after Auschwitz*, 188.

30. Chametzky, "Not What We Expected," 218.

31. As K. Hannah Holtschneider writes, "Indeed the Holocaust remains a reference point for any Jewish museum in Germany since 1945. Whether a museum chooses to conceptualize Jewish history by foregrounding the Holocaust or by directing attention away from it to other episodes, either strategy demonstrates that it is impossible for a Jewish museum in Germany to 'get around' the Holocaust." *Holocaust and Representations*, 3–4.

32. Kugelmann, "Didaktische Impetus," 290.

33. Holtschneider, similarly, asserts that "although the JMB categorizes itself as not being a 'Holocaust museum,' its genesis, construction and permanent exhibition is closely connected to German public debates on the commemoration and representation of the Holocaust and its meaning for contemporary German society." *Holocaust and Representations*, 82.

34. Jaskot, "Daniel Libeskind's Jewish Museum," 152.

35. Venturi, quoted in Woods, *Beginning Postmodernism*, 97.

36. Klein, "From the Ashes."

37. Dimendberg, "Republic of Voids," 956.

38. Mumford, *Culture of Cities*, 4.

39. Marstine, introduction to *New Museum Theory*, 9.

40. Belloli, *Daniel Libeskind*, 34.

41. Libeskind, *Space of Encounter*, 23, 26.

42. Ibid., 26.

43. Ibid.

44. Steakley, *German Opera Libretti*, 276, 281.

45. Libeskind, *Space of Encounter*, 26.

46. Richard Kurth argues in his study of *Moses und Aron* that "transcendental ideas are not commensurable with language." "Immanence and Transcendence," 186.

47. Ibid., 190.

48. Libeskind, *Space of Encounter*, 28.

49. Libeskind, "Between the Lines," 48.

50. Scholem, *Kabbalah*, 88–89.

51. Libeskind, *Jewish Museum Berlin*, 24; Dimendberg, "Republic of Voids," 955; Benjamin, *Einbahnstraße*, 55–56.

52. Libeskind, *Space of Encounter*, 28.

53. Derrida, "Response," 110; Celan, *Selected Poems*, 396.

54. Libeskind, "Between the Lines," 48.

55. Libeskind, *Space of Encounter*, 27.

56. Libeskind, *Jewish Museum Berlin*, 30.

57. Libeskind, *Space of Encounter*, 27.

58. Hertz, *Death*, 94. Callois, similarly, describes two poles of the sacred—one positive and one negative—which are generally opposed to the profane world: "Living energies and the powers of death are joined to form the positive and negative poles of the religious world." *Man and the Sacred*, 43. See also Clifford Geertz on sacred symbols that dramatize not only positive but also negative values. "Ethos," 425.

59. *Shalechet* is on loan from Dieter and Si Rosenkranz.

60. Libeskind, *Space of Encounter*, 28, 204.

61. G. Rosenfeld, *Building after Auschwitz*, 182.

62. Woods, *Beginning Postmodernism*, 104.

63. Vidler, *Warped Space*, 238.

64. Vidler, "Building in Empty Space," 222.

65. Young, *At Memory's Edge*, 152, 183.

3. ARCHITECTURES OF REDEMPTION AND EXPERIENCE: YAD VASHEM AND THE U.S. HOLOCAUST MEMORIAL MUSEUM

1. Safdie, *Safdie Architects*.

2. Safdie, *Harvard Jerusalem Studio*, 44.

3. Safdie, *Jerusalem*, xii.

4. Ibid., x.

5. Ronald Storrs, quoted in Safdie, *Harvard Jerusalem Studio*, 48.

6. Ockman, "Place in the World," 22–23.

7. Safdie, *Harvard Jerusalem Studio*, 38, 44.

8. Goldhill, *Jerusalem*, 326; Karmi-Melamede, quoted on page 325.

9. Safdie, *Harvard Jerusalem Studio*, 13–14.

10. Murphy, *Moshe Safdie*, 95.

11. Safdie, "Yeshiva Porat Yosef," in *Safdie Architects*.

12. Safdie, *Beyond Habitat*, 244, 168.

13. Ibid., 243, 216.

14. Safdie, "Yitzhak Rabin Center," in *Safdie Architects*.

15. The full text of the Martyrs' and Heroes' Remembrance (Yad Vashem) Law and its provisions, which was signed by Moshe Sharett, minister of foreign affairs and acting prime minister; Ben-Zion Dinur, minister of education and culture; and Yitzchak Ben-Zvi, president of the state, may be found at the Yad Vashem website.

16. Young, *Texture of Memory*, 244.

17. Segev, *Seventh Million*, 432–434.

18. The floor of the Ohel Yizkor is inscribed with the names of twenty-two concentration camps in Hebrew and Latin letters, and ashes of the victims are buried under the flagstones in front of the eternal flame.

19. Ockman, "Place in the World," 19.

20. Bartov, "Chambers of Horror," 66.

21. Yad Vashem's *Hall of Names* was designed and planned by Moshe Safdie and Dorit Harel.

22. Ockman refers to Yad Vashem as "a place in the world for a world displaced" in her essay of the same name in Safdie, *Yad Vashem*, 19–26.

23. Cf. Segev, *Seventh Million*.

24. Padan, "Re-placing Memory," 250.

25. N. Goldman, "Israeli Holocaust," 103.

26. Padan, "Re-placing Memory," 250.

27. Liebman and Don-Yehiya, *Civil Religion in Israel*, ix.

28. Bartov, "Chambers of Horror," 67.

29. Cohen, quoted in Jackie Feldman, "Yad Vashem," 1152.

30. Padan, "Re-placing Memory," 252.

31. Ockman, "Place in the World," 21–22.

32. Ibid., 20.

33. Eliade, *Sacred and the Profane*, 26.

34. Cf. Durkheim, *Elementary Forms*.

35. See Friedland and Hecht, "Powers of Place," 18–19.

36. Safdie, "Yad Vashem," in *Safdie Architects*.

37. Safdie, "Architecture of Memory," 94.

38. Ockman, "Place in the World," 21.

39. Safdie, "Architecture of Memory," 94.

40. Ibid., 95.

41. Ibid., 96.

42. Brog, "Victims and Victors," 75, 83.

43. Ibid., 77.

44. Safdie, "Architecture of Memory," 97.

45. Ibid., 98.

46. Ibid., 97.

47. G. Rosenfeld, *Building after Auschwitz*, 291.

48. Eliade, *Sacred and the Profane*, 39.

49. Ockman, "Place in the World," 20, 23.

50. G. Rosenfeld, *Building after Auschwitz*, 260.

51. Muschamp, "How Buildings Remember."

52. J. Freed, "United States," 65.

53. Muschamp, "How Buildings Remember."

54. Ibid.

55. J. Freed, "United States," 61–62.

56. Hertzberg, quoted in Joe Holley, "Arthur Hertzberg: Rabbi Was a Scholar and Social Activist," *Washington Post*, April 16, 2006.

57. H. Freed, *James Ingo Freed*.

58. J. Freed, "United States," 64.

59. H. Freed, *James Ingo Freed*.

60. J. Freed, "United States," 64, 61.

61. Ibid., 65, 62, 64, 73.

62. H. Freed, *James Ingo Freed.*

63. J. Freed, "United States," 63.

64. Ochsner, "Understanding the Holocaust," 246–247.

65. H. Freed, *James Ingo Freed.*

66. Herbert Muschamp, "Shaping a Monument to Memory," *New York Times,* April 11, 1993.

67. Laqueur, "Holocaust Museum," 30; Godfrey, *Abstraction,* 222; Linenthal, "Locating Holocaust Memory," 248.

68. Sirefman, "Formed and Forming," 314; Laqueur, "Holocaust Museum," 32.

69. Elie Wiesel declares the commercialization and misrepresentation of the Holocaust to be nothing less than "'Hilul hashem'—blasphemy or profanation, an act that strikes at all that is sacred." Wiesel goes on to declare that we are "living through a period of general de-sanctification of the Holocaust. . . . All is trivial and superficial, even death itself: there is no mystery in its mystery, it is stripped naked, just as the dead are stripped and exposed to the dubious enjoyment of spectators turned voyeurs." "Art and the Holocaust: Trivializing Memory," *New York Times,* June 11, 1989.

70. Cole, *Images,* 1, 17, 15.

71. J. Freed, "United States," 71–72.

72. J. Freed, quoted in Linenthal, "Locating Holocaust Memory," 247.

73. As Yerushalmi explains, there exists in Judaism a belief in the dialectical relationship between destruction and redemption, as expressed in the idea that on the day the Temple was destroyed, the Messiah was born. *Zakhor,* 23.

4. THE ARTFUL EYE: LEARNING TO SEE AND PERCEIVE OTHERWISE INSIDE MUSEUM EXHIBITS

1. Marianne Hirsch argues that when confronting atrocity images made by perpetrators, viewers become complicit with the perpetrator's gaze. "Surviving Images," 26. Susan Sontag argues that there is "shame as well as shock" in looking at atrocity images and that those of us who gaze at images of suffering without the power to alleviate it become voyeurs. *Regarding the Pain,* 42.

2. Gourevitch, "Behold Now Behemoth," 60, 62.

3. Freedberg, *Power of Images,* 204.

4. Bal, "Guest Column," 10, 13.

5. Greenblatt, *Learning to Curse,* 177.

6. Bal, *Double Exposures,* 87–88, 62.

7. Newhouse, *Art,* 109, 58.

8. Alpers, "Museum," 27.

9. Smith, *To Take Place,* 103–104.

10. Steven Erlanger, "Israel Dares to Recast a Story Set in Stone," *New York Times,* February 13, 2005.

11. Common Holocaust atrocity photographs circulated after the war included photographs of emaciated survivors, piles of corpses, and the "accoutrements of atrocity" (barbed wire, barriers, furnaces, vials of ashes, gas chambers). Zelizer, *Remembering to Forget*, 160.

12. Struk, *Photographing the Holocaust*, 194.

13. Hooper-Greenhill, *Museums*, 23.

14. Freedberg, *Power of Images*, 439, 440.

15. Barthes, *Camera Lucida*, 84, 89, 80–81; Sontag, *On Photography*, 154; Currie, "Visible Traces," 289.

16. Freedberg, *Power of Images*, 234.

17. Benjamin, "Work of Art," 225–226.

18. The layout for the *Tower of Faces* was planned by exhibition designer Ralph Appelbaum, professor Yaffa Eliach, director of the permanent exhibition Raye Farr, photographer Arnold Kramer, and project director Cindy Miller. The *Hall of Names* was planned and designed by Moshe Safdie and Dorit Harel.

19. The *Tower of Faces* might be seen as reversing the "architectural iconography of the watchtower," in the sense that although such a structure is usually associated with the close surveillance of victims, in this case gazing and scrutinizing take place inside the tower—creating what Joan Branham calls an "introspective edifice." "Mapping Tragedy," 57.

20. Yaffa Eliach describes the photographs in her foreword to *We Were Children* as "survivor photos" that "'rescue' these victims posthumously, redeem them from the conflagration that left behind mere ashes and smoke in their wake. The photographs have become the only 'grave' these children shall ever have, the only record of their existence, and for many survivors, the only tangible remnants of their past." Quoted in Liss, *Trespassing*, 36.

21. Dominick LaCapra warns of "vicarious victimhood"—a facile, total identification with victims on the part of the secondary witness to traumatic events. The desirable amount of empathy does not involve full identification but rather "empathic unsettlement," which may result in secondary or muted trauma. *Writing History*, 47, 102.

22. Barthes, *Camera Lucida*, 26–27.

23. Linenthal, *Preserving Memory*, 186.

24. Laqueur, "Holocaust Museum," 31.

25. Levitt, *American Jewish Loss*, 19, 23.

26. LaCapra, *History and Memory*, 10; Liss, *Trespassing*, 33; Hartman, *Longest Shadow*, 31; Liss, *Trespassing*, 34.

27. Benjamin, "Work of Art," 226.

28. Barthes, *Camera Lucida*, 99; Benjamin, "Work of Art," 224–226.

29. The rescue of Jewish Holocaust victims from anonymity and their redemption through memory is necessarily deferred by the fact that it is logistically impossible to recover the name of each and every Jewish Holocaust victim. In this sense, it is perhaps helpful to recognize the symbolism of the effort as well as the ultimate reality of what may be achieved.

30. Yerushalmi, *Zakhor*, 11. Mordechai Shenhavi's suggestion to register all Shoah victims as an aspect of Yad Vashem's memorial task reveals this "traditional Jewish mandate to remember the dead by naming them." Young, *Texture of Memory*, 245.

31. Freedberg, *Power of Images*, 32, 12.

32. Hartman, *Longest Shadow*, 22.

33. Shalev, "Building a Holocaust Museum," 54.

34. Hooper-Greenhill, *Museums*, x, 17–18.

35. As the philosophy of "pure perception," positivism "heralds the advance and arrival of the 'observer.'" Positivists such as Auguste Comte were committed to exploring surface reality rather than the psychological, historical, and political grounds of knowledge. The visual fixity of positivism has been "dominant and consistent within our modern, Western cultural cognitions" and has been upheld largely though scientific practice. Jenks, "Centrality of the Eye," 5–7.

36. Burnett, *Cultures of Vision*, 4–5. Cf. Jay, "Scopic Regimes."

37. Burnett, *Cultures of Vision*, 3.

38. Jenks, "Centrality of the Eye," 1.

39. Chris Jenks defines a scopic regime as "a cultural network that establishes the uniformity of responses to/readings of the sign." "Centrality of the Eye," 15. Cf. Jay, "Scopic Regimes."

40. Burnett, *Cultures of Vision*, 9. W.J.T. Mitchell in *Iconology* describes the "innocent eye" as the idea of a mechanical process of perception uncontaminated by imagination, purpose, or desire. This innocent eye, Mitchell maintains, is blind. Quoted in Jenks, "Centrality of the Eye," 4.

41. Bal, "Guest Column," 9.

42. Ibid., 10, 12–13.

43. Bal, *Double Exposures*, 88.

44. Freedberg, *Power of Images*, 276.

45. Ibid., 28.

46. Hirsch, "Surviving Images," 16.

47. Charles Sanders Peirce defines icons as "Likeness[es] . . . which serve to represent their Objects only in so far as they resemble them in themselves" (*Essential Peirce*, 2:460–461). The iconic function of objects in Holocaust museums and exhibits reaches beyond Peirce's definition. The word "icon" derives from the Greek *eikon* (image) and refers to the painting of a holy person or traditional image of Orthodox Christianity (J. Turner, *Dictionary of Art*, 15:75). Icons have often been associated with magical properties and have been studied as much by theologians as by art historians.

48. Brink, "Secular Icons," 135–136.

49. Goldberg, *Power of Photography*, 135, quoted in Brink, "Secular Icons," 137–138.

50. Stier, "Holocaust Icons," 216.

51. Zelizer, *Remembering to Forget*, 6–7.

52. Stier, *Committed to Memory*, 31.

53. Sontag, *Regarding the Pain*, 86.

54. Gutterman and Shalev, *To Bear Witness*, 32.

55. Yad Vashem, "The World That Was."

56. Benjamin, "Philosophy of History," 257–258.

57. Shalev, "Building a Holocaust Museum," 55.

58. Young, *Texture of Memory*, 30, 47–48, 46.

59. Edward Rothstein, "In Berlin, Teaching Germany's Jewish History," *New York Times*, May 2, 2009.

60. Dan Diner addresses the idea of a German-Jewish "negative symbiosis" in post–World War II Germany that replaced the untenable concept of a German-Jewish symbiosis. "Negative Symbiose."

61. Bankier, "German-Jewish Symbiosis?"

62. Elon, *Pity of It All*, 11.

63. Rothstein, "In Berlin."

64. This phrase was originally used by Abba Kovner in a pamphlet of late 1941 to early 1942 to incite Jews to rebel against their persecutors. It has been often misunderstood and used in objectionable ways to suggest that Jews passively allowed themselves to be murdered. See Bauer, "Background to Nazi Antisemitism."

65. Amos Elon, "German Requiem," *New York Review of Books*, November 15, 2001.

66. Pieper, *Musealisierung*, 297. Peter Chametzky points out that the permanent exhibition stresses "Jewish integration into the general fabric of Germany society" and emphasizes Jewish family histories to assimilate the "otherness" of Jewish experience to the "familiar bourgeois familial sphere." "Not What We Expected," 227.

67. Elon, "German Requiem."

68. Milton, *In Fitting Memory*, 9.

69. Pieper, *Musealisierung*, 297.

70. Rothstein, "In Berlin."

71. Christmann, "Jüdisches Museum," quoted in Reid, "Jewish Museum Berlin." Holtschneider expresses a similar sentiment, without the censure, when she writes that "as soon as visitors enter the main exhibition space, the architecture of the building is largely obscured by the exhibition architecture, which transforms the awkward spaces of Libeskind's building into theatrical stage sets on which the narrative of German-Jewish history is displayed. . . . Only in a few places do the exhibition architecture and that of the building complement one another to produce a powerful sensation of the precariousness of Jewish life in Germany." *Holocaust and Representations*, 91.

72. Reid, "Jewish Museum Berlin"; Storrie, *Delirious Museum*, 174.

5. "WE ARE THE LAST WITNESSES":
ARTIFACT, AURA, AND AUTHENTICITY

1. Amishai-Maisels, *Depiction*, 151.

2. Vico, quoted in Kirshenblatt-Gimblett, "Objects of Ethnography," 394.

3. Williams, *Memorial Museums*, 31; Freedberg, *Power of Images*, 433.

4. Williams, *Memorial Museums*, 29.

5. Linenthal, *Preserving Memory*, 35.

6. I follow here Oren Baruch Stier, who states in reference to the USHMM that the "entire museum is built on and out of this sense of the 'authentic.'" Stier, "Torah and Taboo," 511.

7. Linenthal, *Preserving Memory*, 189; Crane, *Museums and Memory*, 4.

8. Hooper-Greenhill, *Museums*, 129–130.

9. Crane, *Museums and Memory*, 3.

10. Lowenthal, *Foreign Country*, 243.

11. Crew and Sims, "Locating Authenticity," 171–173.

12. Ibid., 172–173.

13. Greenblatt, *Learning to Curse*, 170, 176.

14. Yerushalmi, *Zakhor*, 100, 44–45.

15. Greenberg, "Cloud of Smoke," 54.

16. Muschamp, "How Buildings Remember."

17. Much has been made in critical literature (see Pieper, *Musealisierung*, 149; Liss, *Trespassing*, chap. 2; Crysler and Kusno, "Angels in the Temple," 57; Gitlitz and Davidson, *Pilgrimage*, 182; and Alexander, *Remembering the Holocaust*, 63) of the identity cards handed out to each visitor, which should presumably jump-start a process of identification with a single Holocaust victim. In the words of Crysler and Kusno, the handing out of identity cards "establishes the visitor as a citizen of the museum whose ultimate duty is to 'witness' the past" ("Angels in the Temple," 57). I agree with Philip Gourevitch, who describes the identity cards as a "gimmick" ("Behold Now Behemoth," 57).

18. Benjamin, "Work of Art," 220–222; Greenblatt, *Learning to Curse*, 176.

19. Ibid., 223–224.

20. Stier, "Different Trains," 82–83.

21. Linenthal, *Preserving Memory*, 146.

22. Linenthal, "Locating Holocaust Memory," 253; Benjamin, "On Some Motifs," 158. Walter Benjamin is here quoting Marcel Proust in reference to his magnum opus, *À la Recherche du temps perdu*.

23. Weinberg and Elieli, *Holocaust Museum*, 57.

24. Weinberg, quoted in Linenthal, *Preserving Memory*, 147.

25. Jeffrey Feldman, "Etymology of Opinion," 123, quoted in Engelhardt, *Topography*, 35.

26. Williams, *Memorial Museums*, 29.

27. The series of arguments that took place over the question of whether or not to display this hair in the permanent exhibition is documented in Linenthal, *Preserving Memory*, 211–216. See also Stier, "Torah and Taboo," 522–530.

28. The USHMM's permanent exhibition is arranged as follows: the fourth floor (*Nazi Assault, 1933–1939*) covers the rise and content of National Socialism, the third floor (*Final Solution, 1940–1945*) documents the ghettos and camps, the second floor (*Last Chapter, 1945–present*) concerns resistance and rescue, the fate of children during the Holocaust, liberation, emigration, and post-Holocaust survival.

29. Michael Berenbaum reports that the USHMM asked the State Museum at Majdanek for four thousand shoes. Linenthal, *Preserving Memory*, 147.

30. The first stanza of the poem reads,

 I saw a mountain
 Higher than Mt. Blanc
 And more Holy that the Mountain of Sinai
 On this world this mountain stood.
 such a mountain I saw—Jewish shoes in Majdanek. . . .

31. Celan, *Gesammelte Werke*, 2:72.

32. Felman and Laub, *Testimony*, 3; Celan, *Selected Poems*, 396.

33. Stier, *Committed to Memory*, 119; Linenthal, *Preserving Memory*, 164.

34. Jacobs discusses Majdanek's presentation of shoes in "Remembering Genocide," 170–172.

35. Bartov, "Chambers of Horror," 74–75.

36. Wiesel, "Art and Culture," 405; Linenthal, *Preserving Memory*, 35.

37. Lakoff and Johnson, *Metaphors*, 35, 39, 37.

38. Wiesel, "Art and the Holocaust: Trivializing Memory," *New York Times*, June 11, 1989.

39. Wiesel, "Art and Culture," 405.

40. Laqueur, "Holocaust Museum," 31.

41. The USHMM's website entry on Kristallnacht reports that 267 synagogues were burned or destroyed during the pogroms. United States Holocaust, "Kristallnacht."

42. See Gilbert, *Holocaust*, 69–74, and United States Holocaust, "Kristallnacht."

43. Wischnitzer, *Architecture*, 228.

44. For a discussion of the issues surrounding the presentation of Torah scrolls in the museum, see Stier, "Torah and Taboo," 513–521.

45. Zahavy, English Babylonian Talmud, "*Seder Zera'im* [Seeds], *Berakhot* [Benedictions] 28b." Rashi explains that "meditation" refers to either excessive reading of scripture or childish talk. Others explain it as philosophical speculation.

46. Heschel, *God in Search*, 356.

47. Ibid.

48. Greenblatt, *Learning to Curse*, 176.

49. As Oren Baruch Stier points out, the USHMM's railcar is an authentic Deutsche Reichsbahn boxcar of the "Karlsruhe" type. "Different Trains," 88.

50. Jacek Nowakowski came to the USHMM as associate curator in 1988 and later became the director of collections. Linenthal, *Preserving Memory*, 150.

51. Ibid., 159. For a more detailed account of the restoration of the railcar, see Stier, "Different Trains," 88–89.

52. Hooper-Greenhill, *Museums*, 116.

53. LaCapra, *Writing History*, 102. Traumatic limit events are those events that "involve and convey an unrepresentable, anxiety-producing excess" (92).

54. Oddy, "Spatial Art," 87.

55. Shalev, "Building a Holocaust Museum," 58.

56. Maleuvre, *Museum Memories*, 17.

57. Young, *Texture of Memory*, 132, 133.

58. Wiesel, "Art and Culture," 403, 405.

6. REFIGURING THE SACRED: STRATEGIES OF DISFIGURATION IN *STRING*, THE *MEMORIAL TO THE DEPORTEES*, AND *MENORA*

1. At the time of my last visit in May 2012, *Menora* was not currently on display at the Jewish Museum Berlin, although it is still in the museum's possession.

2. Young, *At Memory's Edge*, 7, 96.

3. Wyschogrod, quoted in Taylor, *Disfiguring*, 299; G. Rosenfeld, *Building after Auschwitz*, 292, 259.

4. Apel, *Memory Effects*, 4.

5. Owens, "Allegorical Impulse," 75.

6. Apel, *Memory Effects*, 7.

7. Tracy, *On Naming*, 41.

8. Caputo and Derrida, quoted in Vanhoozer, "Theology," 18.

9. Taylor, *Disfiguring*, 85.

10. Ibid., 8–9.

11. Julius Schoeps, quoted in Cohen, "Jewish Museum," *New York Times*, August 15, 2000.

12. Langer, *Literary Imagination*; A. Rosenfeld, *Double Dying*; Lang, *Holocaust Representation*; Rothberg, *Traumatic Realism*; Kaplan, *Unwanted Beauty*; Bernard-Donals, *Forgetful Memory*; Huyssen, *Twilight Memories*, 259.

13. Chagall, Shahn, and Baskin, quoted in Amishai-Maisels, *Depiction*, 243.

14. Sartre and Tumarkin, quoted in ibid., 244.

15. Marcuse, "Holocaust Memorials," 57.

16. Bar, "Holocaust Commemoration," 16, 18.

17. Ibid., 19.

18. A megillat Esther is also on display in the USHMM in the On the Eve of Destruction room.

19. Bar, "Holocaust Commemoration," 19, 23–24.

20. Ibid., 27–28, 23–24; Wardi, *Memorial Candles*, 26, 31.

21. Stier, "Torah and Taboo," 513.

22. Yad Vashem, "Dedication Ceremony."

23. Verman, "Torah," 98.

24. Hogan and Aretha, *Holocaust Chronicle*, 252, 478.

25. Dimont, *Jews*, 242.

26. Hogan and Aretha, *Holocaust Chronicle*, 648.

27. Czech Memorial Scrolls Trust. For a narrative of a rescued Holocaust Torah, see A. Goldman, *Holocaust Torah*.

28. Scholem, *Kabbalah*, 171.

29. Czech Memorial Scrolls Trust.

30. Amishai-Maisels, *Depiction*, 297.

31. Scholem, *Kabbalah*, 174.

32. Tzaig, quoted in Bachrach-Ron, "Language of Art," 5.

33. Scholem, *Kabbalah*, 169–172.

34. Ibid., 171–174.

35. Scholem, *On the Kabbalah*, 76–77.

36. See Gottwaldt, "Der deutsche Güterwagen." My thanks to the anonymous reviewer for Rutgers University Press for informing me about Gottwaldt's work.

37. Illinois Holocaust Museum, "Rail Car."

38. Stier, "Different Trains," 83.

39. Ravitzky, *Messianism*, 1.

40. Waxman, "Messianism," 176.

41. Ravitzky , *Messianism*, 10.

42. Ibid., 20, 15.
43. Ibid., 28–29.
44. Waxman, "Messianism," 178–179.
45. Kook, quoted in Ravitzky , *Messianism*, 5.
46. Scholem, quoted in ibid., 3.
47. Waxman, "Messianism," 183.
48. Ravitzky, *Messianism*, 7–8.
49. Moshe Safdie, "Yad Vashem Transport Memorial," in *Safdie Architects*.
50. Ravitzky, *Messianism*, 20. See also Scholem, *Messianic Idea*, 7–10, on the catastrophic nature of redemption and the dialectic relationship between catastrophe and utopia that underlies messianism in Judaism.
51. Scholem, *Messianic Idea*, 11.
52. Amishai-Maisels, *Depiction*, 153.
53. Ibid.
54. The *Children's Memorial* was funded by Abraham and Edita Spiegel, whose two-year-old son Uziel was killed at Auschwitz.
55. Safdie, *Jerusalem*, 196–197.
56. Ibid., 196.
57. For a discussion of the representation of children in Holocaust remembrance, see Jacobs, "Remembering Genocide."
58. Azaryahu and Kellerman, "Symbolic Places," 113, 114.
59. Zerubavel, quoted in ibid., 114. Azaryahu and Kellerman also cite Don-Yehiya, "Hanukkah," 8.
60. Don-Yehiya, "Hanukkah," 16.
61. Bar, "Holocaust Commemoration," 24–25, 28.
62. Bielicky, *Art Margins*.
63. Ibid.
64. Maleuvre, *Museum Memories*, 12, 61, 63, 58–59. Maleuvre builds here on Pierre Nora's concept of *lieux de mémoire*—"places of memory" that become necessary because of a lacking contemporary culture or environment of memory. See Nora, "Between Memory and History."

7. RITUALS OF REMEMBRANCE IN JERUSALEM AND BERLIN: MUSEUM VISITING AS PILGRIMAGE AND PERFORMANCE

1. Bell, *Ritual*, 248.
2. Badone and Roseman discuss these and other unconventional pilgrimages in their book *Intersecting Journeys*. See also Jackie Feldman, *Above the Death Pits*, on Israeli youth voyages to Poland, and Kelner, *Tours That Bind*, on the Taglit Birthright Tour.
3. Smith, *To Take Place*, 104, 105.
4. Bell, *Ritual*, x, 166, 169.
5. Ibid., 74.
6. Duncan, "Art Museums," 91; Jones, *Hermeneutics*, 126–129.
7. Davis, "Performing," 16; Jackie Feldman, "Yad Vashem," 1150.

8. Van Gennep, *Rites of Passage*, 10–11, 20, 192.

9. Turner and Turner, *Ritual Process*, 95; V. Turner, *Forest of Symbols*, 94.

10. V. Turner, *Forest of Symbols*, 30, 19–20.

11. Turner and Turner, *Ritual Process*, 95.

12. Ockman, "Place in the World," 21–22; Bell, *Ritual*, 161.

13. Eliade, *Sacred and the Profane*, 39, 40, 44.

14. Safdie, "Architecture of Memory," 99.

15. Klug, "Memory," 54.

16. Bell, *Ritual*, 37, 67.

17. Gitlitz and Davidson, *Pilgrimage*, 159, 181, 158.

18. Bell, *Ritual*, 158.

19. Milton, *In Fitting Memory*, 271.

20. Cf. Margry, "Secular Pilgrimage"; Eade and Sallnow, *Contesting the Sacred*; Coleman and Elsner, *Pilgrimage*; Cohen, "Pilgrimage and Tourism"; Lennon and Foley, *Dark Tourism*; and Badone and Roseman, *Intersecting Journeys*.

21. Tomasi, "*Homo viator*," 20; Muschamp, "Shaping a Monument to Memory," *New York Times*, April 11, 1993; Steiner, *Nostalgia*, 2.

22. Cf. V. Turner, *Dramas*, and Turner and Turner, *Image and Pilgrimage*.

23. V. Turner, *Dramas*, 166.

24. Cf. Morinis, *Sacred Journeys*; Eade and Sallnow, *Contesting the Sacred*.

25. V. Turner, *Dramas*, 69.

26. Liebman and Don-Yehiya, *Civil Religion in Israel*, 137; Handelman and Shamgar-Handelman, "Presence of Absence," 86, 87.

27. Ibid., 88.

28. Liebman and Don-Yehiya, *Civil Religion in Israel*, 30.

29. Ibid., 143, 144.

30. Bar, "Holocaust Commemoration," 21.

31. Liebman and Don-Yehiya, *Civil Religion in Israel*, 25; Brenner quoted in ibid., 30–31; Liebman and Don-Yehiya, "Symbol System," 122.

32. Liebman and Don-Yehiya, *Civil Religion in Israel*, 32–33.

33. Liebman and Don-Yehiya, "Symbol System," 123, 127.

34. Azaryahu and Kellerman, "Symbolic Places," 121, 112.

35. Ibid., 117, 120.

36. Ibid., 120.

37. Handelman and Shamgar-Handelman, "Presence of Absence," 86.

38. Azaryahu and Kellerman, "Symbolic Places," 121, 111–112.

39. Jackie Feldman, "Yad Vashem," 1157.

40. The outdoor *Valley of the Communities* memorial (1992), designed by Dan Zur and Lipa Yahalom, is a memorial to the Jewish communities destroyed during the Holocaust. Dug out of natural bedrock, it is inscribed with the names of more than five thousand communities.

41. Jackie Feldman, "Yad Vashem," 1151, 1156.

42. Padan, "Re-placing Memory," 252–253.

43. Kligerman, *Sites*, 241.

44. Jackie Feldman, "Yad Vashem," 1150.

45. Andreas Huyssen argues in "Voids of Berlin" that Libeskind's building demonstrates an awareness of the danger of monumentality and avoids such risks by rendering impossible the totalizing gaze of visitors on which monumentalization depends (80).

46. Taylor, "Point of No Return," 131.

47. Scholem, *On the Kabbalah*, 110–111.

48. Taylor, "Point of No Return," 131.

49. R. Patterson, "Void That Is Subject," 71.

50. Libeskind, quoted in Oddy, "Spatial Art," 84.

51. Van Gennep, *Rites of Passage*, 18.

52. Turner and Turner, *Ritual Process*, 96–97.

53. Ward, "Monuments of Catastrophe," 193; Knesl, "Accidental Classicists," 100.

54. R. Patterson, "Void That Is Subject," 70.

55. Schneider, *Daniel Libeskind*, 57.

56. As Holtschneider rightly notes, however, this final exhibit of the Jewish Museum Berlin fails to document the contemporary "social and religious re-organization of the Jewish community" so that its individualized accounts create a "fragmented picture." *Holocaust and Representations*, 111.

57. Pieper, *Musealisierung*, 312. Holtschneider points out, furthermore, that the permanent exhibition fails to mention Mendelssohn's works in Hebrew as well as "his role in creating an explicitly Jewish scientific discourse" because, she argues, this would show Mendelssohn to be "less easily assimilable into a German national narrative." *Holocaust and Representations*, 94–95.

58. Till, *New Berlin*, 202.

59. Wise, *Capital Dilemma*, 146.

60. Henryk M. Broder, "Deutschmeister des Trauens," *Der Spiegel*, April 17, 1995, 222, quoted in Wise, *Capital Dilemma*, 149.

61. Habermas, quoted in Koshar, *From Monuments to Traces*, 8–9.

62. See ibid. for a discussion of Koshar's theory of the "triad": a "three-cornered relationship among highly resonant parts of a memory landscape, individuals, and groups that struggle to invest that environment with meaning" through specific framing strategies, symbols, and themes (10).

63. Young, *At Memory's Edge*, 7.

64. Rüsen, "Holocaust Memory," 266; Pearce, *Contemporary Germany*, 2.

65. Allen, "Libeskind's Practice of Laughter," 21.

66. Libeskind, "Between the Lines," 48.

67. T. Bennett, *Birth of the Museum*, 10, 47.

CONCLUSION: "NOW ALL THAT IS LEFT IS TO REMEMBER"

1. Ophir, "On Sanctifying," 61–63.

2. Ibid., 64.

3. Muschamp, "How Buildings Remember," 3.

4. Améry, "Resentments," 81, 72.

BIBLIOGRAPHY

Adorno, Theodor W. "Cultural Criticism and Society." In *Prisms: Studies in Contemporary German Social Thought*. Translated by Shierry Weber Nicholson and Samuel Weber, 19–34. Cambridge, MA: MIT Press, 1997.

Alexander, Jeffrey C. *Remembering the Holocaust: A Debate*. With commentaries by Martin Jay, Bernhard Giesen, Michael Rothberg, Robert Manne, Nathan Glazer, Elihu Katz, and Ruth Katz. Oxford: Oxford University Press, 2009.

Allen, Stanley. "Libeskind's Practice of Laughter: An Introduction." In "Between the Lines: Extension to the Berlin Museum, with the Jewish Museum," by Daniel Libeskind. *Assemblage* 12 (August 1990): 18–57.

Alpers, Svetlana. "The Museum as a Way of Seeing." In Karp and Lavine, *Exhibiting Cultures*, 25–32.

Améry, Jean. "How Much Home Does a Person Need?" In *At the Mind's Limits: Contemplations by a Survivor on Auschwitz and Its Realities*. Translated by Sidney Rosenfeld and Stella P. Rosenfeld, 41–61. Bloomington: Indiana University Press, 1980.

———."Resentments." In *At the Mind's Limits: Contemplations by a Survivor on Auschwitz and Its Realities*. Translated by Sidney Rosenfeld and Stella P. Rosenfeld, 62–81. Bloomington: Indiana University Press, 1980.

Amishai-Maisels, Ziva. *Depiction and Interpretation: The Influence of the Holocaust on the Visual Arts*. Oxford: Pergamon, 1993.

Apel, Dora. *Memory Effects: The Holocaust and the Art of Secondary Witnessing*. New Brunswick, NJ: Rutgers University Press, 2002.

Arendt, Hannah, ed. *Illuminations: Essays and Reflections*. Translated by Harry Zohn. New York: Schocken Books, 1968.

Azaryahu, Maoz, and Aharon Kellerman. "Symbolic Places of National History and Revival: A Study in Zionist Mythical Geography." *Transactions of the Institute of British Geographers*, n.s., 24, no. 1 (1999): 109–123.

Bachrach-Ron, Yifat. "The Language of Art: Video Art in the New Holocaust History Museum." *Yad Vashem Magazine* 35 (Fall 2004): 4–5.

Badone, Ellen, and Sharon R. Roseman. *Intersecting Journeys: The Anthropology of Pilgrimage and Tourism*. Urbana: University of Illinois Press, 2004.

Bal, Mieke. *Double Exposures: The Subject of Cultural Analysis*. New York: Routledge, 1996.

———. "Guest Column: Exhibition Practices." *PMLA* 125, no. 1 (2010): 9–23.

Bankier, David. "German-Jewish Symbiosis?" An Interview with David Bankier, by Amos Goldberg and Adi Gordon. *Yad Vashem Shoah Resource Center*. December

17, 1997. http://www.yumpu.com/en/document/view/6612708/german-jewish
-symbiosis-an-interview-with-prof-yad-vashem.

Bar, Doron. "Holocaust Commemoration in Israel during the 1950s: The Holocaust
Cellar on Mount Zion." *Jewish Social Studies* 12, no. 1 (2005): 16–38.

Barreneche, Raul A. *New Museums.* London: Phaidon, 2005.

Barthes, Roland. *Camera Lucida: Reflections on Photography.* Translated by Richard
Howard. New York: Hill and Wang, 1981.

Bartov, Omer. "Chambers of Horror: Holocaust Museums in Israel and the United
States." *Israel Studies* 2, no. 2 (1997): 66–87.

Bauer, Yehuda. Background to Nazi Antisemitism and the Holocaust." An interview
with Yehuda Bauer, director of the International Center for Holocaust Studies of Yad
Vashem, by Amos Goldberg. *Yad Vashem Shoah Resource Center.* January 18, 1998.
http://www.yadvashem.org/odot_pdf/Microsoft%20Word%20-%203856.pdf.

Bell, Catherine. *Ritual: Perspectives and Dimensions.* New York: Oxford University Press,
1997.

Belloli, Andrea P. A., ed. *Daniel Libeskind: Radix-Matrix; Architecture and Writings.*
Translated by Peter Green. Munich: Prestel-Verlag, 1997.

Benjamin, Walter. *Einbahnstraße.* Frankfurt am Main: Suhrkamp Verlag, 1997. First pub-
lished 1928.

———. "On Some Motifs in Baudelaire." In Arendt, *Illuminations,* 155–200.

———. "Theses on the Philosophy of History." In Arendt, *Illuminations,* 253–264.

———. "Die Wiederkehr des Flâneurs: Zu Franz Hessels 'Spazieren in Berlin.'" In *Ange-
lus Novus: Ausgewählte Schriften.* Vol. 2. Frankfurt am Main: Suhrkamp, 1966.

———. "The Work of Art in the Age of Mechanical Reproduction." In Arendt, *Illumina-
tions,* 217–251.

Bennett, Jill. *Empathic Vision: Affect, Trauma, and Contemporary Art.* Stanford, CA:
Stanford University Press, 2005.

Bennett, Tony. *The Birth of the Museum: History, Theory, Politics.* London: Routledge, 1995.

Bernard-Donals, Michael. *Forgetful Memory: Representation and Remembrance in the
Wake of the Holocaust.* Albany: State University of New York Press, 2009.

Bielicky, Michael. Interview by Sven Spieker. *Art Margins: Contemporary Central and
East European Visual Culture.* November 15, 2009. http://www.artmargins.com/index
.php/ podcast/ 119-interviews/526-interview-with-michael-bielicky-sven-spieker.

Bloch, Ernst. *Erbschaft dieser Zeit.* Frankfurt am Main: Suhrkamp Verlag, 1973.

Blumenthal, W. Michael. Inauguration speech. Jüdisches Museum Berlin. January 23,
1999. http://www.jmberlin.de/site/EN/05-About-The-Museum/06-Directors-And
-Board/01. Speech no longer available at this site.

———. Speech. Jüdisches Museum Berlin. August 16, 2000. http://www.jmberlin.de/
site/EN/05-About-The-Museum/06-Directors-And-Board/01. Speech no longer
available at this site.

Bradley, William. "Evocative Images." *Studies in Art Education* 23, no. 1 (1981): 33–39.

Branham, Joan. "Mapping Tragedy in the U.S. Holocaust Memorial Museum." In *The
Tragic in Architecture,* edited by Richard Patterson, 54–59. Chichester, UK: Wiley
and Sons, 2000.

Brink, Cornelia. "Secular Icons: Looking at Photographs from Nazi Concentration Camps." *History and Memory* 12, no. 1 (2000): 135–150.

Brog, Mooli. "Victims and Victors: Holocaust and Military Commemoration in Israel Collective Memory." *Israel Studies* 8, no. 3 (2003): 65–99.

Buber, Martin. *Eclipse of God: Studies in the Relation between Religion and Philosophy.* New York: Harper, 1952.

Burnett, Ron. *Cultures of Vision: Images, Media, and the Imaginary.* Bloomington: Indiana University Press, 1995.

Callois, Roger. *Man and the Sacred.* Translated by Meyer Barash. Urbana: University of Illinois Press, 2001.

Celan, Paul. *Gesammelte Werke in fünf Bänden: Zweiter Band; Gedichte II,* edited by Beda Allemann and Stefan Reichert. With Rolf Bücher. Frankfurt am Main: Suhrkamp Verlag, 1983.

———. *Selected Poems and Prose of Paul Celan.* Translated by John Felstiner. New York: Norton, 2001.

Chametzky, Peter. "Not What We Expected: The Jewish Museum Berlin in Practice." *Museum and Society* 6, no. 3 (2008): 216–245.

Chidester, David, and Edward T. Linenthal, eds. *American Sacred Space.* Bloomington: Indiana University Press, 1995.

Christmann, Holger. "Jüdisches Museum eine Enttäuschung." Interview with Julius H. Schoeps. *Frankfurter Allgemeine Zeitung Feuilleton.* September 10, 2001. http://www .faz.net/aktuell/feuilleton/interview-julius-h-schoeps-juedisches-museum-eine -enttaeuschung-130623.html.

Cohen, Erik. "Pilgrimage and Tourism: Convergence and Divergence." In *Sacred Journeys: The Anthropology of Pilgrimage,* edited by Alan Morinis, 47–64. Westport, CT: Greenwood, 1992.

Cole, Tim. *Images of the Holocaust: The Myth of the "Shoah" Business.* London: Duckworth, 1999.

———. "Nativization and Nationalization: A Comparative Landscape Study of Holocaust Museums in Israel, the US and the UK." *Journal of Israeli History: Politics, Society, Culture* 23, no. 1 (2004): 130–145.

Coleman, Simon, and John Elsner. *Pilgrimage: Past and Present in the World Religions.* Cambridge, MA: Harvard University Press, 1995.

Crane, Susan, ed. *Museums and Memory.* Stanford, CA: Stanford University Press, 2000.

Crew, Spencer R., and James E. Sims. "Locating Authenticity: Fragments of a Dialogue." In Karp and Lavine, *Exhibiting Cultures,* 159–175.

Crysler, Greig, and Abidin Kusno. "Angels in the Temple: The Aesthetic Construction of Citizenship at the United States Holocaust Memorial Museum." *Art Journal* 56, no. 1 (1997): 52–64.

Currie, Gregory. "Visible Traces: Documentary and the Contents of Photographs." *Journal of Aesthetics and Art Criticism* 57, no. 3 (1999): 285–297.

Czech Memorial Scrolls Trust. Homepage. Accessed May 17, 2013. http://www.czech memorialscrollstrust.org/.

Davis, Tracy C. "Performing and the Real Thing in the Postmodern Museum." *TDR* 39, no. 3 (1995): 15–40.

Derrida, Jacques. "Response to Daniel Libeskind." In Belloli, *Daniel Libeskind*, 110–112.

Dimendberg, Edward. "A Republic of Voids." In *A New History of German Literature*, edited by David E. Wellbery and Judith Ryan, 952–959. Cambridge, MA: Belknap, 2004.

Dimont, Max I. *Jews, God, and History*. 2nd ed. New York: New American Library, 2003.

Diner, Dan. "Negative Symbiose: Deutsche und Juden nach Auschwitz." *Babylon* 1 (1986): 9–20.

Don-Yehiya, Eliezer. "Hanukkah and the Myth of the Maccabees in Zionist Ideology and in Israeli Society." *Jewish Journal of Sociology* 34, no. 1 (1992): 5–23.

Don-Yehiya, Eliezer, and Charles S. Liebman. "The Symbol System of Zionist-Socialism: An Aspect of Israeli Civil Religion." *Modern Judaism* 1, no. 2 (1981): 121–148.

Duncan, Carol. "Art Museums and the Ritual of Citizenship." In Karp and Lavine, *Exhibiting Cultures*, 88–103.

———. *Civilizing Rituals: Inside Public Art Museums*. New York: Routledge, 1995.

Durkheim, Emile. *The Elementary Forms of Religious Life*. Translated by Karen E. Fields. New York: Free Press, 1995.

Eade, John, and Michael J. Sallnow, eds. *Contesting the Sacred: The Anthropology of Christian Pilgrimage*. London: Routledge, 1991.

Eisen, Robert. "Midrash in Emil Fackenheim's Holocaust Theology." *Harvard Theological Review* 96, no. 3 (2003): 369–392.

Eliach, Yaffa. *We Were Children Just Like You*. Brooklyn, NY: Center for Holocaust Studies, Documentation, and Research, 1990.

Eliade, Mircea. *The Sacred and the Profane: The Nature of Religion*. Translated by William R. Trask. New York: Harcourt, Brace and World, 1959.

Elon, Amos. *The Pity of It All: A Portrait of the German-Jewish Epoch, 1743–1933*. New York: Picador, 2002.

Engelhardt, Isabelle. *A Topography of Memory: Representations of the Holocaust at Dachau and Buchenwald in Comparison with Auschwitz, Yad Vashem, and Washington, D.C.* Brussels: Lang, 2002.

Fackenheim, Emil L. *God's Presence in History: Jewish Affirmations and Philosophical Reflections*. New York: Harper and Row, 1970.

———. *The Jewish Return into History: Reflections in the Age of Auschwitz and a New Jerusalem*. New York: Schocken Books, 1978.

Fehrs, Jörg H., and Maren Krüger. *Discovering the Jewish Museum Berlin*. Berlin: Stiftung Jüdisches Museum Berlin, 2001.

Feldman, Jackie. *Above the Death Pits, Beneath the Flag: Youth Voyages to Poland and the Performance of Israeli National Identity*. New York: Berghahn Books, 2008.

———. "Between Yad Vashem and Mt. Herzl: Changing Inscriptions of Sacrifice on Jerusalem's 'Mountain of Memory.'" *Anthropological Quarterly* 80, no. 4 (2007): 1147–1174.

Feldman, Jeffrey D. "An Etymology of Opinion: Yad Vashem, Authority, and the Shifting Aesthetic of Holocaust Museums." In *Representations of Auschwitz: 50 Years of*

Photographs, Painting, and Graphics, edited by Yasmin Doosry, 122–126. Oświęcim: Auschwitz-Birkenau State Museum, 1995.

Felman, Shoshana, and Dori Laub. *Testimony: Crises of Witnessing in Literature, Psycho-analysis, and History.* New York: Routledge, 1992.

Felstiner, John. *Paul Celan: Poet, Survivor, Jew.* New Haven, CT: Yale University Press, 1995.

Freed, Hermine. *James Ingo Freed: The Architecture of the United States Holocaust Memorial Museum.* New York: Hermine Freed Video Production, 1995. Videocassette (VHS), 46 minutes.

Freed, James Ingo. "The United States Holocaust Memorial Museum." *Assemblage* 9 (June 1989): 58–79.

Freedberg, David. *The Power of Images: Studies in the History and Theory of Response.* Chicago: University of Chicago Press, 1989.

Freud, Sigmund. *Das Unheimliche: Aufsätze zur Literatur.* Edited by Klaus Wagenbach. Hamburg-Wandsbek: Fischer Doppelpunkt, 1963.

Friedland, Roger, and Richard D. Hecht. "The Powers of Place." In *Religion, Violence, Memory, and Place,* edited by Oren Baruch Stier and J. Shawn Landres, 17–36. Bloomington: Indiana University Press, 2006.

Gadamer, Hans-Georg. *Truth and Method.* 2nd ed. Translation revised by Joel Wein-sheimer and Donald G. Marshall. London: Continuum, 2004.

Geertz, Clifford. "Ethos, World-View and the Analysis of Sacred Symbols." *Antioch Review* 17, no. 4 (1957): 421–437.

———. *The Interpretation of Cultures: Selected Essays.* New York: Basic Books, 1973.

Giebelhausen, Michaela. "The Architecture *IS* the Museum." In *New Museum Theory and Practice: An Introduction,* edited by Janet Marstine, 41–63. Malden, MA: Black-well, 2006.

Gilbert, Martin. *The Holocaust: A History of the Jews of Europe during the Second World War.* New York: Holt, Rinehart and Winston, 1985.

Gitlitz, David Martin, and Linda Kay Davidson. *Pilgrimage and the Jews.* Westport, CT: Praeger, 2006.

"Global Directory of Holocaust Museums." Israel Science and Technology Homepage. Accessed April 23, 2013. http://www.science.co.il/holocaust-museums.asp.

Godfrey, Mark. *Abstraction and the Holocaust.* New Haven, CT: Yale University Press, 2007.

Goldberg, Vicki. *The Power of Photography: How Photographs Changed Our Lives.* New York: Abbeville, 1991.

Goldhill, Simon. *Jerusalem: City of Longing.* Cambridge, MA: Belknap, 2008.

Goldman, Alex J. *I Am a Holocaust Torah.* Jerusalem: Gefen, 2000.

Goldman, Natasha. "Israeli Holocaust Memorial Strategies at Yad Vashem: From Silence to Recognition." *Art Journal* 65, no. 2 (2006): 102–122.

Goldstein, Leah. "A View to Memory: The New Holocaust History Museum." *Yad Vashem Jerusalem Magazine* 34 (Summer 2004): 10–11.

Gottwaldt, Alfred. "Der deutsche Güterwagen: Eine Ikone für den Judenmord?" *Museums-Journal,* Ausgabe I/1999, S. 14–17.

Gourevitch, Philip. "Behold Now Behemoth: The Holocaust Memorial Museum; One More American Theme Park." *Harper's Magazine*, July 1993, 55–62.

Graburn, Nelson H. H., ed. *The Anthropology of Tourism*. New York: Pergamon, 1983.

Greenberg, Irving. "Cloud of Smoke, Pillar of Fire: Judaism, Christianity, and Modernity after the Holocaust." In *Auschwitz: Beginning of a New Era? Reflections on the Holocaust*, edited by Eva Fleischner, 7–55. New York: KTAV, 1977.

———. *The Jewish Way: Living the Holidays*. New York: Touchstone, 1993.

———. *Living in the Image of God: Jewish Teachings to Perfect the World; Conversations with Rabbi Irving Greenberg as Conducted by Shalom Freedman*. Northvale, NJ: Aronson, 1998.

Greenblatt, Stephen. *Learning to Curse: Essays in Early Modern Culture*. New York: Routledge, 1990.

Gutterman, Bella, and Avner Shalev, eds. *To Bear Witness: Holocaust Remembrance at Yad Vashem*. Jerusalem: Yad Vashem, 2005.

Halbwachs, Maurice. *Les cadres sociaux de la mémoire*. Paris: Presses Universitaires de France, 1952. Originally published in *Les travaux de l'année sociolgique*. Paris: Alcan, 1925.

———. *On Collective Memory*. Edited and translated by Lewis A. Coser. Chicago: University of Chicago Press, 1992.

Handelman, Don, and Lea Shamgar-Handelman. "The Presence of Absence: The Memorialism of National Death in Israel." In *Grasping Land: Space and Place in Contemporary Israeli Discourse and Experience*, edited by Eyal Ben-Ari and Yoram Bilu, 85–128. Albany: State University of New York Press, 1997.

Hansen, Miriam Bratu. "*Schindler's List* Is Not *Shoah*: Second Commandment, Popular Modernism, and Public Memory." In *Visual Culture and the Holocaust*, edited by Barbie Zelizer, 127–151. New Brunswick, NJ: Rutgers University Press, 2001.

Hartman, Geoffrey. *The Longest Shadow: In the Aftermath of the Holocaust*. Bloomington: Indiana University Press, 1996.

Haskell, Molly. "A Failure to Connect." *New York Magazine*, May 15, 1978, 79–80.

Henning, Michelle. *Museums, Media, and Cultural Theory*. Maidenhead, UK: Open University Press, 2006.

Hertz, Robert. *Death and the Right Hand*. Translated by Rodney Needham and Claudia Needham. With an introduction by E. E. Evans Pritchard. Glencoe, IL: Free Press, 1960.

Hertzberg, Arthur, ed. *The Zionist Idea: A Historical Analysis and Reader*. New York: Meridian Books, 1960.

Heschel, Abraham Joshua. *God in Search of Man: A Philosophy of Judaism*. New York: Farrar, Straus and Giroux, 1976.

Hirsch, Marianne. "Surviving Images: Holocaust Photographs and the Work of Postmemory." *Yale Journal of Criticism* 14, no. 1 (2001): 5–37.

Hoffmann, E.T.A. "Der Sandmann." In *Nachtstücke*. Frankfurt am Main: Insel, 1982.

Hogan, David J., and David Aretha, eds. *The Holocaust Chronicle: A History in Words and Pictures*. Lincolnwood, IL: Publications International, 2000.

Holtschneider, K. Hannah. *The Holocaust and Representations of Jews: History and Identity in the Museum*. Routledge Jewish Studies. London: Routledge, 2011.

Hooper-Greenhill, Eilean. *Museums and the Interpretation of Visual Culture*. London: Routledge, 2000.

Huyssen, Andreas. *Twilight Memories: Marking Time in a Culture of Amnesia*. New York: Routledge, 1995.

———. "The Voids of Berlin." *Critical Inquiry* 24, no. 1 (1997): 57–81.

Illinois Holocaust Museum and Education Center. "Rail Car." Accessed May 17, 2013. http://www.ilholocaustmuseum.org/pages/rail_car/132.php.

Jacobs, Janet Liebman. "Remembering Genocide: Gender Representation and the Objectification of Jewish Women at Majdanek." In *Religion, Violence, Memory, and Place*, edited by Oren Baruch Stier and J. Shawn Landres, 163–176. Bloomington: Indiana University Press, 2006.

Jaskot, Paul B. "Daniel Libeskind's Jewish Museum in Berlin as a Cold War Project." In *Berlin Divided City, 1945–1989*, edited by Philip Broadbent and Sabine Hake, 145–155. New York: Berghahn Books, 2010.

Jay, Martin. "Scopic Regimes of Modernity." In *Vision and Visuality*, edited by Hal Foster, 3–23. Seattle: Bay, 1988.

Jencks, Charles J. *The Language of Post-Modern Architecture*. 4th ed. New York: Rizzoli, 1984.

Jenks, Chris. "The Centrality of the Eye in Western Culture: An Introduction." In *Visual Culture*, edited by Chris Jenks, 1–25. London: Routledge, 1995.

Jones, Lindsay. *The Hermeneutics of Sacred Architecture: Experience, Interpretation, Comparison*. Cambridge, MA: Harvard University Press, 2000.

Kaplan, Brett Ashley. *Unwanted Beauty: Aesthetic Pleasure in Holocaust Representation*. Urbana: University of Illinois Press, 2007.

Karp, Ivan, and Steven D. Lavine, eds. *Exhibiting Cultures: The Poetics and Politics of Museum Display*. Washington, DC: Smithsonian Institution Press, 1991.

Katz, Jacob. "The Jewish National Movement: A Sociological Analysis." In *Jewish Society through the Ages*, edited by Hayim Hillel Ben-Sasson and Shmuel Ettinger. New York: Schocken Books, 1971.

Kelner, Shaul. *Tours That Bind: Diaspora, Pilgrimage, and Israeli Birthright Tourism*. New York: New York University Press, 2010.

Kirshenblatt-Gimblett, Barbara. "Objects of Ethnography." In Karp and Lavine, *Exhibiting Cultures*, 386–443.

Klein, Julia. "From the Ashes, a Jewish Museum." *American Prospect* 12, no. 3 (2001): http://prospect.org/article/ashes-jewish-museum.

Klein, Kerwin Lee. "On the Emergence of Memory in Historical Discourse." *Representations* 69, special issue, *Grounds for Remembering* (Winter 2000): 127–150.

Kligerman, Eric. *Sites of the Uncanny: Paul Celan, Specularity, and the Visual Arts*. Berlin: Gruyter, 2007.

Klug, Lisa Alcalay. "Memory Gets a New Home." *Hadassah Magazine*, January 2006, 54–55.

Knesl, John. "Accidental Classicists: Freed in Washington, Libeskind in Berlin." *Assemblage* 16 (December 1991): 98–101.

Koshar, Rudy. *From Monuments to Traces: Artifacts of German Memory, 1870–1990*. Berkeley: University of California Press, 2000.

Kugelmann, Cilly. "Der didaktische Impetus des Jüdischen Museums Berlin." In *Erinnern und Verstehen: Der Völkermord an den Juden im Politischen Gedächtnis der Deutschen*, edited by Hans Erler, 289–293. Frankfurt am Main: Campus Verlag, 2003.

Kurth, Richard. "Immanence and Transcendence in *Moses und Aron*." In *The Cambridge Companion to Schoenberg*, edited by Jennifer Shaw and Joseph Auner, 177–190. Cambridge: Cambridge University Press, 2010.

LaCapra, Dominick. *History and Memory after Auschwitz*. Ithaca, NY: Cornell University Press, 1998.

———. *Writing History, Writing Trauma*. Baltimore: Johns Hopkins University Press, 2001.

Lakoff, George, and Mark Johnson. *Metaphors We Live By*. Chicago: University of Chicago Press, 1980.

Landsberg, Alison. *Prosthetic Memory: The Transformation of American Remembrance in the Age of Mass Culture*. New York: Columbia University Press, 2004.

Lang, Berel. *Holocaust Representation: Art within the Limits of History and Ethics*. Baltimore: Johns Hopkins University Press, 2000.

Langer, Lawrence L. *The Holocaust and the Literary Imagination*. New Haven, CT: Yale University Press, 1977.

Laqueur, Thomas. "The Holocaust Museum." *Threepenny Review* 56 (Winter 1994): 30–32.

Lennon, John, and Malcolm Foley. *Dark Tourism: The Attraction of Death and Disaster*. London: Continuum, 2000.

Levitt, Laura. *American Jewish Loss after the Holocaust*. New York: New York University Press, 2007.

Libeskind, Daniel. "Between the Lines: Extension to the Berlin Museum, with the Jewish Museum." *Assemblage* 12 (August 1990): 18–57.

———. *Jewish Museum Berlin: Architect Daniel Libeskind*. With a photo essay by Hélène Binet. Berlin: G+B Arts International, 1999.

———. *The Space of Encounter*. London: Thames and Hudson, 2001.

Liebman, Charles S., and Eliezer Don-Yehiya. *Civil Religion in Israel: Traditional Judaism and Political Culture in the Jewish State*. Berkeley: University of California Press, 1983.

Linenthal, Edward T. "The Boundaries of Memory: The United States Holocaust Memorial Museum." *American Quarterly* 46, no. 3 (1994): 406–433.

———. "Locating Holocaust Memory: The United States Holocaust Memorial Museum." In *American Sacred Space*, edited by David Chidester and Edward T. Linenthal, 220–261. Bloomington: Indiana University Press, 1995.

———. *Preserving Memory: The Struggle to Create America's Holocaust Museum*. New York: Columbia University Press, 2001.

Liss, Andrea. *Trespassing through Shadows: Memory, Photography, and the Holocaust*. Minneapolis: University of Minnesota Press, 1998.

Lowenthal, David. *The Past Is a Foreign Country*. New York: Cambridge University Press, 1985.

MacCannell, Dean. *The Tourist: A New Theory of the Leisure Class*. Rev. ed. New York: Schocken Books, 1989.

MacDonald, George F. "Change and Challenge: Museums in the Information Society." In *Museums and Communities: The Politics of Public Culture*, edited by Ivan Karp, Christine Mullen Kreamer, and Stephen D. Lavine, 158–181. Washington, DC: Smithsonian Institution Press, 1992.

Macdonald, Sharon, and Gordon Fyfe, eds. *Theorizing Museums: Representing Identity and Diversity in a Changing World*. Cambridge, MA: Blackwell, 1996.

Maleuvre, Didier. *Museum Memories: History, Technology, Art*. Stanford, CA: Stanford University Press, 1999.

Marcuse, Harold. "Holocaust Memorials: The Emergence of a Genre." *American Historical Review* 115, no. 1 (2010): 53–89.

Margry, Peter Jan. "Secular Pilgrimage: A Contradiction in Terms?" In *Shrines and Pilgrimage in the Modern World: New Itineraries into the Sacred*, edited by Peter Jan Margry, 13–46. Amsterdam: Amsterdam University Press, 2008.

Marstine, Janet. Introduction to *New Museum Theory and Practice: An Introduction*, edited by Janet Marstine, 1–36. Malden, MA: Blackwell, 2006.

Miller, Judith. *One, by One, by One: Facing the Holocaust*. New York: Simon and Schuster, 1990.

Milton, Sybil. *In Fitting Memory: The Art and Politics of Holocaust Memorials*. Detroit: Wayne State University Press, 1991.

Mitchell, W.J.T. *Iconology: Image, Text, Ideology*. Chicago: University of Chicago Press, 1986.

Morinis, Alan, ed. *Sacred Journeys: The Anthropology of Pilgrimage*. Westport, CT: Greenwood, 1992.

Mumford, Lewis. *The Culture of Cities*. New York: Harcourt, Brace, 1938.

Murphy, Diana, ed. *Moshe Safdie*. Vol. 1. Mulgrave, Victoria: Images, 2009.

Muschamp, Herbert. "How Buildings Remember." *New Republic*, August 28, 1989, http://www.tnr.com/article/world/how-buildings-remember.

Myers, Jody Elizabeth. "The Messianic Idea and Zionist Ideologies." In *Jews and Messianism in the Modern Era: Metaphor and Meaning*, edited by Jonathan Frankel, 3–13. New York: Oxford University Press, 1991.

Newhouse, Victoria. *Art and the Power of Placement*. New York: Monacelli, 2005.

Nora, Pierre. "Between Memory and History: Les Lieux de Memoire." *Representations* 26, special issue, *Memory and Counter-Memory* (Spring 1989): 7–24.

———. *Realms of Memory: Rethinking the French Past*. Edited by Lawrence D. Kritzman. Translated by Arthur Goldhammer. New York: Columbia University Press, 1996.

Novick, Peter. *The Holocaust in American Life*. Boston: Houghton Mifflin, 1999.

Ochsner, Jeffrey Karl. "Understanding the Holocaust through the U.S. Holocaust Memorial Museum." *Journal of Architectural Education* 48, no. 4 (1995): 240–249.

Ockman, Joan. "A Place in the World for a World Displaced." In Safdie, *Yad Vashem*, 19–26.

Oddy, Jason. "A Spatial Art." *Modern Painters* 15, no. 1 (2002): 84–89.

Ophir, Adi. "On Sanctifying the Holocaust: An Anti-theological Treatise." *Tikkun* 2, no. 1 (1987): 61–66.

Otto, Rudolf. *The Idea of the Holy: An Inquiry into the Non-rational Factor in the Idea of the Divine and Its Relation to the Rational.* Translated by John W. Harvey. New York: Oxford University Press, 1958.

Owens, Craig. "The Allegorical Impulse: Toward a Theory of Postmodernism." *October* 12 (Spring 1980): 67–86.

Padan, Yael. "Re-placing Memory." In *Constructing a Sense of Place: Architecture and the Zionist Discourse,* edited by Haim Yacobi, 247–263. Burlington, VT: Ashgate, 2004.

Patterson, David. *Open Wounds: The Crisis of Jewish Thought in the Aftermath of Auschwitz.* Seattle: University of Washington Press, 2006.

Patterson, Richard. "The Void That Is Subject." In *The Tragic in Architecture,* guest edited by Richard Patterson. *Architectural Design* 70, no. 5 (2000): 66–75.

Pearce, Caroline. *Contemporary Germany and the Nazi Legacy: Remembrance, Politics, and the Dialectic of Normality.* Basingstoke, UK: Palgrave Macmillan, 2008.

Pearman, Hugh. "Daniel Libeskind Interview." *Gabion: Retained Writing on Architecture.* 2001. http://www.hughpearman.com/articles2/libeskind.html.

Peirce, Charles Sanders. *The Essential Peirce: Selected Philosophical Writings.* 2 vols. Edited by Nathan Houser and Christian Kloesel. Bloomington: Indiana University Press, 1992–1998.

Pieper, Katrin. *Die Musealisierung des Holocaust: Das Jüdische Museum Berlin und das U.S. Holocaust Memorial Museum in Washington, DC; Ein Vergleich.* Köln: Böhlau, 2006.

Posener, Alan, and Hannes Stein. "Triumph des guten Gefühls." *Die Welt,* September 11, 2001, http://www.welt.de/print-welt/article475115/Triumph-des-guten-Gefuehls.html.

Ravitzky, Aviezer. *Messianism, Zionism, and Jewish Religious Radicalism.* Translated by Michael Swir. Chicago: University of Chicago Press, 1996.

Reid, Susannah. "The Jewish Museum Berlin: A Review." Accessed on May 18, 2013. http://www.historisches-centrum.de/aus-rez/reid01-1.htm.

Richter, Dagmar. "Spazieren in Berlin." *Assemblage* 29 (April 1996): 72–85.

Roper, Katherine. *German Encounters with Modernity: Novels of Imperial Berlin.* Atlantic Highlands, NJ: Humanities Press International, 1991.

Rosenfeld, Alvin. *A Double Dying: Reflections on Holocaust Literature.* Bloomington: Indiana University Press, 1980.

Rosenfeld, Gavriel. *Building after Auschwitz: Jewish Architecture and the Memory of the Holocaust.* New Haven, CT: Yale University Press, 2011.

Rossi, Aldo. *The Architecture of the City.* With an introduction by Peter Eisenman. Translated by Diane Ghirardo and Joan Ockman. Revised by Aldo Rossi and Peter Eisenman. Cambridge, MA: MIT Press, 1982.

Rothberg, Michael. *Traumatic Realism: The Demands of Holocaust Representation.* Minneapolis: University of Minnesota Press, 2000.

Rubenstein, Richard. *After Auschwitz: History, Theology, and Contemporary Judaism.* 2nd ed. Baltimore: Johns Hopkins University Press, 1992.

Rüsen, Jörn. "Holocaust Memory and Identity Building: Metahistorical Considerations in the Case of (West) Germany." In *Disturbing Remains: Memory, History, and Crisis in the Twentieth Century*, edited by Michael S. Roth and Charles G. Salas, 252–270. Los Angeles: Getty Research Institute, 2001.

Safdie, Moshe. "Architecture of Memory." In Safdie, *Yad Vashem*, 92–101.

———. *Beyond Habitat*. Edited by John Kettle. Cambridge, MA: MIT Press, 1970.

———. *The Harvard Jerusalem Studio: Urban Designs for the Holy City*. Edited by Rudy Barton and Uri Shetrit. Cambridge, MA: MIT Press, 1986.

———. *Jerusalem: The Future of the Past*. Boston: Houghton Mifflin, 1989.

———. *Safdie Architects*. Accessed May 11, 2013. http://www.msafdie.com/#/projects.

———. "Yad Vashem Holocaust History Museum." *Safdie Architects*. Accessed May 11, 2013. http://www.msafdie.com/#/projects/yadvashemholocausthistorymuseum.

———. *Yad Vashem: Moshe Safdie—The Architecture of Memory*. With articles by Joan Ockman, Avner Shalev, Moshe Safdie, and Elie Wiesel. Baden: Müller, 2006.

———. "Yad Vashem Transport Memorial." *Safdie Architects*. Accessed May 11, 2013. http://www.msafdie.com/#/projects/yadvashemtransportmemorial.

———. "Yeshiva Porat Yosef." *Safdie Architects*. Accessed May 11, 2013. http://www.msafdie.com/#/projects/yeshivaporatyosef.

———. "Yitzhak Rabin Center." *Safdie Architects*. Accessed May 11, 2013. http://www.msafdie.com/#/projects/yitzhakrabincenter.

Schneider, Bernhard. *Daniel Libeskind: Jewish Museum Berlin*. With a preface by Daniel Libeskind. Munich: Prestel, 1999.

———. "Daniel Libeskind's Architecture in the Context of Urban Space." In Belloli, *Daniel Libeskind*, 120–127.

Scholem, Gershom. *Kabbalah*. New York: Meridian, 1978.

———. *The Messianic Idea in Judaism and Other Essays on Jewish Spirituality*. New York: Schocken Books, 1971.

———. *On the Kabbalah and Its Symbolism*. Translated by Ralph Manheim. New York: Schocken Books, 1996.

Segev, Tom. *The Seventh Million: The Israelis and the Holocaust*. Translated by Haim Watzman. New York: Holt, 2000.

Shalev, Avner. "Building a Holocaust Museum in Jerusalem." In Safdie, *Yad Vashem*, 50–60.

Sigaux, Gilbert. *History of Tourism*. London: Leisure Arts, 1966.

Sirefman, Susanna. "Formed and Forming: Contemporary Museum Architecture." *Daedalus* 128, no. 3 (1999): 297–320.

Smith, Jonathan Z. *To Take Place: Toward Theory in Ritual*. Chicago: University of Chicago Press, 1987.

Sontag, Susan. *On Photography*. New York: Picador, 1977.

———. *Regarding the Pain of Others*. New York: Picador, 2003.

Spiegel, Gabrielle M. "Memory and History: Liturgical Time and Historical Time." *History and Theory* 41, no. 2 (2002): 149–162.

Steakley, James, ed. *German Opera Libretti*. German Library. Vol. 52, *Moses and Aron*. Translated by Allen Forte. With a Foreword by Jost Hermand. New York: Continuum, 1995.

Steiner, George. *Nostalgia for the Absolute*. CBC Massey Lectures. Toronto: Anansi, 1974.

Stier, Oren Baruch. *Committed to Memory: Cultural Mediations of the Holocaust*. Amherst: University of Massachusetts Press, 2003.

———. "Different Trains: Holocaust Artifacts and the Ideologies of Remembrance." *Holocaust and Genocide Studies* 19, no. 1 (2005): 81–106.

———. "Holocaust Icons, Holocaust Idols." In *Religion, Art, and Visual Culture: A Cross-Cultural Reader*, edited by S. Brent Plate, 216–223. New York: Palgrave, 2002.

———. "Torah and Taboo: Containing Jewish Relics and Jewish Identity at the United States Holocaust Memorial Museum." *Numen* 57 (2010): 505–536.

Storrie, Calum. *The Delirious Museum: A Journey from the Louvre to Las Vegas*. London: Tauris, 2006.

Struk, Janina. *Photographing the Holocaust: Interpretations of the Evidence*. London: IB Tauris, 2004.

Taylor, Mark C. *Disfiguring: Art, Architecture, Religion*. Chicago: University of Chicago Press, 1992.

———. "Point of No Return." In Belloli, *Daniel Libeskind*, 128–135.

Till, Karen E. *The New Berlin: Memory, Politics, Place*. Minneapolis: University of Minnesota Press, 2005.

Tomasi, Luigi. "*Homo viator*: From Pilgrimage to Religious Tourism via the Journey." In *From Medieval Pilgrimage to Religious Tourism: The Social and Cultural Economics of Piety*, edited by William H. Swatos Jr. and Luigi Tomasi, 1–24. Westport, CT: Praeger, 2002.

Tracy, David. *On Naming the Present: Reflections on God, Hermeneutics, and Church*. Maryknoll, NY: Orbis Books, 1994.

Turner, Jane, ed. *The Dictionary of Art*. 34 vols. New York: Grove's Dictionaries, 1996.

Turner, Victor. *Dramas, Fields, and Metaphors: Symbolic Action in Human Society*. Ithaca, NY: Cornell University Press, 1974.

———. *The Forest of Symbols: Aspects of Ndembu Ritual*. Ithaca, NY: Cornell University Press, 1967.

Turner, Victor, and Edith Turner. *Image and Pilgrimage in Christian Culture: Anthropological Perspectives*. New York: Columbia University Press, 1978.

———. *The Ritual Process: Structure and Anti-Structure*. Ithaca, NY: Cornell University Press, 1979.

United States Holocaust Memorial Museum. "Kristallnacht: A Nationwide Pogrom, November 9–10, 1938." *Holocaust Encyclopedia*. Accessed May 16, 2013. http://www.ushmm.org/wlc/en/article.php?ModuleId=10005201.

Van Gennep, Arnold. *The Rites of Passage*. Translated by Monika B. Vizedom and Gabrielle L. Caffee. Chicago: University of Chicago Press, 1972. First published 1909.

Vanhoozer, Kevin J. "Theology and the Condition of Postmodernity: A Report on Knowledge (of God)." In *The Cambridge Companion to Postmodern Theology*, edited by Kevin J. Vanhoozer, 3–25. Cambridge: Cambridge University Press, 2003.

Verman, Mark. "The Torah as Divine Fire." *Jewish Bible Quarterly* 35, no. 2 (2007): 94–102.

Vidler, Anthony. "'Building in Empty Space': Daniel Libeskind's Museum of the Voice." Afterword to *Daniel Libeskind: The Space of Encounter*, by Daniel Libeskind, 222–224. London: Thames and Hudson, 2001.

———. *Warped Space: Art, Architecture, and Anxiety in Modern Culture*. Cambridge, MA: MIT Press, 2000.

Ward, Janet. "Monuments of Catastrophe: Holocaust Architecture in Washington and Berlin." In *Berlin—Washington, 1800–2000: Capital Cities, Cultural Representation, and National Identities*, edited by Andreas W. Daum and Christof Mauch, 155–200. Washington, DC: German Historical Institute, 2005.

Wardi, Dina. *Memorial Candles: Children of the Holocaust*. Translated by Naomi Goldblum. London: Tavistock/Routledge, 1992.

Waxman, Chaim I. "Messianism, Zionism, and the State of Israel." *Modern Judaism* 7, no. 2 (1987): 175–192.

Weinberg, Jeshajahu, and Rina Elieli. *The Holocaust Museum in Washington*. New York: Rizzoli, 1995.

Weinland, Martina, and Kurt Winkler. *The Jewish Museum in the Berlin Municipal Museum: A Record*. Berlin: Nikolai, 1997.

Wenders, Wim. *Der Himmel über Berlin* (*Wings of Desire*), DVD. Directed by Wim Wenders. Screenplay by Wim Wenders and Peter Handke. Berlin: Road Movies Filmproduktion; Paris: Argos Films; Köln: Westdeutscher Rundfunk, 1987.

Wiesel, Elie. "Art and Culture after the Holocaust." In *Auschwitz: Beginning of a New Era? Reflections on the Holocaust*, edited by Eva Fleischner, 403–415. New York: KTAV, 1977.

———. "Words from a Witness." *Conservative Judaism* 21 (Spring 1967): 40–48.

Williams, Paul. *Memorial Museums: The Global Rush to Commemorate Atrocities*. Oxford: Berg, 2007.

Wischnitzer, Rachel. *The Architecture of the European Synagogue*. Philadelphia: Jewish Publication Society of America, 1964.

Wise, Michael Z. *Capital Dilemma: Germany's Search for a New Architecture of Democracy*. New York: Princeton Architectural Press, 1998.

Woods, Tim. *Beginning Postmodernism*. Manchester: Manchester University Press, 1999.

Yad Vashem: The Holocaust Martyrs' and Heroes' Remembrance Authority. "Dedication Ceremony at Yad Vashem for Torah Scroll Written in Memory of Israeli Astronaut Col. Ilan Ramon; Scroll to Accompany Israel Defense Forces Delegations to Poland. October 13, 2003." Accessed May 17, 2013. http://www1.yadvashem.org/yv/en/pressroom/pressreleases/pr_details.asp?cid=483.

———. Martyrs' and Heroes' Remembrance (Yad Vashem) Law. Accessed May 17, 2013. http://www.yadvashem.org/yv/en/about/pdf/YV_law.pdf.

———. "The World That Was." Accessed May 16, 2013. http://www.yadvashem.org/yv/en/museum/gallery01.asp.

Yerushalmi, Yosef Hayim. *Zakhor: Jewish History and Jewish Memory*. Seattle: University of Washington Press, 1982.

Young, James E., ed. *The Art of Memory: Holocaust Memorials in History*. New York: Jewish Museum/Prestel-Verlag, 1994.

————. *At Memory's Edge: After-Images of the Holocaust in Contemporary Art and Architecture*. New Haven, CT: Yale University Press, 2000.

————. *The Texture of Memory: Holocaust Memorials and Meaning*. New Haven, CT: Yale University Press, 1993.

Zahavy, Tzvee. Online Soncino English Babylonian Talmud. Talmudic Books. Accessed May 16, 2013. http://halakhah.com/pdf/zeraim/Berachoth.pdf.

Zelizer, Barbie. *Remembering to Forget: Holocaust Memory through the Camera's Eye*. Chicago: University of Chicago Press, 1998.

Zolberg, Vera L. "Contested Remembrance: The Hiroshima Exhibit Controversy." *Theory and Society*. Special issue, *Interpreting Historical Change at the End of the Twentieth Century* 27, no. 4 (1998): 565–590.

INDEX

ABOUT THE AUTHOR

JENNIFER HANSEN-GLUCKLICH teaches German language, literature, and culture at the University of Mary Washington in Fredericksburg, Virginia. She received her PhD in Germanic languages and literatures from the University of Virginia in 2011 and has been the recipient of a German Academic Exchange Service (DAAD) Fellowship and a Diane and Howard Wohl Fellowship at the Center for Advanced Holocaust Studies, United States Holocaust Memorial Museum.